The New Art History

The New Art History provides a comprehensive introduction to the fundamental changes which have occurred in both the institutions and practice of art history over the last thirty years. Jonathan Harris examines and accounts for the new approaches to the study of art which have been grouped loosely under the term 'the new art history'. He distinguishes between these and earlier forms of 'radical' or 'critical' analysis, explores the influence of other disciplines and traditions on art history, and relates art-historical ideas and values to social change.

Structured around an examination of key texts by major contemporary critics, including Timothy Clark, Griselda Pollock, Fred Orton, Albert Boime, Alan Wallach, and Laura Mulvey, each chapter discusses a key moment in the discipline of art history, tracing the development and interaction of Marxist, feminist, and psychoanalytic critical theories.

Individual chapters include:

* Capitalist modernity, the nation-state, and visual representation
* Feminism, art, and art history
* Subjects, identities, and visual ideology
* Structures and meanings in art and society
* The representation of sexuality.

Jonathan Harris is Senior Lecturer in the School of Architecture at Liverpool University. He is the author of *Federal Art and National Culture* (1995), co-author of *Modernism in Dispute: Art Since the Forties* (1993), and co-editor of *Art in Modern Culture* (1992).

The New Art History

A critical introduction

Jonathan Harris

London and New York

First published 2001
by Routledge
11 New Fetter Lane, London EC4P 4EE

Simultaneously published in the USA and Canada
by Routledge
29 West 35th Street, New York, NY 10001

Routledge is an imprint of the Taylor & Francis Group

© 2001 Jonathan Harris

Typeset in Sabon by Florence Production Ltd, Stoodleigh, Devon
Printed and bound in Great Britain by St Edmundsbury Press,
Bury St Edmunds, Suffolk

British Library Cataloguing in Publication Data
A catalogue record for this book is available from the British Library

Library of Congress Cataloging in Publication Data
Harris, Jonathan (Jonathan P.)
 The new art history : a critical introduction / Jonathan Harris.
 p.cm.
 Includes bibliographical references and index.
 1. Art–Historiography. 2. Art criticism–Social aspects–History–
 20th century. I. Title.
N7480 .H37 2001
707'.22–dc21 2001019752

ISBN 0–415–23007–1 (hbk)
ISBN 0–415–23008–X (pbk)

Contents

List of illustrations ix

Acknowledgements xi

Introduction 1

Aims and readers 1
New, critical, radical, social 6
Terms and texts 10
Readings, meanings, values, and politics 17
Art history, radical art history, and *real* history 22
Notes 28

1 Radical art history: back to its future? 35

Prejudices, perspectives, and principles 35
For 'new' read 'old'? 39
Politics, modernity, and radical art history 43
Structure, agency, and art 47
Notes 56
Select bibliography 60

2 Capitalist modernity, the nation-state, and visual representation 63

'. . . no art history apart from other kinds of history' 64
Elements within 'the social history of art' 67
Institutions and ideologies 73
Meanings and materialism 81
Notes 88
Select bibliography 91

3 Feminism, art, and art history 95

Politics, position, perspective 96
Greatness, creativity, and cultural value 100
Ideologies, sexual difference, and social change 106
Modernism, modernity, and feminist art history in the 1990s 113
Notes 123
Select bibliography 126

4 Subjects, identities, and visual ideology 129

Psychoanalysis and radical politics after the 1960s 130
Self, sex, society, and culture 136
Psychoanalysis and systems of signification 143
Sight, social ordering, and subjectivity 147
Notes 156
Select bibliography 159

5 Structures and meanings in art and society 161

Signs, discourse, and society 162
Marks and meanings 166
Making and masking the 'real' 170
Perception, narration, and 'visual culture' 178
Notes 188
Select bibliography 190

6 Searching, after certainties

193

Beyond subjects and structures	194
Signs, surfaces, and civilisation	196
Politics, culture, and post-modernism	208
Cultivating nature	213
Notes	222
Select bibliography	225

7 Sexualities represented

227

Matter and materialism	228
Semantic/somatic: Charles Demuth and Rosa Bonheur	232
Body heat	241
The matter of ideals	246
Notes	257
Select bibliography	259

Conclusion: the means and ends of radical art history

261

Radicalism in art history and 'identity-politics'	262
Race and representation	267
Somatic/aesthetic/exotic: bodies and blackness	276
'Arguments and values', not 'theories and methods'	285
Notes	288
Select bibliography	290

Index	291

Illustrations

1 Pablo Picasso, *Bottle, Glass and Violin*, 1912 xiv
2 Gustave Courbet, *The Stone-Breakers*, 1849 xiv
3 Cindy Sherman, *No. 13*, 1978 xv
4 Mary Cassatt, *Lydia at the Tapestry Frame*, c.1881 xv
5 Eva Hesse, *Accession II*, 1967 xvi
6 *Venus de Milo*, n.d. xvi
7 Henri Matisse, *Blue Nude*, 1907 xvii
8 Jan Vermeer, *View of Delft*, 1660–1 xvii
9 Jasper Johns, *Untitled*, 1972 xviii
10 Anne-Louis Girodet, *The Sleep of Endymion*, 1791 xviii

Acknowledgements

Three collegiate events in which I participated recently shaped, and considerably sharpened, my sense of the way to order this book and its core argument. Firstly, the conference 'Theory in Art History: 1960–2000', held at the Courtauld Institute of Art in London in October 1999. My thanks go to Eric Fernie, the Institute's director, with whom I organised this meeting, for his continuing support, interest, and warm friendship. In April 2000 I gave a lecture at the Department of Fine Art at the University of Leeds and presented an early version of my, then quite schematic, thinking to very supportive and constructively critical students and staff. Fred Orton and Griselda Pollock, in particular, were generous and welcoming, though reassuringly stringent and forthright in their comments and questions. In July 2000 I gave a lecture at the conference 'Visual Culture in Britain', held at the University of Northumbria in Newcastle-upon-Tyne. This led me to some serious reflection on the complex meanings and legacies of the 1960s.

My colleague and partner in art history at the University of Liverpool, Anne MacPhee, has been much more helpful and supportive than she can probably imagine. Without her commitment to what I thought was worth the effort this book may never have been written at all. David Dunster, also at Liverpool, really gave me the go-ahead. Further afield, I suspect David Craven, at the University of New Mexico in Albuquerque, doesn't realise how significant his friendship and comradeship has also been – over a number of years now. Al Boime, at the University of California in Los Angeles, has been a regular steadying influence as well. Tim Clark's work and his friendship, the latter only geographically distant, has kept me believing in myself in some low times.

Fred Orton has been a close friend and colleague now for more than a decade, in a relationship absolutely unfettered by either the Pennines or postmodernity's attenuations of feeling: solid as a rock intellectually, politically, and a true friend in much adversity. Geoff Teasdale, another adopted Yorkshire lad, artist, and a scholar at Leeds Metropolitan University, has been similarly acute and caring since my earliest days. David Roffe, literally down the road, has never ceased to help me when I've asked for it. Tom and Kate Hills, Mary Hills, and Ivan, too, have played a continuing part.

Jim and Jules, though innocent of their benign influence, have kept me sane and secure, and, indirectly, made me realise the pleasures and relief of rational inquiry, when there has been the time to pursue it. The significance of my other special friend warrants a separate page.

*

Publisher's note: Every effort has been made to obtain permission to reproduce copyright material. If any proper acknowledgement has not been made, or permission not received, we invite copyright holders to inform us of the oversight.

For the Skylark

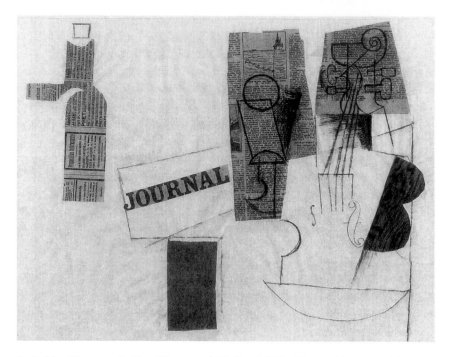

1 Pablo Picasso, *Bottle, Glass and Violin*, 1912. Photo: Moderna Museet, Stockholm

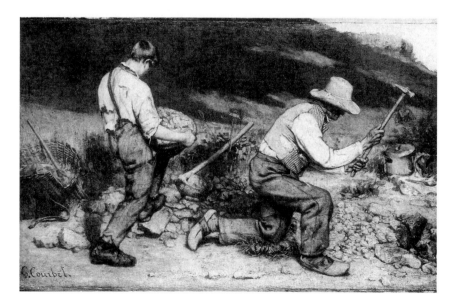

2 Gustave Courbet, *The Stone-Breakers*, 1849. Dresden: Gemäldegalerie Neue Meister

3 Cindy Sherman, *No. 13*, 1978. Courtesy of the artist and Metro Pictures

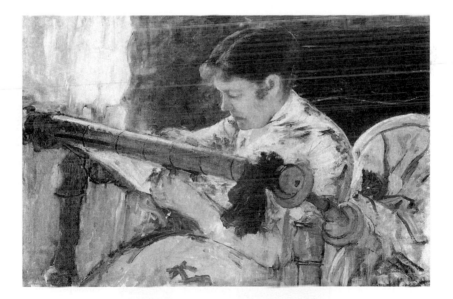

4 Mary Cassatt, *Lydia at the Tapestry Frame*, c.1881. Collection of the Flint Institute of the Arts, Gift of the Whiting Foundation, 1967.32

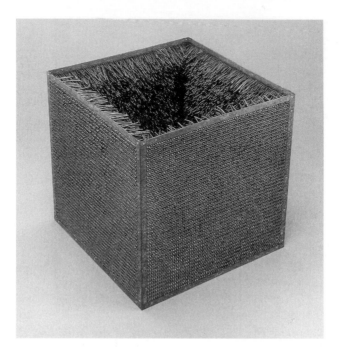

5 Eva Hesse: *Accession II*, 1967. The Detroit Institute of Arts, Founders Society Purchase, Friends of Modern Art Fund and Miscellaneous Gifts Fund. Photograph © 1998 The Detroit Institute of Arts

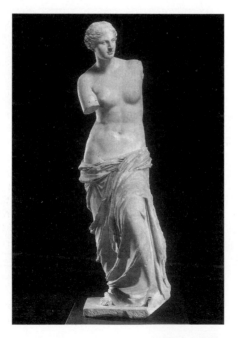

6 *Venus de Milo*, Louvre Museum, Paris. © Photo RMN – Hervé Lewandowski

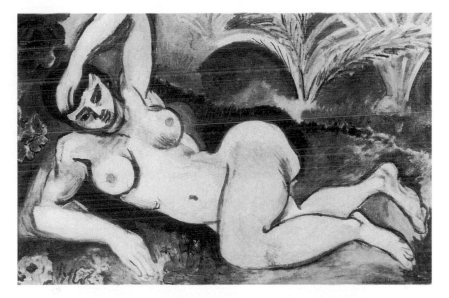

7 Henri Matisse, *Blue Nude* (Souvenir de Biskra), 1907. The Baltimore Museum of Art: The Cone Collection, formed by Dr Claribel Cone and Miss Etta Cone of Baltimore, Maryland. BMA 1950.228

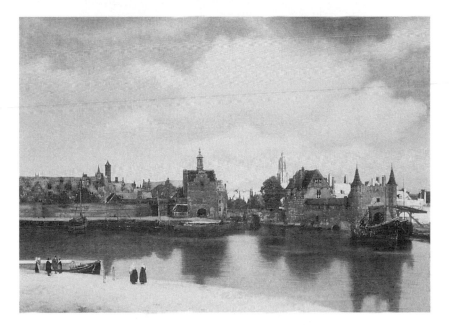

8 Jan Vermeer, *View of Delft*, 1660–1. Royal Cabinet of Paintings, Mauritshuis, The Hague

9 Jasper Johns, *Untitled*, 1972. Courtesy of Rheinisches Bildarchiv, Cologne

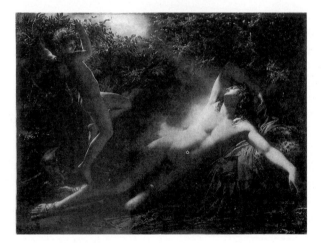

10 Anne-Louis Girodet, *The Sleep of Endymion*, 1791. Louvre Museum, Paris. © Photo RMN – R.G. Ojeda

Introduction

Aims and readers

The discipline of art history has undergone fundamental change over the last thirty years. This book attempts to characterise some of the major aspects of these changes and to provide the outline of an explanation of them. This is a formidable task and my account will necessarily be limited in lots of respects. Nevertheless, my intention is to draw together an account of changes within the intellectual character of the subject with an account of the varying and overlapping 'situations' – institutional, historical, broadly social and political – within which these changes have occurred, in the period since about 1970. Given the relative brevity of this study, kept to this length in order hopefully to attract a readership that is as wide and big as possible, yet also given the ambitiousness of my aim – that is, to provide the beginnings of what might be called a 'social history of art history' since the 1970s – it should be obvious that my choice of themes, materials, and case-studies has had to be highly selective. Indeed, beyond these constituent elements, all my analytic cues (for example, art history 'since about 1970') and basic assumptions (for example, that art history is an identifiable 'discipline' at all, and therefore can be said to have a coherent 'intellectual character') are equally provisional, by which I mean questionable. This study, therefore, is offered as a *contribution* to a developing understanding of the history of an area of knowledge. While I certainly believe my account is true, I recognise that it is based on a particular, contingent focus, related to a set of specific interests, emphases, and arguments that isn't offered, and could not stand, as a full or exhaustive explanation.

1

These qualifications are necessary because I don't want to mislead any of my potential readers about the intended purposes, or possible functions, of this book. I have in mind several different groups of readers who might find my account useful in different ways. One group consists of those studying art history in a formal institutional context – at a university, college, or possibly at high school. I certainly hope that I have provided a compelling account of changes in the discipline and their place in recent social history that will be of value and interest to these students. One of the book's aims is to furnish a kind of contour map of major aspects of recent art-historical study concerned with, for example, visual representations of gender and sexual identity, and to examine the relationship between these art-historical concerns and the emergence, in the same period, of so-called 'new social and political movements', like feminism and gay and lesbian rights activism.

But my study should emphatically *not* be seen as the set 'textbook' or 'course-reader' that provides the Truth, nor as the only resource needed to understand very complex, extensive, and still developing intellectual arguments, scholarship, debate, and politics. It would be ironic if this were to happen, because I try to show that the discipline of art history generally has become much more open, interrogative (questioning), and self-critical than ever before – forcibly challenging, specifically, the assumption of, or belief in, locating a single, unquestionable Truth or History. It is *also* true, however, that academic institutions continue to use art history, like any other academic discipline, as a machine through which to 'process' students in order to 'produce' graduates claimed to be expert in certain skills, knowledge, and ways of thinking. The tensions between the critical intellectual openness of developments in art history and the continuing conservative institutional culture of academia over the past thirty years (related to the functional role of universities in modern capitalist societies) is a major theme within this study.

A second group of readers for whom this book is intended is those who are what might be called the 'operatives' in academia: the teachers who organise and implement the processing of students and produce the graduates in art history. I don't mean to be rude. I am one of the operatives as well, and can see that whatever general attitudes I might *want* to encourage students to adopt – for instance, a questioning of orthodoxy, or a desire critically to consider the place or value of knowledge in contemporary society – at the same time I know that I am inevitably also involved in the work of 'institutional reproduction'. That is, reproducing the discipline of art history, helping

to supply what comes to stand as art-historical Authority and Truth, and producing 'trained' graduates equipped with what appears – to the graduates themselves and to their prospective employers – as fixed, certain, and definitely useful knowledge and expertise. And it *is* right, I think, that students should leave university with confidence in the value and applicability of what they have learnt. But I certainly think it's true that, compared with twenty years ago (when I graduated), the content of that art-historical knowledge and senses of its value and purpose have changed enormously. That change importantly concerns calculations of the *social* value and usefulness of knowledge, and its relationships with broader cultural and historical developments.

The creative, interrogative, and critical scrutiny that, for instance, Marxist and feminist art history has shown over the past three decades significantly emerged out of a slightly earlier 'moment', that around the social and political disturbances of May 1968 that occurred in numerous countries throughout the world. In the riots, demonstrations, strikes, sit-ins, and many other actions which took place in cities such as Paris, one participating group – protesting university students – made it obvious that they clearly *did not* have confidence in the value of what or how they were studying, or in the uses to which that knowledge would be put in the world beyond the lecture theatre. Class and gender politics, then, together with fundamental questioning of the nature of capitalist and imperialist nation-states in the later 1960s and early 1970s acted as a motor for radical developments in art history. The Vietnam War particularly focused opposition to US economic, political, and military power in the world. These campaigns were orchestrated or assisted by radicalised students (and some academics) involved in the 'moment of May 1968' who were determined to pursue directly political and ideological aims, but also related cultural and artistic questions and debate. Such inter-related intellectual interrogation and activism was conceived as a form of struggle necessarily advanced both on the streets *and* in the university seminar room. Both these situations, the participants recognised, were ones where 'real politics', to do with power relations, ideologies, and material interests happened, and where real social change could and should occur. Projected socialist or feminist 'revolutions' – ideas and ideals of a fundamental reordering of social and political life – would have to occur throughout *all* the institutions and social relations within society, including those of academia.

And if Marxists and feminists active outside of academia differed in their understanding of what would constitute an authentic social

and political revolution, and in how such a revolution would or could be brought about, then disputes relating to these different understandings also came to characterise developments within Marxist and feminist art history in the 1970s. Later, other forms of political and ideological activism and intellectual inquiry – based on, for example, questions related to ethnic and sexual identity and representation – also began increasingly to complicate both politics and art history in the 1980s and 1990s. (It is also important to note that often the radical academics and students of art history were themselves part of those groups active *outside* of the university, engaged in pursuing radical social change 'in the society' at large.)

Given that my book is directed at academics as well as students, and is, in a way, 'autobiographical' because it is partly based on my experiences as a university lecturer, I am particularly concerned that my intentions are not misunderstood by my peers. I am profoundly aware that my colleagues in the discipline – all those art historians known and unknown to me – have lived through all or part of this period (and some through many years before it), and are well placed to judge, according to their own experiences, my account of what has happened and why. Radical art history is nothing if not partisan, engaged, and sometimes highly polemical. I hope what I have to say will similarly interest those who teach and produce art history – of all kinds – and encourage them to assess their view of the past three decades, a process which will involve, as it has with me, a valuable reconsideration of their professional lives.

Conceiving the structure of parts and implicit logic to this study has involved attempting to maintain a fine analytic balance. On the one hand, I identify some basic organisational categories and concepts, such as 'Marxist art history' or 'feminist art history' or 'psychoanalytic art history'. On the other, I consider some fluid intellectual 'projects', which represent the development, over a thirty-year period, of internally differentiated and, in some ways, contradictory bodies of work produced by, for example, a single author, or direct partnerships, or a looser tradition of thematic inquiry. 'Categories' and 'projects', however, are not finally mutually exclusive. Categories understood as concepts also change historically, and 'projects' always involve the persistence of certain concerns and values. In this study, 'categories' and 'projects' are really serviceable names for different, but related forms of analytic attention, differentiated ways of bringing something into focus from a particular perspective. These inevitably relate to my own interests and values, which I hope I make clear, though I

approached the writing of this book with the intention of questioning my own ideas as much as clarifying and stating them.

A third group of readers I hope this book will appeal to is those who perhaps have not studied art history formally and certainly don't teach or research it in universities, galleries or museums, or in any other specialist institutional or professional context. This group might include people who do, however, have an interest in art and history, and who regularly watch art programmes on television, who like to visit art galleries and museums or churches, who have art on the walls of their homes, and have read some books about particular artists or art movements. Though parts of the argument I put forward here may be difficult for non-specialists to follow, what I hope will be the generally accessible tone of my account is intended specifically to attract and retain these readers, who perhaps have heard of Marxist art critics and historians like John Berger or T.J. Clark, or of feminists like Griselda Pollock and Lucy Lippard, teachers and authors who have long been associated with political and social critiques of art, art criticism, and art history.

It is often claimed that intellectual developments in the humani ties and social sciences since the 1960s have bred a set of increasingly difficult and technical jargons of analysis intelligible to fewer and fewer initiates. The term 'Theory' has often been used as a synonym for these arcane forms of analysis, and recent 'Theory' in art history has certainly received its share of this kind of criticism. This criticism is sometimes warranted and sometimes not, as I hope to show. The difficulty of some terms and traditions of analysis within art history cannot be avoided, I believe, because the issues that are at stake are undoubtedly complex and require some specialised concepts that should be used in specific and rigorous ways. But the truly radical implication of Marxist and feminist art histories – rich and divergent analyses, that is, of the economic, political, ideological, and aesthetic operation of cultural artefacts and ideas – should be that this knowledge, understood as a set of tools for understanding and helping to challenge and change the social order, is potentially open and valuable to all, not just to those who have studied art history at university level. In order to reach and retain as many readers as possible I have kept my essential arguments in the main text. The notes and 'selected bibliography' sections to chapters contain supplementary material of various kinds: some additional commentary, evidence in the form of quotations, and a substantial amount of reference to relevant bibliographical sources. I recommend that the non-specialist reads my main text and turns to the notes only afterwards, in order to follow up particular points of interest.

The practice and politics of teaching 'theory' in the humanities and social science disciplines within universities, including that of art history, is most crucially a question of accessibility. This is the matter of producing a radical pedagogy appropriate to the social radicalism of the ideas and critiques in radical art history – hard enough, to reiterate, because most universities continue to exist, and are funded primarily, to process students and produce graduates in order to reproduce existing society. But many students, never mind people with a non-specialist interest in art, find the difficulty of recent ideas and arguments a great hurdle to overcome. As someone who, at various points in my life, has been a member of all of these chief reader groups I've identified – the lay person before going to university, the student, and now the academic – I hope I have managed to produce a clear enough argument from which all three groups may learn.

New, critical, radical, social

In my opening section I avoided using the term that may well have drawn you to this book in the first place: 'the new art history'. It is a familiar phrase that has been around for quite a while now, since at least 1982, and probably earlier in informal usage.[1] Though it is an expression that certainly must be examined, because it has become common currency – albeit given very different kinds of value – in this book I will generally use the terms 'radical art history' or 'critical art history' instead, for reasons that I will explain in some detail later in this Introduction and in the following chapter. All three terms, however, imply a negative to them, something *against* which they can be measured and be shown to be superior. 'New', modern, up to date, is set in contrast to 'old', which carries the implication of old fashioned, out of date. 'Critical', questioning, explanatory, is used in contrast to 'unthinking', 'passive' or 'accepting'. 'Radical', fundamental, basic, is opposed to 'peripheral', 'superficial', or 'subsidiary'. In addition, in political terms 'radical' is also used to mean 'extreme', and this can be applied to both left- and right-wing ideas and organisations. (Might there be such a thing, it is worth asking, as right-wing radical art history?) In all these cases the former terms – new, critical, radical – share the sense of meaning *better* and the questions of why, when, and to whom they should have this implication will need to be addressed.

By the mid-1980s, however, the phrase 'the new art history' was the one being most commonly used to name a range of developments

in academic art history related to issues of disciplinary methods and approaches, theories, and objects of study.[2] This set was usually identified as comprising: (a) Marxist historical, political, and social theory, (b) feminist critiques of patriarchy and the place of women within historical and contemporary societies, (c) psychoanalytic accounts of visual representations and their role in 'constructing' social and sexual identity, and (d) semiotic (in Britain, 'semiological') and structuralist concepts and methods of analysing signs and meanings. In contrast, the terms 'radical art history' and 'critical art history' had been used prior to the mid-1980s to designate *only* forms of art-historical analysis linked directly to political motivations, critique, and activism *outside* of the university.

For instance, the German art historians Kurt Foster and O.K. Werckmeister had used the terms 'critical art history' and 'radical art history' in 1972 and 1982 respectively, the latter with an eye specifically to the relationship between Marxist art historical scholarship and anti Nazi activity, coupled with a critique of modern West German capitalist Cold-War society in the late 1960s and 1970s. In broader terms, both Foster and Werckmeister saw themselves as social historians of art, producing analyses of art's ideological role in historical and contemporary societies.[3]

Werckmeister specifically argued that radical or social art history had to be distinguished from *merely* academic, methodological debate in universities. If Marxist critique of society had been intended as an instrument of political practice, he claimed, then Marxist art history could not be 'explained as the advance of a new methodology from within the discipline but must be situated within the larger intellectual and academic movements of that time'. Werckmeister was careful to say, that is, that Marxist art history had authentic roots both *inside* and *outside* the university, in specific institutions and other social organisations within society as a whole. Its emergence into the mainstream of academic debate, however, did not occur until what he called the 'second general and political crisis of late capitalist society, from about 1968 to 1973'.[4]

The term 'social history of art' had also been current from the early 1970s and was effectively another synonym for radical or critical art history. Its use then was related particularly to the work of T.J. Clark, who explicitly invoked the idea as an available tradition in his 1973 book on Gustave Courbet (discussed in Chapter 2 below). In the later 1970s the phrase was adopted by, or applied to, a range of art historians including, for instance, Fred Orton and Griselda Pollock in

England, and, in the US, Albert Boime, and Alan Wallach and Carol Duncan.[5] Clark had been at pains to point out in a polemical 1974 essay, however, that the tradition of 'social history of art' had earlier precedent in the 1950s' writings of Arnold Hauser (as well as in those of, for example, Ernst Fischer, Francis Klingender, and Meyer Schapiro active in the decades between the 1930s and the 1960s). Indeed, Clark claimed that a number of scholars from the earliest decades of the twentieth century, and some from the nineteenth, formed the richest part of the antecedent tradition upon which social historians of art should draw inspiration.[6]

Though the name 'the new art history' had not then entered the language of art historians, Clark, like Werckmeister, saw what danger a purely academic and specialist notion of art-historical development – 'hot-foot in pursuit of the new', he said – would imply. Identifying two art historians, Alois Riegl and Max Dvořák, as 'the really important historians of the nineteenth century', and calling the scholarship of Aby Warburg, Heinrich Wölfflin, Erwin Panofsky, Fritz Saxl and Julius von Schlosser the discipline's 'heroic phase' of development, Clark claimed that contemporary practitioners had neglected that phase's fundamental concern 'with the conditions of consciousness and the nature of representation'. Instead they had reduced the ongoing debate and arguments of these pioneering scholars to a matter of mere 'methods' – formal analysis and 'iconography', which constituted what he called the modern discipline's 'dreary professional literature'.[7] This preoccupation with formal analysis and hunting for symbols now makes up the mainstream of the discipline, Clark argued, and though this art history is being produced in the present its values and purposes were the opposite to that genuine creative intellectual inquiry identified, by various people, as 'critical', 'radical', or 'social history of art'.

Now, inevitably, some hefty generalisations are made when commentators compete to characterise extensive fields of scholarship in a subject like art history. And each commentator necessarily brings to bear his or her own interests and values upon the discipline, its institutional contexts, and society as a whole. Fred Orton and Griselda Pollock, social historians of art who worked and published together in the late 1970s and early 1980s, drawing extensively on both Marx's own texts and subsequent Marxist traditions of social and ideological analysis, have retrospectively characterised that which they opposed (and continue to oppose) in the discipline as 'the institutionally dominant art history'.[8]

Their point is that this definition does not *just* include the ideas and values, selective traditions, and historical narratives produced in universities by academics and reproduced by students – ideas and values, selective traditions and historical narratives, that is, based on monographs of mostly 'great' male artists, along with the 'dreary professional literature' of formal analysis and symbol hunting identified by Clark. 'Institutionally dominant art history' also includes the organisations, such as museums and galleries that collect, curate, and display art, and the corporations that commission and publish art history books. Orton and Pollock's 1979 study of Vincent Van Gogh, which was intended to offer a critique of the 'Great Male Creative Artist-Genius' idea, and to locate the artist as an actual person in a real social and historical world, was lucky enough to find a publisher. However, Thames and Hudson would not accept Orton and Pollock's proposed title, which it saw as a commercial risk because it seemed too unrelated precisely to the popular Male Creative Artist-Genius myth embodied in the art-historical persona 'Van Gogh'. So Orton and Pollock's study *Rooted in the Soil: A Van Gogh Primer* became Thames and Hudson's *Vincent Van Gogh: Artist of his Time*. Some compromise seems implied in the final title, but Orton and Pollock's point is that art history is as much a matter of money and commodities, in publishing and the dealing-gallery, as a matter of ideas and arguments in lectures and seminars.

If these economic and commercial bases to art history are *not* understood, and the discipline's relationship to these wider social and political processes remains unrecognised or idealised, then claims about the radicalism of developments since the 1970s will be deluding and self-deluding. The term 'new art history' has been seen by social historians of art, therefore, as no less than an 'ideological disarming' of such radicalism's true critical and political potential. Adrian Rifkin, for instance, has claimed that the idea of '"new art history" represented a conceptual policing of the potentially fruitful effects of interdisciplinary disintegrations, as well as a neutralizing into a new disciplinary canon of the politics, feminist or anticolonialist for example, that had driven and determined its development'.[9]

My use here, then, of the terms 'radical art history' or 'critical art history' in preference to 'new art history' is intended to indicate the recognition that since 1970 art history developed forms of description, analysis, and evaluation rooted in, and inseparable from, recent social and political activism, while it also took up legacies inherited from scholarship *and* political activism from much earlier times in the twentieth, and nineteenth centuries.

Terms and texts

The chapters that follow this Introduction offer a continuous argument about the relations between forms of radical art-historical analysis and their socio-political contexts of emergence and continuing interaction. My first chapter examines in further detail the distinctions drawn between 'old' and 'new art history', or between 'institutionally dominant art history' and radical art history. It concludes with a short case-study intended to highlight key issues in the book as a whole. This is based on a dramatisation of contrasting positions which are often identified as 'structuralist' and 'Marxist', represented here in discussion of a highly influential essay by Rosalind Krauss from 1980 and a chapter from a recent book by T.J. Clark. Both texts offer accounts of Pablo Picasso's cubist period. *Do* these two essays stand diametrically opposed in analytic and evaluative terms? Or could they be shown, in fact, to share a number of assumptions and values in common? It will become clear as the book progresses that, as I've already indicated in the discussion above on the strain between attention to 'categories' and 'projects', many of the themes and problems that both Krauss and Clark address have *always* been interwoven in much of radical art history, though their unravelling and subsequent rearticulation at certain points in the work of specific authors are also highly significant. Chapters 2 to 7 and my Conclusion examine a variety of texts that exemplify this inter-weaving of concepts, arguments, and analytic procedures.

Each chapter's account is based on a discussion of these exemplary essays and books published during the last thirty years. In a few cases I have included examination of texts by authors who have identified themselves not as art historians, but as art *critics* and sometimes art *theorists*. Both these terms signal a range of differences from usual notions of the *art historian* and of *art history*. One way in which the discipline has fundamentally broadened since 1970 has been to include, within both teaching curriculum and research activities, forms and objects of study which would not have been recognised to be within the 'canon' of traditional art-historical study before the 1970s. We shall return many times in what follows to the definition and problems of the canon – that is, the set of artefacts deemed worthy of study, and by extension, those forms of study equally regarded as legitimate within the discipline – and to the ways and contexts in which canons are assembled and maintained.[10]

I have chosen to discuss only those texts that I think have value, though it will become clear that I have defined value differently

depending on the text under consideration. 'Value' here is largely synonymous with 'exemplary' and I discuss some of the complexities of this notion below. The meanings and problems of exemplarity are important because I made a key decision that this book would be based on the evidence of actual texts, rather than on the generalisations or characterisations that I could have concocted to stand for the kinds of analysis examined. Such characterisations sometimes clearly have pedagogic uses, and it may be the case that I appear anyway to extrapolate from the texts considered, and therefore generalise at certain points in my study. Perhaps a certain amount of this is unavoidable and necessary. But my study is offered as a work of history, as I've said (the beginnings of a social history of art history), and I think the use of texts that have exerted actual historical significance in a number of ways over the period strengthens the historical basis of my argument. Now it is true that the concept of history *itself* has been subject to extreme scrutiny by generations of scholars in many fields since the 1960s, particularly in relation to questions of the nature of *truth* and *reality*. Aspects of these debates will make numerous appearances in what follows. My decision to base this book on actual texts written by real authors (thirty-seven considered in some detail, to be precise) indicates, as I've already made clear, that whatever claims I make necessarily have limited value. This treatment, though, I believe, is more defensible than one that bases judgements on a series of extended generalisations that could be characterised, depending on your point of view, as either compelling *fictions* or groundless *caricatures*.

To say that the texts that I consider in the book are 'exemplary' is really to say that they may be used to *represent* certain things. That is, they are presented here to stand for things absent. By including them here I have made them into representations of those things, though some texts will be used to represent a number of different things. The question of the selection of these texts, and the criteria upon which their selection has been based, raises some of the core problems of 'canon-formation' mentioned above. Likewise, the issue of the *representativeness* of these texts evokes some of the problems art historians, critics, and theorists face when dealing with all kinds of visual artefacts. I acknowledge that these texts have been plundered for my own purposes and, though I strongly defend my interpretations, I hope you will read them all carefully yourself if you haven't already. Indeed, this will be essential to a full understanding of my argument and its possible weaknesses. I do not have the space here to include an exhaustive analysis of these texts, nor to consider fully the treatment of the

artworks discussed by the authors of the texts. You should at least be familiar with the important artefacts examined in each of these texts, a limited number of which are illustrated herein.

What would it mean to say that these are the 'best' texts to have chosen for my purposes? If I had been an 'old' art historian and decided to spend the whole book attacking radical art history on the grounds of its obvious left-wing political bias and inability to recognise the undoubted universality of Great Art, then the 'best' texts to use for this purpose would have been – in terms of their scholarly merit according to the enduring values of academic neutrality and humanism – the 'worst'! In other words, unless criteria are carefully specified, notions of exemplarity remain vague, confusing, and, as in this hypothetical situation, actually contradictory. I think all the texts that I discuss in this study have positive intellectual value; that is, they show various kinds of sustained and rigorous thinking, are very or quite interesting, and are mostly well written. It will become clear, however, that I think some are more interesting, useful, and valuable than others! The nature of my intellectual and political perspective should become reasonably clear, given that I have based my account on what I would define and embrace as 'historical materialist' principles concerned to explain *the rootedness of all art and art-historical ideas and values in material social life*. I develop this notion in the chapters that follow. Marxist art historians have always drawn on historical materialist philosophy developed by Marx himself – though clearly in differing ways and to differing degrees related to specific social, political, and ideological contexts, some of which I examine below. At any rate, it should be clear that I see all of radical art history through the 'window' of this philosophical outlook.

Are the texts that I have chosen exemplary in the sense of representing certain distinct forms or traditions of analysis? Some, for instance those texts by T.J. Clark and Griselda Pollock, have come to be seen as 'models' of a certain kind of radical art history – 'Marxist' and 'feminist' respectively. I am less certain about this sense of exemplarity. It is true that Clark's early book on Courbet draws on versions of Marxist 'ideology critique', and that Pollock's discussion of the relationship between feminist and Marxist theoretical concepts ('Vision, Voice and Power: Feminist Art History and Marxism', first published in 1982) invokes longstanding ideas and arguments in socialist and feminist thinking. In that sense these texts could be said to *reflect*, *embody*, *instance*, or *exemplify* intellectual traditions (all these terms have particular nuances). However, these texts are certainly not

reducible to these generalised 'traditions', and it could be argued that later texts by Clark and Pollock have become much more idiosyncratic, even independent of tradition. Clark's essay on cubism is a case in point.

Though the texts discussed here contain terms, concepts, and forms of argument that could be placed within broader intellectual traditions they *all* also have an irreducible specificity recognisable once a 'close reading' of them has been performed. Many of them also contain concepts and forms of analysis appropriated from other disciplines and traditions in the humanities and social sciences, and so could be said to stand as examples of the 'multi-' or 'interdisciplinarity' Rifkin identified as the basis of radical art history. However, the ability convincingly to interweave hitherto disparate analytic forms is rare and the texts discussed here that achieve it cannot be made to exemplify any general principles or procedures claimed to be present in facets of radical art history. The selection of these texts for discussion here might be taken to indicate, however, that their arguments and evaluations could or should become models for future work. Anthologies in art history, popular as a means of representing new, critical, radical, and social art history since the late 1970s (as well as an inexpensive way for university libraries to deal with ever-expanding curriculum demands), have represented their texts in all of these ways, and in others. In their own way these anthologies themselves comprise particular versions, more or less tacit, of the history of recent art history, criticism, and theory.[11]

I also made a conscious decision to structure this book around texts and their arguments rather than primarily around an account of artefacts (for instance, a selection of paintings, prints, sculptures, photographs, and mixed-media pieces). This approach could certainly be a rewarding means of achieving a similar set of aims and objectives and I do consider some artefacts in each chapter. But my chief interest is in the discussion of forms of art-historical, critical, or theoretical analysis related to broad intellectual currents and their historical significance in social and political life within the twentieth century, particularly in the period after World War II. I am happy, on the whole, to live with the accusation of 'intellectualism' should anyone wish to throw it at me. But I think the injunction – formulated in sometimes crude and sometimes quite complicated ways – that scholars should address themselves primarily, simply, and wholeheartedly to something called 'the works of art themselves' misses some very important points.[12]

It is not only that any, and all, forms of 'attention to', or 'description' or 'seeing of' artefacts require mediating language, ideas, values, and conventional means of communicating this desired communion

13

with the work of art. Some radical art historians who do the most careful looking, including T.J. Clark, Svetlana Alpers, and Fred Orton, are well aware of the intellectual prerequisites for such 'attention to the visual'. It is also a question of considering the assumed nature and role of pleasure and satisfaction in 'looking' and 'seeing', and the wider pleasures and profits associated with intellectual labour in general. For radical art historians it has also been a case of weighing up the pleasures, profits, and, unfortunately, pains of activism in and outside of the university. In the early 1970s pleasure became a sensation, idea, and value put under critical scrutiny by art historians and theorists, such as Laura Mulvey, whose extremely influential essay on the pleasures, profits, and losses possible in looking at Hollywood films, is discussed in my fourth chapter.

In the highly politicised context of university study and research, but also in the Women's Movement broadly around the world after May 1968, questions started to be asked about *who* had *what* kind of pleasure looking at *which* visual representation, to the benefit or exploitation of *whom*? John Berger's 1973 television series and book *Ways of Seeing* brought this debate into a broad public realm for the first time.[13] Not long after this the question of the 'pleasure of theory' also began to be considered: maybe for some – perhaps, indeed, for me – the study, practice, and pleasures of analysis came to equal, even surpass, the study, practice, and pleasures of looking at art! If that were the case then how might this development be related to the radically changing class, gender, and ethnic composition of art historians and theorists in the period since the 1970s? Many of these (myself included) had been brought up on television, film, and video, rather than on traditional paintings, prints, and sculptures found in the parents' homes or art galleries and museums frequented by earlier generations of scholars. In addition, was the development of 'media studies' and 'cultural studies' in the late 1960s and 1970s – discussed in my Conclusion – partly, but importantly, consolidated by a new generation of potential art historians who decided to 'vote with their feet', believing that scholarly activity found a more compelling social and political relevance in the study of advertisements and the wider 'visual culture' of contemporary modernity?

Certainly senses, degrees, and notions of pleasure and satisfaction have an important place in *all* forms of scholarship concerned with looking at visual representations, whether this is acknowledged by authors or not. A range of these senses, degrees, and notions can be found as much in the work of radical art historians (often misrepresented by

their critics as having no interest in 'aesthetic qualities' at all) as in all other kinds. I suggest a tripartite structure of sensibilities which I invoke at various points in this book: there are the scopo*centric* (those who believe they ground their analysis on the act of looking), the scopo*phobic* (those determined to avoid looking altogether, or who find reasons endlessly to defer it), and those somewhere in the middle – where I place myself – the scopo*sceptic* (those who want to see looking at art as much as an historical as a personal activity). Pleasure has links to other key concepts, discussion of which recurs below; these include notions of *quality*, *creativity*, and of course *art* itself, which again attract a very wide range of uses and critiques in radical, as well as in 'institutionally dominant', 'mainstream', or 'old art history'.

A number of other criteria governing the selection of texts discussed here should also be acknowledged and all of these relate to different aspects of their representativeness. As I stated at the outset, one of my most important 'analytic cues' is the demarcation of the historical period under scrutiny: art history 'since about 1970'. I explain in more detail the reasons for the choice of this date below. Accordingly, all of the texts I examine in detail were originally published (if not conceived or written) around that date. Though I argue that radical art history comes substantially out of 'the moment of May 1968', and that its emergence then has organic roots in the 'New Left' politics of 'critical Marxism', anti-imperialist political organisations, and the rise of the Women's Movement, some of its intellectual features, as Clark claimed in 1974, can be traced much further back.

The New Left developed across all of Western Europe and North America, and in other parts of the world as well.[14] Correspondingly, forms of radical art history – with varying emphases and to different degrees – were generated in many of these countries during the 1970s. I have already mentioned, for instance, the political and historical significance of the re-emergence of Marxist art history in what was then West Germany. This study, however, concentrates on developments in the US and Britain, and all the texts considered were written in English, or translated into it, for publication. Even the texts originally written in languages other than English, such as that by Mieke Bal, have, arguably, had their main significance and influence within the debates of what I shall call 'Anglo-US' radical art history. However, I do not intend, through my selection and discussion of English language texts, to suggest the marginality of the work of radical art historians active in many other countries throughout the world, some of whose texts I make reference to in my notes.[15] This study is in no way offered, then, as a

'survey' that might claim or imply any kind of comprehensiveness or neutrality in terms of coverage: such a claim would be no more plausible in the context of my aims than it is when used, as it still often is, to defend 'survey courses' of art history offered to university students.[16]

I have tried to find a balance between discussing essays and books, and between considering essays published in journals and edited collections. This is a balance between examining succinctly stated arguments in essays that have significantly influenced developments in radical art history over the period (some journals, such as *Block* or *October*, were also important catalysts), and considering sustained studies that allow a method of analysis to be more fully demonstrated.[17] I have tried, through my selection, to indicate a flavour of the kinds of writings and places in which radical art history found a voice, but, again, I make no claims as to its comprehensiveness.

Most of the texts were written by either US or Britain-based authors, but the distinction is complex and arguably has broken down to some degree since the 1970s when relatively cheap and quick transatlantic flight became possible for the first time. In some ways, however, the distinction between US and British radical art history and art theory was, and still remains, highly significant. Lucy Lippard's text (discussed in Chapter 3), for instance, is partly concerned with the different intellectual, social, political, and *feminist* cultures operative in US and British society in the late 1970s and the early 1980s. One feature of academic demography since the end of World War II has certainly been the 'brain-drain' of European academics to permanent jobs in North America and this has also influenced radical art history's development (though there has been a certain amount of traffic the other way as well). T.J. Clark, Dick Hebdige, John Tagg, and Victor Burgin, all of whose work is represented here, joined this migration.[18]

Most of the texts were also chosen because they involve discussion of what are usually called the 'empirical objects' of art-historical study and I want the reader to be able to assess the claims of the authors I consider, and the claims I make, in relation to their *own* knowledge of such 'empirical objects'. Running the risk of repetitiveness, it is very important to remind readers that they should familiarise themselves with the texts directly and with their discussion of these objects. By the term 'empirical objects' I don't just mean visual representations, such as paintings, sculptures, films, photographs, and advertisements (though a selection of these is included). Art historians are also concerned with the study of *producers* (in one sense this is a more neutral term than 'artist'), *patrons* and other intermediaries, *styles* of visual representation and

group formations, as well as museums, galleries, and other kinds of organisation that have been involved in the broad culture of art's production, dissemination, and consumption.[19] I have chosen some texts that focus discussion on these, and other phenomena, though there is no agreement that they are all equally 'empirical', much less significant in the same way that most traditional scholars would agree that a painting or sculpture constitutes the primary object of their study. Acts of description and forms of analysis are inseparable from senses of value and pleasure in *seeing* these phenomena at all, *and* in seeing them as worthy of consideration. If the notion that the 'works of art themselves' have axiomatic qualities has been thrown into fundamental doubt because it is recognised that *any* act of description or analysis is necessarily partial and preferential, then equally doubtful now should be the idea that all art historians should properly involve themselves with artefacts instead of, for example, the study of institutions such as art galleries or government funding bodies.[20]

Radical art history also has a 'meta-discursive' dimension, though, concerned with the exploration of abstract ideas, though these usually have a bearing – which sometimes may appear tenuous – on 'empirical' phenomena and the social world in general. 'Theory' has become one name for this inquiry within radical art history, but the users of the term, and the uses to which it has been put, have varied enormously during the period in question. According to some critical commentators, 'Theory' has become a detached and idealised practice in itself, not a constituent element of radical art history but a right-wing invention used as 'a major means of disarming' it. In contrast, theor*ising*, the sociologist Stuart Hall remarked, is a necessary part of any critical intellectual project, but should not become an end in itself.[21] Because I am in agreement with this view I have included consideration of some texts here that are mainly concerned with abstract analysis. Radical art history has always needed and carried out this work of theoretical clarification and debate, often at high and therefore difficult levels of analysis. I examine the nature and functions of both 'Theory' and processes of theorisation at various points in the chapters to come.

Readings, meanings, values, and politics

Any work of history has to have its evidence. The thirty-seven texts I consider here are the primary evidence for my account of the development of radical art history and assessments of its credibility will

depend in large part on readers having access to that material themselves. Most of these texts, in turn, obviously use the evidence of the 'works of art themselves'. But much of art history, and radical art history, simply isn't available for scrutiny as these texts and artworks are. 'Art history' tends to be used to mean that which is *published* or otherwise available in permanent or documented form. This would include, as well as art-historical texts, catalogues of artworks and television programmes, which are often recordings of the exhibition of artworks in particular places at particular times.[22] All forms of museum and gallery displays of artworks are also art-historical phenomena because they inevitably select, order, account for, and judge artworks in all the ways that art historians writing essays and books do. These exhibitions are thus also part, at least potentially, of the history of art history. The collective labour that goes into the conception, planning, and realisation of such endeavours, and all the conversations held by people about the process (as well as their private thoughts in front of the works), *might* count as evidence of art-historical activity if such phenomena were seen as valuable and could be retrieved – that is, made into *available* documentation – and interpreted.

Similarly, and quite significantly, the work conservators do cleaning, repairing, and sometimes radically reconstructing artefacts is also 'art-historical' because these tasks, which might appear to be wholly neutral and value-free, always involve a set of assumptions and judgements – openly stated or tacit – about how an artefact did or should 'look' and therefore what, in a primary sense, it *is*. Some highly controversial cases have occurred, such as the restoration of the Sistine Chapel ceiling, when dispute broke out openly between factions of art historians over the 'correctness' of restoration, both on matters of principle and specific practice.[23] But *all* conservation and restoration is art-historical in the sense I've identified above, whether it generates controversy or not. These practices, too, might, and sometimes have, become evidence within a history of art history.

A third area of what might be called 'non-transcribed' art history concerns the teaching of the subject, which would include all the lectures and seminars, course outlines, essay and examination questions and answers, slide tests, and much else that are produced in schools and universities. Once again, these activities undoubtedly have potential historical significance if evidence of them could be gathered and analysed. Although the examples of museum exhibition and conservation practices do relate to the concerns of radical art history (as some of the texts I examine concerned with displays of visual representations

indicate), the activities of all art-historical pedagogy have particular significance for my study.

I will briefly mention two aspects of its relevance here. The first, as I've already suggested, is that the emergence of radical art history was related to quite dramatic changes in the social composition of both students of the subject and academics who taught and researched it in universities. In the US and Britain since the 1960s a great expansion in higher education occurred which brought in many more lower middle class, working class, women, and non-white students. Significant numbers of these were politicised, initially, by 'the moment of May 1968', and then by involvement in continuing social and political radicalism in British and North American societies throughout the 1970s and beyond. Their cultural backgrounds and experience, relating, for instance, to factors of class, gender, and ethnicity were in sharp contrast to that of the narrow elite of upper-middle, mostly male and white people who had been able to study at universities before the 1960s' expansion. This did not mean that the new constituencies of students and later academics automatically shifted their interests and pleasures away from the traditional paintings, drawings, prints, and sculpture of art-historical study. It *did* contribute, however, to radical art historians mounting very different arguments about the nature and value of these, and other, artefacts, and to their art-historical analysis being linked to the political projects of the New Left and other new social movements in the 1970s and 1980s. And some of these politicised students and academics *did* decide, as I've already said, to shift their attention, all or part of the time, and for a variety of reasons, to the 'mass media' and the new fields of cultural studies and design history. I was one of these.

The second aspect, also already touched upon, concerns the relations between radical art history's theoretical complexities and their relation to teaching. This was and is, inevitably, a question about institutions and the social relations they generate. In the later 1960s socialists and feminists began to analyse the role of universities in reproducing both capitalist and patriarchal society. Universities were seen as hierarchical, paternalistic, socially excluding 'knowledge-factories' involved in maintaining all the forms of exploitation that the student demonstrators of May 1968 had set out to highlight and disrupt. But these institutions were also, comparatively speaking, 'liberal' and *relatively* open institutions that had already begun to open their doors to many who were previously excluded. The doors had opened partly because governments saw that they needed a more highly trained and

bigger professional workforce to oversee the boom in western capitalist societies. But the expansion allowed new social groups to study all the disciplines taught in universities, including art history, which grew in student, staff, and department numbers very significantly during the 1970s and 1980s.

Radical art history developed within this expansion of art history generally, in Britain, for instance, specifically at the University of Leeds and Middlesex Polytechnic during the late 1970s and early 1980s. The former initiated its masters programme in the Social History of Art in 1978 and the latter provided the intellectual and material resources for the launch, in the following year, of the influential journal *Block*.[24] Many other institutions in Britain and the US followed in establishing social history of art and feminist courses at under- and post-graduate level. There has always been a tension, if not a direct antagonism, however, between the intellectual and political radicalism of these currents and the conservative culture of university institutions, which are still – perhaps now even more – functional within the reproduction of capitalist and patriarchal society, and generally remain, despite some significant internal reforms, quite closed, hierarchical, and authoritarian.[25]

The arcane complexities of abstract theorising in radical art history and other humanities disciplines, if not thought through very carefully in terms of pedagogic practice, can mirror this exclusiveness. Without this planning the radical intent and implication of these forms of analysis can be lost, or worse, be experienced as actually oppressive.[26] Given the general decline in Left and feminist activism throughout the world in the 1990s – though other forms of oppositional organisation, based on, for example, racial identity and sexual-orientation politics, have grown in the same period – there is a real danger that radical art history might become simply another academicism, largely unconnected to the world outside. If this were to happen radical art history would be little different, in character and implication, from that ideological entity identified by its critics (myself included) as 'the new art history'.

The ironies in this predicament were perhaps summed up in the announcement by Buckingham Palace in 1999 that the future British monarch, Prince William, might begin an undergraduate degree in art history at the University of Bristol. If deciding to refuse a place at an Oxford or Cambridge college was not in itself sufficient indication of the Palace's 'modernising' intent, then the choice of art history taught in a decidedly 'modern way' clinched the matter. The Dean of Arts at

Bristol was reported as saying that art history there had 'changed over the past twenty years. It is no longer studied in terms of purely artistic progression or influence. Now, every effort is made to help students put works into their historical and social context and see how their meaning is affected by markets, changing taste and different approaches such as feminism.' It was also reported, though, that Prince William would not be socially isolated at Bristol, as the university had many of the 'Sloane contingent' students (upper-class Londoners) who were the 'right sort' for the future king to mix with.[27]

So, radical art history can find itself being taught in one of the most exclusive and excluding contexts (the University of Bristol in the late 1990s had one of the highest proportion of undergraduates from private schools of all British universities), this despite, of course, the wishes and hopes of its proponents. But the social history of radical art history must include recognition of the actual, as well as the intended, situations in which its protagonists found themselves at the end of the 1990s, situations far distant in most respects from those hoped for within the optimism of the late 1960s and early 1970s.

To recapitulate then. I have identified radical art history as the appropriate name for a set of interacting currents of work in art history produced after 1970, genetically related to the 'moment of May 1968' and the emergence of the New Left, and concerned to produce social and political accounts of art and culture. Marxist and feminist radical art historians (particularly the latter) also devoted a good deal of their time to examining and denouncing contemporary mainstream or 'institutionally dominant' art history, as Fred Orton and Griselda Pollock called it. My account seeks to explicate several aspects of radical art history in the chapters that follow through analysis of specific texts and their relationship to the social history of the period. The character and role of university institutions – particularly their tendency to package knowledge, 'process' students, and reproduce hierarchical structures – is one very important context in which radical art history had, and continues, to operate. Another concerns the changing relationship between Marxist and feminist art history and the fortunes of socialist organisations and the Women's Movement (now generally renamed 'Feminism') in Britain and North America over the last thirty years. A third context, which O.K. Werckmeister and T.J. Clark both alluded to in essays written over twenty years ago, is the matter of the influence upon radical art history of a variety of rich and diverse intellectual traditions in literary, linguistic, philosophical, historical, and other studies.

Fred Orton and Griselda Pollock had this influence particularly in mind when they said in their critique of the notion of 'the new art history' that what was 'good about it was not new'. And, in agreeing with Rifkin's view that the term functioned as a form of 'ideological policing', that what was 'new about it is not good'.[28] Though many essays and books published in the 1980s and 1990s have attempted to characterise aspects of radical art history, usefully drawing out particular strands, none have been concerned to place them squarely in the social history of the period or, to put it in another way, to study them, their authors, and their institutional situations as an example of what Raymond Williams called 'the historical sociology of culture'.[29]

Art history, radical art history, and *real* history

A prevalent caricature of the social composition of art history's scholars and students before the 1970s, in Britain at any rate, represents them as upper-class, 'amateur' gentlemen, concerned mainly with appreciating the good taste of the paintings on the walls of their own, or parents', drawing-rooms. Allied to this view is the judgement that there was little or nothing that was intellectually serious about this dilettante pursuit of pleasure in the university. Whatever the relationship between this caricature and what may be established as sociological fact in terms of the backgrounds of students and academics at universities in Britain and the US during the period before the 1960s' expansion of higher education, significant numbers of scholars in other disciplines, including that of history proper, appear to have accepted this dismissive image.

Hayden White, for instance, influential US historian and 'metahistorian' (concerned, that is, with the history of the discipline of history and analysis of its discursive forms), reportedly 'chided art historians with tongue-in-cheek comments about his "coming from the side of campus where *real history* is taught", which he distinguished from the "slide shows to young men and women ripe for a European tour"'.[30] Such scepticism regarding the defensibility of art history's procedures as a form of *historical* inquiry certainly was a significant aspect of the critique of the discipline mounted by radicals who joined its scholarly ranks from the late 1960s onwards. They agreed with Clark and others who saw, in the poverty of thinking and analysis characterising the contemporary practice of mainstream 'institutionally dominant art history', a gross disjunction between such 'dreary professional

literature' and the seriousness of the heroic phase associated with the work of Wölfflin, Riegl, Dvořák, and others.

Yet history, as an academic discipline, as I've remarked, also entered a phase of great and continuing self-scrutiny at about the same time that art history found itself under interrogation by, for example, Marxists and feminists in the universities. In other words, radical art historians began – justifiably, of course, though perhaps somewhat iron-ically – to challenge the validity of art history's *history* at the moment when any and all of history's apparent certainties had already become, or would soon be, subject to critique from scholars of many different antagonistic intellectual and political affiliations.

It is true that, on the one hand, the early 1970s saw, for example, the entrenchment of a school of Marxist history committed to the belief in the objectivity and scientific basis of analysis anchored theoretically in the work of the French philosopher Louis Althusser. This had gener-ated an art-historical variant in the work of scholars such as Nicos Hadjinicolaou, whose essays and influential book made cogent criti-cisms of the poverty of mainstream contemporary art history's forms and assumptions.[31] But other wings of radical art history – I'm thinking of feminist writers in particular – though sometimes highly sympathetic to historical materialist precepts, and prepared to acknowledge that class struggle was a principal part of historical development, assertively shifted attention to other questions and issues relating, for instance, to gender and identity-formation and to the structures that they believed constituted and maintained patriarchal society. Other feminists, some identified or identifying themselves as 'separatist', saw no value what-soever in Marxist history or art history, and, for that matter, sought no pact with socialists outside the academy.[32] (I try to do justice to some of these varying and complex arguments and positions below.)

Still other scholars, developing an interest in art history, some from a base in English studies or anthropology or linguistics, began to mount a critique of art history (and later of radical art history as well) from positions based on principles and forms of analysis now usually, and loosely, called 'post-structuralist' and 'post-modernist'. Several of the chapters that follow deal with work placed within these difficult and shifting categories, linked as they also are to earlier arguments identified as 'structuralist' and to later positions called 'post-colonialist'.

To reiterate a point which I may have already laboured, I have had to wrestle here with both some necessary organising categories, such as these, and with representing intellectual projects and processes that have developed over years and decades which have come to include,

in complex ways, many ideas, methods, and arguments associated with *all* of these terms and traditions of thought. Griselda Pollock's work is a case in point. The fact that she has always seen herself as a feminist first and foremost perhaps only further complicates the story I aim to tell. In fact, Marxist *and* feminist scholars since the beginnings of radical art in history in the early 1970s have always used, and – in that using – revised a myriad of analytic tools and procedures for understanding art and visual culture, often coupling what are sometimes dismissed as *merely* academic procedures such as 'deconstruction' with political and social critique in particular ways at particular times.[33] Norman Bryson's, Victor Burgin's, and Nick Green's essays and books discussed below are examples of these couplings.

My own perspective, I've said, is deeply indebted to historical materialist principles and to Marx's description of capitalist society. Later Marxist traditions (for there have been many, often in open or tacit dispute) have produced immensely valuable work preoccupied with, for example, defining the nature and role of the modern state, the function of ideologies and institutions in modern societies, and the relationship between social relationships and culture understood as the ways in which people represent and 'live out' their relation to society. These traditions also formed part of the root-system of my own intellectual formation as an undergraduate student of art history. I rapidly became aware, however, of the problems and dilemmas inherent in this indebtedness because in the early 1980s I wanted to support, for instance, feminist political activism and could see the value of its intellectual critique of both 'bourgeois' history and art history, *and* of Marxist history and art history.

Once one begins to accept the perspectival nature of understanding, indeed through being able to see the validity of another perspective, it becomes difficult – in fact impossible – to defend absolute notions of 'objective' and 'scientific' truth in historical analysis. The proliferation after 1970 of novel forms of political and intellectual critique, based on, for instance, questions of gender and ethnic identity, or sexual orientation, or regional location, or age, or disability, continued to push radical art history further away from the once normative belief in finding the correct, single answer to what was held to be the most important single question. This necessary and desirable 'relative relativism' has also brought the risk, however, of a 'radical relativism': the idea that *all* perspectives should be held to have equal weight, validity, and value. Such a relativism, if shorn of connection to social values and interests *outside* the academy, arguably constitutes

another form of *academicism* – an innocuous game-playing with ideas – alongside that identified by Rifkin, Orton and Pollock as 'the new art history'. All that one does, and can possibly do, in this anarchic market of equivalently valuable perspectives, they might say, is simply compete to find your own 'theoretical voice', in an academic individualist world parallel to that of the 'free market' for commodities outside of the universities.[34]

The danger implicit in recognising the perspectival nature of vision and understanding lies, then, in doing away ultimately with the notion and value of truth. By this I do not mean truth understood as an unquestionable objective knowledge (that sense had to go, I believe), but truth understood as an account of the world, and of artworks within it, that is based on certain assumptions, ideas, and values that can be stated, backed up with evidence as part of an argument, and that therefore remain subject to dispute. Truth or knowledge in this sense has a crucial *heuristic* aspect to it, which opens the claims made to potential revision through experience, argument, and reflection. Such a notion remains based on principles of value that can't themselves finally be 'proved' through experience (for instance, that men and women should have equal rights), but which are still essentially rooted in ethical and social values, that is, connected to a sense of their efficacy within the world – actual, and possible – inside and outside of the academy. Arguably, and worryingly, a 'radical relativism', implying precisely the end of this sense of truth, *has* made inroads into the academy, into the humanities disciplines and into art history, and is represented by the idea, for instance, that we have entered what several art historians, associated with deconstruction, have called a 'post-epistemological age'.[35]

Such developments have complex links to two other related phenomena that will be touched upon in discussion at various points in the chapters that follow. The first is the range of intellectual, institutional, and political positions and practices grouped under the rubric of 'multiculturalism'. This involves a number of relativising positions held by, for instance, artists, art historians, critics, social workers, politicians, state administrators, and others. The second is the connected notion, practice, and critique of what is – usually pejoratively – called 'political correctness' in matters of culture and public policy. Both are highly politicised areas of debate and practice, both intensely visible within university institutions (particularly in the US), and both connected in complex and changing ways since the early 1970s to arguments and debate about identity and representation in radical art history.[36]

25

Maintaining a sense of the 'world beyond' the academy is very important, then, both within radical art history's understanding of its own institutional development, and within its narratives and analyses of art and artists. Notions of 'perspective' and perspectival knowledge are particularly resonant here, along with another linked metaphor, in which society is invoked as 'context', sometimes more crudely as 'background', against which the artworks or other items of visual culture are stood as 'text' or 'foreground'. The perspectivalism of understanding and vision is directly acknowledged in these common terms for the figuring of analytic attention, found as much in the 'institutionally dominant art history' (e.g. 'Van Gogh and his world') as in its radical counterparts. Many radical art historians whose work I discuss below grapple with the problems of 'text/context' formulations in dealing with particular artists or artworks. For instance, Clark does so in the case of Gustave Courbet and the circumstances of his work in Paris around 1848, and Anne Wagner in her treatment of three different women artists, for whom context means both a broader society and the specific situation of marriage, in all three cases, to influential male artists.

However, in recent valuable critical accounts of the principles underlying art-historical practice, by, for instance, Richard Schiff, Norman Bryson, and Mieke Bal (the latter two also represented below as practitioners of art history informed by structuralist and psychoanalytic concerns), both mainstream and some forms of radical art history are charged with seriously neglecting the problems of 'text/context' formulations. The danger is that the metaphor and its variants (e.g. 'background/foreground') often imply the objective 'givenness' of what is always an analytic construction:

> Precisely because it has the root 'text' while its prefix distinguishes it from the latter, 'context' seems comfortably out of reach of the pervasive need for interpretation that affects all texts. Yet this is an illusion. As Jonathan Culler has argued: 'But the notion of context frequently oversimplifies rather than enriches the discussion, since the opposition between an act and its context seems to presume that the context is given and determines the meaning of the act. We know, of course, that things are not so simple: context is not given but produced; what belongs to a context is determined by interpretative strategies; contexts are just as much in need of elucidation as events; and the meaning of a context is determined by events. Yet whenever we use the term *context* we slip back into the simple model it proposes.'[37]

As the reader will perhaps have noticed, in offering this study as the beginning of a social history of radical art history, I have already invoked the 'text/context' distinction several times. Indeed, I am literally concerned first and foremost with texts (the habit of some radical art historians of calling all artworks 'texts' has its own virtues and problems, again discussed recurrently below), which I try to relate to lots of other kinds of materials, some being other texts. All of these other materials I am relatively happy to call 'context', or 'the world beyond', etc., because I hope I have made it plain that these terms operate here as a kind of necessary short-hand in an analysis which must bring certain things into a foreground and leave other things, temporarily, to the *side*, or *behind*. The use of metaphor cannot be avoided: better embrace it, while remaining clear of its constant operation.

I do believe that radical art history's texts only really make sense when understood as part of a social and political history of Western European and North American society since the watershed of the 1960s. Most of the evidence that I provide here, in whatever detail, as part of that history, also has a textual base to it as well, because the historian arguably relies upon such sources more than on any other kind of material to constitute the matter upon which interpretation of the past is based. And that goes for the art historian as well, though this will be disputed by many traditional and radical, 'old' and 'new' scholars, who continue to believe the evidence 'of the artworks themselves' are the primary materials for their *scopocentric* inquiries. I investigate some of the significant agreements and arguments between these scholars, and further problems present in all of these suggestive and polemical oppositions, in the next chapter, in a prelude to dealing at length with the texts and multiple 'contexts', the analytic frames, of radical art history.

It should be made clear, finally, that despite the negative senses there are to terms such as 'the new art history' and 'Theory', I *do* still wish to defend a notion of 'theory' as a necessary part of any serious and critical project. Theory was (and is) needed in this sense both to allow understanding of existing traditions of thought and disciplinary practice – the critique of existing 'institutionally dominant art history' – and to allow us to invent and mobilise forms of argument and procedures of description, analysis, and evaluation required in the formulation of alternatives to the dominant practices.

'Text/context' formulations, arguably part of any radical art-historical practice, are *theoretical* in this sense. That is, they are based on principles of selection, articulated through concepts and values that

have ethical and social roots and implications. To recognise the theoretical sense of any art-historical account is to recognise its provisional, constructed, and therefore potentially revisable nature. Theory understood in this way represents a liberation from imposed orthodoxy, in its pedagogic or professional institutional forms, and is thus a necessary part of a politics for social *and* intellectual change. It also must help to make arcane and possibly socially excluding arguments clear and accessible. My goal in this study then is identical to that of Terry Eagleton's in his *Literary Theory: An Introduction* in the early 1980s:

> I have tried to popularise, rather than vulgarise, the subject. Since there is in my opinion no 'neutral', value-free way of presenting it, I have argued throughout a particular *case*, which I hope adds to the book's interest ... I hope the book may help to demystify those who fear the subject is beyond their reach. Some students and critics also protest that literary theory [or radical art history] 'gets in between the reader and the work' [of art]. The simple response to this is that without some kind of theory, however unreflective and implicit, we would not know what a 'literary [or artistic] work' was in the first place, or how we were to read it. Hostility to theory usually means an opposition to other people's theories and an oblivion of one's own. One purpose of this book is to lift that repression and allow us to remember.[38]

Notes

1 Perhaps its earliest documented usage was as the title (albeit, appended with a question mark) for a conference held at Middlesex Polytechnic, London, in 1982. See Jon Bird: 'On Newness, Art and History', in A.L. Rees and Frances Borzello (eds) *The New Art History*, London: Camden Press, 1986. Norman Bryson used the term as part of his title for a collection of essays published two years later, *Calligram: Essays in New Art History From France*, Cambridge: Cambridge University Press, 1988.

2 See the range of essays, both in support and critical of the notion, in Rees and Borzello *The New Art History*, and Marcia Pointon *Art History: A Student's Handbook*, London and New York: Routledge, 1994 (first published in 1980, second edition 1986), especially Preface and 2: 'Art History as a Discipline'.

3 K. Foster 'Critical Art History, or a Transfiguration of Values?' *New Literary History*, vol. 3, no. 3, 1972: 459–70; O.K. Werckmeister 'Radical Art History', *Art Journal*, Winter 1982: 284–91. British art

historian Adrian Rifkin notes that the 'Art and Society' forum of the regular History Workshop conference, closely associated with socialist organisation and thought, was the place where radical art historians in Britain met in the early 1970s. See 'Theory as a Place', in 'Rethinking the Canon: A Range of Critical Perspectives', *Art Bulletin*, June 1996: 209–12.

4 O.K. Werckmeister 'Radical Art History': 284.

5 T.J. Clark *Image of the People: Gustave Courbet and the 1848 Revolution*, London: Thames and Hudson, 1973; *The Absolute Bourgeois: Artists and Politics in France 1848–1851*, London: Thames and Hudson, 1973; Albert Boime *The Academy and French Painting in the Nineteenth Century*, London and New York: Phaidon, 1971; see the collection of essays by Fred Orton and Griselda Pollock in their *Avant-Gardes and Partisans Reviewed*, Manchester: Manchester University Press, 1996; Carol Duncan and Alan Wallach 'The Museum of Modern Art as Late Capitalist Ritual', *Marxist Perspectives*, Winter, 1978: 28–51 and 'The Universal Survey Museum', *Art History*, December, 1980, 3: 447–69.

6 T.J. Clark 'The Conditions of Artistic Creativity', *Times Literary Supplement*, May 24, 1974. 561–2.

7 Clark 'The Conditions of Artistic Creativity': 561.

8 Orton and Pollock *Avant-Gardes and Partisans Reviewed*: iv.

9 Rifkin 'Theory as a Place': 209. See also Rifkin 'Art's Histories', in Rees and Borzello (eds) *The New Art History*: 157–63; and Griselda Pollock 'Theory, Ideology, Politics: Art History and Its Myths', in 'Art History and Its Theories: A Range of Critical Perspectives', in *Art Bulletin*, March 1996: 16–22 (especially 'Concluding Thoughts').

10 Frank Kermode has pointed out that the original sense of 'canon' referred to biblical scripture given sacred, though infinitely reinterpretable, meanings. See *Forms of Attention*, Chicago: University of Chicago Press, 1985: 76–9. Also see Richard Brettell 'Modern French Painting and the Art Museum', in 'The Problematics of Collecting and Display, Part 2', in *Art Bulletin*, June 1995: 166–9.

11 See, for instance, Francis Frascina and Jonathan Harris (eds) *Art in Modern Culture: A Critical Introduction*, London: Phaidon/Open University, 1992; and Brian Wallis *Art After Modernism: Rethinking Representation*, New York: New Museum of Contemporary Art/David R. Godine, 1984.

12 See Raymond Williams' valuable discussion, and fundamental rejection, of this injunction in *Culture*, London: Fontana, 1981: 119–21.

13 John Berger *Ways of Seeing*, Harmondsworth: BBC TV/Penguin, 1972. See also Vivian Gornick and Barbara K. Moran (eds) *Women in Sexist Society: Studies in Power and Powerlessness*, New York: Basic Books, 1971; and Elizabeth C. Baker and Thomas B. Hess (eds) *Art and Sexual Politics*, New York: MacMillan, 1973.

14 See, for instance, Alexander Cockburn and Robin Blackburn (eds) *Student Power: Problems, Diagnosis, Action*, Harmondsworth: Penguin/New Left Review, 1969; Paul Jacobs and Saul Landau *The New Radicals*, New York: Vintage, 1966; and, for a critical and speculative overview of its intellectual facets, Peter Starr *Logics of Failed Revolt: French Theory After May '68*, Stanford: Stanford University Press, 1995.

15 See, for instance, in Germany Martin Warnke (ed.) *Das Kunstwerk zwischen Wissenschaft und Weltanschauung*, Gutersloh: Bertelsmann Kunstverlag, 1970; and Horst Bredekamp *et al. Frankfurter Schule und Kunstgeschichte*, Berlin: Weinheim V.C.H., 1992; and, in France, Norman Bryson (ed.) *Calligram: Essays in New Art History from France*, Cambridge: Cambridge University Press, 1988.

16 On the radical selection involved in all survey courses see the special edition of *Art Journal*, Fall 1995, edited by Bradford R. Collins, and Robert S. Nelson 'The Map of Art History', in *Art Bulletin*, March 1997: 28–40. Drastic selection is an inevitable condition of all kinds of art-historical work, given the sheer volume of new material published every year. See Michael R. Leaman 'Cultural Value and the Aesthetics of Publishing', in 'Money, Power, and the History of Art: A Range of Critical Perspectives', *Art Bulletin*, March 1997: 11–14. The effective 'balkanisation' (fragmentation) of the discipline into mostly unrelated specialisms and sub-specialisms has increased dramatically in the last thirty years, making the idea or ideal of a single, coherent art history impossible. This balkanisation is related to the growth of both academics and student numbers and has had significant effects on the sociology of the professional art and architecture historian in the US and the UK. It helped bring about the end, for instance, of what Hans Belting in *The End of the History of Art?* (Chicago: University of Chicago Press, 1987: ix) called 'that conception of a universal and unified "history of art" which', he claimed, rather dubiously, had 'so long served . . . both artist and art historian'. Richard Brilliant, editor of *Art Bulletin*, the US professional association journal for art historians, claimed in 1991 that, as a result of raging diversification special 'interests and special interest groups . . . founded their own journals, thereby diffusing the very concept of "art history" [and that] this had led to the partial, if not complete, removal of many of these groups from *The Art Bulletin*'s potential audience. On the model of scientific communities, these specialists want to read and be read by like-minded persons in ever-narrowing circles of scholar-critics and their pupils, often bound closely together by shared attitudes toward language and method', 'Editorial: The Squeaking Wheel, or *The Art Bulletin* at Seventy Eight', *Art Bulletin*, September 1991: 358. A symptom of, and moment within this fragmentation, occurred in the mid-1970s when the College Art Association of America and the Society of Architectural Historians

stopped holding joint conferences for reasons related to both the unmanageable size of these organisations and their dividing professional interests. See Marvin Trachtenberg, 'Some Observations on Recent Architectural History', *Art Bulletin*, June 1988: 208–41 (208).

17 See *The Block Reader in Visual Culture*, London and New York: Routledge, 1996; and *October: The First Decade 1976–86* and *October: The Second Decade 1986–96*, Cambridge, Mass.: MIT Press, 1986 and 1996 respectively.

18 While the US has certainly attracted (or appropriated) major British art historians, it is also true, however, that some British series publications (such as Open University teaching materials) have operated a measure of 'counter-imperialism' through their dissemination into US academic art history.

19 Williams' *Culture* is a good introduction to the study of all such phenomena.

20 See, for instance, Marcia Pointon (ed.) *Art Apart: Artifacts, Institutions and Ideology in England and North America from 1800 to the Present*, Manchester: Manchester University Press, 1994.

21 D. Morley and K. Hsing Chen (eds) *Stuart Hall: Critical Dialogues in Cultural Studies*, London and New York: Routledge, 1996: 149. Hall claims that 'theorising' – citing the example of structuralism – has been idealised into 'Theory', particularly in US academic culture.

22 For the sake of clarity I shall refer to 'art history' when discussing the discipline. The term 'history of art' is sometimes used, as in M. Pointon *The Students' Handbook* (19), to refer to that which is studied. She distinguishes this from 'art history' understood as 'the cluster of means through which it [that is, art] is studied'. This, I would argue, is a pedagogically useful, but ultimately rather confusing distinction: 'art history' and 'history of art' are inevitably interlinked at all levels of description, analysis, and evaluation.

23 See Michael Daley and James Beck *Art Restoration: The Culture, the Business, the Scandal*, London: J. Murray, 1993.

24 On the institutional origins of radical art history in Britain, see Introduction to *The Block Reader in Visual Culture*; Fred Orton and Griselda Pollock 'Memories Still To Come . . .', in *Avant-Gardes and Partisans Reviewed*; and John Tagg 'Art History and Difference', in A.L. Rees and F. Borzello (eds) *The New Art History*: 164–71.

25 See Hollis Clayson, 'Materialist Art History and Its Points of Difficulty', in 'Art> < History: A Range of Critical Perspectives', in *Art Bulletin*, September 1995: 367–71; and Barbara Anderman, 'An Interview with Albert Boime', *Rutgers Review* 15, 1995: 71–87 (especially 84).

26 See Mieke Bal on what she calls the 'theory police', 'Signs in Painting', in 'Art History and Its Theories: A Range of Critical Perspectives', *Art Bulletin*, March 1996: 6–8 (particularly 7).

27 *Guardian* (London) Higher Education section, 7 September 1999: ii–iii.

28 *Avant-Gardes and Partisans Reviewed*: xviii.

29 *Culture*: Chapter 1. See, in addition to books already mentioned, M. Barnard *Art, Design and Visual Culture*, London: MacMillan, 1998; M. Cheetham *et al. The Subjects of Art History: Historical Objects in Contemporary Perspective*, Cambridge and New York: Cambridge University Press, 1995; S. Edwards (ed.) *Art and Its Histories*, New Haven and London: Yale University Press/Open University, 1998; E. Fernie *Art History and Its Methods*, London: Phaidon, 1995; I. Heywood and B. Sandwell (eds) *Interpreting Visual Culture*, London and New York: Routledge, 1995; C. Jencks (ed.) *Visual Culture*, London and New York: Routledge, 1995; N. Mirzoeff *An Introduction to Visual Culture*, London and New York: Routledge, 1999; L. Schneider Adams *The Methodologies of Art: An Introduction*, Boulder, Col.: Westview Press, 1996; J. Spencer *The Art History Study Guide*, London: Thames and Hudson, 1996; J.A. Walker and S. Chaplin *Visual Culture: An Introduction*, Manchester: Manchester University Press, 1997.

30 Quoted in Thomas F. Reese 'Mapping Interdisciplinarity', in 'Inter/disciplinarity: A Range of Critical Perspectives', *Art Bulletin*, December 1995: 544–9, (548, n. 27). The cultural sociologist Pierre Bourdieu was even more blunt: 'It is instructive to glance at the case of art history, which, never having really broken with the tradition of the amateur, gives free rein to celebrating contemplation and finds in the sacred character of its object every pretext for a hagiographic hermeneutics superbly indifferent to the question of the social conditions in which works are produced and circulate.' *Outline of a Theory of Practice*, Cambridge: Cambridge University Press, 1977, 1–2.

31 N. Hadjinicolaou *Art History and Class Struggle*, London: Pluto, 1978. Other disciplines in the humanities, including English studies, also spawned their 'Althusserians'. See, for instance, Pierre Macherey *A Theory of Literary Production*, London: Routledge and Kegan Paul, 1978. They were particularly influenced by Althusser's *For Marx*, Harmondsworth: Penguin, 1969, and *Lenin and Philosophy and Other Essays*, London: New Left Books, 1971.

32 On socialist-feminism see, for instance, S. Rowbotham, L. Segal and H. Wainwright *Beyond the Fragments: Feminism and the Making of Socialism*, London: Merlin, 1979. For an overview of debates within feminism in relation to art and art history, and an extensive bibliography, see Thalia Gouma-Peterson and Patricia Mathews 'The Feminist Critique of Art History', *Art Bulletin*, September 1987: 327–57.

33 One of the best introductions to deconstruction remains Christopher Norris' succinct *Deconstruction: Theory and Practice*, London: Methuen, 1982. See also his more caustic *Deconstruction and the Interests of*

Theory, London: Pinter, 1988, and Terry Eagleton's jaded *Illusions of Post-modernism*, Oxford: Blackwell, 1996.

34 This seems to be the standpoint, for instance, of Cheetham, Holly and Moxey in their *The Subjects of Art History*: 'By paying attention to the multiplicity of perspectives (which are often in indirect conflict with one another), a student may be emboldened to find his or her own theoretical voice. Obviously, no serious scholar of art history can hope to master all of the interpretative viewpoints now on offer, but a passing familiarity with some of the most visible can only help to encourage the engendering of others as yet unheard' (2). Tellingly, they leave a direct consideration of social class out of their selection of essays.

35 Ibid., 'In many quarters, it is now recognised that history is not about the truth, that there is no way in which contemporary understanding can come to grips with the events of the past with any degree of finality or closure.' For an example of such radical relativism in the humanities, see, for instance, Stanley Fish *Self-Consuming Artifacts: The Experience of Seventeenth Century Literature*, Berkeley: University of California Press, 1972.

36 Definitions and discussion of multiculturalism and 'political correctness' issues and practices tend to blend into each other. In relation to the arts and art history, with special reference to 'p.c.' debates in universities and museums in the US, see, for example, Ira Shor *Culture Wars*, Chicago: University of Chicago, 1986; Frances K. Pohl 'Putting a Face on Difference', in 'Aesthetics, Ethnicity, and the History of Art: A Range of Critical Perspectives', *Art Bulletin*, December 1996: 616–21; Paul Berman (ed.) *Debating P.C.*, New York: Laurel, 1992; Pat Aufderheide (ed.) *Beyond P.C.*, Saint Paul, Minn.: Graywolf Press, 1992; Neil Harris *Presenting History: Museums in a Democratic Society*, Washington, DC: Smithsonian Institution Press, 1995; Association of Museum Directors *Different Voices: A Social, Cultural and Historical Framework for Change in the American Art Museum*, New York: Association of Art Museum Directors, 1992; James Cuno 'Museum Art History and Politics: Whose Money? Whose Power? Whose Art History?', in 'Money, Power, and the History of Art: A Range of Critical Perspectives', *Art Bulletin*, March 1997: 6–10; and Martha Rosler 'Money, Power, Contemporary Art', in 'Money, Power, and the History of Art: A Range of Critical Perspectives': 20–4. Her essay on state funding mechanisms for visual arts in the US concludes, as Rifkin's did in reference to 'new art history', that *official* multiculturalism/'p.c.' also functions as a kind of ideological disarming, taking radical ideas and values, and effectively policing them. Funding institutions, Rosler says, 'now speak of "managing diversity", betraying a pernicious instrumentalism guaranteed to evoke horror in those artists.' (24).

37 Norman Bryson and Mieke Bal 'Semiotics and Art History', *Art Bulletin*,
 June 1991: 174–208 (175). See also Richard Shiff 'Art History and the
 Nineteenth Century: Realism and Resistance', *Art Bulletin*, March 1988:
 25–47 (in particular 27).
38 Terry Eagleton *Literary Theory: An Introduction*, Oxford: Blackwell,
 1983: vii–viii.

Radical art history

Back to its future?

Prejudices, perspectives, and principles

Critical, social, or radical art history – the terms I've selected in pref-
erence to 'new art history' – all presume an opposite, or at least a
sharp contrast, against which the former terms have been defined, and
in distinction to which are claimed to represent a decisive advance.
That 'opposite', I've suggested, has been given a number of names as
well: for example, 'mainstream', 'institutionally dominant', or 'tradi-
tional' art history. And in relation to 'new' (a term, like 'modern', still
bursting with overwhelmingly positive connotations, many associated
with advertising rhetoric), it is, of course, 'the old' that is rejected, as
comprehensively redundant and 'out of date'. The first part of this
chapter presents a preliminary investigation of these pairs of binary
oppositions (new/old, radical/traditional, etc.). *Not*, it should be
stressed, in order finally to be able to say that it's absolutely clear
which art historian, text, or concept, belongs properly to either the
former or latter categories within these oppositions.

Now, I *do* think there was (and still is) a broad agreement between
practitioners of radical art history about what kind of analytic princi-
ples and procedures were (and are) inadequate, an agreement based on
a range of intellectual, political, and pedagogic reasons. However, the
polemical aspect to this debate, or what has symptomatically often been
called a 'crisis in art history', has sometimes operated at a level of
incautious generalisation and thumbnail sketches (on both sides).[1]
More detailed consideration of a wide range of materials in art history

represented as radical or traditional, old or new, would reveal, I believe, ambiguities and complexities that some protagonists on *either* side of the divide (whatever it is called) have usually failed, or been unwilling, to acknowledge. The categories of both 'traditional art history' and 'radical art history', I suggest, contain authentic pluralities: their materials are internally fractured, highly diverse, and sometimes contradictory in assumptions, principles, and practices.

T.J. Clark, as I have already noted, argued in 1974 that a contemporary art history 'hot-foot in pursuit of the new' misses the point that the development of the discipline in the early twentieth century had contained many of the core elements that a truly radical art history must incorporate. Speaking from a Marxist perspective, however, he was not prepared to discuss the relevance of the issue of gender and visual representation, which was then at the centre of radical art history's other dominant wing: feminism.[2] An admittedly generous interpretation of Clark's position, however, might be that the historical materialist basis of his perspective was one within which certain kinds of feminist *could* shape a compatible account of gender and representation – in short, a historical materialist theory of patriarchy. This may be a useful way, for instance, of characterising the work of Griselda Pollock, particularly in the period between 1975 and 1985.[3]

Clark remarked in that 1974 essay that contemporary scholars needed what he called an archaeology of the subject in the early twentieth century, a 'critical history, uncovering assumptions and allegiances'.[4] One thing that Marxist and feminist art history has certainly made clear is its broad political allegiances and values. Clark's point was not that study of Warburg or Wölfflin or Panofsky would reveal them to have been Marxists (and certainly not feminists!). Rather, it was that intellectual work always has a base of social values and interests which initiates and then drives the inquiry in certain directions. Such founding principles and perspectives might also be described as 'prejudices', though this term now, like 'discrimination', tends to have only negative connotations (partly because they have become bound up, especially since the 1970s, with the language of multiculturalism and 'political correctness').

But the *positive* meanings of 'prejudice' and 'discrimination', within scholarly activity, are to do with acknowledging that all intellectual tasks begin with the identification of a problem or issue that requires examination. This is always a problem or issue identified by an actual person, for whom that problem or issue is important – significantly linked, that is, to their understanding of the world and of the

importance of specific things within it. The genesis of all intellectual activity, therefore, is inevitably related to a person's world-view, perspective, and the interests and values associated with it. Marxist and feminist art historians in the early 1970s made clear their basic world-views, perspective, and interests and saw – indeed, often proclaimed – these as the overriding motivation for their inquiries. This attitude was certainly counter to the orthodox view held and conveyed by many in the discipline that art history, like any other university subject, essentially was a body of objective knowledge, safe in, and secure of, its neutral truthfulness.

Ernst Gombrich's work, over many decades, was a case in point.[5] He expressed his position succinctly enough in a lecture at Oxford University in 1973, the same year as the publication of T.J. Clark's two Marxist studies of French art in the mid-nineteenth century. The following statement might stand, therefore, as an exemplification of the values of 'traditional art history'. While what Gombrich called the 'social sciences' (partly a euphemism for Marxist sociology) certainly might serve as 'handmaidens' to art history, he admitted, providing relevant social facts and documentation, it was art history's recognition and maintenance of the canon of great art which:

> offers points of reference, standards of excellence which we cannot level down without losing direction. Which particular peaks, or which individual achievements we select for this role may be a matter of choice, but we could not make such a choice if there really were no peaks but only shifting dunes.

While Gombrich concedes that 'what we call civilisation *may* be interpreted as a web of value judgements which are implicit rather than explicit' (my italics), his meaning is clearly that it is the job of the properly trained, 'expert' art historian, in contrast to other academics in 'handmaiden' roles, to *recognise* actual greatness in art. The perspective and values of the art historian are authentic and irreducible *because* they accord so accurately with the objective reality of the canon. Gombrich's statement is, therefore, a classic defence of scholarly neutrality, based on the certainty that art history's canon of artworks represents unquestionable value and greatness. (His *The Story of Art*, as nearly everyone connected to art history must now know, includes not a single woman artist.) The canon of great art, and its confirmation in, and by, art history, are thus both integral parts of the humanism of western liberal-democratic society.[6]

Yet many other art historians usually pigeonholed as 'old' or 'traditional', or part of the 'institutionally dominant' have acknowledged the prejudice and partiality of interests necessary in academic work. Such recognition has never been the monopoly of radicals in the discipline. One of Clark's heroic progenitors, Panofsky, understood that the necessary partiality of interests meant that scholars could not avoid bringing ideas, indeed theories, into their work. 'Theory', he remarked in 1940, 'if not received at the door of an empirical discipline, comes into the chimney like a ghost and upsets the furniture.' He also declared, however, that scholars in art history should maintain an openness within the conduct of their inquiry and not be blinded by their initial, inevitably prejudiced perspectives. 'It is no less true', Panofsky continued, 'that history, if not received at the door of a theoretical discipline dealing with the same set of phenomena, creeps into the cellar like a horde of mice and undermines the groundwork.'[7]

Riegl, another of Clark's heroes – though associated with what some radical art historians have dismissively termed 'formalism' (that is, the analysis and evaluation of 'the works of art themselves', *outside* of social and historical circumstances) – also demonstrated awareness of the inescapably limited and partial nature of understanding.[8] Would the best art historian, he wondered, be the one with no interfering subjective taste at all? Otto Pacht, a member of the so-called New Vienna School of art history, puzzled over the same issue. Particularly critical of the predominance of Panofsky's iconographic methods, based on Renaissance art, which he believed had wrongly become the basis for all art-historical analysis, Pacht questioned whether, although a modern viewpoint gave us access to a work of art that was previously a closed book, there was anything to guarantee that what was seen was true and authentic, rather than a total distortion.[9] Hans Sedlmayr, another member of the New Vienna School, writing in the 1930s in Germany, in fact saw art's subjective interpretation by scholars as the *only* means through which the work's 'aesthetic nature' – its most important feature, Sedlmayr thought – could be revealed, along with its structure, and, ultimately, its relationship to the world and to society.[10]

Some art historians, then, long before the development of radical art history, acknowledged that individual and group interests and values were fundamentally and inevitably implicated in intellectual projects, in the selection of what to study, and how to understand artworks and their history. These interests and values ranged from subjective and personal factors through to aspects of attention and perspective which

radical art historians would later call 'ideological', that is, based on the place (and questioning of the role) of scholars in social and political circumstances and institutions.[11] One brief example will have to suffice. In 1958 the art historian James Ackerman, scholar of Renaissance culture and senior US academic, gave a lecture at the College Art Association annual conference which berated its members' conservatism and aimed to prompt the profession to begin to consider the relations between its academic concerns and contemporary American society. This intervention, later published in the C.A.A. journal, prefigured, according to a recent commentator, the radical developments in US academia in the 1960s. Ackerman's lecture encouraged academics to equate 'communication with social responsibility generally' and prompted art historians to see themselves not as disinterested inter- preters of the past, but as active participants 'in the effort to reform society by challenging its values and ameliorating its ills'.[12]

For 'new' read 'old'?

It *is* possible to show, then, that some putatively 'old' or 'traditional' art historians understood that their scholarly work was 'perspectival', interest-based, and 'prejudiced', in the positive senses discussed above. Might it equally be the case that some radical art historians could be convicted of the traits associated with 'institutionally dominant' disciplinary practices? I have pointed out, for example, that feminists began to attack Marxist art history in the 1970s because of its avoid- ance of, or tendency to allocate marginal significance to, issues of gender, sexual identity, and representation (as traditional, Gombrichian art history did).

Rifkin's claim that feminist and anticolonialist politics and issues had been at the forefront of 1970s' developments in the subject may also be read as an implicit critique of the place of Marxism (or, at any rate, of some work bearing that name) in radical art history. Recent evaluations of Marxist art history by critics such as Donald Preziosi and Whitney Davis – neither of whom would want to associate themselves with most of 'traditional' art history – make this implicit criticism explicit. Marxist art history, from their 'deconstructionist' position (a term discussed in Chapters 6, 7, and my Conclusion), is based, they claim, on essentialist illusions about, and idealisations of, the world and of art that are as bad as those associated with Gombrichian art history. Davis' critique is partly based on challenging

Marxist belief in the centrality of class from his analytic perspective that draws extensively on psychoanalytic principles.[13] This is combined with identifying – as feminism does – the significance of other social and sexual identities in historical, cultural, and artistic development, about which Marxism had mostly been silent. Davis has a particular interest, for example, in the visual representation of gay and lesbian people, and in their social and political organisation (one of his essays is discussed in Chapter 7).

Preziosi, writing from the viewpoint not of an explicit 'politics of identity', but from the philosophical basis of post-structuralist philosophy (particularly the work of Jacques Derrida), condemned Marxism as a new form of what he calls 'logocentrism'. By this he means that Marxism has simply supplanted one previously dominant ideology of art-historical scholarship (the belief that the discipline was appropriately concerned with the celebration of artistic genius and the universality of aesthetic quality) with another (based on belief in the centrality of class struggle and the final determination of art by socio-economic developments).[14] Both Davis' and Preziosi's judgements, it should be clear, are based on the limited sources they have chosen to exemplify a particular position or tradition which they wish to attack. To recognise this, however, is not to conclude that their analysis of Marxist art history is simply invalid. Like Davis – and feminist and black art historians – Preziosi's criticisms most importantly raise the issue of what should follow from the recognition that there *are* multiple social identities, modes of analysis, and forms of political struggle relevant to the study of art. The relationship between these multiple identities and possible histor*ies* of art, and the broader visual culture, is extremely important. To what extent, for instance, may Marxist, feminist, gay and black art historians want, or be able, theoretically and politically to reconcile their perspectives and interests? How might one set of interests and values affect the others? Is some kind of synthesis of theoretical principles and political standpoints (in art history as much as in modern democracy) either possible or even desirable? These issues return time and again in the chapters that follow.

It has also been noted by a number of commentators that radical art historians, including many Marxists and feminists, reproduce a highly significant aspect of 'old' or 'traditional' art history (perhaps its most defining feature) when they use their novel analytic procedures in order to reinterpret artworks which remain safely within the established canon. This is true, for instance, of T.J. Clark (in his discussion of Courbet, Edouard Manet, Jackson Pollock, and many others) and

Griselda Pollock (the Impressionists, Van Gogh).[15] Now, for whatever different reasons they give for concerning themselves with canonical artefacts and producers, what radical art historians actually do is *read* against the grain of orthodox understanding. 'Reading' in this sense means radically to rearticulate and reposition; it is an active and 'inter-rogative', rather than passive and 'receptive', process which sets out to create new meanings.[16] Often it has been done by radical art historians (for whom such *reading* is often their primary practice) in order to subvert the established evaluation of what have been seen as canonical artworks and, for that matter, canonical art-historical texts.

With this intention, I suggest, Rifkin *reads* Warburg's 1938 'Lecture on Serpent Ritual', and is prepared to declare it no less than the founding text for modern cultural studies. Mathew Rampley, pursuing the same logic (and polemical point), manages to discover that Warburg is also a proto-feminist and proto-post-modern allegorist, and therefore compares favourably with intellectuals such as Friedrich Nietzsche, Max Weber, and Walter Benjamin, scholars revered by radical art historians.[17] 'Reading', understood as this active, reinter-pretative, and creative process, based always on particular perspectives and interests, can quickly make a *complete* nonsense of any 'new/old' or 'radical/traditional' distinctions. A Marxist text, for instance, could be dismissed as 'old' because of its silence on gender; a 'struc-turalist' or 'psychoanalytic' text as 'traditional' because of its silence on class and politics.[18] Conversely, a traditional iconographic study of, for example, Michelangelo's paintings and sculptures could be *read* as 'radical' because the reader detects implicit homophilial features; a Riegl text propounding the notion of *kunstwollen* (art's internal, self-propelling will-to-development) construed as 'critical' because it draws attention to features of art's process of semiosis – its material means of signification. Indeed, Riegl's interest in the decorative crafts of late Roman society, to mention another facet of radical art history, has been lauded – in contrast to the semiotic reading – as an antecedent of recent attempts to break down the hierarchies of high/low art.[19] What limits can, or should, be set on this kind of *reading*? It should be clear by now that different wings within radical art history appear to have sharply contrasting principles, analytic practices, and modes of evaluation. Even *within* its wings there are significant differences as well. This is equally true, indeed, of the perspectives from which protag-onists of *all* kinds speak, read, and look – the values of Panofsky and Gombrich, for instance, embody important contrasts within the category of 'traditional art history'.

The significance of 'looking' (and its correlate 'seeing') and the value attributed to this activity within the study of visual art is particularly important. It relates to the tripartite distinction I made earlier between scopocentric, scopophobic and scoposceptic positions. Perhaps these are notions that could be said to relate, in fact, to *different* kinds of looking, and to different sets of metaphors – understandings – of what *really* looking and *really* seeing must involve. Mieke Bal, for instance, whose work is particularly associated with 'intertextual' semiotic, structuralist, and psychoanalytic modes of analysis, somewhat surprisingly seems to concur with Otto Pacht's assertion that 'in the beginning was the eye, not the word', when she claims that the 'subject of the discipline, the visual image' should be allowed to speak.[20] Indeed, it has been claimed that Pacht's work anticipated the 'analytic moves of a semiotics of art', later to be associated particularly with his friend and contemporary Meyer Schapiro (I discuss an essay by Schapiro in Chapter 5).[21]

Other art historians associated with radical art history, however, have concluded that this attitude ('in the beginning was the eye, not the word'/'the visual image should be allowed to speak') constitutes no less than a form of 'semiotic idealism'. By this derogatory term they mean a perspective which wants to 'see' something called 'the visual' in art as a clearly separate and autonomous entity. Separate and autonomous in two ways. First, in the sense that the essential visual character of the representation is reconceived as 'image' – which has a powerful connotation of immateriality – and is thought to be capable of being abstracted from its material vehicle (be it, for instance, the artefact of a painting, photograph, or drawing). Second, in the belief that the essentials of this 'image' could be understood independently from the various worlds, or contexts – social, historical, intellectual – in which that artefact has had, and might have in the future, an existence.[22] Marcia Pointon might be said to take up a diametrically opposed position on this issue when she claims that art history 'is about writing (despite the prior claims of sight), and writing allegorizes an experience in such a way as to annihilate the momentary engagement of the viewer and the object; that engagement thereafter becomes no more than a trace, a memory, within a space of representation'.[23] Whatever problems of its own this stipulation may raise, my own position is much nearer to Pointon's than to Bal's.

One art historian whose work has always been difficult to place within any schema of the discipline's recent development – sometimes seen as 'new', sometimes as 'traditional' – is that of Michael Baxandall.

Author of several highly influential books on Renaissance art and society, and studies in the philosophy of aesthetics, his range of interests has sometimes embodied the kind of interdisciplinarity that Rifkin defined as a key element of authentic radical art history.[24] His book on Renaissance art in fifteenth century Italy was subtitled 'A Primer in the Social History of Pictorial Style'. Baxandall's work, however, has never included a consistent discussion, or definition, of ideology of the kind that has always been key to work within Marxist and feminist art history. For this reason Baxandall's intellectual positions have hovered suggestively in between 'old' and 'new', 'radical' and 'traditional' (and, it might be concluded, this is really no bad thing). He is certainly highly sceptical, however, of notions of the primacy of 'the visual' within the work of art historians, remarking that we 'do not explain pictures: we explain remarks about pictures – or rather, we explain pictures only insofar as we have considered them under some verbal description or specification'.[25] His rather understated implication is that art historians, in mistaking the latter reality for the former ambition, deceive both themselves and their readers.

T.J. Clark made a similar point when he remarked that debate in art history should be seen as really about arguments and principles of explanations – ways of understanding – rather than blandly about 'approaches' and 'methods' of looking, as though these could ever be detached from questions of position and value.[26] Accounts of art history and art-historical accounts which *do* reduce the matter blandly to 'approaches and methods' constitute an academicism, doing the same ideological work of disarming radical inquiry as that done by the propagation of the term 'new art history'.

Politics, modernity, and radical art history

New art history in this pejorative sense, in the late 1990s in Britain, could be seen as an academic correlate for the negative meanings given to Tony Blair's 'New Labour' government elected in May 1997. Although Blair and his reformers in the Labour Party had invented that term as an election slogan, meant to signal that the Party had ceased being dangerously left wing and unresponsive to the needs of business and the broad middle classes – in short 'modernised' out of any recognisable socialist ideology – the phrase 'New Labour' almost immediately became appropriated by those *hostile* to Blair's political and intellectual project.[27] For those socialists inside the Labour Party who saw the

modernisation as an effective betrayal of the organisation's radical political potential, 'New Labour' meant the eradication of any authentic political debate within the party and, in government, the running of the country in the interests of corporate capitalism.

In the 1970s some radical academics in British art history had seen the Labour Party as a possible agent of radical political change – even socialist revolution – in the country. The term 'new art history', already attacked by critics in the mid-1980s, arguably suffered a kind of attenuated embarrassment ten years later when, finally, after nearly twenty years of right-wing Conservative Party rule, Britain elected a politically deracinated Labour Government, seen by its left-wing critics, rather like new art history, as all 'methods and approaches', and no 'argument and principles'. The terms 'new' and 'modern' are powerful, but unstable epithets: amongst the most value-laden and ideological labels, and for that reason perennially used and fought over, in both academic debate and in political organisation. These terms have functioned in important ways since the 1970s, along with other pairs of terms, selected to demonstrate a divide in art history between good and bad, the defensible and the indefensible – though the arguments mounted have always relied upon highly limited evidence. New can be seen as old, traditional as radical, in particular, and perhaps perverse – or at least polemical – arguments of the 'Warburg was a feminist' kind.

Clark's notion of the 'heroic phase' of art history in the first third of the twentieth century was intended to confound the simplistic idea that 'old' art history was bad when placed against its modern – that is, contemporary – forms. He argues that it is contemporary art history's ignorance of the heroic phase and the reduction of its representatives' arguments and principles to 'methods and approaches' that has impoverished the discipline. But while Clark's stress had been on the questions of consciousness and ideology raised by art historians such as Dvořák and Warburg, in the broad philosophical context of Clark's historical materialist perspective, it was as much feminist disputes around gender and representation as it was the class politics of Marxism, which ignited both polemic and real argument in the mid-1970s.

In 1978, for instance, Lisa Tickner, lecturer at what was then Middlesex Polytechnic, published an essay in the second edition of the new journal of the British Association of Art Historians. An analysis of developments in feminist art since 1970, and including illustrations of work by women artists using their own, and other people's bodies, in pieces on sexuality, gender stereotypes, and body decoration, the article

provoked a sarcastic response from the editors of the 'old fogey' connoisseurial art magazine *Apollo*. This will stand well as an example of the values and perspectives of the contemporary 'institutionally dominant art history'.[28]

Apollo's editorial begins by calling Tickner 'miss', a term that functions, whether intentionally or not, as an insult – trivial perhaps – but which underlines the traditional, and from a feminist perspective, conservative 'gender politics' of the magazine. The editorial goes on to wonder whether Tickner's piece was meant seriously at all, comments that it is rich material for satire, and then makes a series of jokes on Tickner's account of the work of women artists. Prurient implicit references to masturbation, men's toilets, and phallic imagery follow which tell us mostly, I think, about the private school backgrounds and repressions of *Apollo's* male editors. It is *their* schoolboy Benny Hill-style tittering, rather than Tickner's essay or the illustrations of women's art, which now seems bizarre. The editorial is historically interesting, however, because it suggests a world in which British art history and publishing was still dominated by a crass upper-middle-class male clique.

Following this 'humour', the editors then make another remark that conservative academics and critics have often made about radical art history: that it simply isn't to be taken seriously intellectually, it isn't 'highbrow' (though they don't give any examples of what would be 'highbrow'). This move bifurcates the discipline into good and bad, serious and silly, legitimate and improper. The editorial refers to hard-pressed students who might find Tickner's essay a rest from 'real' academic work, so it is important to see that this bifurcation has important pedagogic and therefore political implications: the question of who decides what gets taught, and what *ought* to be taught as legitimate, serious art history. And, of course, to whom? What would women students in 1978 have made of Tickner's essay, and the *Apollo* response, compared, for instance, with male students? The same question is begged in relation to men and women academics. The *Apollo* response represents one answer to the question about the values of some men then occupying the senior academic, art market, and art publishing spaces within British 'institutionally dominant art history'.

The editorial concludes with another light-hearted, though I suspect intended-to-be-offensive, reference to 'Miss Lisa Tickner' and her 'patron saint Mistress Linda Nocklin' (spelt incorrectly), wondering facetiously how a 'male chauvinist Fascist-pig' should understand these women, their history, and, by implication, their feminism. What *Apollo*

gets right, therefore, is the fact that feminist art and art history are directly *political* developments, not simply the innocuous stuff of faddish academic debate. There is a definite scent of (male) anxiety about this realisation in the editorial's joking, sneering, and dismissive tone. Feminism, perhaps more than Marxism – which has always remained a set of intellectual traditions and political organisations overwhelmingly controlled by *men* – was perceived by *Apollo*'s editors as a threat, in art history and as a political movement for radical social change. In addition, in the 1970s and early 1980s, as Griselda Pollock's and many other scholars' work demonstrates, feminists often collaborated with Marxists, in art history and in direct political action outside the university. If neither feminism nor Marxism were palatable separately to those responsible for articulating *Apollo*'s views and values, then their combination would have represented an even more unsettling prospect.[29]

Radical art history, to offer a provisional definition now, before moving on to explore some of the important texts constituting its history since about 1970, is the name for *a set of inter-related intellectual currents that entered into shifting alignment with some forms of directly political argument and activism.* In the 1970s and early 1980s these were predominantly Marxist and feminist, as I've suggested, but they were followed quickly by scholars and activists concerned with, for instance, ethnicity and sexual orientation. To some extent these were all perspectives and social movements *already* interacting – sometimes collaboratively, sometimes in tension and dispute – in the middle and late 1960s in Western Europe and North America. In art history, feminist black scholarship emerged in the later 1970s and early 1980s, and gay and lesbian scholarship a little later still, though – as always – it is a question of what criteria and what evidence are selected to indicate a claimed development.

Some of the most important conceptual insights and analytic methods used by scholars associated with these developments in art history over the last thirty years were drawn from a variety of sources outside of the discipline. These came, for instance, from sociology, social theory and anthropology, psychoanalysis, semiotics and structuralism, critical theory, and post-structuralist philosophy, as well as from the interdisciplinary subject now called cultural studies. But these intellectual *traditions*, which are often also the names for established academic disciplines or subject areas, were never simply free-floating or neutral in social and political terms, ready to be simply plucked by scholars and activists and used for their own ends. These currents were, by the middle 1960s, already bound up with political and social issues

and action in wider society – most dramatically, perhaps, in France around 'the moment of May 1968'.

The Marxist philosopher Louis Althusser, the psychoanalyst and theorist Jacques Lacan, the feminist Julia Kristeva, and the post-structuralist philosopher Michel Foucault, to name only four of the figures whose work has fundamentally shaped radical art history, were all active, in different ways and with different and sometimes contradictory intentions and values, in that moment of 1968 and its aftermath. What my study attempts to chart, then, are the main contours of this *changing alignment of intellectual current and political position*, in a set of chapters which takes different aspects of radical art history and brings to bear upon them my own perspective and interests. The separation of these alignments into chapters is partly a matter of practical organisation, as I've said, but partly necessary because there have always been tensions and disputes, camps and divisions, within radical art history. In the following short case-study which closes this chapter I begin to explore these issues of alignment and dispute in radical art history. The chapters that follow it plot other alignments and tensions and I increasingly bring materials from the successive chapters into dialogue and dispute with each other, as the facets in radical art history since 1970 begin to coalesce in my study.[30] Together these chapters constitute an attempt to describe, illustrate, analyse, and reflect on the bases of the arguments and principles that radicals in art history have mounted in pursuit of their intellectual, moral, and socio political objectives.

Structure, agency, and art

Key texts

Rosalind E. Krauss: 'In the Name of Picasso' 23–40 [1980, originally presented as a lecture at a symposium on the cubist legacy in twentieth-century sculpture], in Rosalind E. Krauss *The Originality of the Avant-Garde and Other Modernist Myths*, Cambridge, Mass. and London: MIT Press, 1985: INP.

T.J. Clark: 'Cubism and Collectivity', Chapter 4 in T.J. Clark *Farewell to an Idea: Episodes from a History of Modernism*, Newhaven and London: Yale University Press: 1999: CC.

Rosalind Krauss and T.J. Clark have both been prominent within radical art history since the 1970s, though the political character and implications of Krauss' work has remained far less clear than that of Clark's, which has always been associated intimately with Marxism and the social history of art. In contrast, Krauss' many books and essays have never attracted a single convincing label, partly because her work has always mobilised quite an eclectic range of critical values and analytic procedures.[31] Within this range, however, psychoanalytic and structuralist motifs have probably dominated. Along with accounts of the connections between contemporary social processes and representational practices in art now understood as 'post-modernist' – a critical term with which she has also been associated – psychoanalytic and structuralist strands in her work have often connoted, rather than *directly expressed*, political perspectives or values. This is because, as I have already suggested, psychoanalytic and structuralist ideas became bound up in various new and quite convoluted ways, both with each other, and with political movements, in the Parisian moment of May 1968.[32]

Krauss' essay 'In the Name of Picasso' was originally presented as a lecture on the legacy of cubism in twentieth-century sculpture, in the wake of a huge retrospective exhibition of that artist's work held at the Museum of Modern Art, New York, in 1980.[33] This text has come to be seen primarily as an attack on traditional art history's obsession with artists' biographies, an obsession that reaches its most extreme when dealing with modern artists, and with Picasso in particular, as numerous commentators have observed.[34] Contrary to this, Krauss argues that Picasso's artworks, particularly the collages from the 1910s, such as *Bottle, Glass and Violin* (Illustration 1) should be understood in radical isolation from *all* biographical or anecdotal evidence. This is because, she claims, the formal and material structures of these works constitute no less than modern art's achievement of autonomy from the role of representing things in the world. It is within this autonomy, she claims, that their greatness – that is, their aesthetic greatness as perfectly resolved artworks – lies.

Clark's essay on an aspect of Picasso's cubist period, based partly on seminars given at the University of California at Berkeley, was published as the fourth chapter of his 1999 book *Farewell to an Idea: Episodes from a History of Modernism*. This book continues and significantly extends Clark's account of modern art, which he traced in earlier studies of, for instance, Courbet (discussed in the following chapter), Manet, and Jackson Pollock, published over a twenty-five-year period.[35]

Clark's essay deals with some of the same issues raised by Krauss nearly twenty years earlier. A brief consideration of the two texts together is a useful way of becoming familiar with some of the most fundamental issues within radical art history. These are important questions and arguments about the characterisation and inter-relation of three areas of inquiry central to formulating what might stand as *adequate explanations of artworks*. (All of the texts examined in the following chapters deal with these issues in one way or another.)[36]

These concern (1) the notion of 'structure', understood in two senses. First, 'structure' used empirically to refer to artworks understood as specific forms of 'ordered composition' in themselves, for instance paintings or sculptures. Second, 'structure' used as an abstract term to identify the broad set of conditions and conventions out of which, and within which, artworks are produced, disseminated, and interpreted. Both Krauss and Clark are aware of the shortcomings in the idea of 'art in context' that Bryson and other commentators have identified, which I discussed briefly in the Introduction. Clark signals his awareness by beginning his essay with a discussion of a photograph from 1912 showing a group of paintings by Picasso arranged around a doorway. Within the photograph the paintings are literally put 'in a context' wherein they might be seen and understood. By beginning with the photograph Clark indicates that art historians always construct contexts and that, like the photograph, these contexts are literally 'framing' devices, to be used self-consciously.[37]

Krauss and Clark deal (2) with the question and significance of 'agency', that is, all the factors involved in the *making* of artworks by actual, historical individuals (sometimes pairs, or groups of producers). They reach very different conclusions, however, about the importance, for instance, of artists' motivations and intentions as producers. Clark, on the one hand, in his use of the concept, demonstrates the continuation of the 'social history of art' tradition in his essay, and in the book as a whole. Within the social history of art the agency of producers of various kinds – makers of artefacts, other artists, dealers, critics, etc. – will *always* form a significant part of any explanation. Krauss, on the other hand, demotes issues around the agency of the producer in favour of a preference for seeing the artworks 'themselves' as the most important kinds of 'agent' in art's history (rather as if they were people, and capable of making decisions about their own meaning); a position she has inherited from earlier art critics and historians.[38] *Both* texts, however, make problematic in interesting ways the distinctions commonly made between 'structure' and 'agency'. Clark,

49

as a Marxist, proposes that 'context' (structure) and 'making' (agency) are *necessarily* interactive, effectively part of a single historical process.

Krauss and Clark *do* agree, however, that (3) Picasso's paintings and collages from the 1910s are great works of art, and deserve their canonical status within art history. But they offer sharply different reasons *why* this is the case. One of the most important questions I shall pose throughout this book is: how are the senses of the value of artworks discussed in the texts I consider related to their authors' formulation of 'structure'/'agency' issues? This question can be turned round into a provisional hypothesis. This is *that the analysis and evaluation of artworks can be directly related to the explanation of general historical and social development explicitly or tacitly held by those producing such analysis and evaluations*. Krauss and Clark are my first test case.

Krauss, along with all radical art historians, finds unacceptable the tendency to fetishise the biographical details of modern artists, and to use such detail as the most important, or in some extreme cases, virtually *only* evidence for the explanation of artworks. If such details have been used fetishistically in the accounts of what she calls the 'Autobiographical Picasso' (INP: 24), then what meanings for both 'art' and 'explanation' can be inferred from reliance on this material? She cites as an example of this kind of art-historical explanation the case of Picasso's painting from his 'blue period', *La Vie* (1904), which, until 1967, she claims, had been seen 'within the general context of fin-de-siècle allegory', along with works like Gauguin's *D'Où Venons Nous?* and Munch's *Dance of Life*. In that year, however, a scholar identified one of the figures in Picasso's painting as the artist's friend Casagemas, another painter, who had committed suicide in 1902. Since this identification Picasso's painting, Krauss says, has been predominantly reinterpreted as a narrative of his friend's sexual impotence, a failed homicide, and eventual suicide (INP: 29).

What kind of an art history is it that sees an artist's work as 'inextricable from his biography'? Krauss' answer is 'a history of the proper name', one turned 'militantly away from all that is transpersonal in history – style, social and economic context, archive, structure' (INP: 25). This history, or aesthetics, of the proper name, that reduces art to a mere documentation of incidents in an artist's life, is peculiarly inappropriate – 'grotesque' (INP: 39) – when it comes to Picasso's cubist collage period. This is because these works, including *Bottle, Glass and Violin* (1912), she claims, in fact exhibit a *self-referential* quality, an autonomy of significance and value, which ranks them as amongst the greatest

achievements of modern art. For these works, therefore, to be read bio-graphically, or indeed, understood as referring significantly to *any* social or historical phenomenon, would be to *desecrate* them. Literally, she claims, because it would constitute erecting an aesthetics of the proper name 'specifically on the grave of form' (INP: 39).[39]

Krauss' rejection of 'biography as art history', however, is *not* followed (in this text, anyway) by her development of an argument that defines or examines Picasso's collages in relation to issues of 'style, social and economic context, archive, structure'. Instead, she spends some time defining concepts of signification and meaning, explaining the structural linguistics of Ferdinand de Saussure (discussed further in Chapter 5), and attacking the predominant art-historical account of representation based on the Aristotelian idea that paintings work to imitate, through visual resemblance, forms and events in the world (INP: 27). Such a still powerful view – the Panofskyian analytic tradi-tions of iconography and iconology are based on it – does not recognise, she claims, the multiplicity of ways of representing found in art around the world. Riegl's work on late Roman sculpture's lack of naturalism confirms this, she remarks, because he showed that the meaning of those sculptures could not be 'netted by, or completed within, the confines of that material object the sculpture could be said to repre-sent' (INP: 27).[40]

Picasso's cubist collages, like such non-naturalistic Roman sculp-ture, Krauss says, contain and exemplify representational structures that are ambiguous and polysemic, irreducible both to biographical or historical phenomena, or, in fact, to any 'unequivocal reference' (INP: 28). In this sense, works like *Bottle, Glass and Violin* are 'allegorical' works, as Picasso's *La Vie* had also been, based on 'an open-ended set of analogies' relating, she claims, to themes of 'maturation and devel-opment', before the local and specific biographical reading took charge (INP: 28–9). Notice, however, that although she makes the case for these works having a 'multiplicity of reference' (INP: 39), she strongly opposes the biographical reading, which, presumably, would also be at least one possible interpretation alongside the others. Krauss, like all art historians – radical or traditional – sometimes argues that mean-ings are *intrinsic* or *immanent* to artworks (when she is pressing her own reading) and sometimes *extrinsic*, the product of particular *inter-pretations* (when she wishes to attack other readings).

Krauss goes on to explain why the collages are the complex works of multiple reference she believes they are, and why this multiplicity of reference predominates over any particular references present within

the collages, be they the scraps of newspaper with words like 'journal' printed upon them, or fragments containing news stories, or the drawn or painted shapes that imitate the schematic outlines of glasses or violins. No, she says, it is the collage composition as a *structured whole in itself* which matters most and which ultimately refers most significantly to itself *as* a composed structure – to abstract questions exactly concerned with the nature of 'reference, representation and signification' (INP: 32). Directly contrary to what she calls the 'semantic positivism' (INP: 32) of traditional art history based on the proper name, these collages refer instead to 'the very system of form' itself, and cubist collage as a novel form in modern art is really about 'the representation of representation' (INP: 37). When Picasso indicates through line or shading the outline of parts of a violin – for instance, the two f-shaped soundholes that are found in many of the collages, such as *Bottle, Glass and Violin* – their role there is *not* to refer to any actual violin or even to the idea of a violin, Krauss claims. Instead, it is to draw attention to the activity of visual representation itself (the business of 're-presenting' actual things from the world that are absent or referring to things that don't have any physical existence at all, like ideas or values), and to techniques – like foreshortening – which are part of art's armoury of representational forms (INP: 33).

For Krauss, then, Picasso's cubist collages are works of a kind of 'material philosophy', achieving what she calls 'a metalanguage of the visual' (INP: 37). It is their elaboration of this meta-language that makes them great artworks. This is because their 'form' – that is, their material nature and significatory structure – is entirely fitting with this meaning and purpose, which is precisely to make problematic the belief that representation gives us the world, or what she calls its 'perceptual plenitude and unimpeachable self-presence' (INP: 38). Instead collage points, she claims, to the opposite – the *absence* of actual presence – as the very condition of representation. This is a condition which also involves 'the systematic play of difference' (INP: 35), of representation being not one thing, or another. Krauss believes that collage had an important role in the emergence, around 1980, of postmodern art and art theory, both practices similarly centred on the representation of problems in representation and on the consequential question of the changed understanding of meaning and value in contemporary art and society (post-modern art and art theory is discussed in Chapter 6).

Clark's text, and the book as a whole from which it is taken, interrogates similar questions, but presents radically different answers. Unlike Krauss, Clark starts from an interrogation of Picasso's intentions

and motivations and throughout the essay is prepared to use anecdotal material as part of the marshalling of evidence within his argument.[41] Like Krauss, however, he also teases away at the meaning of pictorial elements within Picasso's works produced between about 1908 and 1915 (although he deals mostly with paintings rather than collages), agreeing with her that a great deal of ambiguity or multiplicity of reference can be found within them. *The Poet* (1912), for instance, a cubist 'portrait', Clark says, is a 'good figure of exactly that ambivalence in Cubism' (CC: 174). But Clark's opening discussion of the photograph of the paintings propped up in front of a doorway is specifically *about* the artist's possible reflections on them, and on what he might do next:

> Did Picasso consider these paintings finished when he had them photographed? Presumably he did. And if later he changed his mind in one or two instances, and altered the paintings in slight but detectable ways, then why? What could have occurred to him as still needing work? What kinds of changes did he make? (CC: 169)

The uncertainties, changes of mind, and alteration of paintings that Clark suggests may have characterised Picasso's work in the period around 1912 are mirrored in Clark's own understanding of how to both adequately describe and analyse these works. Unlike Krauss, he declares that on these matters he has no certain answers – though it's clear that Clark, like Krauss, believes these works are great art. However, all he can offer as explanation, he says, are 'a series of stabs at description, full of crossings-out and redundancies' (CC: 175). But this would-be faltering account turns out to be a kind of analytical reflection of what Clark thinks is true of the paintings themselves. Like Krauss, his interpretation is claimed to be basically faithful to the true nature or meaning of the works. Classic cubism, he says, 'is not a grammar of objects or perceptions: it is a set of painterly procedures, habits, styles, performances, which do not add-up to a language game' (CC: 223). Nor, one might say, do they add up to the 'meta-language' that Krauss claims for the collages.

Every discussion of paintings that Clark goes on to consider, for instance *Ma Jolie* (1911–12), *Man with a Guitar* (1912–13), *Woman with a Mandolin* (1912), or *The Architect's Table* (1912), ends with the declaration that the work *fails* to constitute a resolved representation or to present a clear meaning or value, be it either in Krauss' terms, or in those of a conventional modernist art historian such as William Rubin.[42] Without mentioning Krauss by name, it is fairly clear,

I believe, that Clark wants to attack her semiotic notion that Picasso's cubist works can be seen to be clear in their significance: ' "Now we've discovered what signing amounts to!" This never quite happens, it seems to me, for reasons bound up with modernity (and maybe signing and consciousness in general)' (CC: 221). True, Clark concedes, Picasso's paintings, such as *Ma Jolie*, *are* a kind of practical critique of illusionism, as Krauss suggests. This 'portrait' shows pictorial conventions such as foreshortening '*as* resources; or devices ... that is, as ways of making a painting' (CC: 180). *Reservoir, Horta da Eloro*, a cubist 'landscape' from 1909, equally fastens, Clark claims, 'on the aporia [contradiction] and undecidables of illusionism' (CC: 203).

But the resources of illusionism, Clark insists, although played *with* by Picasso, are not, and cannot be, *played out*, which Krauss claims finally is the achievement of that artist's collages and the substance of their autonomy and greatness as artworks. For Clark illusionism, as a set of conventions of representations, will not go away, will not 'fade out of the picture, making sophisticated excuses [as Krauss does?]. It will go on doing its damnest: a palpable likeness will be insisted upon, however much the particular means used to generate likeness are shown as untrustworthy' (CC: 201). Cubism negates those illusionistic conventions, but it cannot surpass or transcend them, or the world in which they were originally produced and the interests of which they continue to serve. What sort of a world was that, and what place do the conventions of artistic representation have within it? It is, inescapably, the modernity of early twentieth-century capitalist society, and modern art, whatever else it is, is a part of that world, though its avant-garde artists, since the mid-nineteenth century, have continually sought ways to subvert, negate, or transcend it.

Clark's account of modernity is key to his whole argument, and separates him comprehensively from Krauss' position. For Clark, unlike Krauss, notions of 'structure' in art-historical analysis *must* refer to broad historical and social circumstances. Modernity includes art and artists, but these are unintelligible for Clark if they are not seen as part of the historical development of modern capitalist society. The overall theme of *Farewell to an Idea*, and indeed, of Clark's earlier books (discussed in the following chapter), is the utopian attempt avant-garde artists made, and which their artworks represent, both to locate themselves within, as part of, social and historical modernity, but also, through their artworks, to transcend those conditions and conventional representations. Modernist art, and Picasso's cubist paintings – if they represent anything coherent – for Clark represent the heroic failure, he

believes, to transcend, negate, or subvert, these conditions and conventions. This means that these works *must* fail to achieve the autonomy – a kind of wished-for sacredness – which Krauss wishes to grant them. Instead, they should be looked at, Clark says, 'in the light of – better still by the measure of – their inability to conclude the remaking of representation that was their goal' (CC: 187).

Why should they fail? The failure is inevitable, Clark appears to argue throughout the book in a number of case-studies, because modernist art's 'action' on, and in, representation is finally only a kind of dream or forlorn hope, a kind of madness of proposed transformation even, that it can change the way art and the world looks (CC: 173–5). Picasso's cubism was one example, Russian constructivism a second, Jackson Pollock's 'drip-painting' a third – all three practices produced in very different historical circumstances, but all part of capitalist (in the second case, Soviet) modernity's rocky history. The cubism of Picasso and Georges Braque between 1910 and 1911 briefly constituted what *appears* to have been a genuine social and artistic 'collectivity', admittedly of only two, Clark remarks, but in 'bourgeois society you settle for the collectivity you can get' (CC: 221). Yet later he is quite clear that Picasso's works are greatly superior to those of his collaborator, citing Picasso's infamous remark that Braque during this period 'was my wife' (CC: 223). Clark's implication is that this description expressed the harsh truth of their relationship (marriage: another failed utopian dream?), however unpalatable the acknowledgement of inequality was and remains.

For Clark, the paintings produced in this moment, although utopian and ambitious, have a 'dark mode' (CC: 220), 'a darkness and obscurity' (CC: 186), that reflects their inevitable 'epoch-making failure' (CC: 187) to produce a new world in and from art. These paintings – and the collages, I suspect Clark would say – *only look* as if they have begun a cognitive revolution, which is Krauss' grand claim for them. In fact they have produced what Clark calls 'a counterfeit of such a description – an imagining of what kinds of things might happen to the means of Western painting if such a new description arose' (CC: 215).[43] This apparent 'cognitive' shift is simply another metaphoric turn in modern art, the habit of which, he says, can be acquired by anyone; indeed 'the history of twentieth-century painting is largely made up of people acquiring them' (CC: 223). Picasso realises at this time, Clark claims, that painting is only a matter of 'devices' and that in his realisation there is 'disenchantment', or what might, ironically, be better called 'disillusion' (CC: 220).

Clark reflects (and, I would think, hopes) that his analysis – these 'stabs at description and crossings-out' – might upset some of cubism's admirers because what he has concluded robs these 'founding monuments of modern art of one kind of authority' (CC: 215). That is probably true. Krauss, I suspect, would find herself having little sympathy with Clark's argument. He goes on to say that if those who find his account disturbing think the basis for it lies in his 'Marxist determinism', then they will be 'entirely right' (CC: 215). In the following chapter I deal in more detail with a number of examples of Marxism in radical art history, beginning with a highly influential text in Clark's earlier articulation of the bases for the social history of art.

Notes

1 See, for example, Mieke Bal *Reading 'Rembrandt': Beyond the Word-Image Opposition*, Cambridge: Cambridge University Press, 1991, especially 25–8; Hans Belting *The End of the History of Art?*; Irving Lavin 'The Crisis of "Art History"', in 'Art History and Its Theories: A Range of Critical Perspectives', *Art Bulletin*, March 1996: 13–15; and Donald Preziosi *Rethinking Art History: Meditations on a Coy Science*, New Haven and London: Yale University Press, 1989.

2 'The Conditions of Artistic Creation', *Times Literary Supplement*. Clark goes some way to rectify this omission in later work. See, for instance, *The Painting of Modern Life: Paris in the Art of Manet and His Followers*, Princeton: Princeton University Press, 1984, Chapter 2 'Olympia's Choice'; and *Farewell to an Idea: Episodes from a History of Modernism*, New Haven and London: Yale University Press, 1999, Chapter 2 'We Field-Women'.

3 Pollock's commitment to historical materialist principles, but also to a critique of Marxism, is discussed in Chapter 3. Other feminists have shared a similar perspective. See, for example, Lynda Nead *Myths of Sexuality: Representations of Women in Victorian Britain*, London: Basil Blackwell, 1988, and *The Female Nude: Art, Obscenity and Sexuality*, London and New York: Routledge, 1992.

4 'The Conditions of Artistic Creation': 561.

5 Gombrich's *The Story of Art*, first published in 1950, for instance, long ago attained the status of a kind of 'bible' of basic art-historical truths taught in schools, colleges and universities. Radical art history has yet to unsettle its pervasive influence in many spheres of formal education and popular interest in art history.

6 *Art History and the Social Sciences: The Romanes lecture for 1973*, Oxford: Oxford University Press, 1973: 54. Note the term 'web' that

Gombrich uses – it is implicitly pejorative, implying that if the canon is seen *only* as a set of subjective value-judgements then scholars are effectively 'caught' in them and their relativism. For a defence of liberal humanism, see, for example, Richard A. Etlin *In Defense of Humanism: Value in the Arts and Letters*, Cambridge: Cambridge University Press, 1996.

7 E. Panofsky 'The History of Art as a Humanistic Discipline' (1940), in *Meaning in the Visual Arts*, Chicago: University of Chicago Press, 1982: 22.

8 'Formalism' is an extremely complex and multi-layered term, with a range of both positive and negative connotations. For a succinct and intelligent discussion of its origins in Russian literary theory after World War I, see Tony Bennett *Formalism and Marxism*, London: Methuen, 1979.

9 Pacht discusses Riegl's question in *The Practice of Art History: Reflections on Method*, London: Harvey Miller, 1999: 28–9.

10 See Christopher S. Woods' interesting account of Hans Sedlmayr, an active Nazi in the 1930s, in his Introduction to *The Practice of Art History: Reflections on Method*: 10.

11 The art historian John Pope-Hennessy noted, for instance, that the fact that different art historians reached contradictory conclusions from the same evidence indicated that 'the subjective element in art history was disproportionately large ... it was not only works of art that needed to be looked at in the original but art historians too, since their results were a projection of their personalities', 'Self-Portrait of an Art Historian', *New York Times*, 8 December 1985. Jean-Paul Sartre had aphoristically summed up the irreducible significance of individual lives within history when he noted that '[Paul] Valery is a petty-bourgeois intellectual, no doubt about it; but not every petty bourgeois intellectual is Valery', in *The Problem of Method*, London: Methuen, 1963: 56.

12 James T. Ackerman 'On American Scholarship in the Arts', *C.A.A. Journal*, xvii, 1958: 357–62, discussed by Irving Lavin in 'The Crisis of "Art History"', in 'Art History and Its Theories: A Range of Critical Perspectives', *Art Bulletin*: 14.

13 See, for instance, Davis 'The Subject in the Scene of Representation', in 'The Subject in/of Art History: A Range of Critical Perspectives', *Art Bulletin*, December 1994: 570–5.

14 Preziosi *Rethinking Art History*: 160–8. See Whitney Davis' interesting and extensive review in *Art Bulletin*, March 1990: 156–66.

15 See, on this issue, Richard R. Brettel 'Modern French Painting and the Art Museum', *Art Bulletin*: 167.

16 On 'reading' as this active process, see Roland Barthes 'Myth Today', in *Mythologies*, London: Jonathan Cape, 1972; and 'The Death of the Author', in *Image-Music-Text*, Glasgow: Fontana/Collins, 1977.

17 A. Rifkin, in 'Theory as a Place', *Art Bulletin*: 210–11; and Mathew Rampley 'From Symbol to Allegory: Aby Warburg's Theory of Art', *Art Bulletin*, March 1997: 41–56.

18 Many examples of these disputes occur within the chapters that follow. They indicate that although radical art historians may share some broad principles that I've characterised as 'historical materialist', these do not translate necessarily (or even usually) into any consensus about answers *or* political positions. It should be clear, for example, that historical materialism and Marxism are by no means synonymous.

19 On Riegl, see Svetlana Alpers *The Art of Describing: Dutch Art in the Seventeenth Century*, London: John Murray/University of Chicago Press, 1983: xx.

20 Mieke Bal 'Seeing Signs: the Use of Semiotics for the Understanding of Visual Art', in Mark Cheetham *et al. The Subjects of Art History*: 91. Pacht's remark is quoted in his son's preface to *The Practice of Art History*: unpaginated.

21 Christopher Woods, introduction to Pacht, *The Practice of Art History*: 11.

22 Christopher Woods 'Theories of Reference', in 'Art History and Its Theories: A Range of Critical Perspectives', *Art Bulletin*: 22–5 (23). Although all traditional artworks necessarily have material form, including paintings, Pacht and Bal seem to see the flat surface of paintings, prints, etc. as their paradigm of what an 'image' is. More obviously three-dimensional 'images', such as sculptures, resist the analytic separation of image from surface (material form) much more strongly.

23 Marcia Pointon 'Pricing or Prizing Potential in the 1990s', in 'Money, Power, and the History of Art: A Range of Critical Perspectives', *Art Bulletin*, March 1997: 17–20 (20).

24 See, for instance, M. Baxandall, *Giotto and the Orators*, Oxford: Clarendon Press, 1971, *Painting and Experience in Fifteenth Century Italy*, Oxford: Oxford University Press, 1972, *The Limewood Sculptors of Renaissance Germany*, New Haven: Yale University Press, 1980, and *Patterns of Intention: On the Historical Experience of Pictures*, New Haven and London: Yale University Press, 1985. See also Adrian Rifkin (ed.) *About Michael Baxandall*, Oxford: Blackwell, 1999.

25 *Patterns of Intention*: 1.

26 'The Conditions of Artistic Creation', *Times Literary Supplement*: 561.

27 A virtual synonym of 'New Labour', *Blairism*, has recently been included in the *New Penguin* dictionary. Paul Laity, writing in the *London Review of Books* (7 September 2000: 18) noted that the compilers had a difficult time finding an appropriate definition. 'One happy draft referred to "the absence of a fundamental underlying ideology" and "close attention to prevailing public opinion" . . . the final words chosen were more bland: "especially regarded as a modified form of traditional socialism"'.

28 See Lisa Tickner 'The body politic: female sexuality and women artists since 1970', *Art History*, June 1978, vol. 1, no. 2: 236–49. This essay, *Apollo*'s editorial response, and Tickner's response to that, which *Apollo* never acknowledged, never mind published (it subsequently appeared in *Art Monthly*, no. 23, 1979: 22–3), are collected in Rozsika Parker and Griselda Pollock (eds) *Framing Feminism: Art and the Women's Movement 1970–1985*, London: Pandora Press, 1987: 263–77. John Onians, editor of *Art History*, made a point of publishing material associated with radical art history in the first few numbers of the journal. These included essays by, for example, Fred Orton and Griselda Pollock, and Alan Wallach and Carol Duncan (see previous references).

29 These issues are discussed many times in several of the following chapters. A late 1970s' attempt to theorise the relations between Marxism and Feminism was that by Rosalind Coward and John Ellis *Language and Materialism: Developments in Semiology and the Theory of the Subject*, London: Routledge and Kegan Paul, 1977.

30 Of course it will be up to the reader to decide if my notion of radical art history is *too* capacious. It should be clear in what follows that I am aware of the sort of tensions that might explode the idea that those I call radical art historians do share basic principles. This is to say that I acknowledge that my account is also an active *reading*, and perhaps tendentious in parts.

31 See, for instance, *The Optical Unconscious*, Cambridge, Mass. and London: MIT Press, 1993, and *The Picasso Papers*, London: Thames and Hudson, 1998.

32 Psychoanalytic ideas and practices had earlier relation to political and social issues. See, for example, Sherry Turkle's *Psychoanalytic Politics: Freud's French Revolution*, New York: Basic Books, 1978 on the historical and institutional development of psychoanalysis, particularly in the US. On the political implications of broadly structuralist or 'formalist' philosophy and criticism in Eastern Europe, see Fredric Jameson *The Prison-House of Language: A Critical Account of Structuralism and Russian Formalism*, New Jersey: Princeton University Press, 1972.

33 See the exhibition catalogue *Pablo Picasso: A Retrospective*, New York: Museum of Modern Art, 1980.

34 See, for example, Eunice Lipton *Picasso Criticism 1910–1939: The Making of An Artist Hero*, New York: Garland, 1976.

35 See reference in n. 2 above and in Introduction, n. 5.

36 On the problems of defining 'explanation', see the range of relevant essays included in Charles Harrison and Fred Orton (eds) *Modernism, Criticism, Realism*, London: Harper and Row, 1984.

37 Clark has examined the notion of 'context' numerous times. See, for instance, his discussion of Cecil Beaton's photographs of Jackson Pollock paintings used as a backdrop for *Vogue* models, in *Farewell to an Idea*, Chapter 6.

38 This is the tradition usually identified, derogatively, as 'formalist'. One classic statement of this position is Clement Greenberg 'Modernist Painting', first published in 1961, and reprinted now in numerous collections, such as Francis Frascina and Jonathan Harris (eds) *Art in Modern Culture*.

39 One of the strongest *historical* challenges to Krauss' position comes from Patricia Leighton, who links Picasso's collages explicitly to the politics of the Balkans in the period before World War I. See 'Picasso's Collages and the Threat of War 1912–1913', *Art Bulletin*, December 1985: 653–72, and *Reordering the Universe: Picasso and Anarchism 1897–1914*, Princeton: Princeton University Press, 1989.

40 See Alois Riegl *Late Roman Art Industry*, Rome: G. Bretscheider, 1985.

41 See, for example, CC: 211, 221–2.

42 Though he also thanks Rubin: 'Modernist critics (and Rubin is one of the best of them) got a lot of things about modernism right; only a half-wit would be hoping for an account of Cubism somehow magically purged of their terms . . .', CC: 178.

43 Though Clark offers important caveats on the use of the term 'counterfeit': 215.

Select bibliography

Art Bulletin 'Art History and Its Theories: A Range of Critical Perspectives', March 1996: 6–25

Art Bulletin 'Rethinking the Canon: A Range of Critical Perspectives', June 1996: 198–217

Art Bulletin 'Writing (and) the History of Art: A Range of Critical Perspectives', September 1996: 398–416

Barnard, M. *Art, Design and Visual Culture*, London: MacMillan, 1998

Baxandall, M. *Giotto and the Orators*, Oxford: Clarendon Press, 1971

Baxandall, M. *Painting and Experience in Fifteenth Century Italy*, Oxford: Oxford University Press, 1972

Baxandall, M. *The Limewood Sculptors of Renaissance Germany*, New Haven and London: Yale University Press, 1980

Baxandall, M. *Patterns of Intention: On the Historical Experience of Pictures*, New Haven and London: Yale University Press, 1985

Belting, H. *The End of the History of Art?* Chicago: University of Chicago, 1987

Collins, B.R. (ed. special issue) 'The Survey In Art History', *Art Journal*, Fall 1995

Eagleton, T. *Literary Theory: An Introduction*, Oxford: Blackwell, 1983

Edwards, S. (ed.) *Art and Its Histories*, New Haven and London: Yale University Press/Open University, 1998

Fernie, E. (ed.) *Art History and Its Methods*, London: Phaidon, 1995

Harrison, C. and Orton, F. (eds) *Modernism, Criticism, Realism*, London: Harper and Row, 1984

Krauss, R. *The Picasso Papers*, London: Thames and Hudson, 1998

Leighton, P. *Reordering the Universe: Picasso and Anarchism 1897–1914*, Princeton: Princeton University Press, 1989

Lipton, E. *Picasso Criticism 1910–1939: The Making of An Artist Hero*, New York: Garland, 1976

Nelson, R.S. 'The Map of Art History', in *Art Bulletin*, March 1997: 28–40

Pacht, O. *The Practice of Art History: Reflections on Method*, London: Harvey Miller, 1999

Pollock, G. *Differencing the Canon: Feminist Desire and the Writing of Art's Histories*, London and New York: Routledge, 1999

Rifkin, A. (ed.) *About Michael Baxandall*, Oxford: Blackwell, 1999

Capitalist modernity, the nation-state, and visual representation

Key texts

T.J. Clark 'Preface to the New Edition' and 'On the Social History of Art', in *Image of the People: Gustave Courbet and the 1848 Revolution* London: Thames and Hudson, 1982 [originally 1973]: IP.

Albert Boime *The Academy and French Painting in the Nineteenth Century*, London and New York: Phaidon, 1971: AFP.

Alan Wallach *Exhibiting Contradiction: Essays on the Art Museum in the United States*, Amherst: University of Massachusetts Press, 1998: EC.

John Barrell *The Dark Side of the Landscape: The Rural Poor in English Painting 1730–1840*, Cambridge: Cambridge University Press, 1980: DSL.

John Tagg *The Burden of Representation: Essays on Photographies and Histories*, Basingstoke: Macmillan, 1988: BR.

'... no art history apart from other kinds of history'[1]

T.J. Clark, writing in the 1981 preface to *Image of the People: Gustave Courbet and the Revolution of 1848* (first published in 1973), explains that his book had been written mostly in the winter of 1969–1970, in what seemed then, he says, '(and still seems) ignominious but unavoidable retreat from the political events of the previous six years' (IP: 6).[2] Though Clark gives no more detail about the nature of this ignominious retreat, by mentioning it at all he signals that his book on the painter Courbet – whom he presents as a revolutionary artist working in a time of revolutions in France in the mid-nineteenth century – itself was partly born out of the political and social radicalism of the mid- and late 1960s. Clark himself had been involved in this radicalism, our now familiar 'moment of 1968', as a 'Situationist', the name chosen by a group of activists engaged at the time in a variety of artistic, political, and philosophical projects in a number of western countries.[3]

It is fitting, then, that his book on Courbet, particularly its introductory chapter 'On the Social History of Art', highly influential as an argument setting out the principles of Marxist art history, should begin by indicating the roots of such a radical art history in *contemporary* history. But Clark equally makes it clear that the relation of his study to the events of the later 1960s is complex and ambivalent: the book comes, at least in part, out of the retreat from what can only be the *failure* of that recent radical movement for social and political change. 'May 1968' *did not* usher in a post-capitalist, libertarian, or non-Stalinist socialist future. Though the legacy of that radicalism is diverse, even contradictory, the moment of 1968 did not thwart the development of capitalism or erode significantly the power of nation-states and their ruling elites.[4] Written in recoil from this period of failed activism, then, Clark's study of French art in the mid-nineteenth century was, he says, 'unashamedly – or at least unapologetically – academic'. By 1981, looking back, he says it can be seen to have taken part in a process of 'recuperation' (IP: 6).

'Unapologetically' academic, perhaps, because Clark had the sense in 1970 that no other course of action at that time for a radical remained possible *other than study and reflection*. Activism 'on the streets' for a contemporary revolution bringing radical change having failed to deliver, Clark turns to Paris, Courbet, and 1848 to study instead 'the history of a distant revolution and its cultural dimension' (IP: 6). 'Recuperation', perhaps, because Clark has anticipated that a merely 'academic' radicalism in art history – that is, one split from any

basis in action outside of the university – would be appropriated by 'institutionally dominant art history' for its own ends. In this process of 're-couperation' – which means here a recovery that loses something vital to the original quality of that which is recovered – Clark admits that his main line of enquiry, into when 'art was ... an effective ... part of the historical process' (IP: 10), was transformed by the 'Right' into merely 'a 'contribution' to some dismal methodological change of gear' (IP: 6). The 'new art history' – academic 'contributions and methods', rather than political 'arguments and perspectives' – raises its ugly head once again.

This chapter examines five examples of Marxist art history produced since the early 1970s. All these texts, in specific ways and to different extents, allude to the relations between their historical objects of study and the social circumstances in which their authors produced their arguments. Clark's account of Courbet and the Revolution of 1848 makes few, if any, explicit references to society around 1970. Perhaps for this reason also he was prepared to admit in the 1981 preface that his study was unapologetically, if not 'unashamedly', 'academic'. Other texts I consider here – those by John Barrell on English landscape painting (1980), John Tagg on photographic history and theory (1988), and Alan Wallach on art exhibitions and institutions in the US (1998) – in contrast, make occasional or quite continuous allusions to contemporary circumstances.

Clark's 'On the Social History of Art', though serving as the introduction to his study of Courbet, also makes several important claims about what a Marxist art history should seek to achieve, and in so doing provides an outline of the theoretical perspective from which Clark spoke in the early 1970s.[5] Art history, as my epigram at the head of this section proclaims, for Marxists must be a branch related to other kinds of history – economic, cultural, political – which together constitute the intellectual framework for understanding human social development. Perhaps the most important argument, which Clark's book as a whole goes on to exemplify, is that Marxist art history needs to produce accounts of specific historical moments or 'conjunctures' – relatively *short* slices of history – in which the relations between artists, art practices, artworks, institutions, and the broader political and historical circumstances can be examined in detail. The principles and analytic procedures of this 'conjunctural analysis', related in the 1960s to the influential Marxist philosophy of Louis Althusser, was in sharp contrast to an earlier Marxist art history, associated particularly with Arnold Hauser. That 'epochal history' had produced, on the whole,

sweepingly generalised accounts of art's development over centuries, identifying abstractly defined 'styles' of art (for instance, 'realism' or 'naturalism') with equally abstractly defined notions of 'modes of production' and 'social ideologies' (for instance, 'capitalist bourgeois individualism'). There was certainly value in this earlier moment of Marxist art history, acknowledged by later Marxist art historians such as Alan Wallach.[6] After 1970, however, Clark and other art historians began to attend to the specificities of artworks, artists, and the complex conditions and circumstances of their production. This analytic specificity simply had not been possible within the highly schematic and formulaic account of art and history which Hauser's 1950 magnum opus, also called *The Social History of Art*, had offered.[7]

Clark characterises this formulaic crudity by suggesting how an account of Courbet's art might be seen within a perspective reliant upon such generalisations. This was the idea, he says, that paintings by Courbet, such as *The Burial At Ornans* (1848) or *The Stone-Breakers* (1849) (Illustration 2) 'is influenced by Realism which is influenced by Positivism which is the product of Capitalist Materialism. One can sprinkle as much detail on the nouns in that sentence as one likes; it is the verbs which are the matter' (IP: 10). But if Clark has in his critical sights the crudities and vague abstractions of a certain kind of Marxist art history that certainly isn't part of what he calls the discipline's 'heroic phase', then he is equally out to attack conventional mainstream art history, focused only on attention to artists, artists' 'movements', and formalistic accounts of artworks.[8] This kind of impoverished art history is founded on the orthodox assumption, Clark says, that 'the artist's point of reference as a social being is, *a priori*, the artistic community', rather than a wider engagement with social and political circumstances (IP: 10). Such orthodoxy isolates and idealises both artist and artwork. In contrast, art-historical 'conjunctural analysis' works to identify and relate these certainly real specificities to other forms of evidence needed adequately to understand a particular historical moment.

The value of Clark's text, then, is to posit theoretically, and then to exemplify through a case-study based upon Courbet's work around the 1848–1851 period, the relationship of elements that may be shown to constitute 'the historical process' (IP: 10). Put another way, Clark's object of analysis is what he calls 'the complex relation of the artist to the total historical situation, and in particular to the traditions of representation available to him' (IP: 12). The great value of Clark's position is that, as a model or hypothesis, it can be applied, heuristically

'tested out', on many different historical conjunctures, in which the range of elements – individual artists, artworks, institutions, critics, institutional circumstances, etc. – may be combined and assessed in different kinds of configurations. No one can know in advance what the results of such possible empirical analyses might reveal. Although the *principles* underpinning the inquiry are stated and are clearly 'perspectival' (that is, related to certain interests and values – those of historical materialism), the *process* of research remains open and dependent upon how the 'relation of elements' within different conjunctures are identified and examined. This is in diametric contrast to what Clark sees as the formulaic reductivism inherent in Hauser's 'historicism', in which a crude Marxist mantra of epochal development in both art and history – in which the verbs, again, do all the work – replaces any specific and relatively open inquiry.[9]

Elements within 'the social history of art'

It would be entirely wrong, however, to describe the social history of art as simply a framework of analytic devices. There is a kind of formalism (or whiff of apparent neutrality) in this idea, though it is extremely important to retain the sense that the argument and inquiry is a *relatively* open-ended process, not value-free but not prejudged either. Clark, in his preface, brings his writing of the Courbet book into relation with the radicalism of the 1960s, with which he was involved. Hauser's *The Social History of Art* was also, at least in part, fixated on a notion of revolution in art and society. It was written with the specific actuality and legacies of the Russian Revolution, and the doctrine of Soviet Socialist Realism, in mind.[10] Twenty years later, Clark's account of Courbet, which is both an empirical case-study *and* a theoretical model for research, enshrines very different notions of 'revolution' – actual and ideal – within the social history of art's intellectual foundations.

In turning his attention to Courbet, to 'social realist' paintings like *The Burial at Ornans* or *The Stone-Breakers*, and to the critical political situation in France between 1848 and 1851, Clark establishes for art both an ideal and an agenda. Both are concerned with how art has operated, and might again, as an active element in, and of, social change. The period between 1848 and 1851, he says, was 'a time when art and politics could not escape each other. For a while in the mid-nineteenth century, the State, the public and the critics agreed that art

had a political sense and intention. And painting was encouraged, repressed, hated and feared on that assumption' (IP: 9). Clark's intention, therefore, is to ascertain how the relations between art, artist, and the broader society were organised and transformed in *that* moment, but with a view to other moments, some dramatically contemporary. Once again his 1981 preface says directly what his main text might be thought only implicitly to indicate. If Courbet's 'revolutionary' realism had failed in 1850 to find a class that could 'produce and sustain alternative meanings to those of capital' (for such a class did not then exist, Clark claims), then later collaborations and collisions between such a class and artistic practice had occurred in only 'botched and fragmentary' forms in the twentieth century, 'against the grain of the Bolshevik Revolution, around the edges of the Worker's Councils in Berlin, Barcelona or Turin, and nowadays perhaps in the struggle of the Polish working class to reimpose soviet rule' (IP: 7).[11]

The theme of modern art's relation to, and implication within, the political revolutions of the late nineteenth and twentieth centuries, and the ideologies and politics of anarchist, socialist, and communist organisations, finds continuous presence in Clark's work from the early 1970s onwards. This presence takes form in both idealistic (utopian) and critical (sceptical, melancholic) motifs: for Clark, modernity in society is inextricably 'tied up' – in the senses of intimacy *and* constriction – with modernism in art and movements for radical left-wing political transformation.[12] Modernism for Clark means a kind of 'realism'. But Clark's 'realism' is *not* the name for a style or set of conventions that offers 'accurately to depict how the world appears' (two predominant art-historical definitions). Modernism is a realism for Clark in the sense that it is a practice and tradition of representation active and intelligible only within, as part of, a conjuncture of social and historical elements.

Modernism's era is also social modernity's era of revolution and counter-revolution, and the interactions between the two at specific historical moments have always been pivotal to Clark's interests. He tracks, in the case of Courbet, for instance, what happens to that artist's paintings when they are caught up 'however tangentially, in [this] process of revolution and counter-revolution: in other words, when [art] lost its normal place in the machinery of social control and was obliged for a while to seek out other spaces for representation – other publics, other subjects, other idioms, other means of production' (IP: 6).[13] Clark's social history of art must be judged, therefore, on its ability convincingly to represent the interaction of these elements within

the conjunctural moment of art's displacement from one set of rela-
tions, and its attempt to find another. This sense of *the work art has
done within history* is opposite to that of conventional scholarship that
presents, Clark says, a 'picture of history as a definite absence from
the act of artistic creation: a support, a determination, a background,
something never actually *there* when the painter stands in front of the
canvas' (IP: 12).

If Clark pits himself against the dominant art-historical account
of history as a kind of anaemic background or inert backdrop to the
study of the work of art, then he is equally critical of the 'mechanistic
Marxist' notion that artworks simply 'reflect' ideologies, social rela-
tions, and history. For this metaphor of reflection also suggests that
artists and artworks can be isolated and abstracted, within a perspec-
tive which wants to see economic and political forces and structures
as always prior, determining, and pre-empting artistic activity. Though
Clark acknowledges the existence and shaping force of what he calls
'the general nature of the structures' (IP: 13) which artists encounter
– for instance 'the structure of a capitalist economy' (IP: 11), or that
of 'pictorial tradition' (IP: 15) – the innovative work of social history
of art lies in locating the 'specific conditions of one such meeting'
(IP: 13) between an artist and these structures.

Clark goes on to examine the conditions of one such meeting,
that between Courbet and the circumstances the artist and his paint-
ings encountered in Paris and the provinces in 1848–1851. This inquiry
includes importantly the question of how Courbet's large 'history
painting' representations of people from the lower orders in French
society – stonebreakers, itinerants, the drunks, for instance, in his
Peasants of Flagey Returning From the Fair (1851) – find, or fail to
find, spaces for exhibition and elicit, or fail to elicit, intelligible crit-
ical response from contemporary commentators on art. Highly
politicised as the whole culture and society in France was then, when
a radical shift in government to either the left or right was possible,
Courbet's paintings take on life and meaning *within* that moment, as
elements *of* it. What Clark wants to explain, he says, 'are the connecting
links between artistic form, the available systems of visual representa-
tion, the current theories of art, other ideologies, social classes, and
more general historical structures and processes' (IP: 12).

It is through the analysis of these connections in a specific instance
– Courbet's paintings and their reception in the conjuncture of
1848–1851 – that Clark believes it becomes possible to discover
what 'concrete transactions are hidden behind the mechanical image of

"reflection", to know *how* "background" becomes "foreground"; instead of analogy between form and content, to discover the network of real, complex relations between the two' (IP: 12). The role of analogy in art-historical discourse is extremely important, Clark remarks. Both conventional art historians and crude Marxist art historians rely upon the idea that the way a painting looks, its visual form, tells us about its meaning. For crude Marxists, Clark says, form in painting can be related 'intuitively' to ideological content. This happens, for instance, if it's claimed that 'the lack of firm compositional focus' in Courbet's *Burial at Ornans* is seen as 'an expression of the painter's egalitarianism' (IP: 10–11). Analogy here means direct equivalence drawn between different things. The relative *disorder* of Courbet's painting – compared with typical contemporary history painting products of the French academy system (discussed by Boime in his text which I consider below) – is seen as a visual equivalent, or 'reflection', of Courbet's rejection of the order of the French political system at the time, and his embrace of socialist ideas. Now Clark admits that the painting indeed has a 'strange and disturbing construction' and that some account of it must be given. He says, however, that he wishes to avoid such intuitive (because unexamined) notions of equivalence and instead will try to keep his account 'in contact and conflict with other kinds of historical explanation' (IP: 11).[14]

One kind of evidence he uses extensively, in this book and in later studies, is that of the documented reaction of contemporary critics to artists' work. This suggests the principle that the social history of art must, as part of its basic task, recover evidence of the contemporary meanings of paintings, those generated, again, within the specificity of historical conjunctures. But Clark is cautious in his explanation of the nature and value of this evidence, relating it to the danger of a simply 'empirical notion of the social history of art' (IP: 11). Clark's point here is that the social art historian must avoid being overwhelmed by the diversity and extent of the evidence that might legitimately be brought into the inquiry of the significance of artworks in particular conjunctures – issues of patronage, sales, criticism, public opinion, etc. This kind of material cannot be marshalled and utilised, Clark remarks, without 'some general theory – admitted or repressed – of the structure of a capitalist economy' (IP: 11). But what happens to the specificity of artworks within this theory? Is there not a danger that they may be lost altogether?

On the one hand there is the possibility, Clark acknowledges, that because the social history of art 'invites us to more contexts than usual

– to a material denser than the great tradition [the canon?] – it may lead us far from the work itself. But the work itself may appear in curious, unexpected places; and, once disclosed in a new location, the work may never look the same again' (IP: 18). Indeed, social history of art requires us to reconsider in very basic terms what an artwork such as a painting like Courbet's *The Stone-Breakers* actually *is*, and what kinds of 'work' it may be said to have done. Some of these basic questions are:

- How was it made? Out of what resources (material, technical, intellectual, with what references to tradition, and to other contemporary paintings, etc.)?
- What can be reconstructed of the producer's motivations and intentions?
- What kind of public was imagined by the producer as the potential viewers for whom the work would be meaningful?
- What public did the artists wish to ignore or alienate?
- What critical and other institutional responses did the work, when and if displayed (and where?), elicit?
- What do these responses tell us about the significance of the painting as part of the 'historical process' at the time?

Some of these issues lead the analysis back, Clark says, to the 'old familiar question' of art history:

> What use did the artist make of pictorial tradition; what forms, what schemata, enabled the painter to see and to depict? It is often seen as the only question. It is certainly a crucial one, but when one writes the social history of art one is bound to see it in a different light; one is concerned with what prevents representations as much as what allows it; one studies blindness as much as vision. (IP: 15)

Barrell's account (discussed below) of the kind of highly selective representation of the rural poor that appears in English landscape painting in the eighteenth and nineteenth centuries, in works by Constable and Gainsborough – artists also influenced by notions of the public for such art and the place of the poor in the changing English social order – exemplifies the attempt to study 'blindness', as well as 'vision'. For Courbet, as well as for these English artists, it was partly a question, then, of what conventions of representation were already available to

be used, or modified – whether they were in the realm of 'high art' or popular traditions (such as the 'wandering Jew' visual motif Courbet adapted) – and how artists imagined a public for whom these visions and blindnesses in representation were intended.[15]

The problem of artists' sense of a public, of whom the artwork is *for* (as well as what it is *of*), becomes chronic in the nineteenth and twentieth centuries as western industrial-capitalism and urbanisation transforms the relatively stable class, and, later, gender, structure of earlier centuries. New publics, new class strata, new kinds of critical commentators emerge, along with new institutions in which to train artists, new relationships between artists and patrons, new spaces to exhibit, and new forms of commercial exchange. By the 1860s an anonymous mass market for art has developed, increasingly outside the control of the state. Modernism in art, for Clark, *is* the relation of artists to these changing conditions, and how these changes get represented in the *work* of the art of the modern tradition that Clark believes begins with Courbet in the conjuncture of 1848.

This tradition, highly significantly, is bound up with the emergence of artistic 'avant-gardes', for whom the issue of the public, and then the 'people' – a highly resonant term increasingly associated with radicalism in art and politics in the later nineteenth and twentieth centuries – becomes central.[16] Courbet declares 'I must free myself ... from governments. My sympathies are with the people, I must speak to them directly' (IP: 9). Avant-garde artists become caught between conflicting senses of whom their work is for, so their motivations revolve, as Clark says: 'inventing, affronting, satisfying, defying [the] public is an integral part of the act of creation' (IP: 15). This instability of reference continued throughout the twentieth century, producing, Clark believes, the most significant modernist artists and artworks (though he seems to see an ending with Jackson Pollock's drip-paintings in the 1950s).[17]

The significance of the modernist tradition for Clark is that, although its artists and artworks are inevitably caught up in the conditions and contradictions of capitalist society, the work these paintings does is critical: it takes those dominant, accepted 'ideas, images, and values' and produces 'new form' that at a certain point 'is in itself a subversion of ideology' (IP: 13). This was the critical work done by, for example, the paintings Courbet managed to have exhibited at the Salon of 1851: they, by turns, disappoint, enrage, cajole, mystify the critics into reaction. For Clark this demonstrates the particular effectivity of avant-garde art within the historical process; it is the real kernel of it specificity and value:

Art is autonomous in relation to other historical events and processes, though the grounds of that autonomy alter. It is true that experience of any kind is given form and acquires meaning – in thought, language line, colour – through structures which we do not choose freely, which are to an extent imposed upon us . . . Nevertheless, there is a difference between the artist's contact with aesthetic *tradition* and his contact with the artistic world and its aesthetic *ideologies*. Without the first contact there is no art; but when the second contact is deliberately attenuated or bypassed, there is often art at its greatest. (IP: 13)

If Clark's outline of the principles and perspective of the social history of art in his introduction to the study of Courbet stresses finally the potentially critical, subversive, import of modernist art, then it achieves this criticality – its 'autonomy' – only *within* its network of relations to all other elements of the effective historical process in a particular conjuncture.

Institutions and ideologies

Clark's social history of art has remained focused on questions to do with the way to make sense of specific artworks. He has always shown, however, that artworks are only really intelligible within accounts that demonstrate their complex 'situatedness', their life within many contexts of relation to other forms of historical evidence. But analysis preoccupied with the interpretation and evaluation of art objects is only one perspective within Marxist art history. Other scholars have concerned themselves particularly with the role of institutions in the production, dissemination, and consumption of art. Some of these studies have dealt additionally with the difficult question of defining 'institution' *theoretically*.

Sometimes the term is used to refer simply to an actual building used for a particular function – the *Museum of Modern Art* in New York, or the *National Gallery of Art* in London, for instance. But such institutions, though they are literally structures, are also active social forces in societies and bound up with important aspects of their organisation. In this sense institutions always have ideological significance, relating to the activities, attitudes, and values of specific groups. Though many institutions are controlled and funded by the state or corporations – the BBC, the Royal Academy, the Metropolitan Museum of

Art, etc. – others, far less formally organised, and some not based in particular buildings at all, have developed outside, and even in opposition to, the power of state institutions. Modern 'movements' in art, in one sense, are a kind of novel institution of the late nineteenth century.

Clark's study of Courbet concerns the period just before the emergence of the first avant-garde groupings in France. Their predecessors' complex relationship to institutions of the French state involved with the organisation of artists' training, patronage, and exhibition is the subject of Albert Boime's 1971 *The Academy and French Painting in the Nineteenth Century*. This book examines the history of these institutions and their relationship to the emergence of French avant-garde artists of the 1860s. Boime's starting point is the contention that unless a proper history of these institutions, and their relation to France's economic and political development, is conducted, then accounts of the development of art in the period, based around the conventional art-historical opposition between 'academic' and 'avant-garde' art, will remain facile (AFP: vii).

Boime's view is that a history of the development of art institutions in France between about 1830 and the 1860s shows that the relationship of later 'independent' movements (for instance, the Impressionists) to those earlier state institutions was crucial. He claims, in fact, that the later 'revolt' of such avant-garde groups actually 'was made possible by the ideas and practices offered them by the academic system' (AFP: vii). The famous first Impressionist exhibition at the 1863 'Salon des Refusés', Boime reminds his readers, was organised by officials of the state aware that the academic system of art training no longer retained public support.

Boime's study attempts to reconstruct the development and transformation of art training techniques used at the national art school in Paris, the École des Beaux Arts, between the 1830s and 1860s. In particular, Boime examines the emergence of the idea and form of the 'sketch' within academic training, a term which later was assimilated entirely to Impressionist techniques and their claimed 'artistic vision', seen necessarily to imply the so-called 'progressive tendencies' of avant-garde practice. Definitions of the 'sketch', then, and other key terms – such as *croquis*, *ébauche*, and *esquisse* – relating to subtle differences in technical procedure used in the production of academic paintings (specifically the 'history painting' genre), particularly concern Boime. His book is structured around the study of several *ateliers*, the master artists' studios in which apprentices learned to paint, and their

relationship to the École des Beaux Arts, at which students enrolled only to learn to draw and to receive lectures on the history and contemporary condition of art in France.

One such atelier was that of Thomas Couture, Manet's teacher. Manet, regarded as the most significant 'independent' of the 1860s, and 1870s is usually seen, along with the Impressionists with whom he had complex links, as the first true modernist.[18] Boime claims, however, that almost 'all of the important representatives of these [independent] movements began their careers in the studio of one or another Academic painter, from whom they absorbed significant lessons for their mature development' (AFP: 185). The idea of the emergence of the 'Independents' as a straightforward heroic battle against the conservatism of the Academy is false, Boime claims: it was actually tendencies that saw the need for change *within* the State institutions of training that contributed to the evolution of those tendencies (AFP: 185).

The fundamental change occurred when teaching practice at the École began to divide into two parts what had traditionally been a single process for producing paintings: the preparatory stage, including the production of *sketches* towards the final painting, and the final painting itself, which had always to display the sufficient degree of *finish* – for example, Anne-Louis Girodet's *The Sleep of Endymion* 1791 (Illustration 10). Gradually, in the first half of the nineteenth century, these two aspects of the production process became associated, respectively, with 'romantic' and 'classicist' tendencies (represented, in the early part of the century, in the work of Delacroix on the one hand, and Ingres on the other). These, in turn, became associated with political attitudes roughly characterised, respectively, as 'progressive' and 'conservative'. Boime's point, however, is that the emergence of these distinctions (exemplified in the 1860s by Manet and the Impressionists on the one hand, and by academic artists like Gérôme and Cabanel on the other), 'could not have occurred if the Academy had not already separated the two phases, and already allocated to each its autonomous role. The qualities eventually associated with the aesthetics of the sketch were exactly those which had been assigned to the preparatory sketch throughout the history of the Academy; the independents had only to shift emphasis from the executive to the generative phase and systematise the sketching procedures' (AFP: 185). The so-called *juste milieu* ('middle of the road') style of a master such as Couture had come to represent an attempted compromise somewhere between the two polarities. A kind of *juste milieu* emerged in French politics as well: the returned monarchy, under Louis-Philippe after

1830, accepted a state constitution limiting his powers. Within this new French state art became a minor instrument of political policy, Boime says, 'a means of pleasing constituents and flattering politicians: politically it provided a form of patronage; culturally it mediated a style for the bourgeois public' (AFP: 13). This emergent middle class wanted neither the 'classicism' of the conservatives, nor the 'romanticism' (or later realism) of the radicals. It was the political *juste milieu* that pressurised the Academy to reorganise the Salon (introduced after 1830) under complete artists' control, and which honoured Manet, against the wishes of the Academic jurors, with a medal in 1881.

But this tendency towards acceptance of change was only one facet of the Academy. Throughout the period the institution also continued to act as part of the French state in affirming and maintaining the norms of traditional authority throughout the century. The history of institutions concerned with visual arts production and exhibition in France is highly complicated, and moves through phases of control first by the Catholic church, then within the academic system (the Royal Academy of France was founded in 1648), which the French Revolution of 1789 inherited. The historical shift over centuries is both social and ideological, Boime remarks: art pedagogy moves into the public, secular, domain and from 'the practical to the theoretical' (AFP: 1).

After the Revolution, the Royal Academy fell along with the king and the new *Institut de France* (founded 1795) took over many of the Academy's functions. The Institut established the 'Class of Fine Art' and recruited teaching staff for the newly created École des Beaux Art. Throughout the post-revolutionary period the Institut suffered crises of identity and function which reflected the highly unstable political culture in France as a whole.[19] Social institutions always contain a variety of groups, factions, and interests, which are sometimes led into disagreement and conflict, although the leaderships within organisations attempt to manage and maintain overall control and direction – but this can sometimes break down fundamentally.

Alan Wallach's 1998 study of US museums and exhibitions, *Exhibiting Contradition*, is also concerned with the role art institutions play in the wider society, including how they come to embody and represent some of society's conflicts and contradictions. His interest is also in their role as producers and conveyors of ideologies, including versions of art history, and the history of the US as a nation-state. At the same time, however, he notes that, although museums 'are profoundly conservative institutions', intended to produce 'an eternal image of the past' (EC: 106, n. 1), some have 'made concessions to,

or even encouraged, revisionist approaches' to both art's history and to that of the US (EC: 6).[20] Wallach is not convinced, though, that these attempts have been particularly successful, believing that 'already inscribed' meanings in art 'work against any sort of critical narrative' (EC: 115).

Fundamental to Wallach's account is his argument that art museums in the US have always had an important role in articulating a history of the nation's development since the eighteenth century. This is a history that is, he says, 'inescapably, a brutal story of expansion and conquest, of ruthless efforts to destroy Native American populations and cultures, of the merciless exploitation of industrial and agricultural labour' (EC: 112).[21] After the Civil War in the 1860s, museums in Boston, New York, Washington DC, and in other cities enshrined the idea of the emergence finally of a national 'civilisation' by institutionalising 'high art as a category' (EC: 3). Not simply in the US but throughout the western world, national and city art museums began to function as symbols of civilisation: both the grand buildings themselves and their collections. Art museums 'sacralize' their contents, Wallach argues, and 'the art object, shown in an appropriately formal setting, becomes high art, the repository of society's loftiest ideals. Indeed, without art museums, the category of high art is practically unthinkable' (EC: 3). The ideological value of 'high art', Wallach says, is that it is claimed to transcend merely local, partial, and perhaps conflicting interests, and stresses instead the 'universal and aesthetic qualities' of the works deemed to contain this transcendent value (EC: 114).

Recently, however, some museums have organised exhibitions critical both of this received history of the bringing of civilisation to the US, and of the category of 'high art' itself. Wallach cites, for example, 'Art/Artefact', held at the Center for African Art in New York City (1988), 'Winslow Homer's Images of Blacks', held at the Menil Collection in Houston (1988–1989), and 'Mining the Museum' – which also explicitly examined the role of exhibitions and museums – held at the Baltimore Museum of Contemporary Art (1992).

An exhibition which Wallach considers in detail, 'The West as America', held at the highly prestigious Smithsonian Institution National Museum of American Art in Washington DC in 1991, caused particular controversy in its attempt to re-examine the significance of paintings of 'wild west' subjects and the relations between native Americans and white settlers. The show's 164 paintings and prints were hung within sections with titles such as 'Repainting the Past', 'Inventing

the Indian', and 'Claiming the West'. The intention of the exhibition was clearly to subvert the usual glorious narrative of western and white settlement. Through exhibiting paintings such as Emmanuel Leutz's *Departure of Columbus* (1855) and George Caleb Bingham's *Daniel Boone Escorting Visitors Through the Cumberland Gap* (1851–1852), the aim of the show was to demonstrate that 'in conquering the West, palette and paintbrush were as much instruments of domination as Colt revolvers or the pony express' (EC: 107). In presenting these paintings as part of a historical critique of the origins of the US their status as 'major or minor works of art' is undermined, Wallach argues, and they begin, instead, to 'take on qualities of historical artefacts: objects created to achieve particular aims' (EC: 107).

This was an exhibition itself influenced by what Wallach calls the development of 'critical and revisionist art history' in the US, which has turned its attention to the ideological roles of museums as well as to artworks, and led some of these institutions to consider 'the nature and effects of their habitual practices' (EC: 106). However, Wallach makes a point similar to that of Boime's concerning the splits inside the Academy and later state art institutions in nineteenth-century France. Proposals for 'critical exhibitions' such as 'The West as America' more or less inevitably meet resistance from opposing factions both within the institutions and outside them, since such proposed shows 'pose the threat of undermining the museum's authority and thus adversely affecting the various elite, corporate, and government interests that that authority normally serves' (EC: 106). Wallach pursues this question of the elites involved in art museum management and policy in an essay concerned with the Museum of Modern Art in New York.

In 'The Museum of Modern Art: The Past's Future' Wallach continues to ponder the role of museums in the maintenance of the category of high art and its claim to universality. His particular interest is in architect Cesar Pelli's renovation and extension of the museum's building (originally constructed in 1939), which involved erecting a fifty-two story condominium tower over the museum's new west wing. This new development, Wallach claims, is related to the changed conditions 'of capital, the state, and public culture' within which the museum finds itself (EC: 74). The new tower and atrium within the original building adds what Wallach calls a structure in stainless steel and glass representative of the 'banality of a futureless, post-modern present' (EC: 4–5). This is in dramatic contrast, Wallach says, to the museum's earlier history in the 1930s and 1940s, with its 'long

ago utopian-modernist hopes' (EC: 5), when the institution, as much as its collection of modern artworks, had 'symbolised an equation between modernity and a vision of a corporate-utopian future of rationality and technological progress' (EC: 4–5).

This projected modernity, however, Wallach claims, by the 1950s had turned into a nostalgia 'for the lost utopianism of the 1930s and 1940s' (EC: 5). Part of Wallach's essay concerns the ways in which buildings – actual structures – as well as institutions, 'signify': what meanings they come to create or represent in particular moments and societies. The original building, designed by the architectural firm Goodwin-Stone, brought about a fundamental change in museum design, Wallach argues, with its 'clear, simple lines and polished surfaces' (EC: 75). These signified industrial and cultural modernity in 'direct contrast' (EC: 75) with the adjacent nineteenth-century brownstone houses, offices and shops on West 53rd Street. This contrast was crucial to the museum's developing aesthetic: the 'building set up an opposition between a present still haunted by a backward, Victorian past and a future of clarity, rationality, efficiency, and functionality' (EC: 78).

There are two inter-related aspects, Wallach claims, to what he calls modern 'museum perception'. First, the kinds of relations (historical, ideological) that are established *within* a museum between viewers and the artefacts on display, concerning 'where the object stands in relation to the viewer's present' (EC: 74). Second, how the building *itself* is a kind of representation of modernity that has evolved (or 'mutated') through history (EC: 74). The modernist future of capitalist – and nation-state – economic, industrial, and urban development, which the 1939 façade symbolised, indeed came to pass, Wallach says, bringing unprecedented economic expansion and the beginning of what has been called the 'American century' (EC: 79).[22] The Museum of Modern Art's interior organisation and exhibition of modernist art from the 1930s represented this development within, and as, a complex modernist aesthetic construct based on Bauhaus architecture and design, fauvism, cubism and surrealism.

In the process, Wallach says, the museum 'produced a history of modernism that justified this aesthetic'; one that 'made it seem historically inevitable' (EC: 75). The museum's interior exhibiting rooms were 'transformed into antiseptic, laboratory-like spaces . . . enclosed, isolated, artificially illuminated and apparently neutral environments' in which modernist artworks [Illustrations 1, 5, 7, and 9] were displayed like 'so many isolated specimens' (EC: 79). The space itself – a 'white

cube', the design of which the museum pioneered – was a kind of 'tech-nologised' space that lent the artworks themselves 'a utopian aura'. Yet this vision of a future for the museum as a repository of *contemporary* artworks faltered quite soon after: the institution abolished its '50 year rule', which had been that works held in the collection for that amount of time would be disposed of to historical collections, and it began to build its own permanent collection of modernist masterpieces.

An expansion of the exhibition space in the museum undertaken by Phillip Johnson between 1962 and 1964 doubled the amount of room for showing the contents of this permanent collection. According to Wallach, a nostalgia for the past of this modernity replaced the utopianism of the museum's corporate elite, emphatically emphasised by Pelli's condominium and atrium which effectively created a second entrance to the museum once the visitor passed through the original 1939 doorway. This quite anonymous high glass atrium, Wallach argues, tends 'to suppress older forms of subjectivity' and constitutes a 'space that has been deliberately spectacularized (more or less in the manner of a thousand 'post-modern' shopping malls)' (EC: 86), with which we are all now familiar. Pelli's design, in a sense, has turned the original museum structure itself into a 'time capsule', made into an artefact from the past now 'experienced through the medium of the atrium's present' (EC: 86).

For Wallach, then, the Pelli extension accentuates – reveals even – the redundancy of the museum's utopian modernist past from the 1930s, a historic relic of futuristic hopes 'overwhelmed by the sleek, banal reality of postwar corporate capitalism' (EC: 2). Any display of artworks in a museum, Wallach's essay implies, is also an interpretation, produced partly by the context of the exhibition itself:

> The issue was not purely visual – how could it be? – but visual-ideological. The surrounding office buildings and especially the condominium tower, itself a part of the Museum's fabric, intensified the contrast between past and present, between utopian hopes frozen in the past, and the unfocused dynamism of the late capitalist present.' (EC: 83)

The fact that these exhibitions *are* also interpretations, 'readings', is revealed when, as the addition of the Pelli extension dramatically demonstrates, the building itself, and its role as a producer and conveyor of values, is perceived to have changed.

Meanings and materialism

The final texts I wish to consider in this chapter extend and elaborate Wallach's notion of the 'visual-ideological' in relation to two other areas of inquiry that Marxists have developed since the early 1970s. These are the representation of class and labour in English landscape painting since the eighteenth century, and the ways in which photography as a set of practices, representations, and associated ideas has been understood. John Tagg's account of the history of photography, which I consider below, also proposes some major revisions to the ways in which many Marxists have understood the concepts of 'institution' and 'ideology', and their significance in developed capitalist societies.

Barrell's 1980 study *The Dark Side of the Landscape: The Rural Poor in English Painting 1730–1840* includes discussion of an exhibition in England that caused controversy similar to the kind described by Wallach, and which also prompted important debate. At the 1976 bi-centenary exhibition of landscape paintings by John Constable, Barrell records, journalists and art historians 'seemed to go out of their way to notice and discuss' the place of human figures in that artist's landscapes from the early nineteenth century, in well-known works like *Boat-building near Flatford Mill* (1815) (DSL: 131). Though Barrell does produce many detailed analyses of paintings by Constable, and others by Thomas Gainsborough, George Morland, George Stubbs, and Richard Wilson (some of which I discuss below), his main point is that different commentators come to see alternative, and even opposed, meanings in Constable's depiction of human figures. The 'visual-ideological' is, therefore, semantically multivalent.[23]

According to Barrell, for instance, the art historian Anita Brookner thought all the characters in Constable's painting 'have the appearance of serfs', and they 'do nothing but work, and would be no doubt disciplined by their employers if they dreamed of stopping'. For the art critic William Feaver, however, the opposite is the case: 'no one does anything that looks much like work'. A third view is that of another critic, Marina Vaizey, who thinks that 'people do work, and in working they are poised, at one with nature' (DSL: 131–2). How could two art critics and an art historian differ so much in what they 'see' – that is, understand – to be going on in these paintings by Constable? How might this 'seeing', Barrell asks, be related to the values and interests of the viewers in question – both these particular viewers, but *all* those who look at art, and indeed, those who produce artworks as well?

Barrell's answer is developed through several chapters devoted to paintings by the group of artists mentioned above. It is that since the seventeenth century – since, that is, the beginnings of the industrialisation of the English countryside, and its agricultural economy – the issue of how to represent (if at all) the activities of rural people had become increasingly fraught. This was true for artists, as for the aristocratic and middle-class patrons who commissioned or bought their artworks, as well as for the wider 'public' in the country as a whole. In some ways, then, Barrell's study is a kind of parallel to that of Clark's, in that the notion of 'realism' in painting and the political implications of visual representation and art practices in general are raised.[24] For these landscape scenes – showing what: happy workers or indolent potential trouble-makers? – had a symbolic and general significance, in that they were capable of being read as a view of England as a nation, and the relations between classes as a whole. This might be an 'ideal view' of social harmony, Barrell says, arguing that Constable indeed wished to show the rural poor within Georgic 'Merry England', harmoniously part of nature (DSL: 133). In others, though, as in some Morland paintings, such as *The Door of a Village Inn* (undated), rural labourers are only ambivalently attentive to work for their landowners, and are possibly drunk or worse. Morland, for Barrell, is the most opposed to an 'ideal image of the rural life' pictured by Gainsborough or Constable (DSL: 6). Morland, instead, shows better 'than any other source what *could not be represented* in the image of the poor': his art, Barrell claims, is an attempt to discover the limits of public tolerance (DSL: 31, my italics).

So art – and, of course, art history – is as much about blindness as vision, as Clark suggests: about what can be shown through a particular perspective as well as about what gets left out. Barrell examines the reasons for both vision and blindness, and finds them to do with economic, political, ideological, as well as artistic and aesthetic factors. His starting point for a social history of art is in the social history of England and the eighteenth century, and the relations between the reality of the transformations in the economic and social infrastructure and ways in which these could be represented in art and in political discourse. His argument, following E.P. Thompson's in *The Making of the English Working Class* (1963), is that the eighteenth century sees the long process begin that transforms the 'paternalist' and what Thompson called the 'moral' economy of English agriculture, into a capitalist economy, which resulted 'as it was partly intended to, in the reduction of the poorer members of rural society to the condition of a landless proletariat' (DSL: 3).

Like Clark and Boime, Barrell's preoccupation is partly with how artists deal with the situation within which their paintings are produced, and this issue is intimately tied to the real and wished-for 'publics' which artists create for their works. Artists are located within relations of patronage with aristocratic and bourgeois patrons, and both these groups have changing interests related to the development of the agricultural and urban economy in England. Barrell assesses how different artists (with their own specific class and regional backgrounds) negotiate these conditions of production. The range of elements actively involved in how artists make decisions is wide – as Clark remarks, the social historian could be swamped by them – and although these usually get defined by traditional art historians as 'aesthetic', Barrell, like Clark, declares they are also moral, social, and ideological. The 'work' these paintings do is precisely to figure, to give image to, these moral, social, and ideological factors, but they do it *in relation to, as, pictorial tradition.*

These have a relation to earlier traditions in England of pastoral poetry and the Roman landscape painting – the Arcadian idyll (DSL: 9). In the eighteenth century another tradition emerged concerned to try to depict a more recognisably *English* land and life. This tradition encountered the problem of how to show the poor as a social class and their (various) places in the contemporary English countryside. Barrell's contention is that:

> For the most part the art of rural life offers us the image of a stable, unified, almost egalitarian society . . . [but] . . . it is possible to look beneath the surface of the painting, and to discover there evidence of the very conflicts it seems to deny. (DSL: 5)

Part of this looking is in order to see what could *not* be represented and to identify the nature of the constraints relating to the organisation of what is and isn't pictured in these representations. Barrell proposes the need to see the history of eighteenth-century England as one of class *stratification* and, at least, of potential class *struggle* in the emerging capitalist social order. This view is in sharp contrast to the still influential notion of the period as 'Merry England', full of social harmony, respectful peasants, and morally decent landowners. However, the market for pictures of the land increases and diversifies throughout the late eighteenth and early nineteenth centuries and it is difficult to relate tastes for certain kinds of scenes directly to particular classes of patrons or those who bought paintings on the developing art market.

The aristocracy, for instance, Barrell remarks, carried on wanting images both of Arcadian paradises, such as those produced by Francesco Zuccarelli, but they also showed 'an interest in more workaday images of English rustic life' (DSL: 8). As a class the aristocracy was caught between the continuing desire to have themselves represented as living lives of leisure, but were also increasingly aware of the 'pressing importance to them to try to preserve and pass on their wealth with their title from generation to generation, by a ruthlessly prudent management of their estates' (DSL: 11). The key issue and definition of 'realism' in art *and* in political economy is raised by these developments. Dealing with the world from the different 'points of view' of artists, landowners, the new urban industrialists, and the rural poor, came necessarily to involve fashioning *believable* representations (accounts in paint, or in political speeches either by Tories like Constable, or by the Socialists on the land and in the towns) of the nature of the real world. Or what its nature should be. And what *all* viewers of pictures choose to see, as much as what painters choose to depict – or *not* to depict – is related to what they *want* to see and how this accords with their interests and values. This is as true of contemporary viewers of Constable's paintings in the 1820s as it is of the art critics and art historians Barrell describes arguing over the same pictures 150 years later. Barrell's claim is that Constable's depicted figures got smaller and smaller and fewer and fewer in number as he grew more cautious about the development of political radicalism amongst the poor and working classes. This diminution and exclusion was a way in which Constable dealt with what he realised was a new reality in English society.

Definitions of 'real', 'reality', and their relation to practices of image-making, are at the core of Tagg's 1988 study *The Burden of Representation: Essays on Photographies and Histories*. Marxists in the period since 1970 did not simply preoccupy themselves with traditional art-historical objects of study – for instance, paintings, drawings, and prints – but began to deal with the relatively newer technologies of visual representation often grouped under the category of 'mass' or 'popular culture' (dealt with in more detail in Chapters 4, 6, and my Conclusion below). Highly significant within an early moment in this new attention, and also part of the impetus behind the development of feminist art history (the subject of the following chapter), was Berger's 1973 BBC television series and book *Ways of Seeing*. Dealing particularly with contemporary advertising – almost entirely a photographic and print technology by 1970 – and its relations with earlier forms of art, Berger's book famously proclaimed in its first sentence:

'seeing comes before words'. Tagg's account of the nature of photo-graphic practices, through a series of historical case-studies (of the conjunctural kind pioneered by Clark, who for a while was Tagg's colleague at the University of Leeds in the late 1970s) and theoretical discussions, argues, to the contrary, that 'seeing' in a fundamental sense must also mean 'understanding', involving either the tacit or explicit use of concepts and values.

The persistent belief that photographs show a truer, more accu-rate, picture of the world, Tagg argues, is, in one sense, a reflection of the ideological power that somehow had become attached to these ubiquitous representations and the way they operate in society. When we 'see' photographs, then, we also bring to them, as part of that vision, a pre-existing idea and evaluation that, yes, those photographs *do* have a prior access to reality. What this means for Tagg, however, is not that photographs really give us the actual world, but rather that 'photographic reality is a complex system of discourses and signi-fications' (BR: 101). His book delineates, through both theoretical analysis and empirical case-studies, the nature of these 'discourses and significations'. Tagg's use of such terms is influenced importantly by intellectual currents in both structuralist linguistics and post-structuralist philosophy. (These developments are discussed in greater detail later in my study.)

Tagg, however, articulates these notions with some basic Marxist tenets. He emphasises, for example, the rootedness of all representa-tional systems within material processes and products developed in particular societies, and stresses the conjunctural nature of cultural and political ideologies, interests, and values. Photography cannot be adequately understood unless these complex sets of conditions are grasped:

> What we begin to see is the emergence of a modern photographic economy in which the so-called medium of photography has no meaning outside its historical specification. What alone unites the diversity of sites in which photography operates is the social formation itself: the specific historical spaces for representation and practice which it constitutes. Photography as such has no identity. Its status as a technology varies with the power relations which invest it. Its nature as a practice depends on the institu-tions and agents which define it and set it to work. Its function as a mode of cultural production is tied to definite conditions of existence, and its products are meaningful and legible only within

the particular currencies they have. Its history has no unity. It is a flickering across a field of institutional spaces. It is this field we must study, not photography as such. (BR: 63)

Though also a social historian of traditional art forms, Tagg sees disjunction rather than continuity between the history of painting and the history of different kinds of photograph*ies*. There is little or nothing, he says, for example, that unites the formal nature and meaning of photographs used as 'evidence' in law, or in scientific, or medical practice, or that connects the formal nature and meaning of those photographs taken by ordinary people on holiday to those taken by 'fine art' photographers, such as Walker Evans or Cindy Sherman, in a work such as *No. 13*, 1978 (Illustration 3).[25] For this reason, Tagg claims that 'the history of photography stands in relation to the history of Art as a history of writing would stand to the history of Literature' (BR: 15). By this he means that the fields of photography and writing in society are so diverse and extensive that they cannot be subsumed within the very narrow range of practices and forms analysed within the usual academic subjects of art history and the study of literature.

According to Tagg, the history of the development of photography in the nineteenth and twentieth centuries is really that of their invention and deployment as forms of 'evidence' mobilised in particular institutions concerned with different, but interlocking areas of social life – many, if not all, overseen by the modernising nation-states in western countries. It is within the British and French legal systems in the late nineteenth century, for instance, that laws are established to manage the production, circulation, and meaning of photographs. These legal discourses and ideologies identify photographs as (i) commodities that can be bought and sold; as (ii) *objet d'art*; and as (iii) evidence that can be used – tested out – in, for instance, courts of law and public inquiries of various kinds.

One of Tagg's case-studies concerns the first 'Royal Commissions' in Britain organised by governments that sought to use photographs as accurate and reliable evidence of social conditions in the cities. One such Commission inquiry investigated slum conditions in Leeds in 1901. Partly because of the credibility its photographs acquired as reliable evidence showing the 'truth' of physical and social squalor in the Quarry Hill district of the city, whole streets of houses were cleared by a city council intent on modernising conditions, with or without the support of the inhabitants. Tagg's claim is that different kinds of photographies grew up as certain forms of evidence in parallel with

the development of particular kinds of 'experts' and 'expertise' within the modernising welfare and corporate nation-states. In the US in the 1930s, for instance, photography was enlisted as a form of secure documentation of the social conditions in the Depression. Tagg believes there is a particularly close link between 'documentary photography' of various kinds and social-democratic, reformist, and left-wing governments and political organisations.[26]

In the period since the 1980s, however, photographic technologies (including those of film and video) have been used to organise comprehensive surveillance of people in societies. This development in Britain specifically has led to a kind of systematic 'visual management' of people's daily activities, justified by the security forces and the legal system who claim it protects the innocent against the potential, as well as actual, infringement of laws by certain groups and individuals in society. This notion and use of photography as a means of surveillance and social control (in prisons, hospitals, schools, etc.) has a sinister aspect to it, examined by scholars influenced by, for example, the post-structuralist philosopher Michel Foucault. His notion of modern society's 'regimes of power', 'mechanisms of discipline', and 'political technologies of the body' deeply marks Tagg's understanding of the deployment and significance of photographic technologies and representations within twentieth-century western modernity.

Like Clark, Boime, Wallach, and Barrell, Tagg is committed to the work of historical scholarship – to the empirical investigation of areas of art and visual culture. This empirical analysis, however, is necessarily based on theoretical assumptions and values relating to Marxist analysis of capitalist society and its systems of visual representation. There is in Tagg's study, as in Barrell's and Clark's, a sympathy for the idea of a world beyond capitalism, and hence a sense of what paintings or photographs *could* be like, or what they *might* mean, in a very different kind of society. Tagg, as much as Clark, however, is reticent on this matter, and highly critical of 'socialist realist' practices already developed in the twentieth century in either modern painting or photography linked to political organisation. Both are wary also of the utopianism present, for instance, in painting after the Russian Revolution, or in post-1945 documentary photography in Britain claiming a particular access to social and political reality.[27]

Towards the end of his study Tagg mounts a brief but significant critique of two feminist scholars – Laura Mulvey and Elizabeth Cowie – whose work on issues to do with gender, identity, and visual representation, he says, has not been sufficiently based on historical

research.[28] Their analysis, he says, effectively disables itself because it is located in 'a timeless space between anthropology and semiology' (BR: 26). Now Tagg is not at all unsympathetic to feminist politics and intellectual inquiry, and is also aware of how feminism in both these modes in the 1970s posed necessary challenges to a Marxism fixated on notions of the pre-eminence of class struggle and the belief that arguments for socialism should only be based on experience of class equality and industrial wage-labour.

His attack, in fact, is directed at the emergence in the 1980s of forms of feminist analysis unhinged, he claims, from serious historical inquiry and dominated by idealist abstractions derived from structural linguistics and psychoanalytic theories. Like Clark, Tagg calls for a return to forms of cultural analysis that attempt to see paintings, or photographs, or films, as part of the 'effective historical process' – the primary goal of social history of art. In the following chapter I turn to the emergence of feminist art history since 1970 and deal with its complex, and increasingly troubled, relationship with Marxism.

Notes

1 T.J. Clark 'On the Social History of Art': 18.
2 Clark's *The Absolute Bourgeois: Artists and Politics in France 1848–1851* was published in the same year. These two separately published studies were the product of his PhD research, undertaken at the Courtauld Institute of Art, University of London.
3 On the Situationists, see Ken Knabb (ed. and trans.) *Situationist International Anthology*, Berkeley: Bureau of Public Secrets, 1981; Guy Debord *The Society of the Spectacle*, New York: Zone Books, 1994; and Anselm Jappe *Guy Debord*, Berkeley: University of California Press, 1999. Jappe's study contains an extensive bibliography on both Debord and the Situationists (its preface was written by T.J. Clark).
4 See Peter Starr *Logics of Failed Revolt: French Theory after May '68*, Chapter 2: 'May '68 and the Revolutionary Double Bind'. Starr's two epigrams for this chapter summarise the ambivalence that 'May '68' symbolises: 'Society took to the skies, not as a bomb does when it explodes, but like a crepe expertly flipped so as to reveal its underside' (Alain Touraine, *The May Movement*); 'Nothing has changed. Everything has changed', Edgar Morin, *Mai 68: La Breche*: 24.
5 Clark elaborated succinctly on this in a private letter to the US art historian Wayne Andersen in November 1973. The aim of both his 1973 books, he says, 'is to provide a detailed, scrupulous form of the social history of art: to focus on a specific period and a limited number of

artists, and to discover the concrete links between the social and polit-
ical history of the time, the imagery and visual style of certain painters,
and the reaction of the public to them', in Andersen *Myself*, Geneva:
Fabriart S.A., 1990: 557.

6 Alan Wallach stated in a letter supporting the 1999 republication of
Hauser's *Social History of Art*: 'If today the boundaries of the discipline
seem more permeable, more open to scholarship in other fields than they
were when Hauser wrote, it is in no small measure due to his pioneering
effort.' Letter to Routledge, 15 November 1998.

7 See *The Social History of Art* (in 4 volumes), London and New York:
Routledge, 1999, and my introductions to these studies. Other books by
Hauser were much more historically specific in their treatment. See, for
instance, *Mannerism: The Crisis of the Renaissance and the Origin of
Modern Art*, London and New York: Routledge and Kegan Paul, 1965.

8 The degree of antipathy Clark harbours for Hauser is clearly expressed
in the 1981 preface: '(how much I regret now the ironic courtesy intended
to Arnold Hauser in the title "On the Social History of Art!")': 6.

9 Since at least the 1970s such 'crude Marxism' has been repeatedly
attacked. See, for instance, Raymond Williams *Marxism and Literature*,
Oxford: Oxford University Press, 1977; Stanley Aronowitz *The Crisis in
Historical Materialism: Class, Politics and Culture in Marxist Theory*,
South Hadley, Mass.: Praeger, 1981; and Ernesto Laclau and Chantal
Mouffe *Hegemony and Socialist Strategy: Towards a Radical Democratic
Politics*, London: Verso, 1985.

10 See *The Social History of Art*, volume 4: *Naturalism, Impressionism, The
Film Age*: 241–6, and my Introduction to Hauser's discussion: xxxviii.

11 The 'soviets', with a lower-case 's', were the autonomous workers' coun-
cils that formed the basis for revolutionary political action in Russia in
1917, emulated in other Eastern European countries afterwards. 'Soviet'
with a capital 's' is generally used to refer to the political state of the
USSR.

12 See Clark's discussion, for instance of J.-L. David, Camille Pissarro, and
the Russian Constructivists in *Farewell to an Idea* (Chapters 1, 2, and 5).

13 Clark's sense of failure, however, was already fairly clear earlier on. He
says in his 1981 preface that Courbet's failure, and that of other contem-
poraries, to find such a public, or subject, or idiom, or means of
production, was already likely: 'one could hardly have expected the story,
in an order already irredeemably capitalist, to be other than one of failure
to find such a space. Bourgeois society is efficient at making all art its
own': 6. On Courbet again: 'A bourgeois artist is shown to fail to make
his art "revolutionary", but his failure is in its way exemplary and at
least serious; it provides us with a touchstone for other such attempts
and in particular it suggests the way in which a struggle against the
dominant discursive conventions is bound up with attempts to break or

circumvent the social forms in which those conventions are embedded. That effort in turn seems to me necessarily to involve some kind of action against the place of art itself, as a special social practice in bourgeois society': 7.

14 Clark remarks, though, that the language of formal analysis in traditional art history is also full of analogies. 'The very word "composition", let alone formal "organisation", is a concept which includes aspects of form *and* content, and suggests in itself certain kinds of relation between them – all the more persuasively because it never states them out loud. For that reason it is actually a strength of social art history that it makes its analogies specific and overt': (IP: 11).

15 This is what Clark calls '. . . the problem of popular art, which is part of this wider crisis of confidence [in the real or imagined public for the work]. In its most acute form – in Courbet, in Manet, in Seurat – the problem was whether to exploit popular forms and iconography to reanimate the culture of the dominant classes, or attempt some kind of provocative fusion of the two, and in so doing destroy the dominance of the latter . . .' (IP: 20). Or Barrell: 'It is not often intended or explicit meanings that I shall be pointing to . . . but meanings that emerge as we study what can *not* be represented in the landscape art of the period': (DSL: 18).

16 See Renato Poggioli *The Theory of the Avant-garde*, Cambridge, Mass.: Belknap Press, 1968, and Peter Bürger *Theory of the Avant-garde*, Minneapolis: University of Minnesota Press, 1984. Clark draws an important distinction between avant-garde and bohemia; see IP: 13–14.

17 See *Farewell to an Idea*, Introduction and Chapter 6.

18 See Clark *The Painting of Modern Life*.

19 'The old Academy was a corporation resting on a pedagogical base which sustained it and was in turn sustained by it. The new division in the Institut retained the hierarchical and prestigious value of the old Academy, but was deprived of its integral pedagogical base. This body, as a group, gave no instruction. The École was therefore a special creation of the Revolution, founded upon the concept of the separation of honorary and pedagogical functions within the government network comprising the arts . . . But by acting aggressively in their advisory capacity, the members of the Academy eventually seized virtual control of the pedagogical institution. Only in 1863 did the government finally move to create an independent mechanism for administering the École' (AFP: 7).

20 See Alan Wallach and Carol Duncan 'The Universal Survey Museum', *Art History*.

21 Wallach cites as an example the Southampton Museum of Art, New Hampshire (now the Parrish Art Museum), opened during the Spanish-American War. This was an institution, Wallach claims, that extolled

'the ideals of western civilisation, symbolised by [the] museum's archi-
tecture and [its] collections ... were inextricably bound up with belief
in a national policy of imperial conquest and colonial domination': 4.
22 Wallach adds an interesting personal note: in visits he made to Manhattan
from Brooklyn as a child just after World War II, the Museum of Modern
Art 'became inextricably bound up in my mind with other emblems
of modernity I was aware of at the time: warplanes at Floyd Bennet
Field; the Empire State Building ... glimpses of a promised future ...'
(EC: 78).
23 A similar controversy occurred around an exhibition of landscape paint-
ings by the eighteenth-century artist Richard Wilson, held at the Tate
Gallery, London, in 1982–1983. See Neil McWilliam and Alex Potts 'The
Landscape of Reaction: Richard Wilson (1713?–1782) and His Critics',
in A.L. Rees and F. Borzello (eds) *The New Art History*: 106–19.
24 Barrell explicitly acknowledges the relevance of Clark's work to his
own: 135.
25 The only uniting factor, perhaps, is that they all are usually claimed, or
assumed, to have a closer 'access to the real world' compared with other
forms and technologies of visual representation, such as painting.
26 For an extensive account of the relations between the state, the corpora-
tions and culture in the US in the first half of the twentieth century, see
Terry Smith *Making the Modern*, Chicago: Chicago University Press, 1993.
27 A useful overview of debates on 'realism' can be found in Paul Wood
'Realism and Realities', in Briony Fer *et al. Realism, Rationalism,
Surrealism*, New Haven and London: Yale University Press/The Open
University, 1993.
28 Laura Mulvey's essay 'Visual Pleasure and Narrative Cinema' is discussed
in Chapter 4. Tagg directs his criticism at Elizabeth Cowie's essay
'Woman as Sign', *m/f* 1978, no. 1.

Select bibliography

Antal, F. *Florentine Renaissance Painting and its Social Background*, London:
 Routledge and Kegan Paul, 1948
Art Bulletin 'Art> < History: A Range of Critical Perspectives', September 1995:
 367–71
Benjamin, W. 'The Work of Art in the Age of Mechanical Reproduction' (1936),
 in Benjamin *Illuminations*, London: Fontana, 1973
Bentmann, R. and Muller, M. *The Villa as Hegemonic Architecture*, Atlantic
 Highlands: Humanities Press, 1992 (with a Foreword by O.K. Werckmeister
 and Introduction by David Craven)
Boime, A. *A Social History of Modern Art, vol. 1: Art in an Age of Revolution
 1750–1800*, Chicago and London: University of Chicago Press, 1987

Boime, A. *A Social History of Modern Art, vol. 2: Art in an Age of Bonapartism 1800–1815*, Chicago and London: University of Chicago Press, 1990

Bowlt, J.E. 'Some Thoughts on the Condition of Soviet Art History', *Art Bulletin*, December 1989: 542–50

Bürger, P. *Theory of the Avant-garde*, Minneapolis: University of Minnesota Press, 1984

Clark, T.J. *The Absolute Bourgeois: Artists and Politics in France 1848–1851*, London: Thames and Hudson, 1973

Clark, T.J. 'The Conditions of Artistic Creativity', *Times Literary Supplement*, 24 May 1974: 561–2

Clark, T.J. 'Preliminaries to a Possible Treatment of *Olympia* in 1865', *Screen*, Spring 1980

Clark, T.J. *The Painting of Modern Life: Paris in the Art of Manet and His Followers*, Princeton: Princeton University Press, 1984

Craven, D. 'Meyer Schapiro, Karl Korsch, and the Emergence of Critical Theory', *Oxford Art Journal*, vol. 17, no. 1, 1994: 42–54

Craven, D. *Abstract Expressionism as Cultural Critique: Dissent During the McCarthy Period*, Cambridge and New York: Cambridge University Press, 1999

Crow, T. *Painters and Public Life in Eighteenth Century Paris*, New Haven and London: Yale University Press, 1985

Doy, G. *Materializing Art History*, Oxford and New York: Beng, 1998

Duncan, C. and Wallach, A. 'The Museum of Modern Art as Late Capitalist Ritual', *Marxist Perspectives*, Winter, 1978: 28–51

Duncan, C. and Wallach, A. 'The Universal Survey Museum', *Art History*, December 1980, 3: 447–69

Frascina, F. *Art, Politics and Dissent*, Manchester and New York: Manchester University Press, 1999

Hadjinicolaou, N. *Art History and Class Struggle*, London: Pluto Press, 1979

Harris, J. *Federal Art and National Culture: The Politics of Identity in New Deal America*, Cambridge and New York: Cambridge University Press, 1995

Harris, J. '"Stuck in the Post"? Abstract Expressionism, T.J. Clark and Modernist History Painting', in David Green and Peter Seddon (eds) *History Painting Reassessed*, Manchester and New York: Manchester University Press, 2000

Hauser, A. *Mannerism: The Crisis of the Renaissance and the Origin of Modern Art*, London and New York: Routledge and Kegan Paul, 1965

Hauser, A. *The Social History of Art* (4 volumes), London and New York: Routledge, 1999 (Introductions by Jonathan Harris)

Leja, M. *Reframing Abstract Expressionism: Subjectivity and Painting in the 1940s*, New Haven and London: Yale University Press, 1993

Orton, F. and Pollock, G. *Avant-Gardes and Partisans Reviewed*, Manchester: Manchester University Press, 1996

Oxford Art Journal, Schapiro special number, edited by David Craven, vol. 17, no. 1, 1994

Pointon, M. (ed.) *Art Apart: Artifacts, Institutions and Ideology in England and North America from 1800 to the Present*, Manchester: Manchester University Press, 1994

Schapiro, M. 'The Social Bases of Art' (1937), in Mathew Baigell and Julia Williams (eds) *Artists Against War and Fascism: Papers of the First American Artists' Congress*, New Brunswick, New Jersey: Rutgers University Press, 1986

Schapiro, M. 'The Nature of Abstract Art', *Marxist Quarterly*, no. 1, January–March 1937

Screen Reader in Cinema/Ideology/Politics, London: SEFT, 1977

Tagg, J. *Grounds of Dispute: Art History, Cultural Politics, and the Discursive Field*, Basingstoke: Macmillan, 1992

Wallach, A. 'Marxism and Art History', in Ollman, B. and Vernoff, E. (eds) *The Left Academy: Marxist Scholarship on American Campuses*, vol. II, New York: McGraw-Hill, 1984

Werckmeister, O.K. 'Radical Art History', *Art Journal*, Winter 1982: 284–91

Werckmeister, O.K. *Citadel Culture*, Chicago: University of Chicago Press, 1991

Werckmeister, O.K. 'A Working Perspective for Marxist Art History Today', *Oxford Art Journal*, vol. 14, no. 2, 1991: 83–7

Chapter 3

Feminism, art, and art history

Key texts

Linda Nochlin 'Why Have There Been No Great Women Artists?', in Nochlin *Women, Art, and Power and Other Essays*, London: Thames and Hudson, 1988 (originally published in *Art News*, vol. 69, January 1971): WAP.

Rozsika Parker and Griselda Pollock 'Preface', 'Acknowledgements', and 'Critical Stereotypes: the "essential feminine" or how essential is femininity?', in *Old Mistresses: Women, Art and Ideology*, London: Pandora Press, 1981: OM.

Griselda Pollock 'Vision, Voice and Power: Feminist Art Histories and Marxism', in *Vision and Difference: Femininity, Feminism and the Histories of Art*, London and New York: Routledge, 1988 (first published in *Block*, no. 6, 1982): VVP.

Lucy Lippard 'Issue and Taboo', *The Pink Glass Swan: Selected Essays on Feminist Art*, New York: The New Press, 1995 (originally published in *Issue: Social Strategies by Women Artists*, London: Institute of Contemporary Arts, 1980, catalogue for exhibition curated by Lucy Lippard): IT.

Anne Middleton Wagner *Three Artists (Three Women): Modernism and the Art of Hesse, Krasner, and O'Keeffe*, Berkeley: University of California Press, 1996: TATW.

Politics, position, perspective

Feminist art history, like social history of art, had its roots in a social and political radicalism that wished to see the world transformed. That world included intellectual endeavour and in institutional terms meant, in particular, those scholarly activities – teaching, research, and publishing – carried out in universities. Perhaps more so than the early 1970s' Marxist art history of T.J. Clark ('in retreat from the events of the previous six years', as he said), feminists interested in art, artists, and art history wanted no one to be in any doubt about the contemporary political origins and aims of their ideas. They were well aware, though, of their links to 'proto-feminist' authors, activists, and causes far preceding the 1960s.[1] This sense of feminism's basis in direct political activity certainly characterises the work of two of the most influential feminists interested in art working in Britain and the US in the period – Linda Nochlin and Griselda Pollock.

One of the original and most fertile essays of feminist art history is Nochlin's 1971 'Why Have There Been No Great Women Artists?', originally published in the relatively mainstream journal *Art News*. Nochlin recounted in 1988 that the essay had been intended for publication in what she called one of the earliest scholarly – yet non-specialist – anthologies of the women's movement, *Women in Sexist Society*, and had been based on research and seminars on women and art conducted at Vassar College.[2] The essay, Nochlin makes clear, was 'written during the heady days of the birth of the Women's Liberation Movement, in 1970, and shares the same political energy and optimism of the period' (WAP: Introduction, xiii). That essay, and the others included in her 1988 collection, were, she said, 'after all, written in specific historical contexts, in response to concrete problems and situations' (WAP: Introduction, xii).

The 'concrete problem' in its most general terms was that concerning the exploitation of women in contemporary society and of how, once this exploitation was recognised (by women), it could be addressed, understood, and acted upon by women wishing to end such exploitation. Nochlin was aware that this problem had relevance to all areas of intellectual inquiry carried out within institutions such as universities, but was clear that exploitation of women occurred throughout society. There could be no simplistic division, therefore, between 'academic' concerns and those beyond the lecture theatre, seminar room, scholarly book, or journal. The 'so-called women question', she says, 'far from being a minor, peripheral, and laughably

provincial sub-issue grafted on to a serious, established discipline [like art history], can become a catalyst, an intellectual instrument, probing basic and "natural" assumptions, providing a paradigm for other kinds of internal question, and in turn providing links with paradigms established by radical approaches in other fields' (WAP: 146).

So, although Nochlin and others would concern themselves specifically with the connection between women's exploitation and visual representation within art and culture, the relation between these inquiries and *all other aspects of the situation of women* was not to be lost or made marginal. Nochlin is also clear that feminists, though they may choose to align themselves with men who support their arguments and actions, must invent their own intellectual perspectives, in the arts, as elsewhere. Women must stop seeing themselves, she says, as part of a 'problem' to be viewed through the eyes of 'the dominant male power elite' (WAP: 151). This vision of radical, even 'revolutionary' social transformation means that '*women* must conceive of themselves as potentially, if not actually, equal subjects, and must be willing to look the facts of their situation full in the face, without self-pity, or cop-outs; at the same time they must view their situation with the same degree of emotional and intellectual commitment necessary to create a world in which equal achievement will be not only made possible but actively encouraged by social institutions' (WAP: 151).

Nevertheless, there has always been a tension in feminism – as in Marxism – between the specialist interests of scholars affiliated to a 'discipline' (if not to a professional organisation, or set of university colleagues) and the wider world in which feminists have organised and agitated to bring such radical social change. Nochlin's account of her interests over thirty years of writing and research demonstrates a profound recognition of this tension. On the one hand, for instance, she can be absolutely definitive and say 'I do not conceive of a feminist art history as a positive approach to the field, a way of simply adding a token list of women painters and sculptors to the canon' (WAP: Introduction, xii). Or that 'feminist art history is there to make trouble, to call into question, to ruffle feathers in the patriarchal dovecotes. It should not be mistaken for just another variant of or supplement to mainstream art history. At its strongest, a feminist art history is a transgressive and anti-establishment practice, meant to call many of the major precepts of the discipline into question' (WAP: Introduction, xii).

On the other hand, however, she notes, feminists interested in art history obviously *do* 'add' something to the existing disciplinary procedures and accounts by, for instance, recovering and writing about

women artists such as the late nineteenth-century painters Rosa Bonheur or Berthe Morisot. Such 'revisionism' constitutes what Nochlin calls a 'recuperation of lost production and lost modes of productivity, [and] has its own historical validity, and, as such, can function as part of the questioning of the conventional formulation of the parameters of the discipline' (WAP: Introduction, xii).[3] Studying Bonheur's and Morisot's marginal place in traditional art-historical accounts of French art would, for example, she claims 'reveal the structures and operations that tend to marginalise certain kinds of artistic production while centralising others' (WAP: Introduction, xiii).

Notice Nochlin's adoption here of the term 'recuperation', used previously by Clark in his account of the reception of his book about Courbet. For him there had been the sense that the radical intention of his study was lost in later 'academicised' readings of it. Nochlin surely was aware of the same danger facing feminists trying to *transform*, rather than simply to add to existing art history. This was the danger that their radical intent – a questioning of the entire enterprise of art history, its core notions of 'aesthetic quality' and 'canonical' objects, for instance – might also be lost, appropriated, or misinterpreted. Looking back from 1988, then, there is an ambivalence to Nochlin's understanding of the progress feminists involved with art history had made. This is an ambivalence similar to that felt by Marxists who, on the one hand, had seen their research and publications appropriated by the discipline – a recuperation certainly bringing changes to what gets taught, and how, in the subject – yet, on the other, had also seen the promise of radical transformation in the wider world go depressingly unfulfilled.

Nochlin's introduction carries both sides of this message. It is true, she reflects, that feminist critique *has* 'entered into mainstream discourse itself . . . as an integral part of a new more theoretically grounded and socially contextualised historical practice' (WAP: Introduction, xi). Universities indeed now run courses on women's studies and an entity called 'feminist art history' has become significant enough to earn 'the honor of a long and thorough review article in *Art Bulletin*, a major journal of the discipline' (WAP: Introduction, xi). However, if in 1970 there had been 'no such thing as a feminist art history', by 1988 the achievement of feminists working in the subject 'makes it sound as though feminism is safely ensconced in the bosom of one of the most conservative of the intellectual disciplines' (WAP: Introduction, xi). Acknowledgement of this double-edged situation facing feminists recurs, one way or another, in nearly all the texts I consider in the

remainder of this chapter, as it haunts those of the previously discussed social historians of art with whom some feminists developed complex relationships in the period after 1970.

Nochlin's essay begins by underlining the importance of intellectual clarification to the political project of feminism. There should be no simplistic distinction, she believes, between feminist 'activism' understood, on the one hand, as protest or oppositional social organisation and, on the other, as sustained reflection and critique of knowledge and its institutional relation to patriarchal power in contemporary societies. Being active in the universities, therefore, is as important as being active on demonstrations, because attempts to bring about radical social change need to include 'historical analysis of the basic intellectual issues which the feminist attack on the status quo automatically raises' (WAP: 145). If feminists are intent on bringing about social change significant enough to be described as constituting a 'revolution', Nochlin states, then they must deal as much with 'the intellectual and ideological basis of the various intellectual or scholarly disciplines – history, philosophy, sociology, psychology, etc.' as engage with 'the ideologies of present social institutions', such as marriage, work, the mass media, health, and education (WAP: 145).[4] Indeed, universities and the relations between higher education in general and all the other institutions and practices of society must form part of the same inquiry and become equally an object and location of political practice for such radical change.

In this way, then, feminist interest in art and in art history follows logically from its core commitment to deal with the attitudes of women *and men* to the status of the former in contemporary society. Contemporary attitudes have been formed historically and *art-historically*. This is the basis for Nochlin's assertion that in the field of art history 'the white, Western male viewpoint, unconsciously accepted as *the* viewpoint of the art historian, may – and does – prove to be inadequate not merely on moral and ethical grounds, or because it is elitist, but on purely intellectual ones . . . the feminist critique . . . lays bare its conceptual smugness, its meta-historical naïveté' (WAP: 146). Echoing the argument made by Clark concerning the need to displace the idea of the isolated creative artist within a social history of art, Nochlin calls for feminist study to be rooted in *institutional* analysis. It will be this understanding of *public* social structures, rather than of the activity of *private* individual artists, that will provide convincing answers to basic feminist questions such as: why have women not figured significantly in traditional histories of art and why have women apparently not been able to achieve success as artists since the Renaissance?

In fact, Nochlin goes further and makes central to her analysis the issues of the organisation of, and power relations within, education: 'understood to include everything that happens to us from the moment we enter this world' (WAP: 150). Women's exploitation historically, and in contemporary society, occurs through this process of socialisation from birth onwards, she claims. This is a socialisation constituted in 'symbols, signs, and signals' (WAP: 150). To understand the absence of women from the canon of great art and artists, therefore, requires, Nochlin argues, the recasting of basic conceptual categories once one accepts that the social institutions of art education, exhibition, *and* art history structure and influence, delimit and organise the actions of individuals operating within them, making certain developments possible and others unthinkable. Therefore, the question, Nochlin says:

> 'Why have there been no great women artists?' has led us to the conclusion, so far, that art is not a free, autonomous activity of a super-endowed individual, 'influenced' by previous artists, and, more vaguely and superficially, by 'social forces', but rather, that the *total situation of art making*, both in terms of the development of the art maker and in the nature and quality of the work of art itself, occur in a social situation, are integral elements of this social structure, and are mediated and determined by specific and definable social institutions, be they art academies, systems of patronage, mythologies of the divine creator, artist as he-man or social outcast. (WAP: 158, my italics)

The outline of this perspective is reminiscent of, and appears congruent with, Clark's account of social history of art principles based on conjunctural historical analysis. If Clark ponders the question of the nature of art's legitimate 'greatness' or value within such an analysis – the 'greatness' of art which he believes finds itself part of the 'effective historical process'; the specific critical *work* it does in such situations – then Nochlin also turns to this question of value and its relations to women in art and art history.

Greatness, creativity, and cultural value

Nochlin, like Clark, is certain that 'traditional' or 'institutionally dominant art history' is not able to begin to deal adequately with the question of the social situatedness of greatness in art because such art

history is steered by core precepts on individuality, individualism, and creativity within which society cannot actually be 'thought' at all. Feminists must not, she warns, 'swallow the bait, line and sinker' of such myths and attempt simply to 'rehabilitate' or 'rediscover' examples of 'insufficiently appreciated women artists' that traditional – patriarchal – art history has chosen simply to ignore (WAP: 147). This would be the 'additive' version of feminist art history likely only to lead to recuperation in the negative sense used by Clark – the appropriation that loses something vital to the intention in the first place. Whatever 'crumbs are thrown to social influence, ideas of the times, economic crises' in conventional art history, Nochlin writes, these act as a kind of smokescreen for the operation of the core ideological assumptions about 'the making of great art . . . Michelangelo and van Gogh, Raphael and Jackson Pollock . . . the Great Artist is . . . [a] . . . genius . . . an atemporal and mysterious power somehow embedded in the person of the Great Artist' (WAP: 153).

However, Nochlin stops somewhat ambiguously short of saying that 'greatness' in art and in artists is simply an ideological matter in the sense of being *untrue*, or that it is only a story that male art historians continually tell themselves about male artists and artworks. She is convinced, though, that traditional art history avoids dealing with questions of institutions and historical conjunctures because such a line of inquiry *might* threaten the core myths of greatness. If such a 'dispassionate, impersonal, sociological, and institutionally-oriented approach' was carried out, she claims, its results would 'reveal the entire romantic, elitist, individual-glorifying, and monograph-producing substructure upon which the profession of art history is based' (WAP: 153). Yet Nochlin goes on, rather speculatively, to maintain the idea (and value itself) that the assertion of greatness in art is *not* simply a function of patriarchal mystification.

Nochlin clearly rejects the bourgeois-humanist and modernist belief that 'art is the direct, personal expression of individual emotional experience, a translation of personal life into visual terms' (WAP: 149) – the 'Van Gogh syndrome' remembering Orton and Pollock's experience. Instead, she claims, again in a manner rather similar to Clark's, that art, and especially great art, 'involves a self-consistent language of form, *more or less dependent upon, or free from*, given temporally defined conventions, schemata, or systems of notation' (WAP: 149, my italics).[5] All artists, men *and* women, in any given period, she remarks, produce work that indicates their common location within the contemporary institutions of society – including those which organise the

training of artists and exhibition of their work. These are the institutions that inculcate particular senses of art's technical, visual, and thematic (subject-matter) conventions. This commonality is certainly much stronger than any identities that feminists might wish to see between women artists simply based on shared sex or 'femininity' (WAP: 148).

Nochlin is quite dismissive of the idea that there might be a particular kind of greatness for women's art separate, or separable, from that made by men. She suggests, in fact, that although many women artists have produced work as good as many men in past centuries, the highest achievements in art *have* indeed been those by male artists, citing Michelangelo, Rembrandt, Delacroix, Cézanne, Picasso, Matisse, de Kooning, and Warhol (WAP: 150).[6] The question for Nochlin, then, is *why* has this been the case? 'What is important', she says, is that 'women face up to the reality of their history and of their present situation, without making excuses or puffing mediocrity. Disadvantage may indeed be an excuse; it is not, however, an intellectual position' (WAP: 176). Attaining convincing answers to her question will lead to a fuller knowledge of what must change for women artists potentially to be able to achieve such an equality of greatness.

Nochlin argues that this potential equality of greatness has, as its basic condition – a condition that guarantees nothing, however – an equality of basic social opportunity. With case-studies drawn from the Renaissance up to the late nineteenth century Nochlin shows that women who have achieved moderate success as artists have nearly always been drawn from powerful social classes, and in many cases had fathers who were also artists. But women were always systematically excluded or occupied only marginal places within the institutions of art education and exhibition in the epoch from the Renaissance up till the effective dissolution of state institutions such as academies in the late nineteenth century.

Nochlin's exemplary 'factor of exclusion' is that concerning the rule in academies across Europe that prohibited women from drawing the male nude model in life-classes. Without being able to train and potentially excel in this pivotal aspect of academic training – examined in detail by Boime in his text discussed in my previous chapter – it was 'impossible for women to achieve artistic excellence, or success, on the same footing as men, *no matter what* the potency of their so-called talent, or genius' (WAP: 176). This social exclusion was represented in art, Nochlin shows, in the painting Johann Zoffany was commissioned to produce showing the founders of the British

Royal Academy in 1772. Pictured attending a nude life-class at which the two women founders of the Royal Academy – Angelica Kauffman and Mary Moser – would have been excluded, Zoffany showed them instead 'present' only in depicted portraits on the wall of the life-class room, thus making them marginal twice over.

By the time this exclusion rule was finally rescinded, which occurred at the Royal Academy in England only in 1893, the academies had already lost their institutional power as the emergent 'independent' avant-garde groupings began to assume significance in developments in modern art.[7] The exclusion from such institutions for many centuries had led to women being 'deprived of the possibility of creating major art works' and to their pigeonholing as producers within only the minor fields of portraiture, genre, landscape, and still life (WAP: 160). The French artist Rosa Bonheur, famous for her paintings of animals in the mid-nineteenth century, was a case in point. Nochlin remarks, however, that Bonheur with her unconventional lifestyle, unlike Morisot or Cassatt, never conformed to the image of the 'lady-painter' in the nineteenth century: 'modest, proficient, self-demeaning' that Nochlin says was the usual outcome of their social exclusion (WAP: 164). (I discuss Bonheur's life and art in Chapter 7.)

Roszika Parker and Griselda Pollock's 1981 study *Old Mistresses: Women, Art and Ideology* certainly builds on several aspects of Nochlin's critique of patriarchy and traditional art history. In addition, however, it moves substantially beyond it by developing an account of the operation of ideology in art, art history, culture, and society *not* simply based on the negatives, the exclusions, and the marginalisms which Nochlin's text stresses. To this end, Pollock and Parker's study, also highly influential in the development of feminist art history in the 1980s, draws on notions of ideology and cultural production already richly elaborated in Marxist history and critical theories.[8] Indeed, the cross-fertilisation of Marxist and feminist analyses in the later 1970s and early 1980s, particularly in aspects of British scholarship, is a significant part of the history of radical art history, and is also related importantly to the strength at the time of socialist-feminist political organisation, both inside the universities and in wider British society.[9] Pollock's 1982 text 'Vision, Voice and Power: Feminist Art History and Marxism' (which I consider below), published initially in the journal *Block*, edited by staff at Middlesex Polytechnic since its first number in 1979, also articulates this productive theoretical interaction, while at the same time stressing its intellectual and political limits.

Parker and Pollock make the category and activity of ideology in culture and scholarship the lynchpin of their analysis. Their study of the experiences of women artists throughout history and of the development of art history as an intellectual discipline always returns to the issue of *what* and *whose* values, perspectives, and interests have been served. They acknowledge that feminist scholars have shown the existence of many women artists since at least the medieval period, and, indeed, that male authors, such as Giorgio Vasari in the sixteenth century in writing his *Lives of the Artists*, included accounts of the women painters Properzia de'Rossi, Sofanisba Anguissola and Plautilla Nelli (OM: 3). Quite considerable surveys of women artists had been made during the nineteenth century and contemporary accounts of women artists show that it 'is no longer necessary to assert that there have been women artists'. The issues have thus to be reformulated (OM: xvii).

Rejecting, then, a merely *empiricist* account of women artists that simply 'adds' them to the list of male artists (and potentially only in a recuperative fashion), Parker and Pollock ask two sets of related questions. One is about the current state of the discipline of art history and why its – mostly male – practitioners have not continued to record and write about women artists, as had been the case until the twentieth century. 'Twentieth century art historians have sources enough to show that women artists have always existed, yet they ignore them. The silence is absolute in such popular works surveying the history of western art as E.H. Gombrich's *The Story of Art* or H.W. Janson's *History of Art*. Neither mentions women artists at all' (OM: 6).[10] Why, Parker and Pollock ask, has this omission occurred precisely in the century that has seen real progress in 'women's social emancipation and increasing education [that] should, in theory, have prompted a greater awareness of women's participation in all walks of life' (OM: 3)?

The second set of questions concerns how to understand the place and identity of women throughout history, *and* in the current organisation of both art practice and art history. 'Our intention', Parker and Pollock say, 'is to explore women's place in the history of art' (OM: xvii). Asking these questions 'enables us to identify the unacknowledged ideology which informs the practice of this discipline and the values which decide its classification and interpretation of all art' (OM: 49). The title of their book alludes to this because, as they explain, the reverential term 'Old Master' has no meaningful equivalent when cast in its feminine form 'Old Mistress' – 'the connotation

is altogether different' (OM: 6).[11] Art history is not, and never can be, they say, the 'exercise of neutral "objective" scholarship'; it is always an 'ideological practice' (OM: xvii).

If the standard forms of contemporary art history – the survey history, the *catalogue raisonné*, and the monograph on a single artist's work – have effectively written women artists out of their accounts, then why should this be the case?

> Why has it been necessary to negate so large a part of the history of art, to dismiss so many artists, to denigrate so many works of art simply because the artists were women? What does this reveal about the structures and ideologies of art history, how it defines what is and what is not art, to whom it accords the status of artist and what that status means? (OM: xviii)

Agreeing with Nochlin, Parker and Pollock assert that a powerful myth about creativity and its essentially male nature is at work within traditional art history and that the absence of women artists from twentieth-century art history's accounts is functional to that notion of creativity; 'crucial', that is, 'to the definition of art and the artist in our society' (OM: 3).[12] Neither do they wish their account to be seen as an attempt to 'prove that women have been great artists' or 'to provide yet another indictment of art history's neglect of women artists' (OM: xvii). These were important elements in the development of feminist interest in art history, Parker and Pollock acknowledge, but they fall short of the necessary task of discovering *why* women's art has been misrepresented and what this 'treatment of women in art reveals about the ideological basis of the writing and teaching of art history' (OM: xvii).

However, *unlike* Nochlin, and in direct contradiction to her defence, however unelaborated, of the existence of 'great art', Parker and Pollock reject the idea that social institutions and ideologies *only* work negatively through exclusion or marginalisation. Women artists, though they *were* excluded from, for example, nineteenth-century academic training, or from prestigious competitions, and forms of state-controlled exhibition, 'negotiated' their particular position and 'were able to make art as much because of as despite their difference'. The history of women in art, therefore, must not be presented simply as a 'fight against exclusion and discrimination by institutions such as academies of art'.[13] Nochlin's ambivalence over the issue of 'greatness' in art is connected, Parker and Pollock believe, to her investment in

the 'institutionally dominant art history' and its associated values: 'To see women's history only as a progressive struggle against great odds is to fall into the trap of unwittingly reasserting the established male standards as the appropriate norm' (OM: xviii).

This view, it should be clear, is *not* simply one to do with a critique of art history or a perspective within feminist analysis of scholarship in general. It concerns the basic question of how different feminists, in particular places and historical conjunctures, have seen their relationship to men and to society as a whole, and whether they have seen feminist political organisation and activism as related to, or divided from, other forms of political and intellectual radicalism. Parker and Pollock's use of the concept of ideology and analysis of the role of ideologies within social institutions indicates their indebtedness to some aspects of Marxist history and theory, and points to a major difference between US and British feminist theory, history, and politics in the 1970s and 1980s.

Ideologies, sexual difference, and social change

Parker and Pollock affirm that the work of women artists *was* recorded and written about in all the centuries prior to their effective exclusion from dominant accounts in the twentieth. They include in their account, for instance, case-studies of Sofanisba Anguissola and Artemesia Gentileschi active in the sixteenth and seventeenth centuries. They analyse the novel conditions of art practice in this period, including 'a new identity and social position for the artist, ways of training, functions of art, patrons and documentation' (OM: 17). But in the nineteenth century, they claim, a particular stereotype of the 'woman artist' became prevalent. This is part of the position, the 'negotiated presence', that women such as Cassatt or Morisot take up in the spaces of French patriarchal culture and society.

Cassatt, they argue, produced works such as *Lydia at the Tapestry Frame* c.1881 (Illustration 4) which depicted 'the phases of women's lives and the social and ideological constraints within which they lived' (OM: 38). 'Femininity', they claim, is revealed in such paintings not as a natural essence, but as 'a social process', a result of their 'introduction into place in the social order', and that such works conduct a subversion of traditional images of women, mothers and female children (OM: 41). On the other hand, Morisot's *Self-Portrait* (1855), they propose, though showing the artist after eleven years of respected

professional work, is 'a supremely defensive image: the expression is tentative through the veil of light pastel, and the face hovers uncertainly on the paper, partially obscured by dark shadow' (OM: 44).

Both paintings are examples of the production of what Pollock, in her essay 'Vision, Voice and Power: Feminist Art History and Marxism', calls 'sexual difference': ways of signifying that both create and confirm the organisation of identity, its representation, and meaning in the culture and society as a whole. Discussing different accounts of feminism's philosophical basis in writings by, for example, Kate Millett, Elizabeth Cowie, and Heidi Hartman, Pollock claims that the contemporary regime of 'sexual difference' is heavily dependent upon the circulation of pictures, photographs and films.[14] Sexual divisions are thus 'the result of the construction of 'sexual difference' as a socially significant axis of meaning:

> Difference in English means a state of being unlike. The word distinction conveys the correct meaning more precisely. Distinction is the result of an act of differentiation, drawing distinctions, a process of definition of categories. Thus masculinity and femininity are not terms which designate a *given* and separate entity, men and women, but are simply two terms of difference. In this sense patriarchy does not refer to the static, oppressive domination by one sex over another, but to a web of psychosocial relationships which institute a socially significant difference on the axis of sex which is so deeply located in our very sense of lived, sexual, identity that it appears to us as natural and unalterable. (VVP: 33)

Not interested, then, in the idea (or ideal) of identifying or claiming women's separate identity or essence – a perspective of some 'separatist' feminists – Pollock and Parker construct a 'relational' understanding of what it is to 'be' a man or a woman. This is based on a sense of a common history to humanity, a perspective shared by Marxists. Feminists should not set women apart from this common history and social location, 'outside the historical process of which men and women are indissolubly part' (OM: xviii–xix).

Sexual difference (and accompanying inequalities of opportunity) is a product of the particular place and experiences of men and women within society's 'social structures of class and the sexual divisions within our society' (OM: 48). In the nineteenth century bourgeois notions of sexual difference in *all* spheres and social institutions became

particularly virulent, Parker and Pollock argue, relegating women to minor and/or passive positions and activities. In domestic and public life, femininity was defined in terms of the 'graceful, delicate and decorative' (OM: 9), and such Victorian 'chivalrous sentimentality' was to give way to a later 'disguised but potent sexism' (OM: 12). Men are to be 'busy with serious works of the imagination on a grand scale but women are occupied in minor, delicate, personal pastimes' (OM: 13). The ideology of 'the essence of womanhood' locates women principally within the home and domesticity (OM: 37). Modern art history, they argue, has inherited this ideology and systematised it: women artists are not only absent from the dominant accounts but have been given a location within them that represents them 'as inevitably and *naturally* artists of lesser talent and no historical significance' (OM: 45).

These attitudes are inexplicable without reference to the social relations between men and women, and between classes in society as well. Patriarchal societies have developed historically and mutated in relation to changing economic and political circumstances, and in the nineteenth century, urban industrial capitalism, within which the male bourgeoisie is the predominant social and sexual class, is central. In turning away from an assumption of women's separate history or identity in capitalist society, and from 'overemphasis' on individual biographies of women (OM: xix), Parker and Pollock articulate a perspective similar to that of Clark's social history of art, focused on an analysis of the relations between the formal structures of artworks and the elements of the broad social structure and conjuncture within which art is produced, disseminated, and consumed.

Pollock's essay 'Vision, Voice and Power: Feminist Art History and Marxism' explicitly examines the kind of affiliation that a feminist critique of art history might have with Marxist principles and historical research. Pollock's essay can also be read indirectly as a commentary on the relations possible – and desirable – between feminist political groups and those of socialist organisations.[15] Lucy Lippard's near-contemporary essay 'Issue and Taboo', written as part of a catalogue for an exhibition of women artists held at the Institute of Contemporary Arts in London in 1980, touches more directly on the issue of political collaboration between men and women, and is discussed below. These two texts represent a phase in feminist art criticism and history in the 1970s and early 1980s when the actual reality and future possibility of a broad alliance for radical social change on a number of fronts – anti-capitalist, anti-sexist, anti-racist

and anti-militarist – was still strong. Though feminist social and political organisations continued into the 1990s, and other 'new social movements' gained strength and visibility in the societies of Western Europe and North America, what certainly diminished, however, was their interaction on an agreed agenda involving the imagining of a post-capitalist future.

One reason for the tensions *already* present in the relationship between feminist and Marxist scholars and political activists in the 1970s and early 1980s was the fact that the latter had concerned themselves fundamentally with *class* formation and antagonism understood as the 'motor' for historical change in societies since the Renaissance. This was, of course, what 'political Marxism' had always been about.[16] Pollock identifies Clark's remarks in 1974 about the danger of an academicism of the 'new' in art history with a criticism of feminism, which he saw, she says, as a mere novelty of fashion along with literary formalism, Freudianism, and film theory (VVP: 19). Although I have offered another interpretation of Clark's words, it is easy to see how inflammatory his remarks could have appeared to feminists at the time. Yet Pollock is actually quite restrained in her response:

> As a feminist, I find myself awkwardly placed in this debate. I agree with Clark that one – and a very substantive one too – paradigm for the social history of art lies within Marxist cultural theory and historical practice. Yet in as much as society is structured by relations of inequality at the point of material production, so too is it structured by sexual divisions and inequalities. (VVP: 19)

Pollock is defending, in other words, Marx's historical materialist principle that *all* social phenomena are rooted in material life and conditions, and that these include biological, as well as economic, practices and relationships. Indeed, human 'production' as a general category involves the intermeshing of biological (including sexual) and class relations: 'producing' children in families, for example, or the job of 'producing' a trained workforce for a capitalist economy often done by women teachers. Marxists have taken the historical materialist principle but in effect limited it to a notion of social organisation, culture, and change governed by class relationships conceived in very narrow terms.[17]

Pollock asserts, in opposition to this Marxist *economism*, the principle of the *equal* significance of sexual relationships, sexual difference,

and sexual conflict in human history. These are neither merely a supplement of, nor reducible to, class conflicts, as Marxists have claimed. Feminism has both identified concepts and experiences that demand their own mode of analysis (for example, the construction of sexual difference, sexuality) and developed a critique of others previously associated only with Marxist critique (for example, labour, social reproduction). This recognition of the inadequacy of previous analytic categories and procedures is the theoretical and political basis of feminists' interest in the place of women artists in past and present society, and of their critique of the discipline of art history.

Pollock believes that this critique is of wide-ranging significance to feminism. Though it is concerned with academic debates and university teaching, art history's accounts of creativity, gender, and the meanings of art has an influential ideological role in society (particularly in the high art/popular culture distinction discussed in my Conclusion below).[18] Feminists are involved, she declares, 'in a contest for occupation of an ideologically strategic terrain. Feminist art history should see itself as part of the political initiative of the women's movement, not just as a novel art-historical perspective, aiming to improve existing, but inadequate, art history. Feminist art history must engage in a politics of knowledge' (VVP: 23).

Any adequate art-historical analysis for Pollock, therefore, must include an understanding of the *inter-relation*, within culture, of patriarchal and capitalist structures. Feminist and Marxist analyses inform each other, she believes, but their radical critiques stand in double but 'not necessarily coinciding opposition to bourgeois art history' (VVP: 22). By this she means that feminists should always remain critical of Marxism's 'unquestioned patriarchal bias' (VVP: 20). Nevertheless, Marxist and Feminist perspectives could enrich each other's development as 'Marxist art historians' prime concern with class relations is brought into question by feminist argument about the social relations of the sexes around sexuality, kinship, the family and the acquisition of gender identity. At the same time existing feminist art history is challenged by the rigour, historical incentive and theoretical developments of Marxists in the field' (VVP: 20).

Pollock goes on to argue that feminist art historians must avoid all the theoretical inadequacies that have beset 'vulgar' Marxist analyses and in this, to a degree, she echoes the arguments made by Clark in the introduction to his study of Courbet. Accounts that are not based on specific 'conjunctural' studies of women artists working at particular times, taking into account all the range of evidences about institutions

and conventions – social, formal, and intellectual – will produce the theoretical and historical errors of what she calls *ideological generalisation, reduction, typification,* and *reflection*.

'Generalisation' occurs, Pollock says, when an artefact, such as a painting, is placed in a category of ideas, beliefs, or social theories of a given society or period simply because of its obvious content (VVP: 28). Now it *is* right, Pollock says, to see relations between different parts of 'intellectual culture'; that, as Clark alluded to in his introduction to the study of Courbet, the 'historical coincidence of realism in art and positivism in philosophy is in some way a result of new forms of bourgeois ideology. But ideology is a process of masking contradictions; it is itself fractured and contradictory. Referring art to ideology does not sort anything out at all; it merely displaces the necessary study of what ideological work specific pieces of art are doing, and for whom' (VVP: 29). To illustrate this point crudely: Courbet's *Stone-Breakers* (Illustration 2) shows two labourers at work in one of the poorest of menial jobs available in France at the time (1849). In doing this, however, it does not necessarily represent a bourgeois celebration of the virtues of hard labour. Clark's account, in fact, drawing on a range of evidence from contemporary sources, edges around saying the picture at the time signified almost the opposite.

'Reduction' occurs when it is claimed, for instance by Marxists, that 'all arguments about the forms and functions of cultural objects' are based on the supposed primacy of 'economic or material causes' (VVP: 28). Henri Matisse, for example, did not paint his *Blue Nude* (Illustration 7) simply because in 1907 this was the kind of picture collectors most wanted to acquire. Collectors' taste, however, *could* have been an active factor in Matisse's choice, as some empirical research might be able to suggest. (Matisse's art is discussed in Chapter 4 and my Conclusion.)

'Typification' involves the claim that a painting or an artist, for instance, can adequately stand for a whole class of something. That, for example, women 'artists are often treated in feminist art history virtually as representatives of their gender, their work expressing the visual ideology of a whole sex'. Pollock remarks that she herself has done this in teaching, relying on an account of Helen Frankenthaler paintings to 'stand for women's point of view' in the Abstract Expressionist movement (VVP: 29). A more defensible claim, though, one that could be subject to empirical inquiry, might be that Cassatt's painting of *Lydia at the Tapestry Frame* (Illustration 4) showed one of the commonest domestic occupations of middle-class women in France in 1881.

Finally, 'reflection' is the belief that an artwork may be taken as a straightforward and fixed 'image' of a society's class or gender structure – that it simply pictures an existing state of affairs, rather than 'works' it in a particular way or even, as Clark believes great art does, somehow attempts to subvert that reality in some way. Clark's claim could be made in relation to Picasso's *Bottle, Glass and Violin* (Illustration 1), seeing it as an attempt to critique and reorganise the conventions of representation. Cindy Sherman's photograph (Illustration 3) might be said to show an attractive girl reaching for a library book: this does not mean, however, that women in contemporary society are consigned to read books rather than write them.

Only a multitude of specific historical analyses will show adequately the diversity of representations, practices, and values that have constituted women's art over the centuries. Pollock gives the examples of Sofonisba Anguisola, whose upper-class position in Spanish court society was a condition which enabled her to become an artist, and Properzia de'Rossi who similarly achieved success partly because her high social standing worked in harmony with the then ascendant idea of the artist as 'superior being'. Too many feminist histories had produced the opposite kind of history, Pollock claims, creating, 'an insulated linear chronology which links women throughout history by virtue of biological sex alone', or histories that attempt to simply relocate women artists, adding them to the dominant narrative.[19] The real 'historicity' of women's oppression and resistance disappears when such homogenising categories are operative, Pollock argues, and these work to eliminate understanding of the conjunctural moments and disjunctive relations significant within particular societies, periods, and classes (VVP: 39).

In opposition to such simplistic, celebratory, linear narratives, Pollock calls, like Clark, for an understanding of society as a 'historical process':

> it is not a static entity. History cannot be reduced to a manageable block of information; it has to be grasped itself as a complex of processes and relationships. I suggest we have to abandon all the formulations such as 'art *and* society' or 'art *and* its social context', 'art *and* its historical background', 'art *and* class formation', 'art *and* gender relations'. All the real difficulty which is *not* being confronted lies in those '*ands*'. (VVP: 30).

For Pollock, then, feminist art history is part of a struggle for a radical reordering of society's social relations and representations at *all* levels

and in *all* spheres. This is a perspective which goes far beyond that of Nochlin's, whose political and intellectual perspective Pollock characterises negatively as 'liberal, equal rights feminism' (VVP: 35). This feminism, in political and scholarly terms, is merely additive, recuperative, and reformist. Nochlin's belief in what Pollock regards as the ideological category of 'great art' indicates this. It is saying: if only the institutions (including that of the artistic canon itself) could be reformed, women would be able to find their rightful place within them. 'In effect', Pollock says, 'Nochlin reinforces the patriarchal definition of man as the norm of humanity, woman as the disadvantaged other whose freedom lies in becoming like man. Individualism, humanism, and voluntarism prescribe the limits of this liberal bourgeois argument' (VVP: 35).[20] This judgement, as much political as intellectual, indicates one sense of the distance between US and British feminism in the early 1980s. Lucy Lippard, art historian and critic, US-based and originally from a conventional scholarly background in the discipline, embraced Pollock's perspective herself at around the same moment.[21]

Modernism, modernity, and feminist art history in the 1990s

Lippard, it could be argued, agreed with Pollock in the early 1980s that a positive relationship could and should exist between Marxism and feminism. Neither a 'marriage', nor a mere cobbling together, however, feminism could perform what Pollock called a 'fruitful raiding of Marxism for its explanatory instruments, for its analysis of the operations of bourgeois society and of bourgeois ideologies in order to be able to identify the specific configurations of bourgeois femininity and the forms of bourgeois mystification which mask the reality of social and sexual antagonisms' (VVP: 49). In her 1980 essay 'Issue and Taboo' Lippard chose to concern herself with contemporary women artists intent on revealing these mystifications.

Lippard's interest in writing about contemporary women artists was based on her involvement with the critical potential of art – feminist *and* socialist – in present-day society. Her work since the 1970s, and that of other feminist activists, artists, and scholars, has exemplified the interface, continuum, in fact, between the principles and aims of radical art history and art criticism.[22] The presence of the term 'issue' in her essay's title, Lippard explains, is a reference to topicality and 'propagation, spreading the word that it is possible to think about art

as a functioning element in society' (IT: 150). The exhibition of work Lippard wrote about, as well as curated, was called 'Social Strategies by Women Artists' and the aim of the show, she says, was to 'replace the illusion of neutral aesthetic freedom with social responsibility by focussing ... on specific issues' (IT: 150). All the participants exhibited work that belonged to 'the full panorama of social-change art', though in a variety of ways that undercut any sense that 'feminism' meant either a single political message or a single kind of artwork. This openness was a key element to the future creative social development of feminism as political and cultural intervention (IT: 150–1).

The show involved works, for instance, by Jenny Holzer and Lorraine Leeson, producers of large-scale, declarative 'agit-prop' art. Holzer's mail art and street leaflets and Leeson's high street posters attempt to turn the techniques of modern advertising over to radical causes. They both invite us to think about the workings of 'the morass of conflicting propaganda that surrounds us' and, in the case of the latter's posters, made for the London's Women's Health Information Centre, deal with specific issues such as abortion, contraception, home care, and women's work hazards (IT: 153/155). In sharp contrast, Mary Kelly's *The Post Partum Document*, which Lippard discusses in some detail, is a very different kind of work. It is an image/text project on the early life of her son, involving diagrams, charts, and a detailed textual analysis of the relation of Lacanian psychoanalysis to Marxist and feminist theory and politics. (Aspects of Lacanian analysis are discussed in the following chapter.) Martha Rosler's exhibits, including mail pieces, photographs, performance, and video also deal with questions of motherhood, as well as domesticity, sex, and careers. Lippard goes on to discuss other divergent kinds of work by, for example, Miriam Sharon, Maria Karras, Alexis Hunter, Margia Kramer, Nicole Croiset, and Nil Yalter.

The main aim of the show, Lippard says, is to show that all feminist art is political 'one way or another' and to show how these examples attempt to address worldwide issues that concern all people: racism, imperialism, nuclear war, starvation, and inflation (IT: 151). The exhibition is avowedly 'feminist-socialist' in its politics (though that might not be an apt description of the political beliefs of all its contributors). Referring to a then recent British book by three women trying to argue for an alliance between feminists and socialists, *Beyond The Fragments: Feminism and the Making of Socialism*, Lippard argues that this development is urgently needed throughout the world:

... the fact that feminism has something to offer to the Left that the Left needs badly is as inarguable in art as it is in political organisation. The transformation of society, at the heart of both feminism and socialism, will not take place until feminist strategies are acknowledged and fully integrated into the struggle. (IT: 150)

Acknowledging that feminists are divided by varieties of basic principle and organisation, between 'socialist feminism' on the one hand, and 'radical or cultural feminism' ('separatist'?) on the other, Lippard claims to be 'on "both sides now"' (IT: 168–70). The show is, she says, partly a means of trying to promote dialogue between women, though the artwork exhibited is not proposed to simply be 'dealing with the politics of being female' (IT: 151).

In a reference that anticipates the slightly later emergence of a radical art history concerned with the art, culture, and politics of post-colonial countries and peoples (discussed in my Conclusion), Lippard claims that the worldwide significance of feminism is partly based on the identification women potentially can have with all 'oppressed and disenfranchised people'. Women in general and people in 'the third world' share a condition of basic inequality bound up with the differential impact upon their lives of intermeshed capitalist and patriarchal structures (third world women have it worst of all, of course!). Such potential identification between feminist and post-colonial struggles is also an important factor, she says, 'in the replacement of colonisation and condescension with exchange and empathy' (IT: 170).

The exhibition and many of the works within it, Lippard says, represent the 'constructive' nature of both contemporary feminism and feminist artworks: both are trying to create a new reality out of bits and pieces that might not sit easily together. This 'collage' of political and artistic interactions, then – a term used by Lippard with very different connotations from those given it by Rosalind Krauss in her discussion of Picasso – represents something of the difficulties involved in creating novel organisation. The 'socialist feminist identity is itself as yet a collage of disparate, not yet fully compatible parts. It is a collage experience to be a woman artist or a sociopolitical artist in a capitalist culture. 'Issue' as an exhibition is itself a collage, a kind of newspaper' (IT: 168).

Lippard includes in her essay discussion of some of the difficulties and tensions present in the creation of this 'collage' of feminist interests, values, and activities. She isn't clear, for instance, whether

there can be something called 'feminist art' clearly separate from that made by men and acknowledges that the show side-steps this debate. Unlike Pollock's radically anti-essentialist stance, however, Lippard remarks that she still believes there *is* a core difference, but that it can't be identified in 'formal terms alone' (IT: 151). She notes that all of the artists included in the exhibition have, to a degree, had success within the mainstream art world. There is no agreement, though, she says, about whether feminists should seek success within it (another version of 'additive' feminism?), or see commercial success instead as completely irrelevant and seek alternative spaces 'for artists disillusioned with the role of art as handed down from above' (IT: 152).

This issue is related, Lippard observes, to the question of the differences between US and British feminism and feminist art and art writing. These, in turn, are inseparable from the broader historical and social differences characterising the two countries.[23] One of the most important of these, and significant for the whole development of radical art history in both countries, is the political culture of the two countries. Although many new social movements for radical change had grown up in the US in the 1960s, as they had done in Britain and Europe, in the US these were not linked to a powerful and continuing tradition of left-wing organisation able to influence central political processes in the country:[24]

> In America, artist-organized tentatives [sic] towards a socialist art movement are marginal and temporary, waxing and waning every five years or so with only a few tenacious recidivists providing the continuity. In England, there are actually Left political *parties* that artists can join and even work with – and the more advanced level of theoretical discussion reflects this availability of practice. (IT: 155)

On the other hand, Lippard notes, her show at the Institute of Contemporary Arts was the first such 'establishment-approved' exhibition in London, while New York, for example, had already been host to several (IT: 328, n. 3). These, however, had not had overt 'political' intentions and this indicated another important difference between the US and Britain. This concerned the extent to which the 'public' for art (remembering Clark's discussion of that concept) – and, for that matter, those powerful within the various art institutions – could tolerate the idea of 'political art' at all. For the Modernist tradition, at least in one of its most influential strands in art and criticism,

had always claimed the 'art for art's sake' disinterestedness and auto-
nomy from society that became particularly associated with abstraction
and its most significant representative movement in the post-World
War II period, the US-based Abstract Expressionists.[25] The movement's
function as a symbol of supreme *male* creativity, literally embodied in
the image, and drip-paintings, of Jackson Pollock, had been noted
in Parker and Griselda Pollock's *Old Mistresses: Women, Art and
Ideology* (OM: 145–50).

The active legacy of this prevalent 'art for art's sake' notion was,
Lippard says, the view 'in the US at least, that art with political subject
matter is *automatically* "bad art"' (IT: 157). This perception, shared
to some degree by many men and women artists who were committed
to radical political and social causes, is linked inevitably to the insti-
tutions within which artists are trained, to the market in which they
sell their work, and to the galleries and museums that offer to buy or
exhibit their art. Art critics, theorists, and historians also have a role
in the reproduction – *and* possible disruption – of this perception.
Echoing Clark's belief in the 'greatness' of art that sometimes inter-
venes in the historical process, Lippard observes:

> It is difficult not to be confused by all these taboos against any
> art that might be useful or even powerful. Several complex factors
> are operating. The most obvious is the tenor (or tenure) of
> Western art education and its insistence that high art is an instru-
> ment for the pleasure and entertainment of those in power . . . If
> such attitudes stem from the ruling class's conscious or uncon-
> scious fear that art may be a powerful form of communication
> and organisation, what are the artists afraid of? (IT: 162)

What kind of 'greatness' for art, that made by both women and men,
might be claimed by feminists? The texts by Parker and Pollock consid-
ered here seem to bracket out of examination the whole question of
authentic *positive* value and quality. Their decision to do this was not,
however, an attempt to deny the principle its relevance as an issue
needing attention by feminists; rather, I would argue, it was a tacit
statement that the question did not have pressing significance *then*,
within their practice of what was really a *negative critique* of conven-
tional art history.[26] Parker and Pollock also exhibit, to repeat, a
considerable degree of hostility to Nochlin's apparent defence of 'great-
ness' in art, often implying that when something is 'ideological' it also
always means it isn't true, and that it misrepresents.

In distinction, Lippard appears to equate 'greatness' with the capacity of art to reach and move and educate a public, and this is the goal, she says, of social-change art, though she admits that much of this in the past had failed on its own terms – watered down 'by stylistic pluralism and academic aimlessness . . . [and] by the artists' own illusions of complexity and espousal of incomprehensible jargon' (IT: 162).[27] But Lippard makes a clear distinction between potential 'greatness' in art understood as a function of its social significance – its conjunctural effectivity – and the idea that certain *artists*, men or women, should aptly be described as 'geniuses', a notion which returns us to the conventional art-historical myths of limitless (male) agency and creativity. Anne Middleton Wagner's study *Three Artists (Three Women): Modernism and the Art of Hesse, Krasner and O'Keeffe*, published in 1996, to which I turn now in conclusion to this chapter, assesses women artists' lives as well as their art and, in the process, reconsiders critically some of the core assumptions of influential feminists writing and active in the 1970s and 1980s.

Wagner's starting point is to claim that feminist art history is still in the process of being made; in fact, that it should never solidify into a fixed position or specialism. Yet she hints strongly that this may already have happened:

> That panels like 'Engendering Art' are regularly included at professional meetings bear witness to the institutionalisation of feminist art history in America. The discourse is said to be expanding, and indeed this seems to be the case, despite (or because of) the fraught roles of sexuality and women and feminism in American public culture, despite the 1980s antifeminist backlash, despite the susceptibility of academic study to intellectual fashion . . . Yet such institutionalisation is not necessarily hegemonic; the culture is diffuse enough that academic panels and women's studies courses do not inevitably mean either widespread acceptance or structural change . . . (TATW: 4)

Of course, many feminists, including Nochlin, Parker, and Pollock, were wary of the dangers of institutionalisation in the 1970s and 1980s and saw it as part of the dilemma encountered in taking radical ideas and politics into institutions like universities, where 'recuperation' is always possible and, indeed, likely.[28] Yet there was never, and is not now, a single 'feminism' to be institutionalised or recuperated. Feminism has *always* been a heterogeneous movement, with many

intellectual currents and perspectives, divided, for instance, between those also committed to socialist goals – like Lippard – and those committed to separatist principles. Another persistent bifurcation has been that between those feminists who saw their actions geared only towards *reformist* changes in the laws of a country, in a reorganisation of institutions that would bring formal and practical equal rights. Others have wished for, and acted with the intention to attempt to bring about a *revolutionary* transformation of society – inventing new institutions, social relations, and modes of behaviour.

Wagner's book is partly, then, a reconsideration of earlier feminist debates about these broader issues, but it is specifically about the nature of art, the place of women within it, and women artists' relation, particularly, to the modernist tradition. She defends, for example, Nochlin's claim that there is a greatness to art that is *not* simply an ideological mystification perpetrated by patriarchal art history. In fact, she calls Nochlin's view an instance of 'unblinkered realism' (TATW: 23). This suggests that greatness in art is simply a fact that Nochlin has been able, and wanted, to recognise. 'If to call a work great is to name it as a vehicle and repository of cultural value – or meaning and understanding – why not hope that this epithet might come to be used of women's art?', she asks (TATW: 24). Yet Wagner, like Nochlin before her, is cautious: she isn't sure, for example, whether feminists should go ahead, in the knowledge that greatness isn't only a myth, and construct its own 'canonical roster, its pantheon of great artists' (TATW: 23).

On the one hand, she says, feminists should acknowledge the greatness of women artists like Judy Chicago. The danger lies, she thinks, in the way that the means and emblems of attributed greatness rest within, are guaranteed by, the 'institutional forms and disciplinary regulations of an art world made to invent and safeguard *male* greatness' (TATW: 23, my italics). She is thinking here of market value, one-person shows, and all the publicity and publishing forms associated with concentration on individual artists. There is a danger here, then, of 'recuperation' as much as in the institutionalisation of feminist art history in the universities. Like Lippard, Wagner then suggests that women's art – though it may have a 'greatness' to it – may be quite different from that of men. Too often in the past, she claims, all that feminists have done is adopted criteria and values for women artists normally applied to men. Instead, feminist art historians need to 'find the terms in which to *see* women's art . . . that make enough cultural or aesthetic sense' (TATW: 25).[29]

Wagner's introductory section is followed by three case-studies that attempt to 'see' women artists in these new terms. Wagner's aim in these case-studies is to examine how gender becomes an 'actively determinant factor in the production and reception of art' (TATW: 4). She chooses three women who lived and worked in the US mostly after World War II and whose careers, Wagner suggests, have an exemplary status for the situation of women in the US in general. The 'recurrent issues' raised by their lives concern, she says, 'the social and professional experience of women who make art, as well as the forms their art takes; they require both public and private negotiation of the roles of woman and wife, as well as that of the artist; they shape the various means used to claim authorship or voice or identity in a work of art, as well as the value placed on that art in the public realm' (TATW: 1–2).

Wagner sees the identity of these women as formed, that is 'negotiated', within these circumstances. Yet, although these three women were exceptional in that they were commercially and critically successful as artists, in other ways their lives 'are typical in a whole range of other respects', and may stand 'to outline a social history of the twentieth century female artist (when she is white, that is) . . .' (TATW: 10). (I consider the issue of the interaction of race and gender factors in my Conclusion.) In addition to the 'social representativeness' Wagner claims for these women, she chose to consider Georgia O'Keeffe, Lee Krasner, and Eva Hesse also because they all practised their own kinds of modernist art – concerned not only with abstraction, but with its relation to figuration. All three, Wagner says, were 'acutely aware' of being female artists and each 'was a modernist by ambition and choice' (TATW: 2). All three had also been through art school education, had married successful male modernist artists, remained childless, and achieved critical acclaim themselves as artists during their lives. I briefly consider Wagner's account of one of these women, Eva Hesse, as the conclusion to this chapter.

Studying Hesse's life, Wagner believes, is, in principle, no different from studying that of any other person. In recognising this, Wagner refuses the 'individual great artist' narrative that constitutes much of conventional art history and which might also have become, she suggests, a mystificatory form reproduced within feminist art scholarship. Hesse can be 'known' through her journals and artworks, through interviews and letters, through what has been recorded about her training and involvement in art institutions of various kinds. These all constitute, Wagner says, representations of her life, and are cultural

artefacts in themselves. Yet those artefacts, *and* her life, should be seen as 'profoundly social – as socially determined' and in this way also her art 'might better be understood "as that of a woman"' (TATW: 203). Hesse's identity, however, is like that of any other person in modern times, 'a rather more unstable construct', a 'relation between the self and the social' (TATW: 27).

The break-up of Hesse's marriage to Tom Doyle in 1965, for instance, is one aspect of the 'negotiation' of conflicting gender roles that marriage assigns to people – the incompatibility, in *both* their minds, of the identities 'wife' and 'artist', though Wagner says that Doyle conventionally believed his partner should do all the domestic chores (TATW: 237–8). Again, this particular instance of conflict between two artists – a man and a woman ('his wife') – has a wider exemplary status, claims Wagner: 'these various expressions of disjunction and recognition . . . should be thought of as profoundly typical, (TATW: 6). According to Wagner, Hesse questioned her identity as a woman and an artist from the very beginning of her education at Yale University. Her 'self-portraits', started in 1960, when she was no longer a student, were an escape, Wagner claims, from the curriculum at Yale she had found restricting. These paintings, however, such as *Untitled* (1960), which plays with conventions of abstraction and figuration, were clearly not 'a matter or effect of external appearances' (TATW: 195).

Her art, according to Wagner, is always a deliberated, considered *representation* of her situation, a set of strategies of self-investigation, a set of questions she asked herself. She is also aware, early on, of being represented by others. Among Hesse's papers, Wagner notes, is a drawing, probably done in 1969, *Project for an installation at the Whitney Museum*. What appears to be depicted is a layout of pictures and the words 'build wall', 'Whitney', 'Processes . . . means as end (title)' and 'catalogue . . . film process'. It looks like the sketch of a show of her work. Along the lower edge of the drawing Hesse had written 'my responsibility to know as I am being categorised in a way that's detrimental to my work' (TATW: 202).

Her journal is another reservoir of such self-interrogation: 'Am I a woman? Are my needs for developing artistically and intellectually incompatible? . . .' (TATW: 220). Wagner suggests that Hesse's early death from a brain tumour in 1970 and the highly selective editing of her journal for three publications in the late 1970s and early 1980s, were factors that significantly skewed later biographical accounts, those by both men and women (TATW: 223). These created a kind of myth

out of the artist's diverse and complex materials, and worked to fit her into a rather dismal preconceived image of what an attractive, young, *tragic*, woman artist – 'a beautiful martyr' (TATW: 203), 'Hesse as wound' (TATW: 198) – should be like.[30] Against these myths and misrepresentations, which verge on being what Krauss calls 'an art history of the proper name', Wagner wants to reassert the significance of Hesse's actual artworks and her practice as a sculptor.

Wagner acknowledges that to do this means arguing for a notion and history of 'Modernism' with a capital M that many feminists, such as Pollock, have felt to be indefensible. Wagner believes there are many different modern*isms* in art and 'in theory' and that to claim, as she says Pollock does, that the paradigm of the Modernist artist 'is inevitably masculine', is simply false (TATW: 14). Citing Pollock's sometime-collaborator Mary Kelly against Pollock herself, Wagner endorses Kelly's view that there is 'no univocal modernism', except that produced by critical discourse attempting to impose such a singularity (TATW: 15).[31] Works of art can always be read again, 'reopened to scrutiny', and women artists, Wagner claims, have sometimes embraced abstraction in art strategically as a means to represent themselves and aspects of their relation to the world (TATW: 15).

This modernism, unrelated to the twin myths of 'art for art's sake' and individual creative genius, has been, Wagner asserts, the necessary resource of recent and contemporary artists, both men and women. Through it, artists as diverse as Berthe Morisot, Linda Benglis, Judy Chicago, and Eva Hesse have tried to image a utopia, or a world outside the body, or inside it, or to express 'presence or absence, voice or voicelessness' (TATW: 20). Hesse's 1967 piece *Accession II* (Illustration 5), a box made of galvanised steel and rubber tubing, is related to, yet differs from, 'minimalist' artefacts constructed by other contemporary artists. According to Wagner, it figures, through its abstract form 'human experience . . . the field of intersection between the bodily and the ideal, the empirical and the imaginary . . . Her work provides an experience of frailty within order, disorder within unity; it urges no fictions of coherence, power and completeness . . . Nor do I think it offers any fictions of the female . . .' (TATW: 275–6). The artefact, therefore, may be read as a metaphor, or question posed, about the 'inside/outside' relations between Hesse's art and her life, and of the wider relations between self and the social. But the artefact emphatically does not *depict* these issues, nor should it be *reduced* to them as if it were a mere 'document'. The 'work' of Hesse's art, for Wagner, as for Clark, must be given its due.

In contrast to this recognition, Wagner notes that Hesse's encounter with the psychoanalytic establishment in the 1950s and 1960s preoccupied some of those responsible for recent accounts of the artist's 'work' which resulted in a seriously inadequate understanding, both of its formal complexities and relation to her life.[32] In the next chapter I consider the impact of psychoanalysis on recent art history, and its relation to both feminist and Marxist concerns.

Notes

1 See Karen Offen *European Feminisms 1700–1950: A Political History*, Stanford: Stanford University Press, 2000.

2 Introduction to Linda Nochlin *Women, Art and Power and Other Essays*: xiii.

3 'Revisionism' has two related meanings: one use is *neutral*, suggesting a mere change to something, such as the 'addition' of women artists to the accounts of traditional art history. The other use is *pejorative*, implying a negative contrast between a minor alteration to an otherwise unchanged situation, and a radical or 'revolutionary' transformation that creates, in effect, a completely new situation.

4 While the Marxism of the epoch between the 1890s and the 1950s had a definite predominant notion of what a socialist revolution would involve (however fallible this notion was), feminism, arguably, has never been led by a faction or single guiding principle able to articulate, never mind impose, such a clear notion. On Marxism and revolution, see the classic statement by V.I. Lenin *The State and Revolution*, Moscow: Progress Publishers, 1979.

5 It is significant that Nochlin has also published major studies concerned with Courbet. See, for instance, *Realism and Tradition in Art 1848–1900 Sources and Documents*, Englewood Cliffs: Prentice Hall, 1966.

6 Nochlin implicitly asks: are women really more 'inward-looking, more delicate and nuanced in their treatment of their medium'? 'Is Fragonard more or less feminine than Mme Vigée-Lebrun? Or is it not more a question of the whole Rococo style of eighteenth-century France being "feminine", if judged in terms of a binary scale of "masculinity" versus "femininity"'? (WAP: 149). She also observes that painters of domestic life have been men as well as women. In any case, she says, 'the mere choice of a certain realm of subject matter, or the restriction to certain subjects is not to be equated with a style, much less with some sort of quintessentially feminine style' (WAP: 149).

7 Nochlin claims, however, that precisely 'the same breaking of traditional bonds and discarding of time-honored practices that permitted men artists

to strike out in directions quite different from those of their fathers in the second half of the nineteenth-century [and in the twentieth century] enabled women, with additional difficulties, to be sure, to strike out on their own as well' (WAP: 169). Nochlin cites the examples of Suzanne Valadon, Paula Modersohn-Becker, Kathe Kollwitz, and Louise Nevelson.

8 See, for instance, Karl Marx *The German Ideology*, London: Lawrence and Wishart, 1970; Karl Marx *Grundrisse*, Harmondsworth: Penguin, 1973; Georg Lukács *History and Class Consciousness: Studies in Marxist Dialectics*, London: Merlin Press, 1971; Antonio Gramsci *Selections from the Prison Notebooks*, London: Lawrence and Wishart, 1971; Jorge Lorrain *The Concept of Ideology*, London: Hutchinson, 1979.

9 The political basis of British feminist interest in art history is underscored by Parker and Pollock in their preface where they declare their study to be, like Nochlin's, a 'product of the Women's Liberation Movement'. They go on to thank the Women's Art History Collective and the collective involved in the publication of the feminist magazine *Spare Rib* (OM: xxi).

10 Neither, it must be noted, did Arnold Hauser in *The Social History of Art*, 1951.

11 Their title came from an exhibition held at the Walters Art Gallery in 1972, organised by A. Gabhart and E. Broun, called 'Old Mistresses: Women Artists of the Past' (OM: 6).

12 Parker and Pollock detail some of the sexist comments made by men about women artists: 'You'll never be an artist', the chairman of an art department said to a female student, 'you'll just have babies' (OM: 6–7).

13 Pollock and Parker, like Nochlin, argue against 'the trap' of identifying an essential femininity within the art of women produced in different historical periods. This was a trap, they believe, that K. Petersen and J.J. Wilson fell into with their book *Women Artists: Recognition and Re-Appraisal from the Early Middle Ages to the Twentieth Century*, New York: Harper and Row, 1976 (OM: 48). Pollock attacks the alternative position – that of wishing simply to *add* women to existing traditional art-historical accounts – elaborated by Germaine Greer in *The Obstacle Race: The Fortunes of Women Painters and their Work*, New York: Farrar Straus Giroux, 1979 (VVP: 39–40).

14 See Kate Millett *Sexual Politics*, London: Rupert Hart-Davis, 1971; Elizabeth Cowie 'Woman as Sign' *m/f* 1978, no. 1; and Heidi Hartman 'The Unhappy Marriage of Marxism and feminism', *Capital and Class* Summer, 1979, no. 8.

15 See also Sheila Rowbotham, Lynne Segal, and Hilary Wainwright *Beyond the Fragments: Feminism and the Making of Socialism*.

16 See Erik Olin Wright *Class, Crisis and the State*, London: New Left Books, 1978.

17 See Sebastiano Timpanaro *On Materialism*, London: New Left Books, 1975; Raymond Williams *Problems of Materialism and Culture*, London: Verso, 1980; and Jonathan Hughes *Ecology and Historical Materialism*, Cambridge: Cambridge University Press, 2000.

18 Pollock claims 'Our general culture is ... permeated with ideas about the individual nature of creativity, how genius will always overcome social obstacles, that art is an inexplicable, almost magical sphere to be venerated but not analysed. These myths are produced in ideologies of art history and then dispersed through the channels of TV documentaries, popular art books, biographical romances about artists' lives like *Lust for Life* about Van Gogh, or *The Agony and the Ecstacy* about Michelangelo' (VVP: 20–1).

19 See note 13 for references. Another exhibition and catalogue essay proposing the second of these arguments was Linda Nochlin and Sutherland Harris' show *Women Artists 1550–1950*, New York: Alfred Knopf, 1976. According to Pollock, this proposal to integrate women into traditional art history means that 'their work will not be permitted to transform our conception of art, of history or the modes of art-historical research and explanation' (VVP: 36–7).

20 On humanism, see Richard A. Etlin *In Defense of Humanism*, and Terry Eagleton's critiques in *Literary Theory*, Chapter 1, and *The Idea of Culture*, Oxford: Blackwell, 2000.

21 See Lippard *From the Center: Feminist Essays on Art*, New York: E.P. Dutton, 1976; *Get the Message? A Decade of Art for Social Change*, New York: E.P. Dutton, 1984; and the US feminist journal *Heresies*.

22 See, for example, Rosemary Betterton (ed.) *Looking On: Images of Femininity in the Visual Arts and Media*, London and New York: Pandora, 1987; and Rozsika Parker and Griselda Pollock (eds) *Framing Feminism: Art and the Women's Movement 1970–1985*, London and New York: Pandora, 1987; and Mara R. Witzling (ed.) *Voicing Today's Visions: Writings by Contemporary Women Artists*, London: Women's Press, 1995 (two volumes).

23 Differences between US and British feminist interest in art and art history are discussed in some detail in Thalia Gouma-Peterson and Patricia Mathews 'The Feminist Critique of Art History', *Art Bulletin*. See also 'Discussion: An Exchange on the Feminist Critique of Art History', *Art Bulletin*, March 1989: 124–7.

24 See John Patrick Diggins *The Rise and Fall of the American Left*, New York and London: W.W. Norton, 1992, especially Chapters 6, 7, 8, and 9.

25 For a selection of essays dealing with the broad politics and criticism of Abstract Expressionism, see Francis Frascina (ed.) *Pollock and After: The Critical Debate*, London and New York: Harper and Row, 1985; and Griselda Pollock 'Killing Men and Dying Women: A Woman's Touch in the Cold Zone of American Painting in the 1950s', in Fred Orton and Griselda Pollock *Avant-gardes and Partisans Reviewed*, 219–94.

26 Pollock's later essays and books have included many 'positive critiques' of women art and artists. See, as well as those studies already mentioned, *Generations and Geographies in the Visual Arts: Feminist Readings*, London and New York: Routledge, 1996; and *Differencing the Canon: Feminist Desire and the Writing of Art's Histories*, London and New York: Routledge, 1999.

27 Neither men nor women have had a monopoly in the use of this, it must be said. On writing, jargon, and intelligibility in art history (radical and otherwise), see 'Writing (and) the History of Art: A Range of Critical Perspectives', *Art Bulletin*, September 1996: 398–416.

28 Pollock has always avoided identifying and thus institutionalising herself as a 'feminist art historian', preferring the title 'professor of social and cultural histories of art'.

29 See, for example, Rosemary Betterton *An Intimate Distance: Women, Artists, and the Body*, London and New York: Routledge, 1996.

30 Comparisons with the poet Sylvia Plath, who was married to Ted Hughes and who also died young (through suicide), have been made by many commentators on Hesse. Wagner, on the whole, finds these comparisons invidious – part of the myth-making that undermines specificity of historical and biographical analysis.

31 See Mary Kelly 'Reviewing Modernism Criticism', *Screen*, 22, no. 3, 1981. Pollock deals with the relationship between feminism and modernism, drawing on Kelly's essay, in 'Feminism and Modernism', in Rozsika Parker and Griselda Pollock (eds) *Framing Feminism: Art and the Women's Movement 1970–1985*: 79–122.

32 References to the post-structuralist and psychoanalytic thinkers Roland Barthes, Hélène Cixous, Gilles Deleuze, and Felix Guattari abound, Wagner says, in the psychologising accounts of Hesse's work produced for a retrospective exhibition held in 1992 (TATW: 198).

Select bibliography

Baker, E.C. and Hess, T.B. (eds) *Art and Sexual Politics*, New York: MacMillan, 1973

Berger, J. *Ways of Seeing*, Harmondsworth: BBC TV/Penguin, 1972

Betterton, R. (ed.) *Looking On: Images of Femininity in the Visual Arts and Media*, London and New York: Pandora, 1987

Betterton, R. *An Intimate Distance: Women, Artists, and the Body*, London and New York: Routledge, 1996

Butler, J. *Gender Trouble: Feminism and the Subversion of Identity*, London and New York: Routledge, 1990

Cherry, D. *Beyond the Frame: Feminism and Visual Culture, Britain 1850–1900*, London and New York: Routledge, 2000

Deepwell, K. *New Feminist Art Criticism*, Manchester and New York: Manchester University Press, 1995

Ecker, G. (ed.) *Feminist Aesthetics*, London: The Women's Press, 1985

Garb, T. *Sisters of the Brush*, New Haven and London: Yale University Press, 1994

Gornick, V. and Moran, B.K. (eds) *Women in Sexist Society: Studies in Power and Powerlessness*, New York: Basic Books, 1971

Gouma-Peterson, T. and Mathews, P. 'The Feminist Critique of Art History', *Art Bulletin*, September 1987: 327–57. (In response, see: *Art Bulletin* 'Discussion: An Exchange on the Feminist Critique of Art History', March 1989: 124–7.)

Greer, G. *The Obstacle Race: The Fortunes of Women Painters and their Work*, New York: Farrar Straus Giroux, 1979

Lippard, L. *From the Center: Feminist Essays on Art*, New York: E.P. Dutton, 1976

Lippard, L. *Get the Message? A decade of Art for Social Change*, New York: E.P. Dutton, 1984

Nead, L. *Myths of Sexuality: Representations of Women in Victorian Britain*, London: Basil Blackwell, 1988

Nochlin, L. and Harris, A.S. *Women Artists 1550–1950*, New York: Alfred Knopf, 1976

Parker, R. and Pollock, G. (eds) *Framing Feminism: Art and the Women's Movement 1970–1985*, London: Pandora Press, 1987

Petersen, K. and Wilson, J.J. *Women Artists: Recognition and Re-Appraisal from the Early Middle Ages to the Twentieth Century*, New York: Harper and Row, 1976

Pollock, G. *Generations and Geographies in the Visual Arts: Feminist Readings*, London and New York: Routledge, 1996

Tickner, L. 'The body politic: female sexuality and women artists since 1970', *Art History*, June 1978, vol. 1, no. 2: 236–49

Witzling, M.A. (ed.) *Voicing Today's Visions: Writings by Contemporary Women Artists*, London: Women's Press, 1995 (two volumes)

Subjects, identities, and visual ideology

Key texts

Laura Mulvey 'Visual Pleasure and Narrative Cinema', in Laura Mulvey, *Visual and Other Pleasures*, Bloomington and Indianapolis: Indiana University Press, 1989 (originally Basingstoke: Macmillan, 1989): VOP.

Peter Fuller 'Acknowledgements', 'Two Preludes', and 'The Venus and "Internal Objects"', in *Art and Psychoanalysis*, London: Writers and Readers Publishing Cooperative, 1980: AP.

Claire Pajaczkowska 'Structure and Pleasure', in *The Block Reader in Visual Culture*, London and New York: Routledge 1996, 31–49: SP.

Norman Bryson 'The Gaze in the Expanded Field', in *Vision and Visuality*, Hal Foster (ed.), *Discussions in Contemporary Culture* no. 2, Seattle: DIA Art Foundation/Bay Press, 1988, 87–108 (and discussion 109–13): GEF.

Donald Kuspit 'The Process of Idealization of Woman in Matisse's Art', *Signs of Psyche in Modern and Post-modern Art*, Cambridge: Cambridge University Press, 1993: PIWMA.

Psychoanalysis and radical politics after the 1960s

What significance did the notions of *individual* identity, 'self', and 'personality', have in the development of radical art history after 1970? My interpretation of texts considered in the previous two chapters has suggested that, despite the quite different interests and values of those identified as Marxists and feminists, there is a broad agreement between them that explanations of art based upon ideologies of individual*ism*, of individual expression, and of individual greatness or genius, were to be treated with extreme suspicion. Radicals decisively shifted their attention away from the action and centrality of individuals toward forms of analysis that located the place and significance of such individuals – for example, artists, art historians, and other viewers of art – within *social* structures. Class and gender, understood as primary or 'determining' categories of social existence, action, and organisation, have predominated within the Marxist and feminist accounts which I've considered. Now, the existence of 'real' individuals was not denied within these accounts; but the effectivity of such individuals in art, society, and in history has been seen by radical art historians primarily in terms of their place *within, as part of*, these social groups. The relationship of the categories of class and gender, both to each other, *and* to other social groups, structures, and forces, has been construed by radical art historians in many different ways. For example, some feminists, such as Pollock and Lippard, argue that the common history of men and women cannot be separated from the analysis of either capitalist society *or* patriarchal relationships. Clark's notion of the mid-nineteenth century French 'public' for art is another category, or object, of study not separable from class and gender issues. I have characterised as 'historical materialist' the perspective of those authors who commonly ground their analysis of art and art history in an examination of social structures – structures that are necessarily rooted in material life and history.

The concept of ideology has also been extremely important for both Marxists and feminists, though the term is used in a variety of different, and sometimes possibly contradictory, ways. At its strongest and most critical, it is used to refer to an assertion, argument, or representation, which is blatantly false or illusory, and which, in its deceptiveness, bolsters the interests of a particular class or group in society. Often this is what Pollock seems to mean when she attacks as ideological the idea of the male 'artist as individual genius': that is, that the notion is both mystificatory and serves the interests of the

male bourgeoisie. Sometimes, however, the term ideology is used to mean simply a 'system of ideas' or 'set of values'. Boime largely sees the pedagogic principles, institutional organisation, and technical procedures of nineteenth-century French academic painting as ideological in this sense. Sometimes the two meanings overlap – Barrell's account of the 'georgic-pastoral' tradition in eighteenth-century English landscape art is an example. These paintings (and related poetic verse) form both a system of values and way of representing, but they are also misrepresentational, he argues, because they ignore the reality of the rural poor.

Some authors, however, identifying themselves or identified by others as Marxist and feminist, have clearly thought that this 'ideology critique' has gone too far or is sometimes inappropriate. Nochlin, for one, tries to maintain the idea that 'greatness' in art can be non-ideological in the sense of it not simply being a mystificatory appellation, though she appears reticent to develop her argument, and consequently her position remains somewhat ambivalent. Both Clark and Wagner appear to agree in principle with Nochlin but are careful – in fact, insistent – to argue that their notion of art's value and potential 'greatness' is always *relational*. That is, that the historical significance of certain artworks is always based on the operation, the 'effectivity' of certain artworks in particular circumstances, in which a great variety of materials – aesthetic, conventional, institutional, ideological – are in play. The personality of the artist, arguably, remains far less a part (or riddle) of the explanation in Clark's case (concerned with Courbet), than in that of Wagner's, whose concern is much more directly with the question of the *identity* (and representation of that identity) of Hesse, both as an individual, and as a representative of a gender.

Marxists and feminists have also been opposed to emphasis on the significance of individuals and individual action for obvious *political* reasons. Socialists since the nineteenth century have seen collective political action by the working class as the only means through which radical changes in society could be brought about. They identified ideologies of competition between individuals and classes as one of the core evils of the capitalist system itself. Feminists equally were aware from the 1960s that they needed a 'movement' of concerted action to agitate for, and bring about, radical social transformation. In all the possible situations of dispute and demonstration – on the streets, in institutions such as factories, hospitals, schools, and universities, in formal political organisations and in cultural activities, in families and

sexual relationships – both real and symbolic solidarity between those sharing problems, interests, and values was seen as a key to survival and success.

Yet within 'the moment of 1968' itself, and from the beginnings of radical art history in the early 1970s, Marxist and feminist activists and scholars *also* began an inquiry into the nature of individuality, of self, of interiority, and of personality. This examination developed in tandem – sometimes harmoniously, sometimes in tension – with both political action and the analysis of collectivities and social ideology.[1] 'Liberation', as a slogan, demand, and implicit political agenda, always had a *variety* of objects for those who articulated the principle – a wide range of economic, social, political, and sexual referents. Within feminism, many of these objectives came to interact within specific social struggles (for example, over economic and legal rights for women prostitutes, or the right for women to choose to have abortions and access to contraception).

'Experience' was another category given special focus within feminist political thought. It could refer to women's common suffering under oppressive patriarchal social life (and solidarity against this experience, in 'sisterhood'), but also to those necessarily 'individual' experiences of the body – in childbirth, for example, and in sexual activity and pleasure. In all these cases, in fact, there is a dialectic between such individual, even 'unique' experiences – taking place in particular minds and bodies – and the issue, and assumption, of their commonality within the group. Feminist critics and historians interested in art and culture began to investigate aspects of these individual and shared experiences of women (and sometimes men). What did women *do*, for instance, when they looked at visual representations of female and male bodies? (Illustrations 3, 4, 6, 7, and 10.) What pleasures, or pains, could be gained within such looking? What was the relationship between looking and sexual identity and gratification? What kind of political *and* personal investments could there be in the activity of looking and the pleasures derived from it?

Laura Mulvey's highly influential 1975 essay 'Visual Pleasure and Narrative Cinema' has a clear and revolutionary answer to these questions. She wishes to analyse how Hollywood films – specifically Alfred Hitchcock's *Vertigo*, *Marnie*, and *Rear Window*, but really *any* popular narrative film, she claims – create images and narratives of sexual desire and sexual roles that work, she believes, to reproduce patriarchal society and its oppression of women. She is certainly aware that women gain pleasure from looking at these images and narratives, but is equally

clear that they must be made conscious of how destructive this form of pleasure in looking is. The stage *after* rejecting this form of pleasure, Mulvey believes, would be that of creating a new kind of film based on a different kind of pleasure:

> This complex interaction of looks is specific to film. The first blow against the monolithic accumulation of traditional film conventions (already undertaken by radical film-makers) is to free the look of the camera in its materiality in time and space and the look of the audience into dialectics and passionate detachment. There is no doubt that this destroys the satisfaction, pleasure and privilege of the 'invisible guest' [the film viewer], and highlights the way film has depended on voyeuristic active/passive mechanisms. Women, whose image has continually been stolen and used for this end, cannot view the decline of the traditional film form with anything much more than sentimental regret. (VOP: 26)

It is particularly significant here that Mulvey explicitly links her critical analysis of commercial films to a prescription for an avant-garde practice in film-making that should replace it, she says, with nothing less than a 'new language of desire' (VOP: 16).[2] Mulvey's interest in narrative film – part of popular or 'mass', as opposed to 'high', culture – radically expands the concerns of feminist art history. (I will continue to use the term 'art history' here mostly for convenience. It begins to sound both descriptively and analytically inadequate, however, because art history is usually associated only with the study of 'traditional' artefacts such as paintings, sculptures, and prints.) At the same time, Mulvey's essay exemplifies radical art history's concern with both scholarly *and* broad social change: novel perspectives, arguments, and analysis linked – explicitly or implicitly – to proposed changes in institutions, and in arts and media practices. The aspect of utopianism present in her text – how could avant-garde film simply *supplant* the commercial cinema? – Mulvey recognised herself when she considered the historical and political significance of her essay in two self-critiques.[3]

Mulvey argues in her essay that the cinema or movie-house as a *site*, and film as a visual-representational *form*, have a particular and special power in contemporary culture. This alignment of site and form constitutes a viewing practice for people 'quite different in its voyeuristic potential from, say, striptease, theatre, shows, and so on' (VOP: 25). 'Filmic pleasure', she argues, is based on the combination of location – the darkened room of the movie-house – and the actors

in the narrative within the movie itself, playing away, as it were, *by themselves*, unaware of those watching. This leads to what she calls the film viewers' 'voyeuristic-scopophilia' (VOP: 25). This is the erotic pleasure gained in looking, while not being watched by those on the screen:

> What is seen on the screen is so manifestly shown . . . [but film] portray[s] a hermetically sealed world . . . a sense of separation and playing on . . . voyeuristic fantasy . . . darkness in the auditorium . . . help[s] promote the illusion of voyeuristic separation . . . an illusion of looking in on a private world. (VOP: 17)

Film, for Mulvey, 'reflects, reveals and even plays on the *straight*, socially established interpretation of sexual difference which controls images, erotic ways of looking and spectacle' (VOP: 14, my italics). Notice 'straight' in this previous sentence: it refers, actually rather unobtrusively, to the question of 'sexual orientation' in looking. Hollywood cinema, for Mulvey, means heterosexual cinema and 'heterosexual looking'. (I turn to the possibility of 'non-heterosexual looking' in some of my following chapters.)

Mulvey believes that a psychoanalytic attention is required to understand film's 'fascination' – that is, its ability 'to charm or enslave through a look, as in witchcraft'. This fascination, she claims, 'is reinforced by pre-existing patterns of fascination already at work within the individual subject and the social formations that have moulded him [sic]' (VOP: 14). Psychoanalysis, moreover, can help reveal how the 'language' of narratives and images of men and women in commercial film come to operate in society at large: how, she claims, 'the unconscious of patriarchal society has structured film form' (VOP: 14). 'Hollywood', really a synonym for commercial film, and society, therefore, are in a kind of dialectical relation of effect, each posing questions about the other. Mainstream cinema, Mulvey says, codes 'the erotic into the language of the dominant patriarchal order' (VOP: 16), and reflects 'the psychical obsessions of the society which produced it' (VOP: 15). It is both made by, and helps to make, this world.

Mulvey has remarked that her essay was written in a period when feminism was developing from a core base of direct political activity into an extensive intellectual and social formation (VOP: vii). Her argument, therefore, was certainly part 'polemic' and, she acknowledged, related to 'immediate interests' (VOP: vii). Reconstructing this original context, or 'condition of production', however, is a difficult task, and

particularly hard many years later for readers in a very different situation (for instance, think of students on an undergraduate media studies course encountering the text). *One* of the things Mulvey's essay may be said to signify, though, was the growing interest of feminists, in the mid-1970s, in debates about aesthetics and culture, following the earlier period of concentration by activists on 'narrow' political and economic issues.

The essay's original publication in the British journal of film criticism and theory *Screen* is also important. Mulvey's text was placed in a magazine with avant-garde ambitions in political theory *and* art practice, that, at the time, was publishing work by scholars and activists trying to forge links between Marxism and feminism. Its core interest in film analysis and theory and, later, in television, was a complement to the contemporaneous work of radical art historians concerned with traditional art media – though the journal also brought analysis of these different media together (with some tensions) at various moments in the 1970s and 1980s.[4]

Mulvey reaffirmed in 1988 the key claim in her essay cited above: that analysis of images and narratives in film is importantly linked to the struggle women have to 'gain rights over their bodies', to recover from men what she called patriarchy's 'mythology of the feminine', rooted in how women and their bodies and sexualities are represented in film seen by both women *and* men (VOP: xii). So, although feminist interest in art history and aesthetics developed, she said, in the wake of political activism around basic economic issues like equal pay and sexual discrimination at work, such scholarly concern should *not* be understood as a mere supplement to these material struggles.[5] Somehow 'images and incomes' are significantly related and the means of connection, Mulvey argues in her essay, is partly through the attitudes and values that Hollywood films convey to their audience of women and men *about* women and men as 'actors' in society.

The conceptual principles that underpin this claim have their origins in the psychoanalytic ideas developed by Sigmund Freud and other analysts, from various traditions, whose writings about the nature of individual self, identity, and sexuality have been appropriated by radical art historians and film theorists over the past thirty years and more. It is important to note, however, that often research and writing produced by analysts dealing with *patients* in the psychoanalytic 'interview' or psychotherapy context became the basis for arguments about cultural *artefacts*, such as paintings and films. It is the case, though, that some analysts, such as Freud and Jacques Lacan,

for example, did also write, sometimes more explicitly speculatively, about art, history, and society.[6] Feminists and other radicals – some Marxists included, such as Peter Fuller, an essay of whose I discuss below – have taken particular concepts (and, arguably, implicit values) from psychoanalytic writing and attempted to insert them into quite different kinds of arguments and analysis.

Self, sex, society, and culture

Mulvey's argument is that core facets of people's sexual nature and identity – such as *scopophilia* (satisfactions in looking) and *desire* (sexual needs and their gratification) – are, in patriarchal society, centred on, and confirm, *only* heterosexual male pleasures and power. One implication of this claim is that the true nature of women's sexuality is radically unknown, though it is *assumed* to be different from male sexuality. Feminism, amongst the freedoms it called for in the late 1960s and beyond, began an attempt to 'liberate' this unknown, though assumed, different sexuality. However, the movement was divided, over this as over other issues, between those, for instance, wishing to form relationships with men, and those advocating separatism. For the former, indeed, sexual (and social) identity might not be a fixed 'gender-specific' phenomenon at all, but actually constructed in, and through, relations with men.

In patriarchal society, however, dominant cultural forms, such as the commercial movie, have produced conventions that rigidly reproduce representations of pleasure and desire that are heterosexual and male-centred. Mulvey's view is that these conventional images and narratives do give pleasure to both men *and* women, to the extent that women have come to look at these images and narratives *as if* they were men, assuming male notions of desire, and thus they have lost, or never experienced, pleasure or desire that might be specifically 'woman-centred', and possibly non-heterosexual. The images and narratives of Hollywood film have allocated women the status of 'being looked at', as *passive* objects of men's attention (and women's desire as well), Mulvey claims, while the image and narrative representation of men in commercial films is as the *active* subject, which, again, has come to provide pleasure apparently for both men and women, confirming them in their social roles within patriarchy.[7]

Pleasure in looking is also tied, Mulvey claims, to various kinds of fears relating to sexuality and identity. Commercial film, she says, has

evolved conventions of image-organisation and narrative-construction that are designed to assuage such anxieties. For example, men all suffer 'castration anxiety', Mulvey claims, echoing Freud, and this is based on the irrational belief that women have all been castrated and the vagina is the visual sign of this having taken place (VOP: 21). Curiosity about the sexual difference between men and women is the basis for scopophilia, which is necessarily linked to the male viewer's own sense and security of self and hence is 'narcissistic', that is, based on self-regard. Castration anxieties, sometimes leading to voyeuristic misogyny, are encouraged, Mulvey claims, by the roles and images women are given in commercial films.

Vertigo, for instance, she suggests, 'focuses on the implications of the active/looking [male], passive/looked [female] split in terms of sexual difference and the power of the male symbolic encapsulated in the hero' (VOP: 24). In countless narrative films, the 'male protago-nist is free to command the stage, a stage of spatial illusion in which he articulates the look and creates the action' (VOP: 20). Women in their 'traditional exhibitionist role', Mulvey argues, 'are simultaneously looked at and displayed, with their appearance coded for strong visual and erotic impact so that they can be said to connote *to-be-looked-at-ness*. Woman displayed as sexual object is the *leitmotif* of erotic spectacle: from pin-ups to strip-tease, from Ziegfield to Busby Berkeley, she holds the look, and plays to and signifies male desire' (VOP: 19).[8]

It is not difficult to see how this claim about commercial film's depiction of the relations between men and women comes to be under-stood by Mulvey to represent patriarchal society in general, and what she calls its cultural 'phallocentrism' (VOP: 14). The penis has become the symbol ('phallus') of men's actual and represented dominance and power generally over women, and Hollywood has continually and remorselessly reproduced this symbolism in its industrial output, espec-ially since World War II. Mulvey claims that, although every narrative film always presents a *specific* representation of the world and of men and women's identities and relationships within it, the medium's ideological role within patriarchy is to inculcate *general* values and attitudes that mask inequalities in actual society. Pleasure gained 'in using another person as an object of sexual stimulation through sight' and narcissistic identification with heroes and heroines on the screen ('ego ideals', the 'star system') 'motivate eroticised phantasmagoria that affect the subject's perception of the world to make a mockery of empirical reality' (VOP: 18).

In this final formulation Mulvey articulates an ideological critique of art similar to that proposed by Griselda Pollock. This is that narrative-movie representations are false and mystificatory, producing ideological effects that do not correspond to how the world really is. In particular, Mulvey claims that commercial films depict women in highly limited and demeaning ways as passive objects of male sexual desire. These filmic representations are destructive because they are offered both as an (in fact, erroneous) account of what the world is really already supposed to be like, and because they offer degrading models of sexuality and social role which continually reproduce these notions. Specifically disturbing to Mulvey and many other feminists is the knowledge that many women appear to gain pleasure from these films, which, they believe, are actually a means through which they are oppressed. In this sense, then, women participate *willingly* in their own exploitation.

One implication of this recognition is that psychoanalytic perspectives and concepts are necessary in order to begin to account adequately for why people – men and women – have tolerated and indeed, gained satisfaction, from activities and beliefs that have actually been instrumental in their own oppression. As Mulvey notes, some Marxists in the 1930s resorted to psychoanalytic arguments to try to explain what was thought to be the 'irrational' appeal of Fascism (VOP: xv).[9] To account for the nature of society means, then, to account also for relevant senses of 'self' that relate to bodily and psychic needs, as well as to economic and political ones. This can also mean the search, through the analysis of artworks or films, for a connection between desires to do with fantasies of individual bodily pleasure, and those related to *supra*-individual ideas of identity, lodged in, for example, a class, or gender, or race, or nation.

Peter Fuller's 1980 essay, 'The Venus and "Internal Objects"', is concerned with the modern history of the antique statue now called the *Venus de Milo*, which was recovered on a beach in Greece in 1821 (Illustration 6). Fuller's text, like Mulvey's, centres on issues of psychic fantasy and identification, and their relation to social history. Both Fuller and Mulvey turned to psychoanalysis because it supplied, they believe, insights into what Mulvey calls 'fantasy as a force and the materiality of desire' that could not be got within existing social history of art perspectives (VOP: xiii). Like Mulvey, Fuller is interested in an artefact with significant social and ideological value. Both bring to their inquiries psychoanalytic ideas which open up the 'possibility of understanding', as Mulvey put it (and this is also true of Fuller's text) 'the mechanics of

popular mythology and its raw materials: images of sexual difference, instincts and their vicissitudes, primal fantasy' (VOP: xiii). Fuller, distinctly unlike Mulvey, however, wishes to use psychoanalytic notions to recover a sense of *universal* aesthetic pleasure able to transcend divisions of both gender and class. To this end, then, Fuller wishes to develop a psychoanalytic argument that is actually *antagonistic* toward the feminist political and cultural arguments encountered in this, and the previous, chapter.

His intention, however, was, he claims, to extend the explanatory capacity of historical materialist, if not 'Marxist', arguments. In a preface to his essay he remarks that his interest in psychoanalytic ideas grew out of a dissatisfaction with 'the aridity of much of the current left debate about the visual arts' (AP: 10). Fuller rejects what he calls the 'crude populism' of contemporary 'social-protest' art (of the kind Lippard had espoused in her catalogue essay also written in 1980), as well as the dense 'structuralist' perspective of Marxist-feminists such as Griselda Pollock. Both positions, he claims, involve a 'rejection of the category of the aesthetic, *tout court*' or understand it simply as a 'manifestation of ideology' (AP: 10).

The category of 'the aesthetic', like that of 'greatness' in art, by the late 1970s, had become controversial and contested on a number of levels, as my consideration of earlier texts has demonstrated. For Fuller the three issues pivotal to the notion and experience of 'the aesthetic' are:

- the existence and nature of beauty in art;
- the status and value of qualitative judgements identifying, for instance, 'good' and 'bad' art;
- the kinds of pleasure that artworks can give people.

Marxism is incapable of dealing with these questions, Fuller argues, because they are not, finally, historical or social matters at all, but relate instead to material and biological aspects of human nature. Fuller believes his investigation of 'the aesthetic' through psychoanalytic ideas will lead to an expansion and enrichment of historical materialist principles because these should include not just the economic and physical worlds built by people, but also their individual and shared *physical natures* as human beings. This 'biological materialism' has a long pedigree in scientific traditions aligned to the perspective of historical materialism, and many philosophers and critics have considered the implications of recognising the physical and *psychic* materiality of

human nature.[10] There is an extremely complex relationship, Fuller claims, between such historical and biological-material aspects to human life and history. And it is certainly the case, he says, that the 'underlying biological condition is mediated by socio-historical experience and its cultural forms' (AP: 19).

The problem, however, with most contemporary Marxist (and feminist) accounts of aesthetic experience, Fuller says, is that it is relegated to the status of being *only* another ideology, like legal or religious or philosophical beliefs. These ideologies are then seen as merely 'superstructural' or peripheral to the real 'economic base' or 'mode of production of material life' in society (AP: 14).[11] 'Ideology' in this strong, critical sense, as I have noted, also carries the implication of meaning misrepresentational, false, and mystificatory. Fuller believes that within such accounts the reality and value of art and aesthetic experience threatens to disappear altogether.

Fuller acknowledges, however, that art *does* have important historical and social meanings, and that aspects of its development can be traced through historical and sociological analyses. However, the most important questions about art – to do with the aesthetic nature of artworks and the aesthetic experience they offer – cannot be answered, he believes, by resort to these disciplines. How and why is it, he ponders, that certain artworks seem to have an enduring appeal (a 'greatness'?) and are able continually to generate aesthetic experience for their viewers centuries after these artefacts were made and whose original cultural and social contexts of intelligibility have been lost? Why, for instance, had the art critic Walter Copland Perry concluded, echoing the views of many, that the *Venus* figure was 'ideal in the highest sense of the word . . . a form which transcends all our experience [and that] has no prototype or equal in the actual world'? (AP: 15) Could the apparent 'timelessness' and 'universality' of such artworks merely be an ideological effect?

A sculpture such as the *Venus*, Fuller believes, can be used to test the value of an account of greatness in art based upon ideas drawn from a variety of pychoanalytic sources including the so-called British 'object-relations' school centred around Melanie Klein, who had been particularly interested in the 'psychodynamic' relations between mothers and babies. The essential link that allows ancient works, such as the *Venus*, to endure aesthetically is that between the depicted female body of the sculpture and the necessary 'embodiedness' of the human minds able to contemplate this work today:

> Much of the pleasure we can derive from this statue today depends upon the expression which the artist has achieved through his mastery of human anatomy and musculature . . . and . . . his techniques and materials. The potentialities of our bodies are much the same as those of the ancient Greeks . . . this statue remains transparent to us and . . . communicate[s] to us actively . . . because we share that common physical condition. (AP: 103–4)

Recognising this shared humanity through the pleasure of viewing great artworks, Fuller believes, is to see a neglected aspect of our human *natural* history, which is the basis and complement of our human *social* history as individuals and as a species. To understand aesthetic experience as related to this natural history is actually to free it from the 'ideology of great individual geniuses' that Fuller, probably almost as much as Pollock, disputes. But instead of dissolving the category of 'aesthetic' entirely, or bracketing it out of the inquiry, as Fuller claims 'structuralist-Marxists' have done, he claims to return it to its material base: in 'the affective potentialities of the human subject, and the material processes in which he or she engages when making [or viewing] a work of art' (AP: 10).

Fuller goes on to argue that artworks which attain such enduring value manage this because they contain reference to, and themselves materially embody, 'constants' in human experience, or, at any rate, aspects of experience which change so slowly that they may effectively be regarded as 'constants'. There are formal elements in Indian temple sculpture, for instance, he claims, which are not just 'class transcendent', but also racially and gender transcendent because they celebrate a more or less universally constant sexual experience (AP: 19 20/105). This assertion *appears* to come close to being a denial both of historicity in human affairs, and of the irreducibly different experiences of particular people – both men and women. It is understandable, then, why Fuller met sharp opposition from both feminists and Marxists when proposing his argument – some of whom placed him firmly in the camp of conservative traditional art history and idealist art criticism.[12] Fuller, however, is actually quite subtle in his account of the *Venus*, paying attention to what he regards as its enduring qualities, which he believes could be explained psychoanalytically, but he also discusses, in some detail, the social history of the statue's interpretation by different 'publics' in Europe since its recovery. These two facets of attention, one might conclude, were never entirely separated out in Fuller's analysis.

Central to both these aspects of the modern meaning of the *Venus* is its fragmented form: the arms are missing and the remaining torso and head itself has visibly been assembled (or reassembled) from a number of parts. Fuller claims that the sculpture has retained a fascination for people *because* of its fragmented form, which depicts an incomplete idealised woman's body. The statue's incompleteness has rendered it 'capable of so many reconstructions, so many specific maternal projections, in such widely varying historical and cultural moments' (AP: 73). For example, the statue has managed to stand, Fuller says, for quite opposed values in the nineteenth century – French Romantic passions in the early part and the insipid idealising classicism of the so-called British 'Victorian High Renaissance' of the 1870s and 1880s (AP: 83). Yet this continuing and contradictory appeal must relate, Fuller claims, to some residue in the sculpture itself which is unchanging, 'a rather plenitudinous residue at that – which did evoke a relatively constant response' (AP: 18).

This 'residue' in the fragmented form, Fuller claims, is bound up with people's innate psychobiological need for symbolic reparation for the loss of their mothers, a theme central to Klein's account of phantasy in ego-development. The absence of the statue's arms certainly created an ambiguous openness about what the complete statue could have looked like, Fuller argues, and this enabled many generations of its viewers to propose, and wish, different meanings for it (AP: 109). For instance, some believed that when complete she carried a trophy, or was a muse that had once played a lyre, or was about to take a bath, had been waving castanets, or was even doing her hair! (AP: 88) However, Fuller claims the attraction of the artwork cannot be fully explained by this ambiguity. Instead, the sculpture in its fragmented form has come to symbolise very basic and competing drives present in the development of the infant's relationship to the mother: 'the innate ambivalence between love and hate' which derives from the fundamental opposition Freud had identified between Life and Death instincts (AP: 112).[13]

Klein developed the idea of phantasy in order to explain the manifestation of this ambivalence in the psyche and acknowledged its possible symbolic embodiment in artworks depicting the maternal body. This phantasy is lodged in an unconscious psychic process:

> . . . the mental expression, the 'psychic representative', of instinct, and emphasises the 'wealth of unconscious phantasies' dating back to the earlier months of life – especially those involving violent, sadistic attacks on the mother's body. (AP: 113)

In normal development, according to Klein, the child learns to accept this ambivalence after passing through the Oedipal phase of recognising his or her actual detachment from the body of the mother, and begins to 'acknowledge that "good" and "bad" are but aspects of the same "whole object", the mother, out there in the world, whom the infant *both* loves *and* hates' (AP: 115). The *Venus*, then, for Fuller, has come to symbolise 'mother' who, in its fragmented form, has 'survived the ravages of a phantasised attack' (AP: 121).[14] This aspect of the sculpture's meaning as form has remained constant since its rediscovery in 1821, evoking in 'its receptive viewers the affects attaching to their most primitive phantasies about savaging the mother's body, *and* the consequent reparative process' (AP: 124). The statue, Fuller remarks, thus can be taken almost as a model of the Kleinian view of art, understood as an activity that, at its deepest level, is always about constituting in material form symbolic wholeness and unity – the phantasied reconstitution of the mother-child union.

Eventually placed in the Louvre Museum in Paris the *Venus* quickly became assimilated within the category of 'high culture', yet was also absorbed within what Fuller calls the 'mega-visual tradition' of advanced capitalist society. Once again, then, Fuller shifts his focus and is prepared to consider the artefact's historical and social relationship with modern culture. *Venus* appeared in many advertisements and was industrially copied in soap-stone maquettes that found their way into living rooms and greenhouses everywhere (AP: 94). The statue thus attained, or retained, the status of representing an ideal – something not actually anywhere – though, even perhaps *because*, its form was fragmented, and apparently battered and mutilated. Ironically, however, the statue was likely to have been thought quite *unattractive* by the Greeks themselves, who prized much more highly statues of idealised men and boys (this preference, and its significance for art history, is discussed in Chapter 7).

Psychoanalysis and systems of signification

Claire Pajaczkowska's essay 'Structure and Pleasure', published in *Block* magazine in 1983, begins, like Mulvey's and Fuller's, with the assertion that orthodox Marxist accounts of art are inadequate because they cannot recognise, or attend sufficiently, to the formal nature of visual representation and refuse to deal with the question of the 'embodied' nature of looking and interpretation. Unlike the Marxists Clark, Barrell,

and Tagg, those who have attempted to mobilise psychoanalytic ideas have argued that some crucial *specificity to representation as a system or structure of signs or marks* has always been overlooked within 'social history of art' analysis. (It was noted in Chapter 2, however, that Tagg explicitly attacked some feminists using psychoanalytic methods, whom he accused of illegitimately *separating* issues of 'signification' and 'meaning' from empirical socio-historical research.)

Pajaczkowska's argument takes the form of a review of several books by French authors, some only published in French, interested in linking psychoanalytic perspectives to accounts of art. Pajaczkowska, however, seeks to place the issues of art's 'textuality' (production of meaning) and notions of the 'gendered gaze' *alongside*, rather than as a *replacement* for, Marxist themes of political economy and ideological critique. She does not acknowledge, however, that scholars such as Clark, Barrell, and Tagg *had already* attempted complex readings of artworks understood both as formal material constructs and as evidence of social history. Clark, in particular, had published essays in *Screen* and elsewhere that addressed specifically some of the issues around art's 'textuality' that Pajaczkowska's own essay raises.[15]

The books Pajaczkowska considers all attempt fusions of ideas from psychoanalytic thought with structuralist or semiotic concepts concerned with identifying and analysing how meanings are made within different kinds of visual representations (structuralism and semiotics are considered in the following chapter). The notion that visual art has a 'textuality' is part rhetorical and part analytical. Its rhetorical, or metaphorical, aspect is intended to suggest that forms of visual representation – paintings, sculptures, photographs, films, etc. – can be read *as if* they were kinds of language with codifiable and systematised meanings, like an alphabet and a system of grammar that are used to create words and sentences which are either uttered or written down.

The analytic value to the claim that visual art has 'textuality' resides in its quality as an insight that meaning in, for example, a sculpture or a painting (Illustrations 5 and 7) is not a simple or intuitive 'expression' of the ideas or feelings of artists, but rather a *production* based on the use of available materials and conventions of representation mobilised and adapted by producers. Mulvey identified such materials and conventions in commercial narrative film, Barrell in the georgic-pastoral tradition of English landscape painting, and Clark in Courbet's use of French 'history-painting' in the mid-nineteenth century.

Pajaczkowska, like Mulvey, affirms that signification in figurative or narrative visual art functions, as in other signifying systems, as both

a 'mirror and as screen'. Such works (Illustrations 2, 3, and 4) offer to show the world and people's identities as already constructed – *like that* – yet they also, in effect, help to constitute both world and identity through the act of representing it *like that*.[16] Pajaczkowska considers a book-length analysis by Jean-Louis Schefer of the oil painting *The Chess Players*, painted by Paris Bordone in c.1700. This depicts two men, facing the viewer, framed in front of a Renaissance-style arched building, while other men in the background sit at another table playing cards, and two women lie on the grass. Schefer's account, however, according to Pajaczkowska, says virtually nothing about this representation understood as a composition constructed in paint. Instead, the 'scene' and its assumed narrative is considered more or less as if it were real – a group of people seen through a window. The 'codes' Schefer appears to identify in the painting are actually readings of phenomena that are depicted in the scene: for instance, those based on light, spatial recession, shown through the grid of paving stones, and the placement of hands. Amongst these codes, Pajaczkowska says, are ones nominated by Schefer as 'the rhetorical', 'the numerical', the 'geometric', and 'the logical'. Each code has a number of variants. For example, within the rhetorical code 'there are a number of tropes: catachresis, hyperbole, and metaphor. In metaphorical troping one element is substituted for another with the same relation: for example, the chess game in relation to the rest of the painting as the painting stands in relation to the viewer, as a game with conventional and formal rules' (SP: 35).

Pajaczkowska attempts to extend Schefer's analysis, which, she argues, remains far too crude and formulaic. She proceeds to read his 'codes' of figuration in the painting psychoanalytically as representation of symbolic doublings and repetitions bound up with what she calls 'the pleasure of identification, a process of stabilising the relations of the subject to the unconscious' (SP: 39). (Along with Schefer, however, she spends very little time dealing with the painting understood as a material artefact signifying through a series of technical and thematic conventions.) Rather like Fuller's notion that viewers of the *Venus* relive the Kleinian phantasy of love and hatred for the maternal body, Pajaczkowska believes that subject identification in looking at pictures of double portraits (another example being Holbein's *The Ambassadors*, 1533) is also a kind of return. This is a:

> repetition of the mirror phase, during which the subject starts to form an ego, a stable and unified sense of self, precisely through a misrecognition, a subjectivity which is an alienation and a

splitting of the self through representation. The doubling and repetition in paintings such as *The Chess Players* is an external-isation of the fantasy of a double, a wish which is the corollary of the alienation of the subject in the mirror phase . . . the basis of which is a denial of the loss of the dyadic unity of pre-oedipal subjectivity. (SP: 39)[17]

Pajaczkowska considers Schefer's text, and other analyses by authors discussed in her essay, to be interesting, but in many ways seriously flawed. She notes, for instance, that these accounts generally show no interest whatsoever in the historical meanings these artworks may have generated for particular viewers since their production. One implica-tion of this criticism is that the deployment of psychoanalytic and structuralist ideas in the analysis of art *can* result in a kind of idealised and dehistoricised explanation, based on formulaically identifying 'signifying structures' claimed to be somehow embedded, immanent, in the artworks. Pajaczkowska is not convinced, in addition, that visual representations do function *as if* they are a spoken or written language with the systematicity this implies (SP: 47). This view of visual art *as a language* is as untenable, she notes, as the virtually opposite notion – held by both the nineteenth-century romantic poet Samuel Taylor Coleridge and the twentieth-century phenomenologist Maurice Merleau-Ponty – that considers visual art to be the opposite to language, as well as superior to it (SP: 34/47).

She notes that several other scholars interested in the operation of visual representational forms have moved away decisively from the so-called 'linguistics paradigm'. Umberto Eco, Christian Metz and C.S. Peirce, for example, have all attempted to create specific taxonomies (classificatory systems) for visual representations of various kinds, including television imagery, film, maps, and diagrams.[18] These analyses go well beyond attempts to see structures of signs or marks in visual representations as approximations of words or sentences in human spoken and written language. Neither is there in paintings, Pajaczkowska notes, a 'structural time flow . . . There may be some form of narrative structure in the production of meaning, and the time taken for the viewer to complete the process of meaning may be consid-erable, but to equate this with the temporality of sentence structures is nonsense' (SP: 37) (Illustrations 2, 4, 7, and 10). Because of this lack of equivalence in syntactic and temporal terms between paintings, prints, and drawings and language it is really impossible to apply the sophisticated and more advanced formulations of film theory to the

analysis of still images, although she agrees there are areas of shared concern. Those are to do with the process of viewer identification with imagery, questions of pleasure in looking, and its relation to sexual difference.

This creation (and reproduction) of sexual difference, in and through representation, is really Pajaczkowska's main concern, as it was Mulvey's, together with its relation to pleasure in looking and the creation of stable social and ideological meanings. So, although Pajaczkowska is concerned with the formal nature of artworks, the subject of her analysis is really how these representations work to produce identities for their viewers. This is necessarily connected to the role of ideologies in society and to power relations in class and gender terms. 'Insofar as it is used to refer to theories of the subject', she remarks, 'as opposed to theories of the text, I think that structural thought, especially that of Marx and Freud, is still the site of the most pertinent, and troubling questions about subjectivity' (SP: 32). Pajaczkowska's analysis, therefore, very critical of the texts she considers, is not offered as an alternative to Marxist accounts, but rather as a way to expand their explanatory adequacy.

Sight, social ordering, and subjectivity

Similarly, Norman Bryson claims that his 1988 essay 'The Gaze in the Expanded Field' is concerned with the relationship between individual viewing subjects, social structure, and power relations. His discussion, however, is pitched at a high level of theoretical abstraction and demonstrates little or no historical analysis (arguably, though, Bryson's insights *could* be adapted or applied to examples of specific historical inquiry).[19] Like Mulvey and Pajaczkowska, Bryson attempts to appropriate psychoanalytic notions, in this case from Jacques Lacan, in order to produce what he believes will be a more defensible account of how relations between individuals (*not* classes, however) and societies are ordered. Bryson's object of study is how this ordering of *individual* identities, desires, and actions may be shown to be part of the wider *social* order. He is concerned specifically with the role of artworks within this process, and with how the organisation of vision of individual subjects – 'the gaze' – is locked into this relationship of part to whole through representation.

Bryson's interests are similar to both Mulvey's and Pajaczkowska's in that his attention to psychic drives and states of sexual and familial

147

development in subject-development focuses on questions of pleasure and satisfaction – and how these are related to looking at, and identifying with, images. His chief preoccupation, however, is in how control is effected in subjects and societies through the mediation of visual representational forms, such as paintings or narrative films. Bryson's perspective, therefore, is Marx*ian* in that he wishes to understand processes at work in 'social ordering' through the work representation does in ordering individual subjects through their vision. There *is* then, a kind of abstracted 'ideological critique' in this intention, although he is careful not to use terms that might lead his analysis to be conflated with Marx*ist* arguments that he regards as crude and unconvincing.[20]

Bryson's argument is partly based on a reading of Raphael's 1504 painting *The Marriage of the Virgin*, which depicts in meticulous perspectival detail a Renaissance piazza and arched building, in front of which are posed a group of figures in contemporary dress enacting a moment from the Christian narrative which lends the painting its title. Bryson is interested in the picture's perspectival system, and the location of the viewer in relation to it. (He ignores completely the painting's religious significance and its place in sixteenth-century Italian society.) From one 'perspective', Bryson says, the scene apparently delivers all to the viewer: 'all the architectural spaces turn towards the viewer, displaying their advertent aspects to one who stands at the place of masterly overview, with every line of flight across the cornices, flagstones and arcades travelling in towards the sovereign spectator' (GEF: 89).

But from another, he claims, the viewer's mastery is completely obliterated. This occurs if we follow the perspectival system not towards us, to our eye and mind, but away towards the disappearance of the scene in the distance of the proposed view. 'The lines of the piazza race away towards this drain or blackhole of otherness placed at the horizon, in a decentering that destroys the subject's unitary self-possession . . . The self-possession of the viewing subject has built into it, therefore, the principle of its own abolition: annihilation of the subject as center is a condition of the very moment of the look' (GEF: 89/91). Bryson links this observation to some psychoanalytic accounts of the act and significance of looking, or, in French *le regard*: 'the gaze', a term which attains particular significance in the dense writings of the psychoanalyst Jacques Lacan.

Now, 'looking' *can* refer quite straightforwardly to such empirical acts undertaken by particular people in particular places at particular

times – for instance, that of a contemporary of Raphael 'looking at' *The Marriage of the Virgin* on a specific day in 1505. However, the terms 'gaze', 'vision', and 'the subject' are used in psychoanalytic and structuralist writings to refer to what are regarded *as abstract processes or faculties* believed to have universal significance within embodied human consciousness *and* unconsciousness. How these abstract notions might be related convincingly to empirical acts of looking by specific people in historical moments is a highly complex question. The difficulty in bringing the two senses together is one measure of the distance between Marxism, understood as an empirical inquiry into actual societies, and the concerns of psychoanalysis, understood as an abstract 'theoretical practice' rather akin to philosophical logic. Could the two ever share a single notion of what constitutes 'evidence' or an 'explanation'?

Bryson, however, is convinced that psychoanalysis has valuable insights to offer those interested in how social orders maintain themselves. Lacan and Jean-Paul Sartre before him, he notes, both saw 'vision' as a faculty which *appears* to put people at the 'centre of a world', in complete 'self-possession', with 'the self as focus of its visual kingdom' (GEF: 88). But the watcher is also always the watched, remarked Sartre, and that sense of self-possession in sight is therefore always threatened as the watcher inevitably becomes the object of some other subject's sight: 'the watcher self is now a tangent, not a centre, a vanishing point, not a viewing point, an opacity on others' distant horizon' (GEF: 89). Lacan, says Bryson, identified the same dispute of authority and meaning in both the procedure of psychoanalysis (when the words of the patient are *subject* to the interpretation of the analyst), and in vision, when 'the viewing subject does not stand at the centre of a perceptual horizon, and cannot command the chains and series of signifiers passing across the visual domain. Vision unfolds to the side of, in tangent to, the field of the other' (GEF: 94).

Bryson argues that for both Sartre and Lacan vision, which partly comes to symbolise the order or *integrity* of the individual subject, is 'menaced': threatened 'from without, and in some sense *persecuted*, in the visual domain, by the *regard* or Gaze' which stands for the subject-hood of some one or some thing else (GEF: 88). Vision, then, is inherently double-edged: there is no ability to see without making the concession of potentially being seen by others, vision is a power that implies the potential power of others. Lacan, Bryson observes, came to understand the entry of the subject into the social arena of visuality as 'intrinsically disastrous: the vocabulary is one of capture, annexation,

death' (GEF: 107). Bryson becomes much more helpfully specific when he remarks that an example of the terroristic nature of visuality would be the situation of women living in patriarchal society, subject to a 'voyeuristic male gaze' of a much more obvious sort (GEF: 107). This example of women being 'under observation' (a revealing medical phrase) implies their passivity and submission to control by men, but also their being subject to the kinds of representations of their social roles and sexualities that concern Mulvey and Pajaczkowska. Bryson also suggests the example of the way in which third world countries and peoples are rendered 'trivial and picturesque' in the West's 'gaze of colonialism' (GEF: 107). (Some examples of visual representations that are part of the colonial gaze are discussed in my Conclusion.)

Bryson summarises his concern in 'The Gaze in the Expanded Field' as being intent on the 'discovery of a politics of vision', and this explicit use of the term 'politics' should clarify some of the ambiguities that surround his essay and those that have always been associated with Lacan's particularly abstruse theoretical formulations.[21] Lacan, also active in 'the moment of 1968', saw his psychoanalytic research as having definite political and ideological implications relating to demands for social and sexual forms of 'liberation' and 'personal expression'. The sexual was *always also* social, as Mulvey and Pajaczkowska affirm. Following Bryson, the same could be said of 'visuality', which is the term he uses to denote vision's cultural and ideological character. Lacan's account of 'vision as socialised' is significant, Bryson claims, because it forms the connection between the seeing subject and the social totality:

> Between the subject and the world is inserted the entire sum of discourses which make up visuality, that cultural construct, and make visuality different from vision, the notion of unmediated visual experience. Between retina and world is inserted a *screen* of signs, a screen consisting of all the multiple discourses on vision built into the social arena. (GEF: 91–2)

It is 'post-modernist' ideas that have recognised this ideological character to vision, Bryson argues, showing that 'the visual field we inhabit is one of meanings and not just shapes, that it is permeated by verbal and visual discourses' (GEF: 107). I explore post-modernism and the interaction of verbal and visual representation in following chapters. Marxists and feminists, however, had understood the point Bryson makes long before the emergence of post-modernism in the mid-1980s,

though they couched their explanations in different language – some, indeed, not regarding it as necessary at all to resort to psychoanalytic concepts.

All the authors discussed in this chapter would agree, I suggest, that a notion of vision, or gazing, or looking, or seeing, as an essentially neutral activity is untenable (though this assumption, or belief, is still quite powerful as an *ideology*, in some academic disciplines and elsewhere). In this agreement, perhaps, lies one aspect of the solidarity of these authors' radicalism in theoretical and historical terms. Bryson, again, is helpfully specific on the relevance of this issue to art history. In the twentieth century, he claims, vision was seen as 'primarily a domain of retina and light', of objective physiological processes. This notion was the basis for a set of related activities concerned with art and culture broadly:

> in art history, formalism; in art theory, the approach to art via the psychology of perception, in the work of Gombrich or Arnheim; in the construction of museum and exhibition spaces premised on the practice of decontextualising the image in order to permit unmediated communion between the viewer's eye and pure form. From these and related activities has emerged the notion of art as a matter of perceptual purity: timeless, sequestered from the social domain, universal. (GEF: 107)

With this last reference one can see how Bryson's psychoanalytic perspective meets up, however unexpectedly, with Wallach's analysis of the ideological role of art museums in modern US society. Both see the vision of curators and art historians, as well as the vision of viewers who visit museums, as necessarily subject to social and ideological values and interests. Bryson, like Wallach, wants to encourage analyses that explore the operations of such vision and their relationship to social and political institutions. The issue of control is never far away. Bryson calls, finally, for studies of how 'power uses the social construct of vision', and how power still 'disguises and conceals its operations in visuality, in myths of pure form, pure perception, and culturally universal vision' (GEF: 108).

Psychoanalytic concepts and Marxist ideological critiques share one important *rhetorical* feature registered in Bryson's remark. This is the belief that these intellectual perspectives work to 'reveal', 'expose', 'bring to light', submerged or hidden deceptions and related social conflicts that find a manifestation within artworks and their attendant

151

circumstances of production and interpretation. Mulvey, Pajaczkowska, and Bryson all emphasise the significance of these concepts and critiques in proposing an understanding of social reality *theoretically* and in *general* historical terms. However, they demonstrate, at least in their studies considered here, little or no interest in the significance of these insights for any actual individuals. In contrast, Donald Kuspit's use of psychoanalytic ideas to make sense of paintings by Henri Matisse tries specifically to do this, and it is to a brief discussion of one of his essays that I turn now in order to conclude this chapter.

Originally published in 1989, Kuspit's essay, 'The Process of Idealisation of Woman in Matisse's Art', mobilises a number of Freudian psychoanalytic concepts in order to offer an explanation of a group of 'primitivist' paintings produced by the artist around 1910. Kuspit's premise is that these paintings may inform us of Matisse's own relationship to women in general – that is, both the *actual* women he knew, and women as *symbolically* meaningful to him, hence 'woman' used as an abstract term in the title for his essay. Kuspit is particularly interested in Matisse's relationship with his mother. Unlike Mulvey, Pajaczkowska, and Bryson, Kuspit has no interest in the ideological relations between visual representation in art and broader cultural and social life. Like Fuller, however, Kuspit's concern with the significance of the body of 'woman', understood symbolically as both sexual partner and mother, might be said to have supra-individual significance. Kuspit preoccupies himself, however, with the examination of a *producer* of depictions of women, rather than with their viewing by, or meaning for, others.

Paintings produced in Matisse's so-called Fauvist ('Wild Beast') period, such as *Gypsy* (1906), *Blue Nude* (1907) (Illustration 7), *Nymph and Satyr* (1909) and *Dance* (1910) exemplify, for Kuspit, the artist's symbolic relation to 'woman'. Kuspit wants to understand these paintings as evidence of Matisse's conscious and unconscious attitude towards women as sources for the satisfaction of the artist's sexual and maternal needs. The term 'primitivism' becomes crucial here in a number of respects. It refers to a range of ideas and values that have become linked in much art history and criticism concerned with modern art:

- In terms of artistic style, the term has been used to denote a tendency in avant-garde painting and sculpture since the late nineteenth century to abstract and simplify aspects of the depicted female body in order to emphasise, for example, angularity in its general form and the significance of breasts and head in particular.

'Primitive' in this sense means *basic*, which carries both formal and symbolic sexual connotations. Picasso's 1907 painting *Demoiselles d'Avignon* is the canonical work in this tradition.

- Within the development of psychological, anthropological, and psychoanalytic research and writing *produced in the same period* 'primitive' was used also to refer to aspects of human behaviour – particularly sexuality, but also the capacity for violence – that were associated with *basic* drives thought to be located in the 'unconscious' (for Freud: the *id*). The 'civilised' or developed parts of the human character, involved in control and self-control, were identified as being located in 'consciousness' (the *ego*) and in 'conscience' (the *superego*).

- The third use of the term 'primitive' refers to those peoples and their artefacts 'discovered' in parts of the world colonised by Western European countries since the sixteenth century, for instance in the 'scramble for Africa' in the late nineteenth century. These peoples were also thought by western scientists and other observers (including artists and art critics) to exhibit forms of *basic* sexual behaviour and a level of cultural and social organisation that western societies had long since superseded in the creation of 'modern civilisation'. (Texts discussed in my Conclusion deal with some of these issues in more detail.)

Aspects of all three senses of 'primitive', arguably, are bound up in Kuspit's account of what he calls:

> Matisse the Fauvist . . . taking formal control of [woman's] body. He found it far too 'hot' and 'sensational' to treat coolly and intellectually, even to perceive it clearly. His Fauvist representation of woman's body makes it into a presence too overwhelming to gain any perspective on . . . Woman was not so much a person as an impersonal power in Matisse's Fauvist paintings. Her body was not a safe form, presenting itself for detached contemplation. Indeed, none of the respectable styles of tradition ensured emotional safety when 'applied' to it, nor did they seem adequate to its expressivity. For the Fauvist Matisse, woman's body was sexually disruptive and fantastic, an unimaginable projection, as it were, as his 'wild' representation of it suggested. (PIWMA: 21)

Matisse's 'primitive' desire for woman, then, requires that his paintings of her body disintegrate the canons of artistic idealised beauty

153

developed in, for example, French academic painting in the nineteenth century, in order to 'reveal' as Kuspit says, 'and revel in . . . its sensual immediacy' (PIWMA: 25). Psychoanalysis, once again then, offers to expose an underlying reality and truth: this time a reality and truth that Kuspit claims lies 'under the surface' both of Matisse's paintings and the artist's mind.

There is an implicit polemic in Kuspit's account of Matisse's art, I suggest, relating to the time of the essay's production in the late 1980s. By then feminism in art history and art practice had become established (and was, according to Wagner, on the way to a kind of institutionalisation). Mulvey, Pollock, and many others had begun to use psychoanalytic ideas in order further to establish how patriarchal society takes hold of actual women, through representation, and projects these as 'woman': the degraded symbol of male power and desire. Women themselves have participated in this projection, Mulvey acknowledges, and gain pleasure from it even as they are exploited by it. Kuspit's concern with Matisse's paintings of women understood as evidence of the artist's psychical relation to 'woman' can be seen as a sort of gauntlet thrown down to feminists who have used psychoanalysis to show women's repression through such representations, which they have regarded as demeaning and dehumanising.

Kuspit, in sharp contrast, *celebrates* what he regards as Matisse's base sexual 'instinct' and its manifestation in his art. In this celebration, surely, is there not also a kind of testing of the water of contemporary (that is, late 1980s) women's attitudes toward male sexual desire and its various representations 'after feminism'? This is not to claim that feminism was then, or is now, 'over' or 'accomplished' (as Wagner denies), but to wonder how women who have lived through feminism's development in the 1970s and 1980s, or women only born after 1970, might relate *now* to questions of male and female sexual identity, desire, and relationships. And, for that matter, how men might relate to these issues.

Kuspit's essay is also, I suggest, a kind of defence of one account of the modernist tradition in art. This is one that celebrates both the *great male artist's intuitive expressiveness* – five of the key words of 'old art history' – and the 'self-sufficiency' and quality of paintings' surfaces understood as artefacts of abstract form, not as naturalistic depictions of things or events in the world. This sexual and modernist expressiveness finds combination in the following *basic* (and bold) statements from Kuspit. That, for example, the artist's:

SUBJECTS, IDENTITIES, AND VISUAL IDEOLOGY

instinctive response to woman's body – an animal body, as he said, that drew out the animal in him – continued to infect his ego demonstration of it as pure form. (PIWMA: 22)

Or that in two groups of paintings by the artist:

pure woman . . . turned out to be the omnipotent phallic woman [the head in the first series and a large part of the body in the second]. (PIWMA: 29)

And that finally:

Woman is the whole universe for Matisse and the whole universe is woman, as the mother is the universe of the child. (PIWMA: 30) . . . The female model is the mother of his art and his mother in disguise. (PIWMA: 33)

Matisse's mother, Kuspit reminds us, had been the parent that supported and encouraged her son in his art, buying him a box of paints and fulfilling his 'deepest wish, making the love between them more satisfying than ever' (PIWMA: 35). Kuspit's 'Matisse', then, is really a symbol of psychic and aesthetic energy, and is premised on resolutely turning away from repressive social structures and social history, toward a reconfirmation of the artist as expressive agent. Matisse's paintings, for all their expressiveness as pictorial surface, express most deeply that which Kuspit sees *beneath the surface* of the artist's consciousness: a drive, through representation, to satisfy his narcissism (PIWMA: 32). Women for Matisse, understood as 'woman', according to Kuspit, appear simply to become idealised vehicles for his satisfaction.

At the same time, Kuspit says, Matisse was frightened of the base instincts that 'woman' excited in him. His post-Fauvist paintings, such as the highly simplified 'cutouts', were an attempt to excise – 'castrate' – this erotic charge through a process of radical and idealised abstraction. They were a way, Kuspit claims, for Matisse to defend 'against the instincts [woman] represented by transcendentalising, with ever greater elegance, the physical body that expressed them in its very form, while unconsciously remaining in bondage to them and the body that was their vehicle' (PIWMA: 22). Elizabeth Cowie had named an essay after this process which Kuspit describes, and which feminists believe has been generalised throughout visual representations in patriarchal culture: it is the process that produces 'woman as sign'.[22]

Kuspit's turn to Matisse and the subject of *agency* is in sharp contrast to the perspective of many radical art historians, and indicates, amongst other things, how psychoanalytic ideas and values have been used by art historians and critics in a variety of ways, some contradictory. I've shown that, by the early 1990s, a significant number of 'radicals', including Wagner, Fuller, and Kuspit, were critically reconsidering the theoretical and historical edifice constructed by Marxists and feminists. All three, in quite different ways, propose a return to emphasis on individuals, agency, and the category of 'the aesthetic'. In the following chapter I consider another facet of radical art history that scholars in the later 1980s and 1990s began to question: the attention to art's materiality and conventions of representation.

Notes

1 See Gilles Deleuze and Felix Guattari *The Anti-Oedipus*, New York: Viking, 1977; Regis Debray *Teachers, Writers, Celebrities: The Intellectuals of Modern France*, London: New Left Books, 1981; Tony Judt *Marxism and the French Left*, New York: Oxford University Press, 1986; Mark Poster *Critical Theory and Poststructuralism: In Search of a Context*, Ithica, N.Y.: Cornell University Press, 1989; Peter Starr *Logics of Failed Revolt*, Part 1 'May '68 and the Revolutionary Double Bind', Part II 'The Tragic Ear of the Intellectual: Lacan', and Part III.

2 Mulvey called for 'an alliance between the radical tradition of the avant-garde and the feminist politicisation of images and representation' (VOP: ix). She collaborated on various film and writing projects with Peter Wollen. See, for instance, their films *Penthesilea* (1974), *Riddles of the Sphinx* (1978), *Crystal Gazing* (1981), and their joint essay 'Frida Kahlo and Tina Modotti', in Mulvey *Visual and Other Pleasures*.

3 See the Introduction and 'Afterthoughts on Visual Pleasure' (1980) in her collection *Visual and Other Pleasures*.

4 *Screen* magazine was published in Britain by the Society for Education in Film and Television. See two of its anthologies of essays, *Cinema and Semiotics*, London: SEFT, 1981, and *The Sexual Subject: A Screen Reader in Sexuality*, London and New York: Routledge, 1992.

5 Mulvey articulated reservations, in retrospect, about what she called the overdevelopment of possibly arcane theoretical analysis in feminism. This, she suggested, '. . . prefigure[d] the present power of the image, and its tendency to take off into pure referentiality and play, losing touch with historical reality . . . Looking back from the late 1980s, it seems as though deeply important changes were engulfing society while I was looking elsewhere, at the cinema or at the unconscious' (VOP: xii).

6 See Jack Spector 'The State of Psychoanalytic Research in Art History', *Art Bulletin*, March 1988: 49–76. This contains an extensive bibliography. One of Freud's most influential essays on art was 'Leonardo da Vinci and a Memory of his Childhood', in *Standard Edition of the Complete Psychological Works* (vol. xi), London: Hogarth Press, 1910.

7 John Berger aphorised this situation in *Ways of Seeing* with the comment that men 'look at women. Women watch themselves being looked at': 47.

8 A major problem with Mulvey's argument is that she does not exemplify her claims about the nature of commercial film with much clear and detailed discussion of actual images and narrative sequences in specific films. For this reason, her essay, in retrospect, seems both historically and pedagogically rather ineffective. Mulvey's own criticisms of the essay indicate other faults or oddities. For instance, why, she asks, did she use the *male* third person singular always to stand in for the spectator? She says this was done in order to emphasise the ' "masculinisation" of the spectator position, regardless of the actual sex (or possible deviance) of any real live movie-goer'. But, she recognises, this prevented important inquiry precisely into how women function as an audience for film. How would her analysis have had to change, she wonders, if she had considered female characters to be 'occupying the centre of the narrative arena'? (VOP: 29).

9 See, for example, William Reich *The Mass Psychology of Fascism*, New York: Farrar, Strauss and Giroux, 1970; Jeffrey T. Schnapp *Staging Fascism: 18 BL and The Theatre of Masses for Masses*, Stanford: Stanford University Press, 1996 (foreword by Hal Foster); and Andrew Hewitt *Political Inversions: Homosexuality, Fascism, and the Modernist Imaginary*, Stanford: Stanford University Press, 1996.

10 See Chapter 3, n. 17 for references.

11 Marx himself, Fuller notes in contrast, had seen Greek sculpture as 'an unattainable model' of greatness in art and thus had held a view that was anything but Marx*ist* (AP: 13). See Dave Laing *The Marxist Theory of Art*, Sussex: Harvester, 1978.

12 Fuller encouraged such dispute by specifically aligning himself with those he called 'formalists' who believe there is an objective basis to 'all "good" sculpture' (AP: 20). He also acknowledged, however, that there were class, culture, racial and gender determined elements in the experience and interpretation of the *Venus* (AP: 105).

13 Fuller rejects the use of Freudian psychoanalytic concepts because, he says, Freud showed little interest in the role of mothers as opposed to that of fathers (AP: 83). See, however, Fuller's 'Moses, Mechanism and Michelangelo', in *Art and Psychoanalysis*; and Elizabeth Young-Bruehl (ed.) *Freud on Women: A Reader*, London: Hogarth Press, 1990. On Klein, see Hanna Segal *Introduction to the Work of Melanie Klein*, London: Hogarth Press, 1976; and *Klein*, London: Fontana, 1979.

14 There had even been a rumour, Fuller notes, that the *Venus* had been found intact and was then deliberately mutilated. In any event, by the time the sculpture arrived in Paris it was certainly damaged (AP: 88).

15 The books Pajaczkowska considers are: J.L. Schefer *Scénographie d'un Tableau*, Paris: Editions du Seuil, 1969; J. Paris *Painting and Linguistics*, Carnegie-Mellon University, 1975; M. Pleynet *L'Enseignement de la Peinture*, Paris: Editions du Seuil, 1969; G. Rosolato *Essais sur le Symbolique*, Paris: Gallimard, 1969; and Julia Kristeva *Polylogue*, Paris: Editions du Seuil, 1977 (translated as *Desire in Language* (ed. Leon Roudiez), Oxford: Blackwell, 1981). See T.J. Clark's 'Preliminaries to a Possible Treatment of *Olympia* in 1865', *Screen*, Spring 1980, and the response by Peter Wollen 'Manet, Modernism and the Avant Garde', *Screen*, Summer 1980.

16 Many commentators have remarked that psychoanalytic criticism seems more plausible and appropriate when applied to figurative and narrative painting in which people and social situations are depicted. This is often because these depictions of people are treated in such analysis as if they *were* actual patients or psychodynamic relationships, rather than representations. Fuller addresses the analysis of abstract painting, however, in 'Abstraction and "The Potential Space"', in *Art and Psychoanalysis*, as does Donald Kuspit in essays 8, 9, and 10 in *Signs of Psyche in Modern and Post-Modern Art*.

17 On what Lacan called the 'mirror *stage*', one of his most influential and complex ideas, see his *The Four Fundamental Concepts of Psychoanalysis*, Harmondsworth: Penguin, 1987: especially 256–9. Malcolm Bowie attempts to summarise this idea, which, like Pajaczkowska, he calls a 'phase' rather than 'stage', in John Sturrock (ed.) *Structuralism and Since: From Levi Straus to Derrida*, Oxford: Oxford University Press, 1979: 121–3. See also Dylan Evans *An Introductory Dictionary of Lacanian Psychoanalysis*, London and New York: Routledge, 1996.

18 See, for instance, Umberto Eco *A Theory of Semiotics*, Bloomington and London: Indiana University Press, 1976; Christian Metz *Film Language*, London: Oxford University Press, 1974; Charles S. Peirce *Collected Papers* (8 volumes), Cambridge, Mass.: Harvard University Press, 1931–58; and Jan Mukařovský *Structure, Sign and Function*, New Haven and London: Yale University Press, 1977.

19 On the value of Bryson's models see, for example, Mieke Bal *Reading 'Rembrandt': Beyond the Word-Image Opposition*: 31–3.

20 Bryson is definitive in his rejection of Marxism in the Introduction to *Calligram: Essays in New Art History from France*: xxii–xxviii. His dismissal of Marxism, however, is thoroughly inadequate in that it does not examine, or even name, a single specific study.

21 Peter Starr argues, to the contrary, that Lacan *wished* to remain unintelligible, and that this was one manifestation of his symbolic 'refusal'

of the possibility of totalitarianism in both thought and social orders: Lacan 'never tired of insisting that his teaching and writings were not made to be understood. Indeed, it has often been noted, the primary function of Lacan's infamous graphs and algorithms, his rigorously poly-valent concepts (the Other, the *objet a*, the real), and his allusive, aphoristic style was to *produce* misunderstandings . . .': *Logics of Failed Revolt*: 37.

22 'Woman as Sign', *m/f* 1978, no. 1.

Select bibliography

Art Bulletin 'The Subject in/of Art History: A Range of Critical Perspectives', December 1994: 570–96

Butler, J. 'The Force of Fantasy: Feminism, Mapplethorpe, and Discursive Excess', in *Differences: A Journal of Feminist Cultural Studies*, vol. 2, no. 2, 1990: 105–25

Burgin, V. *et al. Formations of Fantasy*, London: Methuen, 1986

Cowie, E. 'Fantasia', *m/f*, no. 9, 1984: 70–105

Davis, W. *Drawing the Dream of the Wolves: Homosexuality, Interpretation, and Freud's 'Wolf Man'*, Bloomington: Indiana University Press, 1995

Doane, M.A. *et al. Revision*, Los Angeles: American Film Institute, 1985

Doane, M.A. *The Desire to Desire*, Bloomington: Indiana University Press, 1987

Flitterman-Lewis, S. *To Desire Differently: Feminism and the French Cinema*, Urbana: University of Illinois Press, 1990

Freud, S. 'Leonardo da Vinci and a Memory of his Childhood', in *Standard Edition of the Complete Psychological Works* (vol. xi), London: Hogarth Press, 1910

Godeau, A.S. *Male Trouble: A Crisis in Representation*, Thames and Hudson: London, 1997

Jordanova, L. *Sexual Visions*, London: Harvester Press, 1989

Kristeva, J. *The Powers of Horror*, New York: Columbia University Press, 1982

Kuhn, A. (ed.) *Alien Zone*, London: Verso, 1990

Mayne, J. *The Woman at the Keyhole: Feminism and Women's Cinema*, Bloomington: Indiana University Press, 1990

Metz, C. *The Imaginary Signifier: Psychoanalysis and Cinema*, Bloomington, Indiana University Press, 1975–82

Pietropaolo, L. and Testaferri, A. (eds) *Feminisms in the Cinema*, Bloomington: Indiana University Press, 1995

Rand, E. *Barbie's Queer Accessories*, Durham and London: Duke University Press, 1995

Rose, J. *Sexuality in the Field of Vision*, London: Verso, 1986

Silverman, K. *The Acoustic Mirror: The Female Voice in Psychoanalysis and Cinema*, Bloomington: Indiana University Press, 1988

Spector, J. 'The State of Psychoanalytic Research in Art History', *Art Bulletin*, March 1988: 49–76

Chapter 5

Structures and meanings in art and society

<div style="border: 1px solid black; padding: 1em;">

Key texts

Meyer Schapiro 'On Some Problems in the Semiotics of Visual Art: Field and Vehicle in Image-Signs', in M. Schapiro *Theory and Philosophy of Art: Style, Artist, and Society*, New York: George Braziller, 1994, 1–32: SPSVA.

Norman Bryson *Word and Image: French Painting of the Ancien Regime*, Cambridge: Cambridge University Press, 1981, Chapter 1, 'Discourse, Figure', 1–28: WI.

Michael Camille *The Gothic Idol: Ideology and Image-Making in Medieval Art*, Cambridge: Cambridge University Press, 1989: GI.

Svetlana Alpers *The Art of Describing: Dutch Art in the Seventeenth Century*, London: John Murray/University of Chicago, 1983: AD.

Mieke Bal *Reading 'Rembrandt': Beyond the Word-Image Opposition*, Cambridge: Cambridge University Press, 1991: RR.

</div>

161

Signs, discourse, and society

In the last three chapters I have shown that a range of radical art historians with Marxist, feminist, and psychoanalytic perspectives began to identify certain kinds of 'structures' as pivotal to their analyses. Sometimes these have been actual *physical constructs*, visible to the eye – for example, the 'structure' that is a canvas attached to a wooden frame upon which paint has been applied, or the 'structure' that is a building, such as an art gallery, within which paintings and sculptures have been exhibited. These two basic examples of 'structure', of course, have been the focus of the interests of conventional art historians throughout the twentieth century and long before it. But Marxists and feminists brought *into relation to these structures* other phenomena that had not been identified by most traditional art historians as structures at all. The most significant for Marxists was the idea, which has its beginnings as a metaphor in Marx's own writings, that society itself was a kind of building, with a 'material' base and 'ideological' super-structure, and that through history the development of the former set definite limits upon, and shaped, the latter.[1]

This notion of 'structure' has both empirical and abstract qualities, as do many other kinds of 'structure' identified in texts by art historians I have considered so far. The public or audience for art at a certain moment, for instance, has been understood as a shaping *structure* influencing, and itself being influenced by, for example, taste, conventions, and values in art practice (for example, consider Clark's and Boime's texts on French art in the nineteenth century, and Barrell's on English landscape art in the same and earlier period). Institutions, such as art academies and universities, were identified, by feminists and Marxists, as having important 'social-structural' effects. These are not neutral places and spaces in which activities happen, but entities that organise and regulate, give power to, and exclude, people, and art, on a variety of grounds (for example, consider Nochlin's essay on the exclusion of women from life-drawing classes, and Wallach's study of the museum as an institutional narrator of national identity).

Both Marxists and feminists have argued that society as a whole acts as a 'macro-structure' containing lots of 'micro-structures'. 'Contain' means, interestingly, both to *hold* and to *control* and many authors considered so far have stressed the operation of ideas and values in society systematised themselves as 'ideological structures' bound up with social practices. Marxists give pre-eminence to capitalist economic and political order organised under the class dominance

of the bourgeoisie and the modern state, articulated through the ideologies of, for example, competitive individualism and nationalism. Feminists identify an order of basic exploitation and inequality bound up with the creation of sexual difference, articulated through the various ideologies of patriarchy. Despite these different concerns, however, Marxist and feminist analyses, arguably, have never been *necessarily* mutually exclusive: scholars such as Griselda Pollock, for instance, wished to integrate aspects of Marxism's historical materialist philosophy with feminism's analysis of patriarchal social practices and ideologies (see Chapter 3).

In the previous chapter I examined the arguments of some feminists, along with writers identified with Marxist art history or left-wing art criticism in the 1970s and 1980s, who sought to understand relations between art practices and their social-ideological effects through another 'structuring principle': that of the 'subject' within psychoanalytic accounts of identity, desire, and pleasure. This 'subject's' perception and understanding of artworks was seen as a hitherto missing element that had to be either recovered or newly proposed, in order to understand better the connection between the structure of the artwork and the structure of ideologies and meanings in groups and society as a whole. The term 'subject' also registers perfectly the combination of empirical and abstract elements present in 'structure': 'subject' can refer, within psychoanalytic writings, to both actual individuals, real people who gaze, desire, and identify, *and* to a general set of integrated features claimed to constitute human psychic organisation – including, for example, notions of the 'unconscious', 'ego', and 'sexual drive'.

'Structure', then, is an indispensable idea within virtually *all* radical art history, but has been given many different local meanings and values. In one sense the idea will remain tendentious because accounts of its operation will always depend upon conceptual abstraction from an empirical or factual order of knowledge. For example, the National Gallery in London is certainly a major world museum of art (empirical 'fact'), but it also has an important 'structuring' role in the reproduction of the ideology of the individual male creative genius (abstract 'claim'). Zoffany's portrait of the founders of the Royal Academy shows the two women-founders only within their depicted portraits on the depicted wall in the painting (empirical 'fact'), but this form of representation indicates the 'structuring' operation of patriarchal ideology within the Royal Academy's pedagogic practices (abstract 'claim'). 'Ideology', like 'society', then, though always

embodied in particular institutions, artefacts, and the actions of individuals and groups, has an existence that, at one level, is necessarily abstract and conceptual.

This is also true of 'conventions' in visual representation, and in spoken and written language. All such conventions may be referred to as kinds of *discourse* or particular *modes of signification* that exhibit structural characteristics: agreed ways of communicating using certain materials, such as paint on canvas, light sensitive paper, stone or bricks, or the sounds and written notations of language. Consider, for instance, the organisation of compositional elements in a photographic portrait or a history painting (Illustrations 3 and 10). This sentence itself exemplifies the nature of discourse in written English.

But the 'structure' – in this sense, the *meaning* – of forms and ideas to which both visual conventions in painting and written language relate (and of which they are examples) will always also remain partly conceptual and abstract. Like ideology, the 'structures' of language and conventions in art practices remain tendentious, unsettled, and arguable. Radical art historians in the late 1970s turned their attention to this issue of the material reality of art, to the formal nature of artworks or museums understood as 'signifying vehicles', and to the relationship between these seemingly empirical matters and the role of art as a carrier of disputable, *because abstracted*, meanings and values. This inquiry involved consideration of a specific medium's visual conventions embodied in particular artefacts and the relation of these to language, ideology, and the formation of subject-identity. Two very different examples of this kind of examination were considered in the previous chapter: Mulvey's notion of the discourse of 'narrative film' in *Psycho*, and Kuspit's notion of the discourse of 'primitivist abstraction' in paintings by Matisse such as *Blue Nude*. This turn of radical art historians specifically to the analysis of visual conventions and their relations to language was not posed then, and should not be seen now, as in *opposition* to dealing with the issue of 'society as a whole', or with the ways in which the identity of individual subjects was believed to be formed partly through contact with artworks.

Art historians such as Clark or Pollock, for example, have clearly demonstrated *different* emphases throughout their writings over many years, dealing with certain issues at certain times. Both have attempted, however, to keep the varied local meanings of 'structure' – understood as artistic convention, as public, as subject-formation, as ideology, as society as a whole – relatively fluid and inter-related. This is because both Clark and Pollock have remained essentially historians interested

specifically in the *conjunctural interconnectedness* of artistic, cultural, political, and ideological materials at particular moments in the development of particular societies: Paris in 1848, Brittany in the 1890s, New York in the 1930s, or art education in Britain in the 1980s. Recognition of the interconnectedness of artists, their materials, and the wider social formation should not result, however, in their conflation. Both Clark and Pollock have consistently argued against this, when discussing, for example, theories of ideology based on notions of 'reflection' or 'reduction' (see my previous discussions of this in Chapters 2 and 3).

The emergence of a method of analysis called 'discourse theory' in the 1980s presented another potential reductivism – that of conflating *all* modes of signification with the model of 'meaning-system' that the discipline of structural linguistics, formed around 1920, had based on analysis of the spoken and notational signs of human language. 'Language' became a term used promiscuously in the 1970s and 1980s about any, and virtually all, forms of human activity and production, assuming the vague meaning of 'a set of related elements constituting a kind of structure'.[2] 'Language' in this very loose sense quickly became synonymous with 'discourse', as Stuart Hall has noted, and its application in virtually all areas of intellectual inquiry spawned what he called a general reorganisation of 'our theoretical universe', allowing a reconceptualisation of myriad human practices and products, from artworks to zootsuits, kinship systems to museum curation.[3]

This development did, valuably, bring into focus the issues of subject-identification and ideology, because 'discourse theory' was premised on a rejection of crude Marxist or 'expressionist' theories of representation. However, what started out as a metaphor – talking *as if* clothes or cooking were a language – often ended up in an analytic dogmatism at least as bad as that of reflectionist Marxism itself. This dogmatism is what Hall calls the 'ideological baggage of structuralism': the belief that attention to the formal nature of meaning-production in specific signifying systems – the so-called 'science of signs' – could or should entirely *displace* the analysis of artworks or any other human practice or product understood as elements within a society's 'effective historical process'.[4] What began as a creative and necessary methodological requirement, that of understanding the specific work done by certain kinds of representations (paintings or films or photographs), showing how meaning is 'textually' constituted, threatened to completely replace and *invalidate* the task of relating such analysis to questions of social power and history. Studies that offer to do this, including some of the books discussed by Pajaczkowska in her essay

considered in the previous chapter, have rightly attracted the derogatory label 'formalist'.

One essay or book, however, never adds up to a final position, and cannot be the basis upon which *any* writer is judged. In the course of his career Meyer Schapiro, now often identified as a 'semiotician', adopted a number of arguments and perspectives, based upon the combination, at different moments, of a number of analytic modes related to social and political interests and values. Indeed, during the 1930s in New York he was deeply involved in both Marxist politics *and* art-historical scholarship.[5] About forty years later, however, he published an essay that rapidly attained influential status in the development of structuralist and semiotic analysis of artworks. But this essay, 'On Some Problems in the Semiotics of Visual Arts: Field, Artist, and Society', actually includes within it a wide range of reference to artists and artworks from different historical periods and makes many observations that indicate that Schapiro *did not* abandon interest in understanding artworks as elements of social and cultural history. Indeed, rather like Fuller's examination of what he believed was the material (and materialist) basis of aesthetics, it could be argued that Schapiro's essay equally attempts to ground art-historical inquiry in a complex materialist understanding of art's *formal* expressiveness.[6]

Marks and meanings

The focus of the essay, in semiotic terms, is set narrowly. Schapiro is only interested, he says, in considering what he calls 'the non-mimetic elements of the image-sign and their role in constituting the sign' (SPSVA: 1). Mimetic representations are those that ape the appearance of people, places, and things (Illustrations 2, 3, and 4). By 'non-mimetic' Schapiro means those aspects of signification in art *not* concerned with creating such images of phenomena in the world. By limiting his account to the non-mimetic, Schapiro brackets out of his essay consideration of two of the most significant problems encountered in attempts to connect analysis of the structure of artworks to analysis of social and historical circumstances. But this 'bracketing out', I shall argue, is a postponement, not a cancellation, of the broader inquiry.

First, by avoiding study of the formal-conventional means of depiction *always* involved in mimetic representation – through such devices as perspectival drawing or modelling depth through the use of *chiaroscuro* – Schapiro sidesteps the question of the extent to which

these conventions might be claimed to operate in a manner similar to the conventions that govern signification in spoken or written human language. In doing this he steers clear of the danger of conflating visual signifying *modes* with the *system* of human language held by many at the time to be the model for all signs.[7] Pajaczkowska warns against this conflation in her essay discussed in the previous chapter. In addition, Schapiro, like Clark in his discussion of cubism (see Chapter 1), is very careful *not* to assume that artworks such as paintings have truly systematic properties, though they can sometimes *appear* to present exactly such a convincing 'language' of forms (Illustration 1).

Second, by choosing to ignore in his essay consideration of visual marks that appear to resemble things in the world Schapiro also evades the problem of 'realism'. In the broadest sense this term refers to the issue of the relationship between signs and the reality to which they are believed to refer. Notions of 'realism' in crude Marxist art history, as various commentators discussed in this study have remarked, assume that artworks merely reflect or mirror a real world fundamentally located elsewhere. In doing so, they reductively underplay both the *material reality* of artworks themselves and the active role these have in influencing the behaviour, values, and social identity of their viewers.

I contend that Schapiro's discussion of the 'non-mimetic' in art is based, therefore, on two principles entirely consistent with the radical art-historical arguments we have already met. These are, first, that, although artworks have an irreducible specificity of material means and forms, they can only 'signify' (become meaningful) within a whole society of activities, institutions, and ideologies present in a particular historical moment. Second, that those artworks are material and social phenomena in themselves, though they act on, and in relation to, other social phenomena. Schapiro, then, I will characterise as a historical materialist concerned in this particular essay with some aspects of art's *anthropological* nature. This concept, like 'aesthetic', implies a shared (universal) material human nature believed to be psychobiologically permanent.[8]

Schapiro remarks, for instance, that the basic qualities of 'upper' and 'lower' in paintings (or photographs) are directly connected 'with our posture and relation to gravity' and are perhaps 'reinforced by our visual experience of earth and sky' (SPSVA: 12) (Illustrations 2, 3, 8, and 10). The communication of feeling *through and about* the body, an experience with which Fuller is concerned in his study of the *Venus*, is echoed in Schapiro's observation that the representation of movement in pictures echoes human beings' horizontal, rather than vertical orientation

in the world. This constitutes what he calls human beings' basic 'cryp-toesthesia' and is related to physiological facts of one kind or another. So, for instance, viewers recognise images of the face regardless of style, medium or technique if 'the minimal cues' of recognition are present (SPSVA: 27) (compare Illustrations 3, 4, and 7). How, for instance, Schapiro wonders, do images relate to the human body in general terms? Do the 'left and right sides of the image field have inherently different qualities?' How might they be related to the intrinsic 'asymmetry of the organism' and especially to its left or right handedness? (SPSVA: 19) The predominance of the left profile in visual representations is due, Schapiro claims, to the easier moment of right-handed producers' draw-ing hand and wrist inward, i.e. to the left, as appears also in the freehand drawing of circles (SPSVA: 19) (Illustrations 3, 4, and 10).

Schapiro notes, again like Fuller, that such 'natural features' in representational forms and practices are always bound up with histor-ically specific aspects, though some of these cultural facets themselves remain relatively unchanged over many hundreds of years. Consider, for example, the limited nature of the image-area in visual representa-tions. The margin or 'frame' around an image, for instance, though apparently essential was, Schapiro says, an invention only of the late second millennium BC (SPSVA: 7). Framing conventions in art devel-oped historically from that point, are highly variable, and have come to acquire semantic values in themselves. Schapiro gives as an example the 'cutting' or 'cropping' of foreground objects at the frame in Impressionist paintings, 'so they appear to be close to the observer and seen from the side through an opening', as in photographs which emphasise the partial, the fragmentary, and the contingent (SPSVA: 7) (compare Illustrations 3 and 4). Ranging in examples from pre-history to the 1960s, Schapiro discusses the variety of effects related to framing devices that engender semantic content, including the meaning of abstract pictures hung without frames, in which the 'canvas now stands out from the wall' as a more complete object 'in its own right, with a tangibly painted surface' (SPSVA: 8) (Illustration 9).

The very flatness and regularity of the ground (surface) upon which pictures have been painted is a historical variable, with the quality of smoothness possibly originating, Schapiro suggests, from images impressed upon pottery and architectural surfaces (SPSVA: 3). This smoothness and closure (e.g. the pot's limited surface area) was a condition, Schapiro speculates, for the eventual representation of three-dimensional space. Although no one knows, he remarks, quite when the limitedness of the image-area was introduced, it is the case

that this limitedness conventionalised in particular media of represen-
tation remains the basis for 'our own imagery, even for the photograph,
the film, and the television screen' (SPSVA: 3). Schapiro's account
combines, therefore, reference to thousands of years of historical devel-
opment in visual representation with an interest in traditional as well
as 'mass cultural' forms in his own time. He often draws parallels
between works made in periods separated by thousands of years.
Modern painters, for instance, Schapiro notes, have come to leave at
least some of their preparatory and tentative forms visible and inte-
grated into the final surface of the image. This is a practice which
connotes the value of 'the maker's action in producing the work' and
leads us to see prehistoric cave-art as 'a beautiful collective palimsest'
(SPSVA: 6) (Illustrations 1 and 9).

Never far away from Schapiro's interests is the role of the histor-
ically specific viewer in making meanings for artworks, along with
acknowledgement of that viewer's necessary cultural and social make-
up. Aspects of this role are partly physiologically determined and partly
determined by social conventions and ideologies (although Schapiro
avoids using this term throughout).[9] On the one hand, he notes, if there
is no framing boundary to an image-area, such as in a cave painting,
viewers move to a place in front of the middle of the painting and
thus 'centre the image' in relation to their own embodied sight of the
representation. In western medieval art, on the other hand, producers
of Christian imagery knew that the apportioning of space and size in
the representational field was to be correlated 'with posture and spir-
itual rank. In an image of Christ in Majesty with the evangelists', for
example, 'Christ is the largest figure, the evangelists are second in size'
(SPSVA: 23). Schapiro gives as an example *Christ in Majesty with the
Evangelists and Prophets*, from the Bible of Charles the Bald. However,
Schapiro notes that even this cultural hierarchy is partly 'anthropo-
logical' in that the notion of what should be given prominence in an
image is built, he says, 'on an *intuitive* sense of the vital values of
space, as experienced in the real world', the biggest and most impor-
tant figures in the middle, and the smaller, less important ones towards
the sides (SPSVA: 24, my italics).

In this essay Schapiro's 'anthropologising' tendency *does* over-
shadow his concern with aspects of art that are culturally and histori-
cally specific. He chose to emphasise within his analysis those relatively
constant psychological and physiological features of artworks but,
unlike Fuller, he never claims that these are more important than their
socio-historical facets and meanings. His essay maintains, therefore, a

limited, but clear *analytic* focus that does not offer itself, in relation to other accounts, as a more adequate or more important explanation of art's purposes or meanings. For example, he says that the size of represented objects can be shown to be motivated psychologically and socially, in *different but related* ways. Colossal statues or painted figures larger than life signify the greatness of their subjects; conversely, the tiny format may express the intimate, the delicate, and precious. But size is always also a function of context and context may include function – for example, making a sign visible at a distance, as in a film screen. But size as 'function of value, and size as a 'function of visibility' are not unconnected, he remarks, as colossal statues and giant advertisements equally testify (SPSVA: 22).

Schapiro's discussion of the significance of Renaissance perspectival systems in drawing and painting makes the same double-edged point. On the one hand, he notes, the development of such systems in the fifteenth century indicates the historicity of representational forms and the contextual meanings of scale. In a perspectival picture we know, Schapiro says, that 'the noblest personages may appear quite small', as in Piero della Francesco's famous *Flagellation of Christ* (SPSVA: 26). In this sense, perspective, in imposing a 'uniform scale on the natural magnitudes projected on the picture surface' works, Schapiro claims, to produce 'a further humanisation' of the religious image and its supernatural figures (SPSVA: 24). Social or spiritual importance would be expressed, in the aftermath of perspective, through means other than relative size: in insignia, costume, posture, illumination, or place in the representational field. On the other hand, this process of 'humanisation' can be understood as a development that works to *naturalise* (that is, hide) the religious-ideological significance of such representations. The studies by Norman Bryson and Michael Camille that I discuss next emphasise particularly this socio-political significance of art in the medieval and Renaissance epochs. Bryson's and Camille's studies offer accounts of the period's ideological and institutional regimes of visual representation, religious belief, and political repression. Their inquiries attempt directly to link semiotic analyses to ideological critique.

Making and masking the 'real'

Bryson's 1981 study *Word and Image: French Painting of the Ancien Regime* attempts to meet head-on the two issues that Schapiro's essay either avoided altogether or treated as peripheral: (1) the question of

visual art's 'language-like' qualities and relation to actual (written) language, and (2) the question of the role of visual art in constructing a sense of social reality. In both cases, Bryson's starting point is to argue that the signifying practices with which he is concerned are active and constitutive, rather than passive and reflective, in making meanings in, and about, the world. His introduction 'Discourse, Figure', which I consider here, sets out the basic elements of his critique of conventional art history and his account of the implication of perspectival representations in ideological notions of 'the real' and social reality.

Bryson argues that conventional art history, represented by the studies of E.H. Gombrich, holds that art's signifying capacities had developed, since the fifteenth century at least, in order to more convincingly *imitate* the appearance of objects and events in the world. This idea had not been invented by Gombrich, of course. It had been prevalent in the time of the ancient Greeks and the Renaissance, and so Bryson creates the philosophical triplet 'Pliny – Vasari – Gombrich' to indicate the persistence of this doctrine of *mimesis* over thousands of years of art and history in the west.[10] This is 'the utopian dream of art as a perfect reduplication of the objects of the world' (WI: xv). Bryson's claim is that the making of marks in line and paint that come to be seen as 'copies' of things in the world leads to loss of the understanding of those marks *as* marks. This drive towards fashioning the perfect copy, in antiquity and the Renaissance, and 'mirrored' in Gombrich's twentieth-century art history, represents the urge of men to take hold and possess the world more fully, Bryson believes. But this impulse has always run in tandem with a counter-desire: the wish to strip away from art any aspects which 'impede the release of "aesthetic emotion"' (WI: xvi).

The former drive, towards creation of the perfect copy, is also the drive towards 'meaning' and the creation of a stable reality, and implicates art in society's constitutive ideologies of belief and behaviour. Bryson goes on to illustrate his argument in relation to European religious art of the later middle ages and early Renaissance. To that extent his argument could reasonably be claimed as an attempt to be historical. But his notion of the counter-drive towards 'aesthetic emotion', towards expression that seeks 'fullness and autonomy', release from being tied to textual meanings with ideological implication, is much more speculative and idealist. It may, in fact, be a displaced sign of the utopian politics and values of 'the moment of 1968' itself, in which certain philosophers and writers, such as Julia Kristeva and Roland Barthes (both significant in Bryson's work), expressed desires

to rescue art and meaning from *any* institutional political or ideological causes, on either the Left or Right.[11]

Bryson begins his discussion with a consideration of an undated medieval stained glass crucifixion panel in the apse of Canterbury Cathedral. Around the crucifixion are four smaller scenes: Passover; a group of two figures carrying a cluster of grapes; Moses striking the rock in the desert causing a river to appear; and Abraham sacrificing Isaac. How might the meaning of these scenes interact? Why have they been chosen for juxtaposition? But wait! Bryson explains that we do not need to speculate because set into the semicircle border of each scene is a Latin inscription that *tells* the viewer how to read the composite image. Scripture works here as what Bryson calls a 'master-text', linking the panels to passages from the Gospels (the centre panel shows the crucifixion), the Old Testament (semicircular panels around the crucifixion), and legends (in the margins of the lesser panels). The text works like a 'catechism' of questions and answers in relation to the scenes, linking the panels thematically. How, for example, does the crucifixion resemble the sacrifice of the lamb at Passover? Because, the legend tells us, He who was as spotless as a lamb sacrificed himself for mankind (WI: 3).

Bryson's argument is that this panel exemplifies the control that texts (and beyond that, the 'structures' of ideology) have over visual images in paint or stained glass. The text works with what Bryson calls a 'marked intolerance' to produce a rigorous programme of religious instruction. Images are allowed in Christiandom, for they are an efficient and, indeed, seductive means of communicating to the people. Images 'are permitted, but only on condition that they fulfil the office of communicating the Word to the unlettered [illiterate]. Their role is that of an accessible and palatable substitute' (WI: 1). But they must not be allowed *too* much power in case the meanings read into them deviate from the Church's teaching. Image-worship and iconoclasm (image destruction) can thus both be dangerous, Bryson suggests. The image must submit to the Word, and be as controlled, and controllable, as the verbal sign (WI: 1–2).

Now Bryson presumes a great deal here. For instance, he believes that the verbal and written signs of language carry fixed and stable meanings in themselves *as well* as the capacity to control how visual images are understood. (My following chapter explores in more detail this issue of the indeterminacy of meanings in *any* signifying mode – linguistic or visual – and the implications of this for radical art historians. The 'role of the reader' in creating these meanings looms large.)[12]

Bryson's introduction suffers from the most serious weakness, however, of not being based on any historical evidence regarding how he claims images and texts *actually have been read*. To acknowledge this does not necessarily mean concluding that his hypotheses are wrong, but it indicates that he has marshalled no materials that demonstrate he is either right *or* wrong. His argument constitutes, at best, then, a set of historical claims awaiting possible corroboration.

At worst, it could be said that the theoretical or philosophical aspects of Bryson's inquiry have suffocated what he presents as a historical and empirical investigation concerned with the role specific images and texts have played in the reproduction of ideologies like Christianity in late medieval and early Renaissance society. Bryson wants constantly to move from the social function of imagery in particular historical moments to a number of grand conceptual abstractions: principally to what he calls the *discursive* and the *figural* (WI: 5). Taken from writings in then recent French philosophy, these terms are the names Bryson gives for those parts of our minds, respectively, which think in words and 'with our visual or ocular experience before painting' (WI: 5).[13] Bryson's claim is that while our memory of images is intense, the 'purely visual aspects, unanchored by text, will quickly fade into oblivion' and that, for this reason, it is possible to say that the medieval image is beautiful, certainly, but servile to the word as it becomes the vehicle for textual and ideological meanings (WI: 3). Whatever 'independent life' the Canterbury panel, for example, may have as visual *figure*, once linked to text it 'progressively yields . . . a cultivated transparency before the transcendent Scripture within it' (WI: 3).

Bryson links this tyranny of the word over image to art's drive to perfect the copy. Both are relations (art to language, art to the world) which are the ruination of art's figurative nature. Bryson's tendency to personify art in his argument indicates the presence of a highly romantic undercurrent of idealisation. His rhetoric establishes a battle between the image which 'seeks fullness and autonomy' and 'the external control of discourse' (WI: xvi). The former, those features which he says belong to the image as a 'visual experience independent of language, its "being-as-image"', fights, though it will always lose, to the superior power of language as ideology (WI: 6). Bryson demonstrates this, he claims, by showing two identical illustrations of a late Van Gogh cornfield landscape on successive pages. The first is shown without a caption, so that the picture remains, Bryson believes, intensely 'visual' but conceptually mute. The second is shown with the caption 'this is the last picture that Van Gogh painted before he killed himself', which serves as a

textual anchor, Bryson claims, leading the viewer to see 'in' the picture (and the picture itself as) the full horror of the artist's desperate life and impending suicidal end.[14] The problem with this exercise is that Bryson simply *assumes* that this is how the representation, with or without caption, generates meaning. He does not base his observation – which might well be proved true under test conditions – on any evidence drawn from what might be known of actual historical viewers of the landscape painting.

The same assumption underpins Bryson's account of the significance of perspectival systems in art which have helped to perfect, he claims, the role of the image in organising the ideologies of social order. Citing as his chief example Masaccio's early Renaissance fresco *The Tribute Money*, in the Brancacci Chapel in the church of Santa Maria del Calmine in Florence, Bryson claims the painting's complex perspectival system is so successful in imitating the appearance of the real world that the biblical-textual meaning of the narrative of St. Peter's miracle is completely naturalised. The painting comes to stand, not for meaning (i.e. biblical ideology), but for the undeniable reality of the world itself. 'Realism', for Bryson, does *not* mean the accuracy of an image in imitating the appearance of objects in the world, for the dream of a progressively more faithful copy is simply that: an ideological construct. There can be no Essential Copy, he remarks, because the 'rules governing the transposition of the real into the image are subject to historical change' (WI: 7–8). What the 'real' *is* in any actual society is always an 'articulation', a construction within ideology, by a 'given visual community' (WI: 8).

This 'reality' offered within visual representation, for Bryson, is a product of the *difference* between figure and discourse, what he calls the 'excess of the image over discourse that can only last as long as texts can' (WI: 12). The Masaccio fresco *appears* so much more 'real' than the Canterbury panel because it displays, through its perspectival complexity, he claims, a marked '*excess* of the image over the text' (WI: 10). The 'text', in this sense, is, for Bryson, the part of the depicted visual narrative that relates specifically to the image's ideological anchor – the biblical account of St. Peter's miracle. The creation of the 'effect of the real' depends upon the presence of this kernel of ideological meaning *in relation to* the remainder of the visual representation which Bryson calls the 'figurative excess'. This 'excess' consists of the illusion of three-dimensional depth in the painting and the presence of depicted objects within that depth – for instance, the dress, physiognomy, gestures, and postures of the depicted people both involved in the

biblical narrative, but also those of the observers or bystanders with no 'textual role' included by the artist. The very irrelevance of this figurative excess generated in perspective systems that arouse 'our willingness to believe' guarantees the working of the ideology of the text, Bryson claims, because that excess makes 'the real' possible in the first place and in its illusionism simultaneously masks its formal basis in signification (WI: 12).[15]

Michael Camille's 1989 book *The Gothic Idol: Ideology and Image-making in Medieval Art*, though it draws on aspects of Bryson's philosophical interest in image/text relations, announces itself clearly as a *social history* of image-worship and iconoclasm. A series of questions Camille asks in his preface makes it clear that he is interested in a thoroughgoing historical explanation of the function and meaning of imagery in the twelfth, thirteenth, and fourteenth centuries: What did idolatry (the worship of images) mean to people? Who were labelled idolaters and why? (GI: xxix) The significance of imagery cannot be separated, Camille remarks, from the growth of new and powerful institutions ('structures') in this epoch, including the great cathedrals, rising over the cities, containing a vastly expanded number of visual representations. New forms of institutional and ideological control also began to operate in Western Europe: the Fourth Lateran Council of 1215, for instance, tried to manipulate and monitor the production and use of visual imagery. It tried to erase, in particular, images of genitals, devils and idols, Camille notes, providing a number of examples (GI: 19). Christian religious practices and ideologies are joined by the increasing involvement of lay people in gothic art seeking 'private, rather than clerically codified images' (GI: xxviii). How, Camille asks, did idolatry and iconoclasm relate to those excluded from, and by, the Catholic Church: the pagans, Muslims, Jews, heretics, and homosexuals?

Camille takes as one of his examples the 'fall of idols' theme, repeated many times over in a great variety of treatments in churches and prayer-books throughout Europe in the late middle ages. The basic Christian-ideological message of the image is that when Christ arrives in His singularity (depicted as the Christ-child in his mother's arms) the old pagan gods in their plurality must fall, literally and metaphorically. In one version, in an undated prayer-book held in Blackburn Museum and Art Gallery, the devilish creature in the background 'horned and hoofed . . . droops literally on its column, literally unable to stand in the face of Christ' (GI: 1). In another, a page in a *Gospel of Pseudo-St Mathew* in the Bibliothèque nationale in Paris, the 'stones

themselves crumble and columns of Egyptian temple snap like twigs before the onslaught of the Holy Family' (GI: 2). In a third, a stone sculptural relief on the west front, south portal of Amiens Cathedral, 'the idols bow down and demean themselves as they disintegrate like glass under the high-frequency sound waves' (GI: 2). Camille's point is that the Church is pitting image against image, that is, a 'good' image of Christ against a 'bad' image of devils, and therefore, that 'idolatry' is used by one group against another. 'To some extent', Camille observes, 'iconoclasm and idolatry represent two sides of the same problem: to want to destroy a false image, one had to believe in its evil efficacy, its power over the self as well as over the Other' (GI: xxvii). Loving images that are true, however, could not be idolatry, which is the name only for the crime of the excluded, what Camille calls the 'Other'. How did the Church go about, then, defining and separating 'correct' representations from 'incorrect idols'? (GI: xxvii)

The answer to this question, for Camille, as for Clark and Pollock, will be identical to discovering the historical meaning of certain visual representations. This meaning cannot be found without reference (a) to the experience of empirical subjects (that is, the public for art), and (b) to the relation of both art and this public to wider ideological and institutional structures constituting the whole society at a particular historical moment. Camille's definition of ideology is rigorously Marxist, inflected by the influence in the 1970s and 1980s of Althusserian ideas. An ideology is not simply a system of belief that helped bind medieval society into a mythical 'unity', it is a 'set of imaginary representations masking real material conditions' (GI: xxv).[16] This definition allows Camille to talk about images as directly ideological *in themselves*, rather than ideological only through their association with spoken or written texts, as Bryson's study claims. Camille agrees with Bryson that images take on the guise, or mask, of 'the natural' in purporting to show reality, but he is absolutely adamant that his interest is in showing this happening historically, not merely *in theory*:

> I do not seek to put forward a universal theory of how images work. I rather seek to show how they are so often appropriated to work for one group and, all too often, against another. (GI: xxviii)

Camille's interest in the use of representation as a weapon to oppress a particular social group – 'the Other' – echoes feminist analysis of the involvement of visual art (and conventional art history) in producing

and reproducing patriarchal society (GI: xxx). The notion of 'the Other' will be encountered later in my discussion of the treatment of both homosexuality and ethnicity in radical art history. Camille's text, it should be clear, though concerned with art made about a thousand years ago, has a deeply contemporary political motivation to it.[17]

Camille also makes it clear, with a form of words close to that of Clark's in 'On the Social History of Art', that he is interested in understanding visual art as an *active* process of meaning-making, not simply as a reflection or illustration of an already accomplished social reality. Rejecting the reductive idea that art is 'foreground' and history 'background', he says his aim has been to show how one 'society's perception of the Other [the excluded], and therefore necessarily of itself, was articulated in the duplicitous and dangerous body of the idol' (GI: xxx). But this idol, part of a novel late medieval iconography, is unintelligible without knowledge of its relation to new institutions, laws, and prohibitions. All form part, therefore, of 'social processes and often instruments for social action' (GI: 9). Idolatry was not a product of a pagan or biblical past, or completely overturned by the coming of Christ and the Church: it was a contemporary problem (like soccer hooliganism) that had to be dealt with by contemporary institutions and powers.

This meant that the authorities had to understand, control, and use the power of visual representations carefully:

> Representations provided an illusion of coherence in a fallen world. It was thus essential that their production and reception be regulated and that lines be drawn between licit and illicit forms. Although what was allowed to be represented was never as carefully codified by the Western Church as it was, for example, in Byzantium, this in fact made images far more ambiguous as religious representations. Their very potency was problematic ... being less controllable than the authorised text, images were dangerously divisive: they pretended to be what they were not. (GI: xxvi)

To discover how far the authorities managed to control and use images requires focus on what can be known of the actual experience of viewers, as well as, for instance, knowledge of the policies and plans for such control organised by the institutions of the Church. The available evidence on the former question is not likely to be great, given the paucity of relevant documentation surviving from a period of near

total illiteracy nearly a thousand years ago. But Camille realises that this evidence is what an empirical inquiry into idolatry and iconoclasm requires, *instead of* the conventional procedures of iconology, whose practitioners concern themselves merely 'with the content of images and not their power' in a particular historical moment (GI: xxvi).

Camille's interest in the institutional use of visual representational practices and their place in the maintenance of social order points to the final two texts I shall consider in this chapter, those by Svetlana Alpers and Mieke Bal. These are both concerned with Dutch art in the seventeenth century – another society in the grip of a particular model of what 'reality' was, and how it could be most completely known and represented.

Perception, narration, and 'visual culture'

Alpers shares with Camille a fundamental discontent with the proce-dures of traditional art-historical iconology. Though, like T.J. Clark, she would no doubt acknowledge the relative subtleties of Panofsky's original elaboration of the study of visual representations as evidence of broad cultural and social history, Alpers considers the discipline to be in the grip of a professionalised and reductive model of 'explana-tion' based on the simplistic formula that 'visual symbol = meaning'. Like Camille, Alpers believes the predominance of this formula oper-ates to separate explanations of the 'content' or meaningfulness of visual art from accounts of its 'effective place in the historical process', thus dislocating the analysis of representation from issues of power and ideology in particular societies.

Her 1983 study *The Art of Describing: Dutch Art in the Seventeenth Century* begins with the assertion that iconology simply is not equipped to deal with the nature and function of art in that society at that time. She then proceeds radically to attack the institutional base of traditional art history for continuing slavishly to use models of art and art practice derived from studies of the Italian Renaissance, partic-ularly those of Panofsky and Wölfflin. These models, Alpers claims, have been inappropriately extrapolated for use in the study of art from many other regions and periods:

> To a remarkable extent the study of art and its history has been determined by the art of Italy and its study. This is a truth that art historians are in danger of ignoring in the present rush to

diversify the objects and the nature of their studies. Italian art and the rhetorical evocation of it has not only defined the practice of the central tradition of Western artists, it has also determined the study of their works. In referring to the notion of art in the Italian Renaissance, I have in mind the Albertian definition of the picture: a framed surface or pane situated at a certain distance from the viewer who looks through it at a second or substitute world. (AD: xix)

While Italian artists in the Renaissance came to distinguish between 'the real and the ideal, or between images done after life and those also shaped by judgements or by concepts in the mind', such a distinction never held, Alpers claims, in Dutch art or art theory (AD: 40). Instead, the latter organised forms of representation on the basis of 'different sources of visual perception' (AD: 40). Dutch artists remained committed always to what Alpers calls 'an art of describing', in contrast to the narrative art of Italy (AD: xx).

Discontented art historians have found it difficult to escape the Italian model and find an alternative appropriate language. Some important work had actually been generated, Alpers claims, in the attempts of some scholars to move beyond the consideration of narrative in art. She cites, for example, Alois Riegl's writing on ancient textiles, Lawrence Gowing on Vermeer, Michael Baxandall on German limewood sculpture, and Michael Fried on 'absorptive' or 'antitheatrical (for which we may read anti-Albertian)' French painting.[18] How can art historians rescue the authentic means and meanings of 'description' in Dutch painting, Alpers asks, and avoid the prejudice, held as long ago as in the time of Joshua Reynolds, that this art is necessarily inferior to the idealising narratives of Italian painting? And how can they avoid, at the same time, an alternative reading, *again* based on Italian art prejudices, which claims that beneath the surface of Dutch art's descriptions, such as in Gerard Dou's (undated) *A Poulterer's Shop*, there *must* be a moral lesson hidden in the symbolism of still life painting? (AD: xxiv)

Alpers' answer to this question of finding an appropriate analytic method is similar to Clark's in his outline of the perspective of the social history of art. Dutch art, Alpers stipulates, has to be seen 'circumstantially ... By appealing to circumstances, I mean not only to see art as a social manifestation but also to gain access to images through a consideration of their place, role, and presence in the broader culture' (AD: xxiv). With adequate knowledge of these circumstances Alpers

179

declares that Dutch art (and what she calls 'northern images' in general) will be understood not to 'disguise meaning or hide it beneath the surface'. Rather it will be understood that the meaning of these artworks by their 'very nature is lodged in what the eye can take in – however deceptive that might be' (AD: xxiv).

Alpers considers Vermeer's *View of Delft* (Illustration 8). This picture, like many Dutch paintings of land and townscapes, appears to show faithfully a world existing prior to us which we view. The picture conveys an 'external exactness' unrelated to the idealising concerns of Italian art (AD: xxiii). In addition, in Vermeer's *View of Delft* the depicted view, Alpers claims, appears *as if* it did not have a frame around it (the frame that Alberti offered as his definition of a picture). By this she means that the effect is such that, rather like a photograph, the image on the pictorial surface appears to be an unbounded fragment of a world that continues beyond the canvas (AD: xxv). Moreover the picture's positioning of the viewer in relation to its depicted scene seems contingent: the representation does not *appear* to have been composed with the presupposition of a centrally situated viewer for whom the image has been brought into existence – the sense that is felt in the beholding of Italian art and which was built into the production of these works understood as both technical (perspectively complex) and moral (narrative-ideological) artefacts.

Dutch art, Alpers believes, because it exhibits these features at odds with the Italian tradition, has come to be thought of as unremittingly 'realistic' (i.e. 'lifelike') and 'objective': merely showing an actual world that viewers can choose, or not choose, to look at, and which appears to 'go on' despite the presence or absence of such viewers. *How* is it, then, Alpers asks, that these pictures appear to be like this, and *why*? One answer, which Bryson's text suggests, is because Dutch pictures seem radically *atextual*: without the prompt of organised ideological meanings ('discourse') found in Italian art. If Masaccio's *The Tribute Money* seems simply to 'show reality' when compared with the Canterbury panel's textual tyranny over figuration, as Bryson claims, then Vermeer's *View of Delft*, in comparison again with *The Tribute Money* seems free of textual meaning altogether. (Within Bryson's explanation, of course, the existence of the figural requires (somewhere) the existence of the discursive: they depend on each other to have meaning at all.)

But this answer is not adequate, either in historical or cultural terms, as far as Alpers is concerned. The way Dutch art shows the world is common, she believes, to *many* practices of representation in

the wider society in the sixteenth and seventeenth centuries. The production of paintings, she observes, has a place alongside the contemporary production of maps and mirrors in the low countries. Indeed, the intensely worked 'satin sheen' surfaces of Dutch paintings, such as Ter Borch's (AD: xviii), appear more like maps and mirrors than views from a window (AD: xxv). There is, Alpers believes, what she calls a coherent 'visual culture' in Dutch society that includes painting but which has not separated this technique of representation from many sister crafts of showing. Nor did Dutch society elevate painting into a 'high' idealising art as happened in Italy. Willem Kalf's extraordinarily 'realistic' pictures of porcelain, silver, mirrors, and glass recreate these crafts in paint.

Moreover, these different crafts of showing share a similar technology of visualisation. 'Technology' is not simply the name for a way of doing something: it is a way of thinking about, understanding, and operating upon the world.[19] Van Eyck, Alpers says, shows in the Van der Paele altarpiece that each illuminated reflecting surface makes an image in itself. Lenses and mirrors were the products of craftsmen, but also part of painters' everyday studio equipment. Many Dutch painters, indeed, had been sons of glassblowers and some continued to make and sell mirrors as well as pictures (AD: 71). Painters remained craftsmen in this society, Alpers argues, and in this sense Dutch art had no 'progressive' tradition or specialised history in the Italian sense. Indeed the Italian model, she says, was the exception rather than the rule in Europe, and for this reason there can be no account of Dutch art separate from that of the broader visual culture, a term she owes, she says, to Michael Baxandall (AD: xxv).

Pictures in Dutch culture primarily *document* behaviour, concludes Alpers. They are descriptive, not prescriptive (AD: xxvii). As a map is intended to show a place so that it can be found and navigated, so paintings show objects and places to be recognised. However, this does *not* mean that maps and pictures are uninvolved in the ideological and political structures and disputes of the society within which, and for which, they are produced. As Tagg explains in his account of photography in early twentieth-century England (discussed in Chapter 2), 'documentation' is always an active process of invention, though it may pretend not to be.[20]

Recognition of the descriptive function for representation in Dutch society, in opposition to the process of *idealisation* in Italian art, however, carries important implications for understanding the intentions, motivations, and working methods of their producers and the

social world in which they worked. Again Alpers draws a distinction between this world and that of Italian artists:

> In the north natural knowledge, rather than emphasising the forces of change in the art, was itself part of the past. It based its findings, modern and mathematical though they often were in their working out, on the new technology born of the old established craftsmanly concerns of an earlier age . . . In playing a significant role in the new world of the seventeenth century, northern art did not change its old habits, but rather became newly confirmed in them. We can say that in this respect northern art never took part in the Renaissance in spite of the struggle of the Italianisers . . . We have a case of traditional crafts and skills sustaining or keeping alive certain interests that eventually became the subject of natural knowledge. Northern art came of age, came into a new age, by staying close to its roots. (AD: 71)

Alpers is careful here to say that Dutch painters marry craft tradition to *novel* forms of knowledge and technological abilities. Dutch art's realism, she argues, becomes compellingly intelligible when considered alongside the model of vision developed by the scientist Johannes Kepler in his description of, and experiments with, the human eye. She admits, however, that evidence is scant that Kepler's findings directly influenced artists in their work. Rather, she says she is 'pointing to a cultural ambience and to a particular model of a picture that offers appropriate terms and suggests strategies for dealing with the nature of northern images' (AD: 26).

Kepler wanted to understand how the human eye received a visual representation of the world and discovered that what was seen existed *as a minute image* on the surface of the retina of the eye. In 1604 he described the eye, Alpers says, 'as an optical mechanism supplied with a lens with focussing properties'. This led him to define vision as 'the formation of a retinal image', nothing less, then, than a *picture* (AD: 34). Devices like the camera obscura had been used for centuries to recreate an image from life analogous to this retinal image, both in Italy and the north. If this was the 'closest' possible image of reality then Dutch artists – not interested either in idealising forms or narrating texts – must directly copy this image, that is: produce an image of this image. So instead of Dutch land or townscapes comprising a 'direct confrontation with nature' – which is how in one sense they appear – they are, in fact, painted representations of *other images* made

mechanically in emulation of the retinal image: based on lenses, camera obscuras, eye-glasses, and microscopes (AD: 33). The odd 'stillness' sensed in Dutch paintings perhaps is registered when the viewer's eye meets a view which may actually be a simulation of the retinal image itself. Dutch paintings are, then, more like 1960s' and 1970s' 'hyper-realist' pictures produced by painting meticulously over colour photographs projected onto canvases, than they are like any art produced in Italy in the period since the Renaissance.

Alpers explains that she prefers to use the term 'picturing', rather than the 'usual "picture"', when referring to her object of study because the former stresses the *active* construction of images, rather than the finished product. 'Picturing' emphasises the inseparability of maker, picture, and what is pictured. It is also a term, she notes, that valuably broadens the scope of what can be studied under the rubric of 'visual culture': pictures painted on canvas, yes, but also the 'pictures' of mirrors, maps, artificial lenses, and the eye itself (AD: 26). However, if Kepler's account of human vision and the 'picture' on the retina is what Alpers calls a *deanthropomorphised* one, in which the picturing process appears 'passive' and the eye 'dead', then what can be said of representation's relation to power and ideology in the Dutch social order? (AD: 36)

Mieke Bal, also a student of Dutch art, wants to answer this question without slipping back into the simplistic distinction made in conventional art histories between foreground ('art') and background ('society'), which renders the former into a secondary 'reflection' of the latter's equally inert pre-existing structures. She also wishes to avoid understanding art as the expression of individual genius, one of the supposedly greatest of which – Rembrandt – she makes the nominal subject of her inquiry in '*Rembrandt*': *Beyond the Word-Image Opposition* (1991). She places the name in scare-quotes in order to stress that it is used in art history less as the sign for an actual historical individual than as a symbol for 'male creative genius', much as Orton and Pollock wish to see the name 'Vincent van Gogh' also primarily as an ideological entity.[21] But Bal *does* wish to acknowledge agency – the active nature of signification, 'meaning-making' – in visual art, while also recognising agency's inevitable location in particular historical and social circumstances.

Bal cites, as examples of work done with this intention, studies by both Clark and Alpers, who have brought into play 'economical and political factors and their influence on the structure of public life' (RR: 6). But Bal, citing Jonathan Culler, stresses the problem of defining

context in a manner that *doesn't* relegate historical materials of many kinds to the status of peripheral detail:

> ... the very concept of context is as problematic as that of text ... 'contexts are just as much in need of elucidation as events; and the meaning of a context is determined by events' ... Context ... is a text and thus presents the same difficulty of interpretation as any other text. (RR: 6)

Bal here appears to be using 'text' to refer potentially to *any* item of signification in a society, which presents several fundamental problems of analysis that I have already touched upon – particularly the question of visual representation's relation to language.

Her less contentious stipulation, however, is that a visual artwork may be understood as a 'text' in the sense that as an artefact it can be interpreted, or 'read', in the same way that an actual written text like a novel or poem may be. By emphasising that context is *also* a text she arguably means two things. First, that art-historical accounts are based extensively (if not overwhelmingly) on surviving written documentation of many kinds (actual texts, therefore), *as well as* on the artworks themselves, and that the historian must always select and interpret these texts, in exactly the same way as a literary critic selects and interprets a poem or novel. Second, that the decisive work of the art historian is that of bringing these different kinds of texts into alignment, and within that alignment proposing the place of art (one set of texts), in relation to another (called 'history'). The distinction is an analytic and evaluative one, because artworks remain themselves always as simultaneously 'social' and as 'textual' as any other source of evidence from the past.

Signs of partiality within art-historical analysis and evaluation include names like 'Rembrandt' and 'Van Gogh' that stand, as far as Bal is concerned, for the ideology of 'male creative genius'. All forms of art history divide up the two sets of texts ('art' and 'history') in various ways, stressing, for example, 'agency and expression' (the monograph tradition), 'forms and conventions' ('formalism'), 'base and superstructure' (crude Marxism), or, indeed, some combination of these, and other, systems in the discipline. Bal's intellectual training was in literary studies, she tells us, and it is not surprising that her emphasis on the textual bases of art and history derives from her involvement in interdisciplinary studies involving literature, film, psychoanalysis, semiotics, and art history. Rather than seeing a 'crisis' in the discipline

of art history, a characterisation that was popular in the late 1970s and early 1980s, Bal remarks that the sense of art history's openness to different theoretical and disciplinary perspectives (such as linguistics and anthropology) that characterised that moment of introspection demonstrates the revitalisation of the subject. It may even be the case, she says, that art history in its radicalised forms in the 1990s will become central in the humanities and a source for the reinvigoration of other disciplines (RR: 25).

Is there perhaps a whiff of 'new', as opposed to 'radical', art history here, though? A detectable sense that Bal is talking mostly about the successful 'modernisation' of an academic discipline taught by a professional class in western universities still overwhelmingly populated by an elite of white middle-class European and North-American students? Is Bal simply proposing reading texts *differently* rather than trying to connect such reading to *changing* the world? Does Bal see art history, once again, principally as a matter of scholarly 'methods and theories' rather than of tendentious 'arguments and values'?

Bal's reading of Vermeer's picture *Woman Holding a Balance* c.1662–4, which shows a woman in the motion of trying to hang a picture of the 'Last Judgement of Christ', is partly undertaken, she claims, in order to understand the nature and role of narrative in paintings. Bal wishes to reconcile a semiotics of visual art with what she calls a 'narratology' of it; that is, the particular ways in which *still* visual representations try to 'tell a story' that must unfold in time and words. Bryson's concerns are once again invoked, and Bal credits him with coming nearest to creating what she calls a 'visual poetics'; that is, an account of the rhetorical effects of paintings (RR: 31). Bal's account of Rembrandt's religious paintings, such as the Berlin *Susanna Surprised by the Elders* (1645), and their relation to biblical texts, has as part of its theoretical bedrock Bryson's 'discourse, figure' conceit. Unlike Camille's account of image/text relations in late medieval art, however, Bryson's interpretation includes, as I've noted, a paucity of historical detail – particularly in terms of analysis concerned with the experience of artworks by actual historical viewers.

Bal, though, finally veers away from the ahistoricity of Brysonian audacious philosophical speculation towards the directly political question of the relationship between visual representation and women, understood as both depicted subjects in, and viewers of, artworks. In this task she enlists, as many feminists have, insights from psychoanalytic writing. A brief excerpt from Bal's description of *Woman Holding a Balance* will have to suffice. The painting includes, on the wall of

the depicted room, a hole, Bal explains, where the woman has previously tried to fix the picture of *The Last Judgement*:

> For me it was the nail and the hole that the light made visible, produced; that instigated a burst of speculative fertility [sic]. When I saw this nail, the hole, and the shadow, I was fascinated: I could not keep my eyes off them. Why are they there? I ask myself? Are these merely meaningless details that Roland Barthes would chalk up to an 'effect of the real'? Are these the signs that make a connotation of realism shift to the place of denotation because there is no denotative meaning available? Or do they point to a change in the significance of the *Last Judgement*? (RR: 3)

Bal's argument is too complex and extended for me to adequately paraphrase here, but involves appropriating the Freudian concepts of voyeurism and castration, and related ideas of 'vision', 'blindness' and authority in art and patriarchal society in general (many of these were adumbrated in Chapter 4).

'Rembrandt' is one name for the ideology of a male creative force whose paintings Bal treats as what she calls a 'cultural text', and which she sees as significant for many reasons. One is because paintings by 'Rembrandt' have been subject to particularly avid connoisseurial scrutiny that, over the decades, has radically reduced the corpus of authenticated works. Another is that the popularity of 'Rembrandt's' paintings is such that they have come to straddle, like the *Venus de Milo* discussed by Fuller, the high/popular divide in modern culture, and whose readings are all the more complicated for being socially wider than that of most items of secure, if comparatively obscure, high art. There can be no neutral 'reading' of 'Rembrandt's' work, Bal says, because reading is *always* carried out by particular people with particular perspectives and values at particular times. In this, then, Bal adheres to a historical explanation of artworks, to what she calls 'a radically reception-oriented approach' (RR: 6). The art historian produces only one reading amongst many, however, though this reading may become influential because art historians write their interpretations down and they can be read by others. When this happens, however, readers always also read such readings in necessarily partial ways. And so more new readings are brought into the world.

Not all readings are equal, however. Some authors have more power and influence than others to be able to propagate their interpretations, through lectures given in universities and books published,

for example. It is still assumed widely that such 'expert' knowledge is, or at least should be, truthful and objective. Bal turns to psychoanalysis partly because she believes that scholars should try to understand *why* they read the way they do – *not* because she believes they should attempt to eradicate the subjective factors that have led them to interest in certain artists, artworks, and issues in the first place (RR: 5). Such awareness of the partiality of interests and values has both social and political implications, as does the issue of distinctions between 'high' and 'popular' culture in society. Access to knowledge is similarly an inescapably political matter.

It is ironic, Bal remarks, that 'post-structuralist' and 'deconstructionist' facets of radical art history that emphasise the insecurities of authorship and interpretation have become powerful in universities just when those institutions have opened up a little to excluded women and minorities who previously had no authority to speak or interpret:

> A more open academic and educational policy can make room to include the view of those who respond to art from a less predominant social position. Such a broadening is an indisputable next step towards a better, more diverse and complex, understanding of culture . . . it cannot be an accident that the increasing participation of women and minorities in the academy coincides with a growing resistance to the very practices from which they had formerly been excluded. To put it overly simply, as soon as women began to speak, the subject of speech was no longer relevant; as soon as women began to interpret, there was no more need for interpretation. In other words, the same threat is acutely present as the one that the 'death of the author' poses: As women gained access to signs, the sign was put to death. (RR: 14)

I discuss some of the intellectual developments associated with post-structuralist and deconstructionist art history in the following chapter. Notice, however, two absences in this quotation, despite the laudable nature of Bal's sentiments. First, she makes no mention of working-class or 'blue collar' people in her list of the excluded, who are also often women and those from the 'minorities'. Bal's politics, this omission suggests, are not socialist and certainly not inflected by Marxism. Second, what the broadening of those groups admitted to universities will lead to, she says, is only 'a better, more diverse and complex *understanding* of culture' (my italics) – not a knowledge that can or should lead to *changes* in the world both inside and outside academia. Bal's

politics seem from this evidence reformist and liberal; certainly not anti-capitalist. Might this suggest that radical art history in general, by the late 1980s, had begun to lose its roots in radical politics?

Notes

1 Karl Marx Preface to *A Contribution to the Critique of Political Economy* (1859) in *Selected Writings in Sociology and Social Philosophy* (edited by T.B. Bottomore and M. Rubel), Harmondsworth: Penguin, 1975: 67–81. See Raymond Williams' discussion of the 'base-superstructure' metaphor in *Marxism and Literature*: 75–82.

2 For an account of the origins of linguistics-based structuralism, see Ferdinand de Saussure's *Course in General Linguistics*, New York: McGraw-Hill, 1966; and Jonathan Culler *Saussure*, Glasgow: Fontana, 1979.

3 See David Morley and Kuan-Hsing Chen (ed.) *Stuart Hall: Critical Dialogues in Cultural Studies*: 145.

4 *Stuart Hall: Critical Dialogues in Cultural Studies*: 149.

5 See Meyer Schapiro 'The Social Bases of Art' (1937), in Mathew Baigell and Julia Williams (eds) *Artists Against War and Fascism: Papers of the First American Artists' Congress*, New Brunswick, New Jersey: Rutgers University Press, 1986; and 'The Nature of Abstract Art', *Marxist Quarterly*, no. 1, January–March 1937: 77–98. A selection of essays by Schapiro is included in *Modern Art: Selected Papers on the Nineteenth and Twentieth Century*, London: Chatto and Windus, 1968. Also see the special edition of the *Oxford Art Journal* devoted to Schapiro, edited by David Craven, vol. 17, no. 1, 1994.

6 The essay was reprinted in another collection of essays by Schapiro that demonstrated his continuing social-historical interests: *Theory and Philosophy of Art: Style, Artist, and Society*, New York: George Braziller, 1994.

7 This belief had been summed up by Roland Barthes who famously announced that 'linguistics is not a part of the general science of signs, even a privileged part, it is semiology which is a part of linguistics', *Elements of Semiology*, London: Jonathan Cape, 1967: 11. As this statement suggests, earlier analysts, including Saussure himself, had *not* considered language to be the paradigm of significatory activities. See Stephen Bann's discussion of this question in 'Semiotics', in Raman Selden (ed.) *The Cambridge History of Literary Criticism: From Formalism to Poststructuralism*, Cambridge: Cambridge University Press, 1995.

8 The aesthetic, Terry Eagleton remarks, is 'that peculiar form of matter which is magically pliant to meaning, that unity of the sensuous and spiritual which we fail to achieve in our daily, dualistic lives', *The Idea*

of Culture: 98. For Eagleton's extended deliberation on the connections between aesthetic experience, human nature, and the possibility of radical social transformation, see his *The Ideology of the Aesthetic*, Oxford: Blackwell, 1991.

9 For an important account of the development of Schapiro's Marxism, see David Craven 'Meyer Schapiro, Karl Korsch, and the Emergence of Critical Theory', *Oxford Art Journal*, vol. 17, no. 1, 1994: 42–54. The question of Schapiro's preparedness to consider issues of gender within this philosophical framework is intelligently considered by Patricia Mathews in 'Gender Analysis and the Work of Meyer Schapiro', *Oxford Art Journal*, vol. 17, no. 1, 1994: 81–91.

10 Bryson's concern is only with the development of art in the West, particularly since the Renaissance. In this sense his viewpoint is self-consciously and critically 'eurocentric'. The prejudices and partialities of eurocentricity in art history are considered in some detail in my Conclusion.

11 Bryson's edited collection *Calligram: Essays in New Art History from France* provides a flavour of this kind of idealism, particularly Julia Kristeva's essay 'Giotto's Joy', which first appeared in English in *Desire and Language*, New York: Columbia University Press, 1980 (edited by Leon S. Roudicz). See also Roland Barthes *The Pleasure of the Text*, New York: Hill and Wang, 1975; and Peter Starr's useful discussion, 'Third Terms: Barthes, Kristeva', in *Logics of Failed Revolt*.

12 On 'reader reception' issues and problems, see Robert C. Holub's succinct *Reception Theory: A Critical Introduction*, London and New York: Methuen, 1984.

13 See J.-F. Lyotard *Discours, Figure*, Paris: Editions Klincksieck, 1974.

14 Bryson acknowledges that John Berger had carried out a similar exercise in *Ways of Seeing*: 27–8.

15 Bryson, in an aside, discusses the same 'effect of the real' created in modern advertising techniques such as photographic montage: 'Next to an image of a glass of beer, the campaign I have in mind juxtaposes further images that are apparently unrelated to the product: a bow, an arrow, and the muscular arms of an archer in leather ... [the advertisers believe] that in his innocence the consumer will come to perceive the connoted meanings, of strength, skill and virile glamour, as inherent in the product itself ... the meanings are kept hidden, but the physical products are spotlighted, and if the process works, it is by keeping the consumer unaware that *meanings* are involved at all' (WI: 15).

16 Camille may well have been struck by how often Althusser invoked examples of religious ideology in his essay 'Ideology and Ideological State Apparatuses (Notes Towards An Investigation)'. See, for example, *Lenin and Philosophy and Other Essays*: 156–7, 162–3.

17 Camille links his study directly to 1980s' 'post-modern' society, in which he detects a 'disintegration of categories and critical self-awareness in much contemporary art [that] make it comparable in many respects to

that produced in the Middle Ages . . . similarly a period of deep, unsettled questioning as to the function of the visual in society' (GI: xxvii).

18 Alpers cites Alois Riegl *Late Roman Art Industry*; Laurence Gowing *Vermeer*, London: Faber and Faber, 1952; Michael Baxandall *The Limewood Sculptures of Renaissance Germany*, New Haven: Yale University Press, 1980; and Michael Fried *Absorption and Theatricality: Painting and Beholder in the Age of Diderot*, Berkeley and Los Angeles: University of California Press, 1980.

19 For a valuable case-study, see Raymond Williams *Television: Technology and Cultural Form*, London: Fontana, 1974.

20 See also John Tagg *Grounds of Dispute: Art History, Cultural Politics, and the Discursive Field*, Basingstoke: Macmillan, 1992, especially Chapters 5, 6, and 7.

21 As well as my earlier discussion of this question, see Fred Orton and Griselda Pollock 'Rooted in the Earth: A Van Gogh Primer', and Griselda Pollock, 'Agency and the Avant-Garde: Studies in Authorship and History by Way of Van Gogh', both in *Avant-Gardes and Partisans Reviewed*, Chapters 1 and 13. Krauss' argument in her essay 'In the Name of Picasso', which I discuss at some length in Chapter 1, has similar elements to it, but, from the perspective of historical analysis, she goes so far as to effectively throw out not only the baby with the bathwater, but the bath and the bathroom as well.

Select bibliography

Bann, S. 'Semiotics', in Raman Selden (ed.) *The Cambridge History of Literary Criticism: From Formalism to Poststructuralism*, Cambridge: Cambridge University Press, 1995

Barthes, R. *Elements of Semiology*, London: Jonathan Cape, 1967

Barthes, R. *Mythologies*, London: Jonathan Cape, 1972

Barthes, R. *Image-Music-Text*, Glasgow: Fontana/Collins, 1977

Bryson, N. (ed.) *Calligram: Essays in New Art History From France*, Cambridge: Cambridge University Press, 1988

Bryson, N. 'Semiology and Visual Interpretation', in Norman Bryson *et al.* *Visual Theory*, Cambridge: Blackwell, 1991. (In response, see: Melville, S. 'Commentary: reflections on Bryson', in *Visual Theory*.)

Bryson, N. and Bal, M. 'Semiotics and Art History', *Art Bulletin* June 1991: 174–208. (In response, see: Wolf, R./Dowley, F.H. 'Some Thoughts on "Semiotics and Art History"', *Art Bulletin*, September 1992: 523–8; 'Further on "Semiotics and Art History"', *Art Bulletin*, June 1993: 338–40.)

Eco, U. *A Theory of Semiotics*, Bloomington and London: Indiana University Press, 1976

Frascina, F. 'Realism and Ideology: An Introduction to Semiotics and Cubism', in Francis Frascina *et al. Primitivism, Cubism, Abstraction*, New Haven and London: Yale University Press/Open University, 1993

Hawkes, T. *Structuralism and Semiotics*, London: Methuen, 1977. (In response, see: *Screen Reader on Cinema and Semiotics*, London: SEFT, 1981.)

Iverson, M. 'Saussure versus Peirce: Models for a Semiotics of Visual Art', in *The New Art History*, London: Camden Press, 1986

Marin, L. 'Towards a Theory of Reading in the Visual Arts: Poussin's *The Arcadian Shepherds*', in S. Suleiman and I. Crosman (eds) *The Reader in the Text: Essays on Audiences and Interpretations*, Princeton: Princeton University Press, 1980

Merquior, J.G. *From Prague to Paris: A Critique of Structuralist and Post-structuralist Thought*, London: Verso, 1986

Preziosi, D. *Rethinking Art History: Meditations on a Coy Science*, New Haven and London: Yale University Press, 1989. (In response, see: Davis, W. review of D. Preziosi 'Rethinking Art History', *Art Bulletin*, March 1990: 156–66)

Schapiro, M. 'Nature of Abstract Art', *Marxist Quarterly*, vol. 1, no. 1, January–March 1937: 77–98

Schapiro, M. *Modern Art: Nineteenth and Twentieth Centuries* (2 volumes), London: Chatto and Windus, 1968

Schapiro, M. *Words and Pictures: On the Literal and Symbolic in the Illustration of a Text*, The Hague: Mouton, 1973

Wollen, P. *Signs and Meanings in the Cinema*, London: Thames and Hudson, 1969

Searching, after certainties

Key texts

Victor Burgin 'The Absence of Presence: Conceptualism and Post-modernisms', in *The End of Art Theory: Criticism and Postmodernity*, Macmillan: Basingstoke, 1986 (essay originally written for the exhibition catalogue, *1965 to 1972 – When Attitudes Became Form*, Cambridge: Kettle's Yard Gallery, 1984): APCP.

Dick Hebdige 'Staking out the Posts' and 'Post-script 4: Learning to Live on the Road to Nowhere', in *Hiding in the Light: On Images and Things*, London and New York: Comedia, 1988: SOP.

Fred Orton 'Present, The Scene of . . . Selves, The Occasion of . . . Ruses', in *The Block Reader in Visual Culture*, Routledge: London and New York, 1996: 87–114 (originally published in *Block*, no. 13, 1987–1998): PSSOR.

Kathy Myers 'Towards a Theory of Consumption: Tu – a Cosmetic Case Study', in *The Block Reader in Visual Culture*, London and New York: Routledge, 1996, 167–86 (originally published in *Block*, no. 7, 1982): TTC.

Nick Green *The Spectacle of Nature: Landscape and Bourgeois Culture in Nineteenth-Century France*, Manchester and New York: Manchester University Press, 1990: SN.

Beyond subjects and structures

Radical art historians such as Clark, Wagner, Mulvey, Schapiro, and Alpers have all insisted on the interconnectedness of three kinds of phenomena that constitute their object of study. First, they call for attention to the specificities of artworks' *representational structures* – that is, the literal and conventional signifying materials in (and out of) which, for instance, paintings, photographs, sculptures, and movies have been made. Second, they believe that the 'work' this art does is always done historically, within the *economic, political, and ideological structures of specific societies*. The connecting third 'structure' they have identified as *the viewing subject for art*: the involvement, that is, of people, individually, and in aggregates of various kinds, in the whole process of making meanings.

The traditional and still predominant art-historical conception of human agency has been in terms of art's immediate and individual producers: for instance, painters, photographers, sculptors, and directors.[1] But from my consideration of Pollock's and Bal's texts, amongst others, it has become clear that this apparently straightforward sense of 'maker' subtends a cluster of fraught ideological meanings and values bound up with *phantasies* of artistic authority, power, and creativity which, for feminists, are inseparable from the production of sexual difference in exploitative patriarchal societies. Wagner's commitment to exploring the identity of women artists, such as Eva Hesse, recognises two important problems to which Bal also alludes. On the one hand, the development of this ideology of authorship in art and art history must be interrogated, and its patriarchal prejudices made clear. Feminists with otherwise quite radically divergent views have agreed upon this. On the other hand, feminists have wanted to recover the lives of women artists and explain how these have determined their work as artists. These two problems – these two histories – have been *literally* intertwined, as Wagner demonstrates in her study of the careers of three women artists who lived, as marriage partners and fellow-artists, with three male artists.

So, the *subject producing art* cannot be understood merely as an invention or an abstraction, though ideological inventions and idealist abstractions *have* been built upon knowledge of actual artists – this is when Van Gogh, for Orton and Pollock, becomes 'Van Gogh' and when Rembrandt, for Bal, becomes 'Rembrandt'. Authorship remains, then, a necessary but problematic idea within *both* conventional and radical art history. Another is that of how the *viewing subject for art*

is understood. For Clark, although he has written extensively on the significance of particular art critics – for instance, Charles Baudelaire in relation to Manet, Clement Greenberg in relation to Jackson Pollock – viewing is conceived as a *collective* activity. Clark sees this phenomenon as an important socio-historical force in itself: the problem of 'the audience' or, more complicatedly, 'the public', which, as another kind of structural entity, is a combination of empirical and abstract elements.' Construed in this manner the relevance of its characterisation as a 'structure' becomes more obvious. Individual and separate viewers are reconceived as an entity (an aggregated 'it'), which, though internally divided in a variety of ways in any actual historical case – through, for instance, factors of class, taste, gender, regional location, or of relative significance within institutions – is much more than the sum of individual elements. The audience or public *is* the society as a totality of groups and forces organising, and organised by, the material structures of economic, political and ideological life, including those directly bearing upon art's production and understanding.[3]

Psychoanalytic ideas, as I've shown, have been mobilised by radical art historians in a variety of ways – some apparently contradictory – to attempt to deal with certain aspects of the question of art's reception. Scholars such as Mulvey, Pajaczkowska, Fuller, and Kuspit have argued that, without a complex description of the nature of the embodied human psyche, art-historical accounts of how people engage with, understand, and derive satisfaction from artworks would remain fundamentally inadequate. The issue of 'visual pleasure', and its relation to male sexual desire and the 'male gaze', became an absolutely central problem for feminists in the late 1970s attempting to understand how women and men reproduced 'phallocentric' society partly because they gained considerable somatic (bodily) and semantic (ideological) pleasures through the visual representations of film, photographs, and television. In a different if related direction, Fuller and Kuspit, and perhaps even Nochlin and Wagner, believe that the realm of 'the aesthetic' and its relations to embodied human perception cannot be understood properly either without some reference to psychoanalytic insights.[4]

In this case also the definition of 'the subject' as a *structure of parts* – some conscious, some unconscious – has enabled radical art historians to think through the question of how men and women use visual representations within their mental and sensual lives. There are, however, at least two seriously problematic aspects to radical art-historical accounts that mobilise psychoanalytic concepts. As I noted

SEARCHING, AFTER CERTAINTIES

in the case of Bryson's essay on 'The Gaze in the Expanded Field' the question of the relation of psychoanalytic insights to historical inquiry is particularly vexed. The 'subject' conceived psychoanalytically is usually represented as a 'model' entity – *complete* only as abstract 'psychic structure', in one sense – rather than in terms of actual empirical human beings, living at a particular time or place. At best, the notion of the 'subject' is a self-consciously hypothetical proposition about how real people act and react: this, presumably, is how Mulvey, as a feminist, wishes her psychoanalytically conceived 'subject' to be understood. Mulvey's claims *are* about how real people have watched, or may watch, actual films, and how their pleasure in these filmic representations of identity and sexual desire have acted, or might act, upon them. (How, if at all, then, could such claims be tested?)

At worst, psychoanalytic abstractions have nothing at all to do with historical inquiry or the social use of representations, though it may be interesting and important politically to consider why this kind of 'Theory', in Pollock's pejorative sense, has grown and become prevalent to the extent that it has, especially in the last twenty years or so.[5] This abstracted notion of the 'subject', to repeat, is conceived typically, within psychoanalytic accounts (though there have been some important exceptions), as an isolated *individual* subject, not in relation to other subjects seen as forming the 'structure' of a collective social entity.[6] Victor Burgin's 1984 essay, 'The Absence of Presence: Conceptualism and Post-modernisms', tries to deal with several of these aspects to the problem of 'structure' in relation to then contemporary art practice, art history, and related philosophical inquiry. This last facet to Burgin's essay focuses upon the writings of several French intellectuals, all of whom had been involved, one way or another, in 'the moment of 1968', and who are associated with the elaboration of 'structuralist' ideas in that decade. The term 'post-structuralism' was coined in order to indicate that often *these same writers* had come to acknowledge difficulties within the varied notions of 'structure', which the term, despite its continuing analytic indispensability, had generated.[7] 'Post' means 'after', therefore, but it also means 'in the light of', and 'in relation to'.

Signs, surfaces, and civilisation

Burgin's essay was written for a catalogue to an exhibition of conceptual art, *1965 to 1972 – When Attitudes Became Form*, held at the Kettle's Yard Gallery in Cambridge, England, in 1984. The text,

however, when reprinted two years later in Burgin's collection, *The End of Art Theory: Criticism and Postmodernity*, contained no reference in detail to artists' work included in the show. The essay is really a vehicle for its author to attack, from his perspective of what might be called 'left-wing post-structuralism', conservative values in contemporary art, art criticism, and British capitalist society generally, then in its second term of right-wing government under Margaret Thatcher.

The apparent resurgence of painting in British art in the early 1980s is, for Burgin, a symbol of conservatism in art, and therefore evidence that then emergent cultural 'post-modernism' (of which such painting was claimed to be a part) did not offer any radical alternative to the still powerful critical platitudes of bourgeois humanism and formalist art criticism. I shall turn to 'post-modernism' in a moment. Burgin, working as a professional 'fine art' photographer, as well as a writer and teacher in a British university at the time, believes that artists fabricating photographic/photo-text representations and non-traditional sculptural artefacts are producing an important 'socio-semiotic' critique of both humanism and formalism (Illustrations 3 and 5).[8] These kinds of artworks, in contrast to traditional paintings and sculptures, had been proposed in the early and mid-1980s as part of a subversive 'critical post-modernism', by, for example, Hal Foster, Rosalind Krauss, and Burgin himself. The particular character, and extent, of this 'subversion', however, remains opaque, I believe, as does its relation to the socio-political world of 'post-modernity' claimed to be coalescing, at the same time, outside the doors of the art studios and museums. (Dick Hebdige's account of both 'post-modernity' and 'post-modernism' is discussed later in this chapter.)[9]

Burgin believes that conceptual art's radicalism of means and ideas is in danger of being recuperated by the institutional machinery of museum curation and art-historical explication. As an art of the 1960s conceptualism has, he thinks, an authentic relation to the radicalism of that decade's politics and intellectual culture (radical art history included). Traditional art history is trying to 'process' the diversity of conceptual art's artefacts and practices into a unified 'movement', Burgin claims, which will then be portrayed as undermining something called 'modernism', thus paving the way for 'post-modernism', and a return to painting. This is what happens, he claims, when conceptual art is 'woven into the seamless tapestry of "art history"' (APCP: 29).

Burgin links the revival of a market for new painting in the early 1980s to the ideological potency and value attributed to it by sexist male bourgeois critics and correctly diagnosed by feminists:

> What we can see happening in art today is a return to the symbolic underwriting of the patriarchal principle by means of the reaffirmation of the primacy of *presence*. The function of the insistence upon presence is to eradicate the threat to narcissistic self-integrity (the threat to the body of 'art', the body-politic) which comes from *taking account* of difference . . . (APCP: 47–8)

'Presence' and 'difference' are terms fundamental to the critique of structuralist ideas proposed by the philosopher Jacques Derrida, upon whose writings Burgin draws extensively in his essay. Burgin's politics are anti-capitalist and pro-feminist, and draw, as is evident here, on psychoanalytic notions such as 'narcissism' and 'self-integrity'. Burgin has in mind 'new expressionist' paintings produced in the early 1980s in Britain by artists then claimed by some critics to be part of a 'new spirit' and 'figuration' in art antagonistic to the development, in the 1970s, of conceptual and critical photo-text practices. However, Matisse's 1907 *Blue Nude* will suffice as (and is actually paradigmatic of) the kind of expressionist work Burgin wishes to attack (Illustration 7).[10]

Kuspit's interpretation of Matisse's 'primitivist' paintings, such as *Blue Nude*, though also couched in psychoanalytic language, would qualify, for Burgin, as an example of the humanist account of art's value in bourgeois society. Burgin sees traditional oil paintings as condensations of several key ideological aspects of capitalist, patriarchal, and imperialist western culture, with a history that begins in the Renaissance. The principles of commodity exchange (the basis of a capitalist economy) and individuality are embodied, Burgin claims, in the form of the easel painting born in the sixteenth century. The painting as a *mobile* artefact (that is, no longer painted directly onto a wall, as in the fresco) begins 'commodity connoisseurship' in the Renaissance. This develops further in the eighteenth century when G.E. Lessing's aesthetic philosophy, Burgin argues, entrenches the notion of the specificity and irreducibility of 'the visual' (in contrast to 'the literary'), thus giving rise to the beginnings of modern art criticism (APCP: 39).

Though this tradition reached its most influential height in the 'high formalism' of Clement Greenberg's and Michael Fried's critical writing in the 1950s and 1960s, Burgin claims that a much more ideologically pervasive sexist male bourgeois humanism attended upon the fetishisation of oil painting since the sixteenth century:

> The value of a painting in . . . these early days of humanism . . . became increasingly linked to the notion of individuality: the

individuality of the consumer, certainly, hence all those portraits of princes and rich merchants which fill our picture galleries to this day. Even more, however, the value of painting was linked to the individuality of the producer, to the idea of authorship. (APCP: 35)[11]

'Presence', for Burgin, appropriating Derrida's usage, is the ideological effect that painting, and the criticism of painting, achieves when 'the brush mark (or the dribble, it makes no difference) is [understood as] the index, the very *trace*, of this expressive body, and thus of the "human essence" to which it plays host' (APCP: 34). This might be the sexual essence that Kuspit identifies in Matisse, or the more amorphous 'creative genius' celebrated in conventional art history. Either way it amounts to the same thing: a specific narrative of origins and fundamental meaning founded upon what Derrida calls a 'metaphysics of presence'. This narrative denies that there is an intrinsic openness or plurality to meanings and possibilities in art *and* politics, and works instead to portray expression and value in art and capitalist society as unitary and fixed.

'Structure', then, in terms of accounts of language, or of signifying conventions in visual art, or in terms of 'the subject', and society as a totality, implies, for Burgin, a closure and completeness that is untenable philosophically, historically, and politically. Though he acknowledges that thinking in terms of structures is absolutely necessary, and appears to be a core organising feature of human thought, it is also necessary, Burgin argues, to think the *dissolution* and *supercession* of structures, in language, art, philosophy, and politics. Somehow we need both to have (and believe in), and not to have (and not believe in), structures. Derrida's name for this contradictory sense was 'différance'. Derrida coined this new word in the French language in order to encapsulate the notion of change and dispute. It combines the *structural* meaning 'to differ' ('be unlike, be distinguishable from something else') with the *temporal* meaning 'to defer' ('yield, give way to a person's wishes or authority'). It is the same problem as attempting to reconcile 'structure' and 'agency', or 'historical development' and 'conjunctural moment': to attempt to think form and change *in the same analytic moment*.[12] It is the attempt to understand how meanings are made *and* changed, and to understand why there is volatility or instability in signification at all. (I discuss below Fred Orton's 1987 essay on a Jasper Johns painting which Orton believes exemplifies this conundrum.)

Burgin uses Derrida's notion of 'différance', and his critique of the 'metaphysics of presence' in language to attack bourgeois-humanist modern art criticism centred on fetishising the 'trace' of human essence it claims to find in oil painting. Burgin believes that photography, photo-text works, and non-traditional 'sculptured' objects all potentially undermine this ideological conservatism in art and art criticism, traceable back to Clive Bell and Roger Fry:

> The antiquated legacy of Bloomsbury is today a self-complacent cult of 'taste' and 'response' which stifles 'intellectualisation' to protect a supposed 'authenticity' of expression and feeling – that which comes as 'second nature' [culture], or as Pascal observed, as 'first habit'. The source of stimulus of the aesthetic response (this aesthetics is unwittingly Pavlovian) is the *art object*, which in turn is the representative of the sensibility of *the artist*. (APCP: 31)

The legacy of this art, Burgin claims, is patriarchal, imperialist, capitalist, and elitist – all epithets he uses to attack the US and Britain, then under the regimes, respectively, of Ronald Reagan and Margaret Thatcher. Burgin makes a direct link between the supposed 'high art' status of painting and the mass culture of advanced capitalism. The idea of 'post-modernism' in painting is being appropriated, he observes, 'by a currently ascendant Neo-conservatism ... which combines a rhetoric of renewal reminiscent of that used by manufacturers of detergents ("*New* Spirit in Painting", "*New* object" sculpture [*New* Labour, *New* Art History!]) with a reaffirmation of conservative values' (APCP: 46). Conceptual art is an authentic alternative to this, Burgin claims, because, amongst other things, it attempts to dismantle the hierarchy of media in which painting is assumed to be inherently superior to, most notably, photography (APCP: 34).

Burgin makes an implicit distinction here. 'Photography' in the widest sense, including movies and television, forms what he calls 'an integrated specular regime' within capitalist society (APCP: 37). 'Photography' in Burgin's narrow sense, however, refers to *his preferred* art-photographic practices. Photography in the former sense, he believes, in accordance with most Marxists, has a central role in reproducing the ideologies of capitalist society, particularly, he observes, within its advertising culture. Echoing Bryson's argument in *Word and Image*, Burgin believes social reality is partly constructed in, and out of, the signifying forms of visual-representational technologies. In

contemporary society photographic practices fundamentally constitute what Burgin calls 'the optical system designed to reproduce *quattro-cento* perspective' (APCP: 37).

In agreement with Tagg, Burgin believes this 'reality', and the 'realism' of photography, is simply an ideological construct. It works in dismal dialectical tandem with bourgeois art criticism's fetishism of 'presence' in the supposedly elevated high art of oil painting. This ideology of the:

> special characteristic of art necessarily makes it an autonomous sphere of activity, completely separate from the everyday world of social and political life. The autonomous nature of visual art means that questions asked of it may only be properly put, and answered, in its own terms – all other forms of interrogation are irrelevant. In the modern world the function of art is to preserve and enhance its own sphere of civilising human values [be they formalist or humanist] in an increasingly dehumanising techno-logical context. (APCP: 30)

Painting, because of both popular and academic ideological investment in its claimed expressive sacredness within contemporary capitalist society, is simply *not* capable of exhibiting any socially critical or subversive characteristics.

In contrast, conceptual art practices – for instance, photographic and photo-text work, installations, non-traditional fabricated artefacts – have the capacity, Burgin believes, to destabilise the 'metaphysics of presence' because they insist on critical difference. A difference, in the first place, which is simply a matter of *not being painting*. In the second place, because these practices often utilise text in drawing attention to how *all* meanings – 'differences' – are constructed in language and ideology. In the third place, because some of these practices, including all photographic means, are inherently reproducible – 'differential' – and thus deny, in terms of their material form, the fetishes of origi-nality, uniqueness, and authenticity.[13] In short, conceptual art practices are subversive because what unites them is 'the glimpse ... [they] ... allow ... us of the possibility of the absence of 'presence', and thus the possibility of *change*' (APCP: 48).

'Change' here is metaphorically rich in its intended associations: it refers to change in art, but also to culture and politics. It is a facet of the meaning of post-structuralism that Burgin wishes to ally to the 'new social movements' of women, blacks, and gays that served as

201

political referents for radical art historians in the early 1970s. Burgin is not sure, however, that traditional *socialist* organisation should be included within these movements, though, arguably, his ambivalence is not as extreme as that of Bal, discussed at the end of the previous chapter. (Hebdige takes up the issue of politics in post-modernism more directly, and I discuss his claims below.)

What *is* fundamentally questioned in Burgin's account of politics and political possibility in the 1980s, again echoing the post-structuralist critique of the 'metaphysics of presence', is the supposedly objective and ultimately determining economic reality (the 'base') posited by Marxists as the necessary and primary fuel for the 'engine of class struggle'. In opposition to this instance of another proposed philosophical and historical certainty, Burgin claims that representations (part of the 'super-structure' for Marxists) 'can not be simply tested against the [economic] real, as this real is itself *constituted*, as everyday common-sense "reality", *in* representations' (APCP: 41).

This is not the same as claiming, however, that reality is *simply* a set of representations, or that the *only* things representations do is represent. Commodities, be they oil paintings, art history books, or potential human labour-power, have a place in the wider organisation of economic, cultural, and political order in any particular society. Yet Burgin seems to want to push his argument towards the extreme view that all reality is *is* a fabric of representations, which may lead quickly to the assertion that politics is (and should be) much more about 'identity-formation' than anything else. This view, arguably, became something of an orthodoxy within what was, increasingly ambiguously, called 'the Left' in the later 1980s and 1990s:[14]

> It is comparatively recently that the perception and definition of the field of 'the political' has undergone a radical expansion beyond the traditional ghetto of party politics and considerations of 'class struggle' to now include, amongst other things, consideration of sexuality; 'sexuality' understood not in the reductive terms of the caricature in which it appears in the popular media, but in the complex and subtle understandings to be derived from psychoanalysis, where considerations of sexual difference are seen as governing relations within and between the individual, language, and power. It has now become possible to ask a question which could not previously ever have been thought: 'What are the *forms* of visual imagery consequent upon the forms of construction of the fiction of the subject?' (APCP: 42)

Psychoanalytic critique, once again, seems to be a double-edged sword. On the one hand, it is offered as a means to understand the social and ideological structuring of psychic identity. On the other, it can appear to be an idealist abstraction that threatens comprehensively to 'de-socialise' and 'de-historicise' the 'subject', even as it is manipulated – for example, by Mulvey, Fuller, and Burgin – as a device precisely to understand the significance of visual pleasure in contemporary society. Can it really be both? Burgin, if not Mulvey and Fuller, uses psychoanalytic concepts as a means to understand what he unambiguously calls the 'fiction of the subject'? Where have the real people gone? Are 'selves' only 'constructed' representations? Is this their, and our, only existence?

In contrast, Orton's discussion of the 1972 painting *Untitled* by Jasper Johns (Illustration 9), steps sharply back from Burgin's conclusions, in both art-historical and political terms. The troubling insights of post-structuralist philosophy, Orton implies, are not only compatible with a social history of art, but may actually secure its explanatory power, though that might come, partly and perhaps ironically, from more stringently recognising the *limits* of that power. Orton's essay, published in *Block* magazine in 1987–1988, touches on three related issues that had, by the mid-1980s, come to dominate and problematise the concerns of much radical art history. The first two have already been aired. These are, first, the question of the relationship of language to visual art, and the value of thinking about art *as if it were* a language, or at least shared important properties with language. Second, the need for a reconceptualisation of art's producing agent ('the artist'), in the light of the critiques of authorship and authority posed over the past two decades and more. Third, Orton concerned himself with the consequences of the re-evaluation of modernism in art and art theory that had occurred in the latter half of the twentieth century, particularly in the wake of the claims that it had been superseded by 'post-modernism'.

Orton's essay, unlike Burgin's, avoids any direct political discussion and treats theoretical issues in strict relevance to the discussion of Johns' painting. There is, however, a kind of submerged political position in this strategy. *Block* magazine, after all, had been a key site for radical art historians to publish material and debate issues since 1979.[15] Orton, in collaboration with Griselda Pollock since the late 1970s, had written some of the most 'political' and directly *politicising* essays on modern art and contemporary art history.[16] The mid- and late 1980s was a moment, though, when a reconsideration of the previous fifteen

years of radicalism took place, because it is then that the claims of a break between the modern past and the 'post-modern' present – in all spheres of life – are begun to be heard most insistently.

There is, therefore, the sense of a 'drawing of breath' in Orton's essay. In its insistence that it is the surface of a painting that should form the centre of attention, his essay, in one sense, (ironically) returns art-historical analysis to an apparently definite, empirical, unquestionable object. In another sense, however, the complex, perhaps *unanswerable* questions this attention inevitably gives rise to indicate the extent to which philosophical issues had come to predominate within the 'critical' or post-structuralist-inflected Marxism of that moment.[17] But any definite political and ideological implications of the philosophical doubt that post-structuralist thinking undoubtedly propagates, I infer Orton to be saying, may themselves be doubted. In fact, any such clear and undoubted implications drawn (by Burgin or anyone else), must themselves be subject to this doubt. Perhaps best, therefore, not to jump to any conclusions at all.

Orton chooses to defer.

In doing this, Orton actually operates upon a founding principle that Clark had established in his study of Courbet as basic to conducting the social history of art. This principle is: do not make intuitive analogies between 'form' and 'content' in artworks, or, to extrapolate, between novel forms of analysis (and the novel problems they may have brought into light), and the wider world in which they have been generated.

Orton begins, therefore, with the material basics of an artwork: the physical surface of a modernist painting consisting of four different kinds of surface bolted together into one. The painting itself 'begins with marks', he notes, constituting 'a painted surface insisting on the fact of its flatness. Then, a series of abrupt transitions from panel to panel, facture to facture, image to image . . . emphatic, palpable and human' (PSSOR: 87). Orton concentrates for a moment on the first of the four surfaces, a pattern of hatched lines grouped in contrasting directions. Part of the 'meaning' of these grouped hatched lines forming a pattern is related, Orton says, to the making of the surface of the painting, whatever else they might be 'doing' (PSSOR: 87). This 'doing-ness' of marks indicates the activity of signification in *referring*. But referring to what? How might their references be explained?

Johns, Orton tells us, 'has said that he derived the motif from a car which once passed him on the Long Island Expressway' (PSSOR: 88). Why might that be significant? How might it help to 'explain' the

painting? What does it mean, in fact, to be attempting to explain the painting at all? Orton's essay becomes a deliberation on this problem of explanation. How does explanation now (that is, in 1987) construe the significance of the artefact's 'direct' maker (the 'artist'), and relate this to the range of sundry other people, events, and materials, that might be said to have had a 'hand' in the work's production? Orton is fundamentally interested, then, in the 'agency' that produced the work, but only in a radically reconceptualised notion of what that 'agency' might mean. Some of this term's new senses, indeed, might appear to be closer to those usually associated with the concept of 'structure'. Orton develops this reformed notion of agency against a specific counter-explanation – modernist art history and theory – that, he says, wishes radically to *limit and fix* the meanings of structure and agency.[18] Modernism's explanatory tradition, Orton claims, has always 'misunderstood' or 'played down' the referential function and semantic potential of the artworks it has viewed as worthy of study (PSSOR: 94).

Instead, modernism has asserted, Orton claims, the 'decorative potential of surface' in these works (Johns' included), and sought to stress their reference *only* to other works by their makers, or to those of other artists. Johns, Orton believes, produces artworks that certainly have this decorative surface, but it is *also* an expressive or representational surface, referring to 'vivid subject matter which has been generally overlooked' in modernist description (PSSOR: 94). As such, then:

> Modernist criticism and history, which is relatively socially open in its linguistic mode, is nevertheless comprised of all kinds of interpretative closures like those which work to restrict enquiry and explanation to surface rather than subject, composition rather than signification, 'style' and 'influence' rather than conditions of production and consumption. (PSSOR: 95)

Orton's interest in Johns here, however, is *not* couched in terms of the economic and social conditions that Marxists have usually stressed. In this, Orton is signalling – again through avoidance – his reconsideration of the philosophical underpinnings to his analysis. Instead, Orton develops the idea that *Untitled* may be 'made sense of' in relation to the specific 'subculture' of people, places, and events with which Johns was involved in the early 1970s. Orton cites the art historian Thomas B. Hess, for instance, who had remarked that Johns used his paintings

as a means through which to preserve memories and re-evoke lost experience, specifically by painting 'glimpses of Harlem and of Long Island that have haunted him, bits and pieces of four or five friends' (PSSOR: 90).

References in Johns' paintings, then, have been made intentionally in relation *to*, and are specifically meaningful *for*, Orton claims, this small group of friends. Johns *Untitled* signifies, among other things, this codification. As a homosexual and political liberal in the 1950s, Johns and his circle (including John Cage, Merce Cunningham, Robert Rauschenberg and Frank O'Hara) developed a mode of signifying in their artworks – and social relations as a whole, no doubt – that allowed them to communicate *relatively* closed meanings, in a context of the burning and banning of books in libraries, the jailing of Communist Party members, detention camps for those deemed subversives, censorship of art, and the denial of travel visas to left-wing artists (PSSOR: 99). This subculture developed self-protective means of expression, Orton claims, which tended to be private, euphemistic, and ironic, involving 'a stance of public indifference towards those issues which invite[d] the parading of commitment and belief . . . a protective solidarity between inmates' (PSSOR: 98).

Exploring the terms 'metaphor' and 'metonym', which have an important place in theoretical linguistics (as well as in some psychoanalytic writings), Orton argues that Johns' paintings signify in a way similar to that found in the 'privacy of language' (PSSOR: 92). Johns' work, Orton claims, is *not* productively read as 'metaphorical', that is, as a representation that includes, in addition to 'its literal sense or meaning another sense or meaning' (PSSOR: 90). This is the way that, in contrast, for instance, Picasso's *Guernica* (1937) is usually understood: as a painting depicting a horse, bull, heads and bodies, lamps and other objects in a contorted though recognisable room, but read as symbolising *metaphorically* the bombing of the Spanish town by Fascist forces in 1936. Metaphors 'work' if we see some connection between different things – for example, bull/fascism: one thing in terms of another.[19] However, *Untitled* – figurative, but not iconic in its references – works through metonymic association or 'contiguity': part to whole, whole to part. Johns' painting shows marks in/as patterns, 'a series of fragments, bits of surfaces, parts of the human body, traces of objects. Each pattern, object, imprint is tied by the association of ideas and values to something else, reflexively to Johns' own work, to events and objects in New York', and to more besides (PSSOR: 92).

But *how* to read the references in *Untitled* and other works by Johns is fraught with problems of description and interpretation. The references *might* be said to form a 'syntax' and 'grammar', Orton suggests, in the way that a language does (PSSOR: 91). But there is also a much more exclusive 'code' at work in these paintings, and this code is socially closed. The association between certain marks (such as the hatchings section in *Untitled*) and things known to the subculture around Johns remains unclear. These paintings, then, are allusive and elusive: open to interpretation, and yet evading, or closing down, meanings. They attract the viewer, Orton concludes, yet 'distract the enquiring mind. They seem to hide the subject, give the explainer something to find, and keep explanation cutaneous' (PSSOR: 93).

But Johns' way of being both open and closed is *historically specific and determined*, Orton claims. Johns' way is only Johns' way: *not* a universal or necessary condition of the way all art signifies, or of the way all art is made.[20]

> No one is in a position to provide a secure reading of *Untitled*, 1972. How could it be proven? And how could the proof be proven? The production of meaning is social and institutional, differential and dispersed, contestable and continually renewed . . . I have to acknowledge that I have no explanation of the meaning of *Untitled*, 1972 . . . What can be explained and understood ought to be explained and understood, albeit no explanation is ever sufficient and no understanding ever secure . . . Johns's work has eluded explanation because those who undertake to explain it are constrained by the closed explanatory system with which they approach the job in hand, and because Johns's use of metonymy as a mode of signification is a kind of closure in so far as it allows meaning to escape from all but a few readers who knew what procedures to carry out, competences to execute, or techniques to apply to produce meaning from the work . . . (PSSOR: 109–10)

Orton here reconnects semiological analysis to the concerns of a critical Marxism, arguing that Johns' use of metonymic reference in his 'abstract' yet 'figuring' paintings since the 1950s is shaped 'consciously or unconsciously, by the pre-given availability of certain cultural resources, by social relations which include such resources and their users, and by the constraints and contradictions present in any historical situation' (PSSOR: 92).

Marxism, like any other phenomenon, including painting, may be explained historically. By the mid-1980s the scholars of radical art history with roots in Marxist history and politics, such as Orton, were subjecting their own belief systems to radical scrutiny in the light of developments in art history, philosophy, and the world outside of the university seminar. It is to one of the key essays that undertook this examination that I now turn.

Politics, culture, and post-modernism

Burgin points out in his essay that 'post-modern*ism*' in art, usually dated from the mid-1960s and associated with the rise of pop and later 'conceptual art' groups, has complex roots within the claimed 'post-modern*ity*' of contemporary society. In political terms the 1980s saw a sharp turn to the right in both the US and Britain, with the election of governments in both countries committed, rhetorically at least, to 'free-market' economics and highly conservative social policies. These were bound up closely with a return to an aggressive 'Cold War' with the USSR following the latter's invasion of Afghanistan in 1980, and the election in the previous year in Nicaragua of a left social-democratic government that the US state chose to perceive and represent as a threat to its interests in the region. Systematic attempts were made by the Reagan administration to destabilise Nicaragua and support pro-US elements in other Latin American countries. In 1982 British armed forces fought and won a war with Argentina over the sovereignty of its colony, Las Malvinas (the Falkland Islands), in the South Atlantic.

Two years after that war the Conservative government in Britain, having just been re-elected on a wave of patriotism following its victory over Argentina, and with the opposition Labour Party in disarray, defeated those it considered its most serious *internal* enemy. These were the coal miners – the National Union of Mineworkers (NUM) – who had symbolised and led a radical trades union and socialist movement in Britain since the 1920s. The defeat of the NUM national strike in 1985 marked the effective death in Britain of a collective tradition of dissent based upon the organised working class with roots in economic, social, political, and intellectual radicalism. Six years later the end of the USSR occurred and thus the end of the Cold War between the two superpowers that had lasted – by turns, tepid or freezing – since 1945. In the US a scholar proclaimed, famously or notoriously, 'the

end of history', asserting that the world was now safe from the threat of Communism and that US-led capitalism could advance, supposedly bringing benefits and security to all in what would soon become known as the new world order.[21]

But what of radical art history? Did it come to a kind of end as well in the late 1980s? Though increasingly influential in terms of the teaching faculty and programmes of universities in the West, particularly in Britain and the US, it effectively had its socialist political base cut from underneath it. This was especially true in Britain, which had maintained a vibrant and distinctive Marxist political culture throughout the 1970s and early 1980s. 'New social movements', however – particularly feminism, but also groups formed to contest racism and discrimination against homosexuals and lesbians – became increasingly significant from the mid-1980s onwards, pushing the agenda in some of the scholarly and political directions discussed in my next chapter and Conclusion. In the 1990s a global 'ecological activism', embracing a number of sometimes connected economic, social, and political causes, also emerged. This movement often portrayed itself, and has been portrayed by others (rightly or wrongly) as 'anti-capitalist': that is, critical specifically of the impact of the capitalist monopoly of wealth and power on the people of both 'developed' and 'developing' countries. Yet this 'movement' – actually more of a shifting alliance of disparate, and sometimes antagonistic groups, and certainly not a Party based on any earlier socialist organisational models – had little real ability to oppose this monopoly and its massive concentration in the US and Western Europe.

These 'post-modern' social, political, and intellectual developments, nascent in the 1980s, form the centre of Hebdige's concerns in his essay 'Staking Out the Posts', published as part of his 1988 collection *Hiding in the Light: On Images and Things.* The other essays in this book mostly discuss items from 'popular' and 'mass culture': for instance, motor scooters, cartoons, pop videos and pop music, and design in 'lifestyle' magazines. The relevance of Hebdige's studies to radical art history lies primarily in terms of the critique – implicit and explicit – they pose to the canon of artefacts deemed to be worthy of study. Much radical art history in the 1970s and early 1980s had only marginally increased the diversity of objects subjected to substantive analysis. Indeed, some scholars – Clark and Barrell included – had, quite unapologetically, confirmed the value of the narrow canon of conventional art history.

If 'post-modernism' in cultural terms is to be given a critical efficacy, Hebdige argues, if it is to be rescued from its status as a mere

style label (which Burgin sees it as), then its theoretical and evaluative content must be specified and the many different interpretations of its meanings and values sifted. In this, Hebdige agrees with Hal Foster who had identified 'conservative', 'anti-modernist', and 'critical post-modernisms' in an introductory piece heading an influential collection of essays published in 1985.[22]

Post-modernism certainly *is* a buzzword, Hebdige agrees, but it has become so because it reflects, and itself constitutes, important inter-related changes in art, society, and intellectual understanding. Its growing presence in academic and wider 'cultural commentary' indicates an ambiguous significance, Hebdige notes, as its meanings become stretched 'in all directions across different debates, different disciplinary and discursive boundaries', and as it is used by different factions to 'designate a plethora of incommensurable objects, tendencies, emergencies' – in, for example, architecture, sociology, politics, history, economics, the mass media, art, and art history (SOP: 181). Indeed, 'post-modern' has become a term for many of the items and effects, ideas, and values encountered in *my* account of radical art history's journey from the early 1970s, including:

> the design of a building . . .
> the diagesis of a film . . .
> a television commercial, or an arts documentary, or the 'inter-textual' relations between them . . .
> the layout of a page in a fashion magazine or a critical journal . . .
> the attack on the 'metaphysics of presence' . . .
> the collective chagrin and morbid projections of a post-war generation of baby boomers confronting disillusioned middle age . . .
> a proliferation of surfaces . . .
> a new phase in commodity fetishism . . .
> a fascination for images, codes and styles . . .
> a process of cultural, political, or existential fragmentation and/or crisis . . .
> the 'de-centring' of the subject . . .
> the collapse of cultural hierarchies . . .
> the dread engendered by the threat of nuclear self-destruction . . .
> the decline of the university (SOP: 182)

Hebdige's list is longer, but the point is clear: 'post-modern' came quickly to refer to almost any object or *way of seeing* an object. It also came to refer to a set of 'endings' claimed to have occurred in the

world, centrally within traditions of belief. The end of modernism in art and art criticism. The end of socialism understood both as a utopian dream and as a realisable plan of a different future for the world. The end of the belief in technology as an unqualified 'good' in the world. The end of the related – foundational – belief in the perfectability of human beings: the 'model of the subject secreted', Hebdige says, 'at the origins of Western thought and culture in transcendental philosophy' (SOP: 202).

Were these endings – if it is agreed that they have happened – all bad? Hebdige says 'No!' and I agree. A Marxism based on the crude reflectionism and narrow teleology of class struggle, indifferent or hostile to other kinds of exploitation and struggles in society, such as those over gender or race or age, *is* inadequate and deserves to end if it cannot, or will not, change (SOP: 207). The USSR, though counterweight of a kind to the dominance of US interests in the world, *was* corrupt and unable to provide for its own people, and exploited, as the US continues to do, many other client-regimes in the world. Was its ending, therefore, a good thing? The answer there, in global terms anyway, is less clear, and involves a choice between two undesirable realities, one past, the other present.

What I have called a sophisticated 'critical' Marxism *has* replaced crude Marxism in some political organisations and in much academic discourse – for instance, of course, in radical art history. This is what Hebdige calls a Marxism 'without guarantees' (SOP: 207). That is, a Marxism based *neither* on metaphysical assumptions about the inevitability of revolution (prompted into this change partly by the poststructuralist critique of origins and meaning), *nor* on the dire political example of the USSR as a desirable 'post-capitalist' state. But also seemingly gone is a popular radical socialist movement in Europe (its existence in the US was always much more marginal) connected to forms of activism in the academy premised on, in practical ways related to, broad-based social change, traceable back, as Hebdige says, to 'the blocked hopes and frustrated rhetoric of the 1960s and the student revolts' (SOP: 186).

Seemingly gone also, thankfully, is the 'formalist' account of Modernist art, represented latterly by Greenberg and Fried, that phantasised a radical autonomy of art from life and politics, and claimed to find it in the high art of Abstract Expressionism and Post-painterly Abstraction. But, according to Peter Bürger and T.J. Clark, amongst others, no 'authentic' political-revolutionary avant-garde has come after 1970 to emulate, in changed circumstances, the dadaists, constructivists,

surrealists, and situationists, who practised such radicalism in the age of modernity and modernism. 'Mass' culture, though certainly 'read-able' and sometimes 'entertaining', has become entrenched as a fully *corporate capitalist* culture at the level of economic production and marketing. Its global 'popularity' is now locked into a relation of domi-nance with the forms of surviving 'elite' high culture that are, by turns, made to represent varying dreams of transcendence, religious or idealist. Post-modernity, Hebdige depressingly concludes, is thus 'modernity without the hopes and dreams which made modernity bearable'; hopes and dreams to which Clark has bidden his own farewell (SOP: 195).[23]

So if post-structuralist philosophy and post-modernist culture signal primarily a set of negative positions – *against* totalisation, *against* teleology, *against* utopia – as Hebdige argues, the dilemma or 'crisis' those living in post-modernity face is what to represent, or think, or do, instead (SOP: 186–96). For some post-modernist philosophers the situation is apparently one of the loss of meaning *altogether*. This has been represented in a variety of ways: the loss of any referent located in a verifiable 'real world' (Jean Baudrillard's simulacrum, the 'autistic "ecstasy of communication"'). The emergence of the 'schizophrenic consumer' of advanced capitalism (Fredric Jameson). The 'nomad' bereft of any authentic home or identity drifting across 'milles plateaux' (Gilles Deleuze and Felix Guattari) (SOP: 194).[24]

For sure, these ideas have connections back to the 1960s, when many of the same thinkers were on the 'libertarian left', when the rights of pleasure, the play of desire, and the 'discourse of the body', as Hebdige calls it, had already adumbrated a new kind of politics long before the term post-modernism became common currency (SOP: 189). Some of these ideas and values were implicit in radical art history's roots. Feminism, 'micro politics', the autonomy movement, the coun-terculture, the politics of sexuality, the politics of utterance, 'all these "movements" and "tendencies" grew out of the cracks', Hebdige says, 'the gaps and silences in the old radical articulations' (SOP: 188). But they had no necessary *interconnection* as forms of radicalism, no common ideal or vision of a different world. This, too, could be seen as a strength, because it meant there would be a need, if the desire was there, to openly *construct* alliances, to *form* articulations, not rely upon assumptions of common interests.

Feminists, for instance, had always been wisely suspicious of Marxism. But some had wanted an alliance – of intellectual perspec-tive (at the level of historical materialism) and political action for social(ist) change: 'uniting' men and women against a common enemy

for a proposed common future without capitalism. The promise of this radical, collective, and revolutionary alternative world has certainly, if not conclusively, receded, along with the apparent semantic securities of 'sign', 'structure', and 'subject'. Dreams of a different kind came to replace those of utopian social change: the dreams of advertising in the 'society of the integrated spectacle' of advanced capitalism.

Cultivating nature

Block magazine in the 1980s gave space to radical art historians, such as Clark, Pollock, and Orton, who had developed fundamental critiques of conventional art history but offered reconstructed objects of study still largely drawn from the canon of the discipline. At the same time, however, *Block*'s editors began to encourage those concerned with the study of popular culture – Dick Hebdige amongst them – to write for the journal.[25] In 1982 *Block* published an article by Kathy Myers entitled "Towards a Theory of Consumption: Tu – A Cosmetic Case Study'. The presence of this essay signalled *Block*'s early commitment to the analysis of broad areas of what would later become known as 'visual culture'. This is a term used both *descriptively*, to include advertising, film, and television, and the designed world in general, and *evaluatively*, to indicate a fundamental reconceptualisation of objects, and modes, of study.

This reconceptualisation had begun to take place within the development of a new academic field – it wasn't readily identified, or identifiable, as a specific discipline – called 'cultural studies' that emerged in Britain in the mid-1960s. Like radical art history, what *became* the academic subject of cultural studies had developed importantly from roots in social and political radicalism in the British working-class socialist and trade union movement. In the 1950s workers' education groups linked to trades unions and political parties on the left in Britain sought to describe and explain the changes taking place in the economy, politics, and cultural life of the country.[26] Myers' essay, about a brand of cosmetics sold by a chain store, brings together a range of concerns – the study of product design and marketing, advertising techniques, and the semiotics of advertisements. Myers analyses the relationship between these processes and products, and the formation of 'subject-identities' for women in modern consumer-capitalist and patriarchal society.

Myers' starting point, however, is a critique of traditional Marxist accounts of 'consumption' and in this sense her essay, like Orton's, was

partly a vehicle for assessing the explanatory power of an influential critical theory. Like Hebdige, Myers finds Marxism inadequate in a number of key analytic (and implicitly political) respects. Myers, like Mulvey, Burgin, and Pollock, finds Marxism's blindspot to be its lack of interest in women and their relation to production and consumption in capitalist society. In usual Marxist accounts, Myers claims, consumption has been understood as a *secondary* process, one 'regulated and ultimately determined by the dominant relations of production . . . Consumption is subordinated to the forces of production in the organisation and rationale of capitalism because it does not produce surplus value – the incentive behind capitalist economic relations' (TTC: 167). 'Production' for Marxists, Myers states, means the kind of work associated with working-class *men* since the nineteenth century: heavy industry, factory labour, and the jobs associated stereotypically with men – driving trains, operating cranes, digging for coal, and the like.

'Consumption', in both theoretical and empirical terms, Myers notes, has been given little attention, within both Marxism *and* traditional political-economic science and 'positivist' economics. For the latter, consumption is 'identified as a primarily 'rational' activity which in some sense dictates the play of market forces. In so doing, demand is invested with a power to exercise an authority over the organisation and supply of goods on to the market' (TTC: 167). Myers is driving towards the point that, not only have Marxists failed to understand the historical place of women as workers in capitalist society – as producers – but that *all* accounts fail adequately to recognise the significance now of 'consumer capitalism' as an important facet of the economy as a whole.

Within consumer capitalism (rapidly assimilated to the category of 'post-modernity' in the 1980s, as Hebdige's list indicates: '. . . the layout of a page in a fashion magazine . . .', SOP: 182), women feature *more* importantly than men as consumers. Market research suggests, Myers states, that women make up over 80 per cent of domestic purchasing decisions in the UK. As a consequence, 'it is not surprising that advertising and marketing campaigns tend to address the consumer as "she"' (TTC: 169). Marxist economic studies, then, have, like all patriarchal ideologies, ignored or made marginal kinds of social activity associated with women not thought directly to contribute to the production of 'surplus value' (profits – the chief sign of the exploitation of labour) in capitalist society (TTC: 167).

Myers notes that Marxists have more or less ignored *all* forms of production that take place in the home – the 'private sphere' – where

women have traditionally been assigned responsibilities and some power. Domestic 'labour', such as childcare and cleaning, have not been recognised as labour *at all* in the theoretical senses identified by Marxists; that is, in which labour is clearly 'sold' (commodified) and from which a 'surplus value' or profit is extracted. Rather than being seen as part of the economy, then, 'domestic labour' has been perceived and valued by Marxists and most other men in society, as simply a prop that enables the society to be reproduced, rather than as a 'structurally important part of that process'. Some feminists have actually contributed to this situation, Myers claims, by organising their resistance to women's social marginality around 'domestic labour' campaigns, calling for them to be paid formally for this work. Ironically, in the process, Myers says, these feminists, like Marxists, privilege real 'production' and 'effectively ignor[e] those aspects of women's labour which contribute to consumption' (TTC: 168).

Is consumption 'good' or 'bad', Myers asks? Some feminists have argued that analysis of it could be regressive because it might work to 'entrench women further into the ghetto of the home'. Ironically, therefore, re-evaluation of consumption could 'paradoxically collude with the ideologies which feminism sought to disrupt' (TTC: 169). However, this doesn't seem to have worried Mulvey, who, like Myers, is concerned with the ways in which representations of one kind or another — Hollywood narrative film, a cosmetic product, its advertisement – involve both production *and* consumption. Both Mulvey and Myers are also concerned with how women, through consumption – of film narratives or cosmetics – produce *themselves* as certain kinds of subjects in capitalist, patriarchal society.

Consumption *is* productive, Myers states, 'in so far as it generates meaning for the nature and substance of social life' (TTC: 169). Cosmetics marketing works to identify 'use-values' for its products which are related to already circulating 'social and ideological discourses at work' in society (TTC: 174). Tu is a brand of cosmetic that its marketers wanted to aim at younger women shopping in the chain store Woolworths who came from the lower income groups. Tu had to be 'branded' in competition with other product ranges sold in competing outlets. The creation of an identity for the product range, then, had to precede its marketing. Myers calls this Tu's embryonic 'use-value', conceived by its designers as 'a comprehensive range which will coordinate with modern fashion wear . . . as a symbol of youth, sophistication and modernity . . . as a range which create[s] dramatically effective transformations in appearance . . . [and is] . . . financially accessible' (TTC: 173).

Myers moves on to consider the production of Tu's photo-text advertisements which attempt to convey this brand identity. One can see here the general relevance of Bryson's 'image/text' argument in his essay 'Discourse, Figure' discussed in Chapter 5 – the advertising text clearly *is* crucially involved in the strategy to sell Tu. Advertising, Myers states, 'plays an instrumental role in transforming the products of industry into commodities. It does this by ascribing identities to products' and so helps create the 'reality' of 'subject-identity' (TTC: 169). Myers' analysis of Tu advertisements, however, may be subject to the same criticism made earlier of Bryson's analysis of paintings. Both Bryson and Myers propose readings which they *claim* are how these representations have been seen and understood; neither, however, produce any evidence that any actual, empirical viewers actually saw or understood these representations in the manner suggested. These readings, then, remain those of art-historical and media analysts, though we might *infer*, in the case of Myers, that evidence of sales of the product indicate the success of its advertising campaign and in that sense confirm Myers' claims.

Myers' analysis of advertising imagery and narrative indicates her familiarity with many of the arguments and concepts mobilised by radical art historians. The advertising text understood as a cultural product, she says, 'is indistinguisable from other cultural products, such as magazines or films . . . It aims to identify a product and thus turn it into a commodity, and it aims to transform readers of the advert into consumers of the commodity . . . the job of the creative team is to execute the necessary conditions for a pleasure of the text' (TTC: 177). Myers then considers an advertisement for Tu consisting of two parts. The top half shows a photograph of a woman's head and shoulders. She has a key on a chain held between her glossy red lipstick painted lips, a made-up eye and cheek highlights. A line of text across her body reads: 'Tu. How to hold a conversation without saying a word'. The bottom half of the advertisement contains text on Tu's product range and some inset photographs of puckered and sexually suggestive red lips, along with a Tu lipstick and pot of nail varnish and brush. The suggestiveness of the photograph and line of text (connoting 'you can come home with me') is echoed and reinforced by actual words and phrases in the text below ('all you need is Tu'; 'Others will get the message and you needn't say a word', 'The seductive you', 'lip and nail colours . . . that say exactly what is on your mind. Even if you are too shy to say it out loud' (TTC: 179)).

Myers, drawing on psychoanalytic and semiotic concepts, identifies several 'codes' at work in this advertisement. By code she appears to mean 'specific form of reference', and is perhaps invoking the work of the theoretical-linguistics scholar Roman Jakobson.[27] These include a *psychoanalytic* code, related to pleasure in identification with the image and the promise of sexual fulfilment. (We tend to *assume* the advertising image was designed to appeal to heterosexual women, but could the image have been aimed at lesbians, bisexuals, or men? Even if not directed at them, it undoubtedly would have been seen by them. How might they have reacted?) Myers argues, however, that this code does not work in isolation from others (TTC: 184). A *narrative* code in the advert, she says, which works to relate the ad to the viewer's life, suggests that if you use these products then you can discover that the 'real' you was already there (TTC: 178). What Myers calls a *semic* code also operates in the image. This is the advertisement's specific combination of images and text. The phrase 'The pot is Damned Pretty' only makes sense, for example, when you know that 'Damned Pretty' is the name of a Tu lipstick (TTC: 179).

A *hermeneutic* code, working in tandem with that of the narrative, allows and encourages the viewer of the advert to 'build up a picture' of how the product will work for her. But the advertisement itself cannot and *must not* deliver 'narrative closure' (that is, socio-sexual fulfilment in a new identity) because the point of the ad is to get you to *buy* the product. The advertisement must leave you feeling incomplete *without* the product. Finally, a *cultural* code in the image connects the advertisement to the ideologies and values of the society as a whole, within which the product can find or create a space in relation to people's already formed identities and lives.

Myers observes, echoing Mulvey, that advertisements, like narrative film, represent women as essentially passive, unable to speak, or prevented from speaking – Tu women 'needn't say a word' (TTC: 183). Although women can, and must, buy the product to 'acquire' the image, this action simply reproduces the place and identity of women in patriarchal society, and Tu works to 'reinforce the silent beingness of "women-as-image"'. Women get what they want by being beautiful; their destiny, Myers says, 'is in their face' (TTC: 183). When did such an 'image-culture' begin to emerge in modern society? If it has *always* been present, locked logically into a society based on commodity-production, as Marx and later Marxists have insisted (though they ignored its relations to gender-identity, as feminists such as Pollock, Mulvey, and Myers argue), then it must have been an element in

another, earlier, proposed 'Other' to man, also ready to 'offer itself up' for him – that of the natural world.

'Nature', understood as image and commodity, is the subject of Nick Green's 1990 study *The Spectacle of Nature: Landscape and Bourgeois Culture in Nineteenth-century France*. Based on a doctoral dissertation supervised by Griselda Pollock and Adrian Rifkin, Green's book brings together a cluster of issues and problems relating to arguments and methods within Marxist art history and post-structuralist philosophy. Like Myers, Green is interested in an area of social experience and representation usually neglected, or invisible, within Marxist history. This is what he calls the 'picturing of nature', and its literal and metaphorical 'spaces' in the world and in 'discourse'. For Green, discourse is a concept drawn specifically from the writings of Michel Foucault, though, like Burgin and Hebdige, he attempts to find an alignment, a synthesis of sorts, between post-structuralism and a sophisticated critical or 'cultural Marxism'.

Marxists, such as Clark and Barrell, have written extensively on representations of nature in paintings in France and England in the period from the seventeenth to the late nineteenth centuries. Green's argument, however, is that such studies, though highly valuable, have remained too narrow in focus and, indeed, have worked conservatively to reinforce the value of traditional art history's canonical objects. Green develops two related inquiries in his book. First, he offers a critique of Marxist accounts of the relationship of representations to social reality (based on his appropriation of Foucauldian 'discourse theory', in a manner similar to that of Tagg's account of 'photographic realism'). Second, he attempts to expand the field of visual and textual representations relevant to understanding the form and meaning of 'nature' and 'the natural' in France in the first half of the nineteenth century.

The latter inquiry also involves a radical questioning of the analytic practices and values underpinning social history of art arguments, specifically those of Clark in his studies of canonical French art and society during the development of modern capitalism. Though diplomatically indirect in his criticisms, Green is firm about the inadequacies he identifies in Clark's (and others') work. His view is worth presenting in some detail:

> The sticking-point is the retention by art history, even radical art history, of a set of texts designated *art* as the fulcrum for cultural analysis . . . certain highly wrought and codified objects – whether

oil-paintings, banners, cathedrals, 1950s furniture or critical writing on art – [which] provide not only the way into research but its touchstone. Methodologically, the procedure goes like this. We move from the given set of texts (visual or otherwise) outwards to the wider historical structures within which they are seen to be produced and circulated. In doing so, we cast the net much wider than the received wisdom of art history, to draw in the state and its institutions, family patterns, professional groupings, and so on. From there, armed with such knowledge, a number of conclusions can be drawn out about the connections between texts and social relations ... [however] ... an implicit circularity ... takes us from text to social conditions and back again, reproducing a figure-on-ground, black-on-white relation between something called 'the text' and what may be called history, conditions of production, readers or audiences ... Given the route just mapped, the text-based approach can easily smuggle back in something called art, not now aesthetically but *epistemologically*. Built into the paradigm is the central importance of those initial highly-coded objects/texts for defining the field of study, fixing the limits of visibility. Art still stands as the *métalangue* for how culture as a whole is envisaged. That is to say, what is on offer is a tightly-specified field of texts, products and genre which marginalises all those procedures that cannot be handled in a textual way, that cannot be neatly frozen or framed. Deep down here is a root disagreement about culture. (SN: 3–4)

Now, certain of Green's claims here I find highly questionable – particularly the assertion that 'art' (read: Courbet's paintings in 1848 as analysed by Clark) is proposed explicitly as standing for the 'culture as a whole'. Clark has never made such a statement and is never likely to. Green *infers* (and Clark would not disagree), however, that Courbet's paintings for Clark *are* aesthetically and epistemologically highly significant, within the history of French art and politics in the 1848 Revolution. Clark's argument, after all, is that those paintings get caught up in that moment's 'effective historical process', for a variety of interconnected social, cultural, and political reasons. Green's dispute with Clark, then, put in a rather more prosaic way, is that he doesn't value painting, or those paintings by Courbet, as much as Clark does.

Green, like Myers and Hebdige, wants to include in his historical account of French culture in the early nineteenth century artefacts,

practices, and ideologies that have not hitherto found a presence, or more accurately, been a *focus* of attention, in art history. The *idea* of the French countryside attains a particular image and ideal for the urban population in the first half of the century as the country's commercial and industrial economy, based in cities, develops. Green includes in his study consideration of contemporary illustrated books, theatrical spectacles, jokes, and country houses, dioramas, photographs (and paintings) of the countryside, all produced and circulated he says 'in articulation with other . . . processes of leisure and pleasure, as part of the uneven field of discourses constituting nature' (SN: 3).

'Leisure' itself – as an idea, a set of practices, simply as a possibility – is one of the chief inventions of that dynamic economy and society. 'Tourism' was a product of that new leisure time: a product in the literal sense of being a set of novel commodities (such as holidays, day trips, guide-books, etc.). Leisure also helped to produce a *new kind of person* who could visit the countryside, and find some difference and meaning in an environment *produced as different* from that of urban life and work. Green, like Clark, reveals a personal preference in the choice of his objects of study – his book begins by a consideration of the pleasure he says he has in looking through train windows at the countryside (SN: 2).

Green's notion of this 'discourse of leisure' is intended to include, or 'articulate', artefacts, practices, and ideas, all of which he believes are bound up in these new social experiences of people. These elements make sense together as *a way of life*, and Green borrows as much from British Marxist cultural studies thought, where the idea of culture as 'a way of life' is given particular importance, as from post-structuralist accounts.[28] There is, then, in Green's notion of culture and discourse, a refusal of the *category* of high art understood as a separate and elevated idea and class of objects, rather than an unwillingness to include a study of paintings as significant elements within the discourse of 'nature' in nineteenth-century French society. Green also prefers to use the concept of 'discourse' because he sees it as an advance on crude Marxist accounts of ideology: 'discourse' does not divide up the world simplistically between events and ideas, objects and attitudes, or structures and processes.

Critical or cultural Marxism, however, had itself superseded such 'reflectionist' and 'economistic' accounts of society, culture, and history without having to rely directly, or solely, on the critiques of 'the sign', 'presence' or 'the subject' developed in post-structuralist philosophy. And Green is aware of this. Foucault's notion of 'discourse' is

valuable because it allows an amorphous idea like 'nature' to be thought through and related to an array of implicated phenomena:

> *Discourse* ... designates a coherent pattern of statements across a range of archives and sites that sets the terms for the operation of both truth and power in any field of knowledge. From which it follows that the discourse on nature has to be analysed in terms of its *systematic relations* rather than the properties and characteristics of any particular text or image ... The question is no longer one of analysing an internal field of images in its relations to a set of external determinations – art *and* society, art *and* nature – but of grasping the interdependence of cultural practices along with their mutually reinforcing results. (SN: 3–5)

This does sound rather like another way of saying the same thing that Clark, Pollock, and many others have said, which is not to minimise the value of either Green's critique of crude Marxism, or his useful account of Foucauldian 'discourse theory'.

Green seeks a link between critical Marxism and Foucault's post-structuralist ideas, and the discourse on 'nature' provides one. Green's intention, he says, is to 'bend the "spirit" of historical materialism in new directions' (SN: 7). Marxism's concentration on class formation within a society is necessary, but not sufficient, and the discourse of 'nature' allows a broader investigation, bringing in issues of gender, sexuality, and regional identities (SN: 6). This 'nature' is political, he says, because 'all discourse is political in the broadest sense, in that it shapes the kinds of cultural maps we carry in our heads and act out in our day to day lives' (SN: 5). Green acknowledges, however, that there is a serious danger that the notion of discourse may reduce *all* phenomena to 'the same level of significance' (all 'text' and no 'context'), and that concentration on what Green calls 'the microphysics of discursive power' – for example, sexuality, education, the psychological individual – 'dissolves away any broader categories of class, gender and the state' (SN: 5).

The strength and chief interest of Green's book, indeed, lies within its account of the value of the idea of 'discourse' and its critique of art-historical procedures, including those of its radical exponents (whether or not his analyses and judgements are always reliable). *The Spectacle of Nature* is evidence of the productive *and* problematic collision of Marxism with post-structuralist ideas in the early 1990s, a moment in which radical intellectual and political principles and

practices entered a crisis from which, arguably, they are yet to emerge. Much less convincing is Green's treatment of the artefacts and practices neglected by art history – for instance, Theodore Rousseau's paintings of landscapes, such as the *Allé d'l'Isle-Adam*, an exhibition piece which oscillated, Green says, 'between a serious-minded "realism" and a mode of consumption as tableaux or deluxe artifice' (SN: 133). Or Green's discussion of the diaries of bourgeois businessmen who took trips to the countryside to 'renew' themselves (SN: 134–8), living out, as Green says, the 'ideology of nature ... at the level of personal identity' (SN: 7). These studies certainly provide evidence of the discourse on nature with which Green is concerned, but they don't do so in the spirit of compelling affiliation that Clark manages in his treatment of Courbet's 1848 paintings – because he *admires* them so much. If the danger of discourse theory is that potentially everything *is* reconceived as, reduced to, 'text', as Green notes, then the problem is precisely that you may end up not being able to see the wood for the trees.

'Nature', in conclusion, figures for Green as an essential *historical* category, bound up with the social use and meaning of space in modern and modernising life (SN: 6). 'Space' is never a 'neutral vacuum but involves ways of reading and structures of experience which, even when they seem most private and personalised, are in fact profoundly social' (SN: 6). Nature, whatever objective limits and forces it operates on the humanly-made world – and these should not be underestimated, as they have been within a lot of recent cultural studies and 'post-modern' writings[29] – is usually also culturally and socially shaped. This is true of another core aspect of 'the natural' (as Fuller and Kuspit concede) and the subject of my final chapter: the sexualised human body and its changing historical representation in a variety of visual media.

Notes

1 This common-sense notion of 'agency' is antithetical and antipathetic to that of 'structure', when the latter is portrayed as an abstract 'society' repressing the creative instincts and expressive needs of artistic geniuses. See Janet Wolff 'Social Structure and Artistic Creativity', in *The Social Production of Art*, London: Macmillan, 1981.

2 See Clark's *Image of the People*, 14–15; and his case-studies of public reactions to Courbet's work in Chapters 4, 5, and 6. The 'public' and 'the people' also figure significantly in Clark's account of French painting after the Revolution of 1789, 'Painting in the Year 2', in *Farewell to an Idea*, Chapter 1.

3 See Gail Day on the concept of mediation in Clark's work, 'Persisting and Mediating: T.J. Clark and the Pain of "the Unattainable Beyond"', *Art History*, vol. 23, No. 1, March 2000: 1–18; and Jonathan Harris '"Stuck in the Post"? Abstract Expressionism, T.J. Clark and Modernist History Painting', in David Green and Peter Seddon (eds) *History Painting Reassessed*, Manchester and New York: Manchester University Press, 2000, Chapter 2.

4 See also Gisela Ecker (ed.) *Feminist Aesthetics*, London: The Women's Press, 1985.

5 See G. Pollock 'Theory, Ideology, Politics: Art History and its Myths', in 'Art History and Its Theories: A Range of Critical Perspectives', *Art Bulletin*: 16–22.

6 See Slavoj Žižek *For They Know Not What They Do: Enjoyment as a Political Factor* Verso: London, 1991.

7 See, for instance, Roland Barthes *The Pleasure of the Text*; Michel Foucault *Madness and Civilisation: A History of Insanity in the Age of Reason*, London: Tavistock Publications, 1967, *The Order of Things: An Archaeology of the Human Sciences*, London: Tavistock Publications, 1970, *Discipline and Punish: The Birth of the Prison*, Aylesbury: Penguin, 1977, *The History of Sexuality (volume 1)*, London: Allen Lane, 1979; Jacques Lacan *Écrits: A Selection*, New York and London: Norton, 1977, *The Four Fundamental Concepts of Psychoanalysis*, New York and London: Norton 1981; Jacques Derrida *Writing and Difference*, Chicago: University of Chicago, 1978, *Of Grammatology* Baltimore, Md, and London: Johns Hopkins University Press, 1978, *Truth in Painting*, Chicago: University of Chicago Press, 1987.

8 See photo-text work by artists such as Hans Haacke, Rudolf Baranik, Martha Rosler, Peter Dunn and Loraine Leeson, and Burgin himself. On definitions and accounts of 'conceptual art', a notoriously vague term, see, for instance, Tony Godfrey *Conceptual Art*, London: Phaidon, 1998, and John Bird and Michael Newman (eds) *Rewriting Conceptual Art*, London: Reaktion, 1999, and my review of the latter, 'Conceptual Art: No Beginning No End', *Art Monthly*, no. 234, March 2000: 51.

9 See Hal Foster 'Post-modernism: A Preface', in H. Foster (ed.) *Post-modern Culture*, London: Pluto Press, 1985 (published in the US as *The Anti-Aesthetic*, Port Townsend: Bay Press, 1983) and, in the same collection, Rosalind Krauss 'Sculpture in the Expanded Field'. See T.J. Clark's essay on the idea of 'post-modern', 'Origins of the Present Crisis', *New Left Review*, 2, March April 2000: 85 96.

10 Burgin has in mind artworks shown in exhibitions/catalogues such as *A New Spirit in Painting*, London: Royal Academy, 1981, and *The Vigorous Imagination: New Scottish Art*, Edinburgh: Scottish National Gallery of Modern Art, 1987.

11 On the links between humanism and formalism in twentieth-century art criticism, see Jonathan Harris 'Ideologies of the Aesthetic: Hans Hofmann and Abstract Expressionism', in David Thistlewood (ed.) *American Abstract Expressionism*, Liverpool: Tate Gallery Liverpool and Liverpool University Press, 1993.

12 The social theorist Anthony Giddens developed the idea of 'structuration' in order to attempt to capture the same doubled and contradictory sense (structure and agency: structure in agency: agency in structure), see, for instance, *Central Problems in Social Theory*, London: MacMillan, 1979. Chapter 1, and *The Constitution of Society: Outline of the Theory of Structuration*, Cambridge: Polity Press, 1984, Chapter 1.

13 See Walter Benjamin's canonical text on the social and philosophical implications of photography, 'The Work of Art in the Age of Mechanical Reproduction' (1936), in W. Benjamin *Illuminations*, London: Fontana, 1973, reprinted in F. Frascina and J. Harris (eds) *Art in Modern Culture*.

14 Terry Eagleton is scathing of the idea that politics should be reduced to the identity-politics of cultural difference, not least because these new forms of struggle seem to have little, or no relation to any anti-capitalist project. See *The Idea of Culture*: particularly 65–7. However, some have sought specifically to articulate such differences to a common struggle. See, for instance, Ernesto Laclau and Chantal Mouffe *Hegemony and Socialist Strategy: Towards a Radical Democratic Politics*.

15 For the full list of back essays, see *The Block Reader in Visual Culture*: 314–18.

16 See the selection, and further references, in Orton and Pollock *Avant-Gardes and Pastisans Reviewed*.

17 See, for instance, Nicos Poulantzas *State, Power, Socialism*, London: New Left Books, 1978; Barry Hindess and Paul Hirst *Marx's Capital and Capitalism Today*, London: Routledge and Kegan Paul, 1978; Chantal Mouffe (ed.) *Gramsci and Marxist Theory*, London: Routledge and Kegan Paul, 1979; Stuart Hall *et al. Culture, Media, Language*, London: Hutchinson, 1980; Stanley Aronowitz *The Crisis in Historical Materialism*; Ernesto Laclau *Politics and Ideology in Marxist Theory*, London: Verso, 1982.

18 On modernism's restrictions, see Charles Harrison and Fred Orton 'Introduction: Modernism, Explanation and Knowledge', in *Modernism, Criticism, Realism*.

19 On metaphor and metonymy, see Roman Jakobson 'Closing Statement: Linguistics and Poetics', in Thomas Sebeok (ed.) *Style in Language*, Cambridge, Mass. and London: MIT Press, 1960, and 'Two Aspects of Language and Two Types of Aphasic Disturbances', in Jakobson and Morris Halle *Fundamentals of Language*, The Hague: Mouton, 1956.

20 On the notion of 'determination' and related concepts in Marxist cultural theory, see Raymond Williams *Marxism and Literature*, section II.

21 Francis Fukuyama *The End of History and the Last Man*, New York: Free Press, 1992.
22 Hal Foster 'Post-modernism: A Preface', in Foster (ed.) *Post-modern Culture*: xi–xii.
23 See Clark *Farewell to an Idea*, and my review 'Get Back, Setting Suns', *Art Monthly*, no. 230, October 1999: 50–1. See also Clark's foreword on the legacy of the Situationists, in Anselm Jappe *Guy Debord*, Berkeley and London: University of California Press, 1999.
24 Hal Foster's *Post-modern Culture* includes essays on these themes by Jean Baudrillard ('The Ecstacy of Communication') and Fredric Jameson ('Post-modernism and Consumer Society').
25 Judith Williamson, contributor to *Block*, had already produced a full-length study *Decoding Advertisements: Ideology and Meaning in Advertising*, London: Marion Boyars, 1978. Other early influential texts on advertising include Roland Barthes *Mythologies*, and Raymond Williams, 'Advertising: The Magic System', in *Problems in Materialism and Culture*
26 On British workers' education, see Tom Steele *The Emergence of Cultural Studies 1945–1965: Cultural Politics, Adult Education and the English Question*, London: Lawrence and Wishart, 1997, and Nannette Aldred and Martin Ryle (eds) *Teaching Culture: The Long Revolution in Cultural Studies*, Leicester: NIASE, 1999. For an account of US cultural studies, see Henry A. Giroux and Peter McLaren (eds) *Between Borders: Pedagogy and the Politics of Cultural Studies*, London and New York: Routledge, 1994.
27 See Jakobson 'Closing Statement: Linguistics and Poetics', in Thomas Sebeok (ed.) *Style in Language*.
28 See Raymond Williams *The Long Revolution*, Harmondsworth: Penguin, 1965: 'The Analysis of Culture'.
29 See Sebastiano Timpanaro *On Materialism*, and Terry Eagleton *The Idea of Culture*: in particular 92–100.

Select bibliography

Barthes, R. *The Pleasure of the Text*, New York: Hill and Wang, 1975
Barthes, R. 'The Death of the Author', in *Image-Music-Text*, Glasgow: Fontana/Collins, 1977
Bennett, T. *The Birth of the Museum: History, Theory, Politics*, London and New York: Routledge, 1995
Clark, T.J. 'Origins of the Present Crisis', *New Left Review*, 2, March–April 2000: 85–96
Crimp, D. *On The Museum's Ruins*, Cambridge, Mass.: MIT Press, 1995
Eagleton, T. *Illusions of Post-modernism*, Oxford: Blackwell, 1996

Fiske, H. *Reading the Popular*, Boston: Unwin Hyman, 1989

Florence, P. and Reynolds, D. (eds) *Feminist Subjects, Multimedia, Cultural Methodologies*, Manchester: Manchester University Press, 1995

Foster, H. (ed.) *Postmodern Culture*, London: Pluto Press, 1985 (published in the US as *The Anti-Aesthetic*, Port Townsend: Bay Press, 1983)

Harris, J. 'Grounding Postmodernism', in Shearer West (ed.) *The Bloomsbury Guide to Art History*, London: Bloomsbury, 1996

Haug, W.F. *Critique of Commodity Aesthetics: Appearance, Sexuality and Advertising in Capitalist Society*, Minneapolis: University of Minnesota Press, 1986

Jameson, F. *Postmodernism, or the Cultural Logic of Late Capitalism*, Durham and London: Duke University Press, 1991

Klugman, K. *et al. Inside the Mouse: Work and Play at Disney World*, Durham and London: Duke University Press, 1995

Kowinski, W.S. *The Malling of America: An Inside Look at the Great Consumer Paradise*, New York: William Morrow and Co., 1985

McGee, P. *Cinema, Theory, and Political Responsibility in Contemporary Culture*, Cambridge and New York: Cambridge University Press, 1997

Mellencamp, P. (ed.) *Logics of Television: Essays in Cultural Criticism*, Bloomington: Indiana University Press, 1990

Orton, F. *Figuring Jasper Johns*, London: Reaktion, 1994

Penley, C. and Ross, A. (eds) *Technoculture*, Minneapolis: University of Minnesota Press, 1991

Squiers, C. (ed.) *The Critical Image: Essays on Contemporary Photography*, London: Lawrence and Wishart, 1990

Waldman, D. 'Critical Theory and Film: Adorno and "The Culture Industry" Revisited', *New German Critique*, no. 12, Fall 1977: 39–60

Wallace, M. *Black Popular Culture*, Seattle: Bay Press, 1992

Wallis, B. (ed.) *Art After Modernism: Rethinking Representation*, New York: New Museum of Contemporary Art/David R. Godine, 1984

Chapter 7

Sexualities represented

Key texts

Kermit Champa 'Charlie was like that', *Art Forum*, vol. 12, March 1974: 54–9: CWLT.

Albert Boime 'The Case of Rosa Bonheur: Why Should a Woman Want to be More like a Man?', *Art History*, vol. 4, no. 4, December 1981: 384–409: CRB.

Natalie Boymel Kampen, Introduction/John Clarke 'Hypersexual Black Men in Augustan Baths', both in Natalie Boymel Kampen (ed.) *Sexuality in Ancient Art: Near East, Egypt, Greece, and Italy*, Cambridge: Cambridge University Press, 1996: SAA.

Alex Potts Introduction, 'The Body of Narcissus', and 'Nightmare and Utopia', in *Flesh and the Ideal: Winckelmann and the Origins of Art History*, New Haven and London: Yale University Press, 1994: FIWOAH.

Whitney Davis 'The Renunciation of Reaction in Girodet's *Sleep of Endymion*', in Norman Bryson, Michael Ann Holly, and Keith Moxey (eds) *Visual Culture: Images and Interpretations*, Hanover and London: Wesleyan University Press/University Press of New England, 1994: 168–201: RRG.

Matter and materialism

Radical art history is art-historical materialism. Its proponents have attempted to reconceive *at all levels* the materiality of art. Whatever their specific attentions (and blindnesses), the work of all scholars discussed in this book has shared one presupposition: that a turn, or return, to some fundamental aspect of art-making and art-interpretation is necessary. 'Fundamental', in this sense, is synonymous with 'material', though there are different kinds of related materials.

Some scholars have stressed the materials out of which artworks have been made. That is, both the *literal* materials (for example, paints, brushes, oil, water, canvas, studio; stone; photographic paper; celluloid film; etc.), and the *conventional* materials (for example, techniques, skills, genres, idioms, themes, ideas, and ideologies). 'Material', here, is *not* an antithesis to 'ideas' or 'values' – the latter are also 'material' in the sense of constituting sources and resources for art, and are as indispensable as the literal tools and materials used to produce a painting, or a photograph, or a film. And art's 'conventional' materials always also exist in *literally material form*: within drawings or painted sources, or as illustrations in books or magazines, or as instructions in textbooks, or arguments in printed or hand-written critical reviews, and so on. Even if a source exists *only* in someone's memory – say Jasper Johns' memory of the pattern on the side of the car he passed on the Long Island Expressway – then its existence is *still literally material*. In this case, 'psycho-chemical', within the mind/brain of the artist.

In this fundamental sense, then, all 'culture' – that is, all manifestations of human activity – is *always* material, *always* has material existence.[1] The term 'material culture', usually deployed well-meaningly, by anthropologists or design historians, in order to designate artefacts of the humanly-made world, and opposed to 'idealist' or 'high art' notions of culture, is therefore both tautological *and* misleading, because the notion *may imply* a distinction between 'material' and 'ideal' artefacts that does not, and cannot, exist. I said in my previous paragraph that investigation of the literal and conventional materials out of which art is made is a 'for instance' of art-historical materialism. Though indispensable, it is *not* radical art history's founding, or essential, interest. To suggest that it was might imply that art and artists somehow exist *before* a social and historical world with which they then ('later') interact, a view arguably held by much traditional art history. Although art historians – traditional *and* radical – obviously focus on art within their inquiries, this focus should be recognised as an analytic and an

evaluative *emphasis*. It is not an assumption, or claim, about the onto-logical *priority* of a set of phenomena that can only actually ever exist *within, as part of*, a whole world.

Radical art history is 'historical materialist', then, because it presupposes that art, and art history, can only be made, and under-stood, by specific people in specific social circumstances existing at specific historical moments. Social historians of art have tended to concentrate on the 'conjunctural moment' in which artworks have been *initially* produced and interpreted – for instance, Clark's study of Courbet's painting in 1848–1849, or Barrell's on Constable's art in the early nineteenth century. But others, such as Wallach and Boime, have considered the 'life' of artworks long after their actual production – Wallach, for instance, in his consideration of how paintings are constantly reinterpreted within museum curation and exhibition, Boime, in his analysis of the significance of *'juste milieu'* art practices and values for the Impressionists of the 1860s.

Feminists have also adopted the principle that artists, art prac tices, and art history itself, may adequately be explained *only* if the socio-historical conditions of their existence are understood. Griselda Pollock, Rozsika Parker, and Lucy Lippard, indeed, have indicated an indebtedness to Marxist philosophy and history (and, in addition, in the latter case, a socialist political commitment). However, though committed to an analysis of the rootedness of all cultural activity in the material life of changing human societies – this is what is meant by 'historical materialism' – feminists have rejected the claim made by Marxists that the *sole* key to the organisational and developmental character of those societies is located in class struggle around economic activity and exploitation.

Feminists, rightly, have seen this identification of 'material' with 'economic' as a philosophical and analytic *reduction*. In opposition to it they have turned their attention to the materiality of gender and sexual difference, which they propose as *at least* as significant as class formation and struggle in the history of human societies. Feminists also fundamentally question the category of 'production' within Marxism, as Myers' text illustrates. Material production, they argue, involves the making of babies *as well* as the mining of coal; the production of family life *as well* as the production of goods. Which is most important? Both! 'Production' and 'reproduction' are therefore *interdependent* conditions of each other, in the same way that decent health-care and child-care provision cannot simply be made dependent or consequent upon the wealth generated by the *prior* work done by men and women in

factories, offices, universities, or art studios. Child-care facilities and good health are as much the *preconditions* of being able to work well as they are possible *because* of the wealth work generates.

Radical art historians, then, understand and articulate connections between their scholarly work and such basic social and political issues, though the *visibility* of the connections in their teaching and writing varies enormously. It was the varied, creative, and optimistic radicalism of the later 1960s that provided much of the energy for the work done by Marxists and feminists in the following period. In the later 1980s and 1990s, this sense of the rootedness of radical scholarship in a desire for fundamental social change has certainly diminished, as Burgin's and Hebdige's texts indicate. What I have called a 'drawing of breath' has undoubtedly taken place, with scholars as diverse as Wagner, Kuspit, and Fuller reassessing their political and art-historical beliefs as the economic growth and idealism of the 1960s and early 1970s gave way in the turn to the political right which occurred in the US and Britain in the 1980s. Marxism and 'actually existing socialism', that is, the USSR, both underwent a fundamental philosophical and political questioning in the period, as the encounter between post-structuralist ideas and radical art historians, such as Orton and Green, indicates. But while this interrogation left these scholars on the whole *more* secure about the credibility of Marxism's explanatory claims (because these were significantly qualified), the fortunes of western traditional mass political organisation based on socialist ideals fell to an unprecedented low level, from which no significant recovery now seems likely.

The political energies of 'new social movements', however, existed alongside the resurgence in Marxism and libertarian socialist ideals in the 1960s, and fed the emergence of radical art history in the 1970s. Chief amongst these movements was feminism, but civil rights movements, anti-racist and anti-imperialist organisations, and homosexual and lesbian rights groupings were also central within the formation of the 'New Left'. In the 1980s and 1990s, with the decline in socialist organisations, these 'identity-politics' groups have expanded, both in terms of the range of their activities and in their intervention within academic disciplines such as art history. *'Radical art history' is not, therefore, and never has been, the name for a unified 'party' or 'ideology', and if it is true that all its practitioners have shared the broad 'historical materialism' of perspective outlined above, then it is also true that there have been many antagonisms and divisions within radical art history since the 1970s.* Those between Marxists and

feminists are now well known. Some have remained at the level of productive debate from which both have benefited. Others have led to bitter conflict, such as that between 'separatist' feminists with no interest in either what they see as 'male' Marxist theory or socialist political belief. Of course, there has also been both debate and bitter conflict *amongst* Marxists and *amongst* feminists.

Wagner, for instance, includes in her study a robust attack on certain aspects of Griselda Pollock's critique of Modernism. Like Fuller, Wagner is concerned to retrieve, or construct, a notion of 'the aesthetic' and understand its relations to the materiality of actual women's lives, although she believes that aspects of aesthetic response may be supra-ideological, if not 'universal'. In this sense, both Wagner and Fuller could be described as 'anti-Marxist', if 'Marxism' is used here to designate the mechanistic or crude idea that 'the aesthetic' is nothing more than a mystifying ideological 'reflection' of economic relations between classes.

The idea of the 'materiality of the sign' sometimes has a similarly anti-Marxist element to it. Although Bryson, Mulvey, Pajaczkowska, Alpers, and Bal all propose that art can be meaningful *only* within socio-historical circumstances, they all believe equally that crude Marxism has denied, or underplayed, the material reality of visual art. By this they mean an understanding that the specific signifying forms, processes, and discourses in visual art are *irreducible to any other forms, processes, and discourses*. Although, for example, Bryson wants to show how perspective helps to create an 'effect of the real', or Mulvey how Hollywood filmic narrative 'engenders' identity as active or passive, neither believe that Marxism has the resources to explain how these processes of signification work. Both, along with Kuspit, also hold that the *materiality of embodied consciousness and unconsciousness is a necessary aspect of such an explanation*, and therefore that some psychoanalytic concepts are indispensable. Sexual drives, 'voyeuristic' and 'fetishistic' gazes, 'symbolic' pre- and post-oedipal relations between viewer and object, object and producer, are all notions appropriated by these and other scholars, in order to *concretise* the workings of signification in art.

Fuller, along with Tagg, Wagner, Mulvey, Bryson, and Green, though, understands that identifying the specificity and irreducibility of signifying practices in paintings, photographs, sculptures, and films is not the same as declaring their *autonomy* from particular social circumstances. The relationship between the two is always complex and always a matter of judgement. Fuller and Kuspit, I've suggested,

are partly engaged in a polemic with what they see as crude Marxism *and* feminism. Wagner's critique of Pollock has a similar feel to it, though her position is much more nuanced and deliberated. Fuller rapidly moved from a Marxist to an anti-Marxist position in the 1980s. Wagner, as she says, is contributing to a still 'unfinished' feminism.

Where, however, might homosexual and lesbian activists, scholars, and artists stand in relation to such issues? What kinds of productive relation might the study of the representation of sexual orientation in art and art history have with the political and intellectual perspectives encountered so far in my study? What material resistances might the depicted 'sexualised body' hold for radical art history?

Semantic/somatic: Charles Demuth and Rosa Bonheur

Kermit Champa's essay 'Charlie Was Like That' appeared in the US journal *Art Forum* in 1974 and is one of the earliest affirmative studies of a modern homosexual artist – Charles Demuth. By 'affirmative' I mean that the argument in Champa's essay is explicitly supportive, both of Demuth, and of the *idea* of a history and criticism of art and artists in terms of the issue of sexual identity. Of course, many conventional art-historical studies have been published of artists known, or rumoured, to be homosexual – most famously, perhaps, Michelangelo and Leonardo da Vinci. However, the sexual orientation of these artists figured little, if at all, in most of these accounts, and when it *did* find mention it was not from the perspective that homosexuality was a basis for political action, or the 'coming out' of gays part of a revolution in modern sexual and social life.[2]

Champa's account of Demuth – one of the most famous 'Precisionist' painters in the US in the first half of the twentieth century – considers the artist's life and social situation, as well as his artworks. Couched more as a piece of biographical art criticism than as an art-historical investigation, Champa, a scholar of Impressionist painting, proposes what most other radical art historians would consider a traditional and rather conservative account of 'the aesthetic', and of aesthetic quality, in Demuth's art. 'Gay and lesbian studies' was in its infancy in the mid-1970s but it remains true of this academic development that it is a diverse *field* of issues, rather than a singular 'theory', and even less so a unitary 'method'. The political implications of its development are also complex and ambiguous, though most of its practitioners would place themselves 'on the left', and in favour of social

tolerance. Like feminism, however, gay and lesbian political organisation is politically and ideologically heterogeneous: likely now to have its 'bourgeois' elements, as well as its socialist and separatist wings. In academic terms this heterogeneity means that the study of a gay artist *may* go hand in hand with holding very conservative beliefs about the nature and value of art.

Champa does not make clear either the political or ideological significance of Demuth's homosexuality. That is, Champa makes no statements that indicate the meaning of homosexuality beyond the reasonable inference that it is, for some, a natural and positive experience, although 'straight' society (as feminists argue about patriarchy) has clearly made life for homosexuals difficult and sometimes dangerous. Champa's account of Demuth echoes some of the points made by Orton about Jasper Johns, a homosexual artist living in the US a few decades later. Mentioning turn-of-the-twentieth-century 'arts' homosexuals, such as Oscar Wilde and Aubrey Beardsley, Champa remarks that these people developed, out of sexual guilt, 'elaborate codes of sexual presentation' that operated as defence mechanisms *and* as 'a positive stylistic force' (CWLT: 55). 'Code' here has the same ambivalent sense it has in Orton's discussion of Johns: it means both a way of *disguising* (you have to know the code to understand the meanings) and a way of *signifying* (demonstrating a value or belief or feeling).

Demuth's use of engineering and construction symbolism in paintings, such as *Paquebot, Paris* (1921), or *Waiting* (1930) – pictures showing funnels and ventilators on what could be buildings or ships – recalls, Champa claims, the interest that the French homosexual writer Baron Huysmans displayed in the form of railway locomotives. In Huymans novel *A Rebours* ('Against Nature', 1884) the protagonist, des Esseintes, recalled earlier sexual excitement from 'two great man-made ladies' – the engines put into service by the French national railways. By using this symbolism, Champa claims, Huysmans obviated the need to 'recall the physical source of real sexuality' (CWLT: 56). The symbolic idiom or code, however, was flexible, Champa notes, and Demuth would use flowers or fruit or acrobats as such vehicles at different moments in his career.

But when is a funnel only a funnel, and when is it a penis symbol? Champa has no answer to this question and, in a sense, it is not a problem anyway for him. Demuth's funnels are *always* symbols simply because Champa stipulates that they are. Champa's style of thinking and writing is, as I've said, more journalistically art-critical than

academically art-historical. Issues to do with the determination of meaning and reference that preoccupy radical art historians barely register at all in Champa's discussion of Demuth. Champa takes it as read that by the 1910s homosexual artists 'submerge decorously but without total concealment naughty and frequently chaotic sexual suggestions' (CWLT: 55). He does, however, suggest a connection between such symbolism and the development of a 'Freudian culture' in New York in which artists and critics were involved. This near 'mania for amateur Freudian analysis' in the years around World War I, Champa remarks, entailed an 'earnest and playful search for phallic and vaginal symbolism in seemingly neutral objects' (CWLT: 57).

The Dadaists Michel Duchamp and Francis Picabia were both in New York in 1915 and catalysed the production of this kind of symbolism in art and in its interpretation. Demuth wrote a poem for 'Richard Mutt' – the name inscribed by Duchamp on his *Urinal* (1917) first exhibited at this time – containing reference to symbolic meanings: 'One must say everything – then no one will know/To know nothing is to say a great deal' (CWLT: 58). Duchamp's *Bride Stripped Bare by Her Bachelors, Even* (1915–1923) was, according to Champa, a 'quintessential clue to Demuth's sense both of meaning and of quality in art – decadence, Freudianism and New York Dada' (CWLT: 58).

For Champa, however, the quality of Demuth's pictorial symbolism lies in its relative obscurity, and it is possible that Champa believes the same thing about Demuth's representation – and even evaluation – of his homosexuality:

> . . . to call the playful and troubling sexual suggestiveness of his work from the teens strictly homosexual is to miss the mark – randomly sexual, yes, distinctively homosexual, no. From this comparatively early and productive period in Demuth's life, sexual innuendos, whether represented by actual figures or indirectly by flowers or other plant life are ambiguous and pictorially supportive. Later on in the 1920s, as industrial and still-life paintings become increasingly programmed to elicit the shapes of genitalia, usually male, overt sexual imagery emerges and appears dominantly homosexual; and much later in the early 1930s, when this imagery becomes flagrantly, almost defensively, explicit, the result is a pictorial disaster. (CWLT: 55)

In good modernist fashion Champa's account of the 'achievement of quality' in Demuth's art is what philosophers call 'irrefutable':

meaning not that it is beyond doubt but the opposite – couched in such terms as not to be open to rational doubt at all.[3] One *believes* the stipulation or not, in the same way that one has faith, or not, in God. Like Kuspit's discussion of Matisse's primitivist paintings, Champa claims that Demuth's art sought something 'esthetically pure', something spiritual beyond the sexual symbolism (CWLT: 59). Matisse attempted to achieve this, Kuspit claims, by moving beyond the primitivist representation of the nude and fashioning an idealised and abstract form instead. Demuth, in contrast, retained a range of symbolic forms but when they became too explicit the work was a 'pictorial disaster' (CWLT: 55).

A further element of ambivalence perhaps creeps into Champa's account when he says that Demuth had probably had little 'real sexual experience of any sort' until his 'ultimate surrender to homosexuality' (CWLT: 55). Before the 1960s homosexuality remained mostly socially unsanctioned and illegal, so in one sense Champa is merely confirming that people with homosexual desires before then mostly repressed them or sought coded and secretive forms of giving them representation. Demuth's art was one such form. Despite his expression, however, Demuth remained guilty, Champa claims, although towards the end of his life he 'came out' flagrantly both in terms of his art and sexual life. Once this happened, his art – now overtly homosexual – declined (CWLT: 55). Interestingly, Champa's notion of 'quality' is rather like Clark's in some respects – based on believing that Demuth's paintings resist meanings, seek and propose tensions in their symbolism, and produce a degree of doubt and confusion in the public.[4]

In one sense, this similarity is not so surprising. Demuth's art is modernist and so is the art that Clark examines. 'Modernist' here means a concern with contemporary social reality and experimentation with forms for the figuring of aspects of that reality in art. The iconography of machinery and sexual identity are both part of that modernity. Champa was courageous in 1974 to propose this reading of Demuth and particularly to remark that the artist's sexuality *had* to be addressed openly. The paintings, he said, 'in their provocativeness seem to demand it. There is, finally, more potential for error in avoiding the issue of cultivated sexuality in Demuth than in phrasing it wrongly. To avoid it means to overlook so much contained in so many images that there remains too little left to see, and Demuth wanted his pictures seen above all' (CWLT: 55).

All artists and all artworks *could* be understood in terms of sexuality and sexual symbolism. That most art is assumed to reproduce

heterosexual and male sexual proclivities underlines the predominance – the 'neutrality', naturalness, and inevitability – that heterosexuality has attained in our society, particularly in the last century. For this reason, but *not* for this reason alone, sexuality in art and artists has become an interest of those who question sexual identity and sexual proclivity – be they men or women.[5] Albert Boime's 1981 essay 'The Case of Rosa Bonheur: Why Should a Woman Want to Be More Like a Man?', published in the British journal *Art History*, brings together questions of sexuality and political identity, in a period – the mid-nineteenth century in France – when neither feminism nor lesbianism were established or even really marginally socially acceptable.

Bonheur, like Demuth, had been a highly successful artist, renowned as one of the greatest painters of animals in the history of western art and certainly, Boime notes, the best known woman artist of the nineteenth century (CRB: 384). How might her career as an artist and identity as a woman in French society at that time be related? Boime, like Champa, embarks on an investigation as much concerned with Bonheur's life and relationships as with her art and professional standing – on the principle that the two, as Wagner argues in relation to Eva Hesse a century later, are necessarily inter-related and mutually informing. These accounts all suggest that what might be called 'critical biography', entailing an *empirically-informed* socio-historical analysis of the life of individuals – emphatically not the myth-making of traditional monographic and patriarchal art history – has a significant place in radical art history as part of the task of reconceptualising 'agency'.

Like other great women in the arts in the nineteenth century, such as the novelists George Sand and George Eliot, Bonheur committed herself to what Boime calls a 'wholly independent and unconventional way of life' (CRB: 384). Though choosing not to adopt a man's name under which to work, Bonheur instead lived a life that fused, and confused, traditional male and female gender identities, embracing 'elements of a masculine guise', such as wearing men's clothes, rolling her own cigarettes which she chain-smoked, and hunting (CRB: 384). Of course, none of these pursuits were then, or are now, *intrinsically* male or masculine activities. They had, though, come to signify maleness and masculinity. In this sense they might be 'read' as a kind of text Bonheur wrote for herself, alongside the highly naturalistic paintings of animals she produced: both being two kinds of 'reality effect', as Bryson might say. Other attitudes and values she possessed, according to Boime, included toughness and resoluteness, the admira-

tion of heroic action, and despising of cowardice. Though in one sense these were the abstract virtues prized from the time of the French Revolution – part of the 'rhetorical-ideological' armoury of the Republic – they are the values one, ideally, would want all adults, men or women, to share, as long as they were to be put in the service of defensible aims and beliefs.

Bonheur's attitude towards other women and marriage appears to indicate her awareness of the inequalities and oppressions under which her sex laboured. Her way of dealing with this awareness – in the absence of any developed political movement or shared understanding that could be called 'feminist' – consisted in adopting 'almost always' the masculine point of view, Boime claims (CRB: 385). Through this choice she *personally* rejected women's subservience, in a number of ways that were at once symbolic and actual. For instance, Bonheur refused to undertake domestic roles and praised a disciple of hers for preferring art to marriage, believing the latter 'more often than not takes a woman in', turning her into a 'subaltern . . . never permitted to express her authentic self' (CRB: 385). Bonheur's paintings, Boime notes, hardly ever contained images of women. Though Bonheur was often critical of men, she identified with them as a kind of 'masculinised woman', but believed animals were superior in many ways to both (CRB: 398).

Though she lived with women for many years in intimate rela tionships – Nathalie Micas for forty years and then Anna Klumpe – there is no evidence, Boime concludes, that she had sexual relations with her partners (CRB: 386). What would it mean, then, to call her a 'lesbian'? The term, like 'homosexual', is really a creation of the late nineteenth and early twentieth centuries, denoting a *type of person* and an *identity*. Before then, arguably, there had only been homosexual or lesbian *acts*.[6] We must be careful, therefore, not to impose historical categories and values that simply were not part of what might be called the 'discourse' of sexuality in Bonheur's own time. Her life and art might better be understood as one that 'registered' symptomatically the inadequacy and oppression of contemporary socio-sexual relations (for men and women), but which could offer no ideal or actual resolution of them.

Boime, then, suggests that Bonheur's life was an 'expression of revolt against the compartmentalisation imposed on women of her time', a compartmentalisation she tried to obviate by combining the best traits of men and women (CRB: 386). To this end she drew upon aspects of thinking within the utopian Saint Simonist movement of the

time, with which she had been involved since a child. Saint Simonism taught that in modern society the 'social individual' was really a couple – a man and a woman who, together, formed a symbolic androgyne (CRB: 387). But Bonheur's views remain impressionistic and rhetorical, for instance, telling a friend 'at present I detest women folk. I now like only men, because I find them in general so stupid that it flatters me!' (CRB: 386). Nevertheless, according to Boime, Bonheur wore a masculine cloak, literally and metaphorically, in order to attack French males and, by definition, male-dominated French society (CRB: 386).

Bonheur's paintings of animals, and her success as an artist in the France of the Second Empire, suggest, however, that her political views had a complex relationship with her heterodox social values. To repeat, it would be simplistic to claim that feminist or homosexual 'identity-politics' positions have *ever* had any necessary or inevitable connection to anti-capitalist or socialist traditions of mass working-class radicalism, or to Marxist philosophy and history. Their emergence as part of the New Left in the 1960s in Western Europe and the US indicated that a *set of contingent alliances* had been created between groups, though in that moment as well there had been significant separatist elements in antagonism with organised socialist and Marxist organisations.[7] Bonheur's support for academic painting in France, which she admired over that of avant-garde groups, and her friendships with the government and the restored monarchy, represented in the period by Bonaparte III, demonstrates no clear identity between the politics of her 'private' and 'public' lives.

Though Bonheur *did* attempt to merge the two in some respects – her choice of dress, smoking habit, stated opinions, for instance – it could equally be argued that she took conservative political values into her home and art: into how she acted as 'head of her household', and what she chose to depict in her paintings. She was courted by the government of the day, Boime claims, because her pictures of animals, such as *The Horse Fair* or *Cows and Sheep*, both exhibited at the Salon of 1853, were painted in a realist style that appealed to consensus taste, but which handily eliminated the political implications of works produced at the same time by radicals such as Courbet and Millet (CRB: 390). Her fascination with horses in particular had significant conservative political and social implications: the indigenous breed *la percheronne*, depicted in *The Horse Fair*, was a favourite of the king and associated with a region of the country with strong nationalist politics (CRB: 391).

In her private life, Boime claims, Bonheur created a relationship with Micas that prefigured the 'butch-femme syndrome': her partner assumed the role of devoted wife and domestic manager, releasing Bonheur to pursue her career as an artist. Bonheur saw Micas's role 'primarily in terms of the kitchen' and came to believe that the institution of marriage, although unequal and oppressive, was 'indispensable to social organisation' and the primary bonding agent of society (CRB: 385). The radical politics of the Left to which she had been exposed through Saint Simonism was replaced, Boime says, by the eventual commitment Bonheur made to the pro-capitalist and repressive policies of the Second Empire (CRB: 386–7). In art her interests and values also turned conservative. Though her early work had contributed to the development of *naturalism* in the 1840s – a style and group of artists antipathetic to then dominant academic doctrine – Bonheur came to despise later offshoots, such as impressionism and neo-impressionism, and identified with Gérôme and Bourguereau rather than Monet and Pissarro (CRB: 386).

In paintings such as *Le labourage nivernais* (1848), showing a herd of cattle being used to plough a field, the insignificance of people in the scene is noticeable. Rather like Constable's reduction of the size of figures in paintings at about the same time (discussed by Barrell, whose study I consider in Chapter 2), Bonheur has made the male farm labourers marginal. It is the animals that appear active and dominating. Bonheur perhaps enacts two kinds of displacement in this painting. Like Constable, she minimises the role of peasants' labour in her depiction of the organisation of agricultural life and work as this human labour may prove unreliable – after all, what might Courbet's *Stone-Breakers* do instead of break stones? Break the heads of the bourgeoisie? (Illustration 2) But Bonheur also minimises their humanity in relation to the value she gives to animals. This reflects, Boime claims, her anti-social attitudes, 'as if the animal kingdom constituted a more humane society than that formed by mankind' (CRB: 395).

Boime is in two minds over this picture. By bothering to represent, however marginally, the 'labouring poor', she 'reached', he states, 'a more radical audience through its celebration of rural work'. But the painting's emphasis on the animals also made it 'acceptable to more conservative reviewers' (CRB: 390). Boime gives no evidence, however, that the painting *did* 'reach' such a radical audience. What does 'reach' mean here, anyway? To claim, in addition, that the work 'celebrates' rural work is tendentious. His assertion is backed up with the statement that Bonheur's political ideal was related to that of the Barbizon

School of painters, who in the 1840s espoused an 'agrarian vision' that championed 'the untarnished innocence of the country' over 'corrupt city existence' (CRB: 390–1). But this information is circumstantial and does not help either to confirm or undermine Boime's account of the significance of the painting. At best his judgement is, like Bryson's on the meaning of medieval pictures, hypothetical: awaiting some historical *evidence* relating to how the painting may have been understood by actual viewers at the time.

Bonheur had paintings accepted for the annual Salon exhibitions of 1842, 1843, 1844, and in 1848 she won a gold medal for *La labourage nivernais*. As well as finding favour with the king, she sold her paintings to an affluent middle class, located in England and the US, as well as in France. Boime concludes that her pictures had 'socio-political' implications, but that these were not as 'suggestive' as those in works by the leading realists, Courbet and Millet (CRB: 390). She received the first *Légion d'honneur* ever conferred upon a French woman, evidence, Boime believes, of her success and assimilation within the establishment, as well as of her 'political and economic clout' with friends and patrons of the day (CRB: 392).

Bonheur's intellectual composition was complex and eclectic: she rejected organised religion but was, Boime asserts, 'profoundly religious and sentimental' (CRB: 393). She fused ideas drawn from astrology with notions of 'metamorphosis' and 'metempsychosis' (a contemporary belief in the ability to transform human nature and temperament, through, for instance, physical reincarnation). This mixture of magic, religion, and science from the period was symbolised in her understanding of the meaning and value of animals, claims Boime (CRB: 393). In one sense, this was a simple idealism, with an implicit derogation of human interests and society: the beasts are more frank, grateful, and noble than most human beings (various versions of this kind of idealism propel contemporary 'animal rights' movements). Animals are also *ennobled* in Bonheur's paintings by being shown in isolation from people, or in dominance over them. Animals exist in these representations, it appears, *by themselves*, 'rather than as accessories to people or as metaphors for the human predicament', Boime says (CRB: 395).

But, of course, it is Bonheur who gives them this significance in her art and Boime who attempts to make sense of it. Their 'animal nature' is entirely humanly-constructed in these visual representations (and their subsequent interpretation) and tells us far more about Bonheur and her critics than about cows and sheep. For example, Boime claims that cow and ox herds, because they exhibit less obvious

distinction between male and female 'sex typing', came to symbolise, for Bonheur, a collective life in which being clearly male or female was not so significant (CRB: 398). This is an attractive idea as it suggests a link between Bonheur's 'cross-dressing' (literally and metaphorically) and her evaluation of animal life. But who is to say that cows do not distinguish so clearly between male and female? This may well have been Bonheur's *belief* or *wish*, and she may have tried to represent it in her paintings. The claim, as it stands, however, can have no more validity than that. To go beyond it we would need to hear from the horse's mouth, as it were, or rather, from that of the cow! Once again, Bonheur (and Boime) are imposing attitudes – *anthropomorphising* animals which is ironic because Boime's claim is that Bonheur was doing the opposite: identifying the absolute *difference* between animals and humans. One limit that a philosophical, historical, or 'natural-historical' materialism must recognise, then, is the inability of humans truly to know how, or if at all, animals can be said to 'think' or 'ex-perience' their own bodily existence and everything else in the world around them.[8]

Boime's discussion of the relationship between Bonheur's attempt to live a life that didn't so rigidly distinguish between male and female, and her depiction of animals that she appears to have believed do not distinguish between sex, verges on being another simplistic analogy between 'form and content' that Clark warns against in his outline of a social history of art. The danger lies partly in the very attractiveness – the neatness – of the conceit, but also in the lack of any evidence that can be defended as 'historical' and 'empirical'. The positive aspect of Bonheur's idealism was her belief that animals could symbolise her 'desire to transcend the limitations of her earth-bound condition', as Boime rightly notes (CRB: 400). She wanted change, for herself and others, and her investment in animals was a way in which this desire for change found an expression. But it was a *belief*. Belief is of a different order of knowledge from that of historical *argument* and historical *truth*, though the three are related.

Body heat

This question of evidence, argument, and truth is central to the concerns of John Clarke in an essay he published in 1996 concerned with 'Hypersexual Black Men in Augustan Baths'. The essay, on depictions of such men in mosaic tiles by bathing pools in Roman houses, is part

241

of a collection, edited by Natalie Boymel Kampen, entitled *Sexuality in Ancient Art: Near East, Egypt, Greece, and Italy*. Kampen's introduction, like Clarke's essay, is admirably careful to define its terms and protect the security of the historical and theoretical claims it makes. Published over twenty years after Champa's piece and sixteen years after Boime's, this collection suggests that, in this intervening period, a robust and reflexive *collective* consideration of sexuality in the study of ancient art has taken place.

Kampen introduces her collection of essays by remarking that a distinction in the study of sexual elements in ancient art has to be made between 'the erotic' and 'sexuality'. The former, concerned with 'the representation of sexual behaviour and of images designed to arouse the viewer' had been replaced by the latter, which had a far greater range of reference. This includes 'the study of the representation of the body, of the way social categories and individuals are defined by sexual identity as well as sexual conduct, and of the way that imagery allows human beings to find and measure themselves as sexual' (SAA: 1). Nevertheless, the definition of what 'sexual' actually means, she asserts, had been gradually *reduced* in the nineteenth century, due to the development of psychoanalytic, sociological, and philosophical theories. Recently this narrowing had been reversed and the question of what is 'sexual', or part of 'sexuality', opened up (SAA: 2). By this she means that feminist and post-structuralist thinkers have, in the last thirty years or so, created a vigorous debate on the subject.

Within this debate, Kampen notes, a series of distinctions has been made between, for instance, sexuality and *gender* (what in gender is not sexual?), between sexuality and 'the erotic', and between sexuality and *sex acts* (SAA: 2). Feminism has dynamised the entire field of inquiry:

> That sexuality includes bodies, clothed as well as nude (are all bodies sexual, and if so, how and under what conditions?), *Realpolitik* as well as activities in bed, menstruation, procreation, and menopause, as well as 'sex' (in the sense of 'having'), was a concept still largely outside the period frame except for incipient feminist work. (SAA: 2)

Feminism has been responsible, she claims, for 'sexuality' being redefined as an essential element of the 'formation of social relations, historical beliefs and events, and individual and collective behaviours and identities' (SAA: 5). Certainly the work of feminist art historians

considered in my study bears out this assertion. Kampen also argues that Foucault's studies of the history of sexuality (indeed, the idea that sexuality could have a *history* at all), along with the popularisation of psychoanalytic ideas by feminists in the 1980s, led to the reconceptualisation of sexuality as 'a defining feature of personality and cultural structures' (SAA: 2–3).

It was partly the shift from 'the erotic' to 'sexuality' that led to the possibility, Kampen notes, that *male* bodies and *male* sexual identity could become the subject of study (I consider bell hooks' discussion of images of black male athletes in my Conclusion).[9] The distinction between sexuality and *gender* also played its part: with it came 'the possibility of talking about sexuality without its being a taken-for-granted part of the subject of women, without its becoming part of the essentialised WOMAN so difficult to escape' (SAA: 2). Clarke's essay on depictions of black men is a case in point.

He begins with a question. Mosaic images of black men figure extensively in the decoration of three houses from the Augustan period at Pompeii. They appear in two motifs: as bath attendants and paired swimmers, and in both the men appear 'hypersexual'. This 'technical' term means that these men are depicted with 'unusually large penises' ('macrophallic'), or with erect penises ('ithyphallic') (SAA: 184). The mosaics were constructed within houses that belonged to wealthy 'white' men (presumably, of what we would now call 'Italian' origin, though no more information is given by Clarke). Why, he asks, did the artists responsible for these representations choose to depict 'black Africans with huge penises or prominent erections'? And were these features intended to arouse the viewer in a sexual way? (SAA: 184). Clarke's concern is directly historical and empirical, and merits comparison with others considered here who have similarly defined their primary task (e.g. T.J. Clark, Barrell, Boime on the French Academy, Orton, Wagner, Pollock), and others arguably more concerned to propose 'theories', albeit with direct or indirect historical implications (e.g. Mulvey, Bryson, Green, Myers, Boime on Bonheur).

Clarke wants to know, that is, how to understand the significance of these figures within 'the cultural codes of Augustan-period aristocrats' (SAA: 184). He begins by reviewing the study of Hellenistic and Roman visual art and the place of 'sexual images' – not just those of black men – within it. No adequate understanding of the hypersexual black men in the Pompeii mosaics will be reached until they can be placed, Clarke claims, within this broader history of visual art, which must include 'their full contexts, including their original placement and

use by the people who commissioned them and lived with them' (SAA: 184–5). These representations must be considered in relation to answers to the following questions: how did the societies in which they were produced regulate sexual practices? Was their understanding of 'sexuality' like or unlike ours?

Clarke's point is that the *intentions* of the artists who produced these mosaic depictions, or the way in which they were seen by their immediate users, will not be understood properly if we impose assumptions or values upon them drawn from our own time about what we might believe to be the evident or natural meaning of a represented erect or large penis. Clarke concedes that it may not even have been the case that all *contemporary* viewers in Pompeii saw the images in the same way, but considers that to miss this possible variation would be a minor inaccuracy in comparison with simply assuming that late twentieth-century reactions to them are correct. Clarke's task, then, is to establish what 'cultural baggage' the ancient viewer carried which 'gave these visual constructions a meaning quite different from those we might give them' (SAA: 195).

Clarke moves from his initial questions to a provisional answer. He believes the mosaic representations 'chiefly encode nonsexual cultural constructions rather than sexual ones'. In their baths context, he asserts, the depicted black Africans are not primarily intended as objects of 'sexual desire or titillation' (SAA: 185). How does he arrive at this judgement? The motif of the bath attendant, he notes, is widely diffused in the epoch, although the available evidence does not include works produced in the first century after Christ. The macrophallic black man recurs, however, in many second- and third-century mosaics contemporary with those in Pompeii (SAA: 185). Clarke embarks on a discussion of many images, at Pompeii and elsewhere, noting that in some, such as in a mosaic in the House of the Menander in Pompeii, a black man with a spear for fishing is depicted without a penis visible at all. Roman art and literature, he notes, continues the Greek distaste for men with large penises and suggests that those representations of black men's macro- or ithyphallic penises located in bathhouses contrast 'sharply with the truly erotic paintings and mosaics found in the bedrooms of Roman houses between the first century . . . and the third century . . . These invariably show couples, either demigods or humans, engaging in sexual intercourse' (SAA: 195).

When is a funnel just a funnel? When is an erect penis *not* a sexual sign? Clarke's answer is straightforward and based on historical evidence, rather than on, for instance, psychoanalytic ideas. This is not

to conclude, however, that his answer is necessarily *correct* (as if there is only ever one right answer to any question), or even more *interesting* than one that might be based on psychoanalytic thinking. But it *is* a historical answer. The macro- or ithyphallic black men depicted in baths mosaics were intended to function not sexually, but *apotropaically* – that is, as magical symbols to ward off evil spirits thought by the Pompeiians to lurk in places like baths and swimming pools.

The socio-physical situation of the images is crucial, then, to a historical understanding of their meaning there and then. Baths might seem like an obvious place for *us* to consider sexual imagery appropriate, but does not make sense in terms of known Roman and Pompeiian beliefs and practices:

> Both the Greeks and Romans believed it important to take special precautions in the baths . . . very real dangers of falling, drowning, being burnt by hot pavements and walls, or even suffocating in over heated rooms [were present] . . . but the worse problem was of *phthonos* or *invidia*, best defined as grudging envy that directs ill will against another person who possesses beauty or good fortune. (SAA: 191)

Greeks and Romans believed that such 'ill will', projected through the envious person's (the 'invidus') 'Evil Eye', could cause illness, physical harm, and even death. Baths were the place where the beauty of individuals, against whom the invidus' 'Evil Eye' was directed, was clearly evident. Baths, by extension, were thought to be places where demons lurked. How to guard against this?

Greeks and Romans believed that certain representations they called *apotropaia* could ward off the Evil Eye. These included images inscribed on amulets, and mosaics in baths. The depicted black man with a large or erect penis was regarded as a powerful apotropaic image because Greeks and Romans believed an 'un-Roman body type caused laughter' – especially if equipped with a large penis – which was the 'opposite pole of the anguish produced by the dark forces of evil: where there is laughter, it scatters the shades and the phantasms' (SAA: 192). Not surprisingly, images of dwarves, pygmies, and hunchbacks also served apotropaically, but the 'grossly exaggerated phallus' was the most common apotropaic symbol in ancient Roman floor mosaics. Such images sometimes had other minor 'referential' or 'anecdotal' functions. Clarke notes, for instance, that occasionally the depicted black men

carried shovels, symbolic of the fires that heated the baths; their black ('sunburnt') skins might be intended to indicate the danger of the fire heating the water (SAA: 192).

Clarke remarks that the common Roman image of African black men ('Aethiopes') with large penises has become a stereotype in post-World War II US culture, and that the prevalence of this stereotype, along with the attitudes with which it is associated, may also influence our sense of the meaning of Pompeiian representations made thousands of years ago. Inevitably, this involves attitudes about the connections between race, power, and sexuality (now and in the past). Clarke claims that Romans, on the whole, took slaves that were *not* black and that the fascination they had with Africans was with their *visual* appearance, rather than their *social* status:

> Romans put no legal constraints on blacks solely on the basis of their skin; there are no Greek or Roman scientific treatises on race as an immutable category. Roman society seems to have acknowledged the Aethiopes's somatic differences without necessarily debasing them by using the racist social structures familiar to Euro-American culture. (SAA: 188)

Idealisations and hierarchies of human racial identity, like those of the 'animal kingdom', are always *projections*. They tell us a great deal about the agent doing the projecting – both the direct producer of such ideals or hierarchies (in, for instance, art or literature), as well as about the society in which the producer lives. I conclude this chapter with a discussion of two texts concerned with two such projections – the first about one of the earliest art historians, and the second about an artist working in France amidst both the idealism and reality of the French Revolution.

The matter of ideals

Alex Potts's 1994 study *Flesh and the Ideal: Winckelmann and the Origins of Art History* is an interpretation of an interpretation, or, to put it more contentiously, a projection upon a projection. Potts 'reads' Johann Winckelmann's *History of the Art of Antiquity* – one of the 'founding texts' of art history – through a combination of socio-historical and psychoanalytic concepts. Winckelmann's account of the meaning and value of Greek sculpture, which he saw as the

unsurpassable ideal in art, became the 'Enlightenment's classic text' on ancient art, and as such, Potts argues, is a repository of ideas with aesthetic, social, political, ideological, and *sexual* implications (FIWOAH: 9). Potts's radical conclusion is that Winckelmann's claims about Greek art cannot be understood without seeing how desire – socio-political *and* homosexual – motivated, indeed saturated, his interests.

If desire – that is, belief, wish, projection – had this significance within the working out of Winckelmann's ideas, then it is similarly true of *any* later art historians for whom Winckelmann's work has been a resource. This would perhaps be *especially* true of accounts that strenuously, *homophobically*, deny and reject Winckelmann.[10] Desiring/fearing, dreaming/dreading, idealising/demonising: all art history, in fact, is about these things, whatever else its practitioners might think, or wish, they are doing. For the dark underside of Winckelmann's idealisation of Greek art is, Potts argues, one that recognises that this ideal must always attain (or retain) material embodiment in sculptural or graphic form, and is, inevitably, subject to the 'disturbance of bodily desire and ideological conflict' (FIWOAH: 1). Desire, and its satisfaction or denial, then, can never not be political.

Winckelmann's writings, Potts claims, are particularly important and interesting because they display an 'unusually eloquent account of the imaginative charge of the Greek ideal in art' (FIWOAH: 1). The 'ofs' here are interestingly ambiguous. They include the 'of' pertaining to Greek art (that is, its 'affect'), and the 'of' pertaining to Winckelmann's understanding of Greek art (the effects of it *on* Winckelmann). These two 'ofs', in fact, bleed together, are never really separate: the effects art has, are *always* upon, and affect, particular viewers. There is no 'affect' without a viewer, although traditional art history that presents itself as 'neutral' or 'objective' often implicitly denies the specificity and variety of particular viewers. Neither does it recognise that viewer's partiality, in terms of *material interests*: for instance, the viewer's gender, class background, age, cultural values, education, sexual proclivities, and so on (the order in which these are listed betrays, perhaps, an aspect of my own partiality). Potts's account extends this 'ofness': his is a partial and interested reading of Winckelmann's partial and interested reading of Greek art.

The most shocking aspect of Winckelmann's writings, Potts says, is that through them it becomes clear that Winckelmann liked men's bodies sexually. Actually, Potts doesn't say this so directly, but I paraphrase in order that there be no doubt at all. Potts actually says that:

... the most visibly striking aspect of his writing on Greek art [is] the unapologetically sensuous homoeroticism of his reading of the Greek male nude. His projection of the Greek nude as an erotically desirable masculinity is both more immediate and, if anything, more richly invested than his imagining it as the symbolic embodiment of freedom. The ideal erotic figure for him is not a feminine object offered up for the delectation and domination of a male gaze. It is rather a finely formed male body. As such it becomes for the male viewer both an object of desire and an ideal subject with which to identify. (FIWOAH: 5)

The bodies of men – and young men in particular – are what Winckelmann desires. These are bodies with which he might interact physically, in sex, though Potts prefers to use the slightly euphemistic term 'erotic', which Kampen describes as part of an older art-historical argot. Winckelmann also desires these bodies as images and ideals of value *beyond* sexual use. What kind of value might this be? Potts mentions two pivotal terms here: 'freedom' and 'an ideal subject'.

What relationship might there be between physical (material) embodiment, sexuality, 'freedom', and an 'ideal subject'? Is the account of such a possible relationship Winckelmann's, Potts's, mine, or yours? Or a combination of the desires of all four? After all, sexual desire and questions of value are interests – if not preoccupations – of virtually all of us. Potts's point is that Winckelmann recognised that no one (himself included) could finally separate sexual desire from social and political ideas and ideals. The materiality of sexual desire – sexual desire is always desire *for an object* – conjoins with the materiality of social and political power that is embedded in relationships, institutions, and ideologies that are also partial and interested, unequal and exploitative. Winckelmann knows that one of his chief interests – in men's bodies – is contrary to the normative heterosexuality of European eighteenth-century life within which he exists. No doubt his attention is drawn to Greek culture and art because one of the ideas (and 'ideals') that survives from that time is that the highest 'love' that is possible is that between men, not between men and women.

Winckelmann chose as an illustration for the beginning of his *History of the Art of Antiquity* an antique gem representing a dead or fatally wounded female nude lying prone in the arms of a naked warrior. This arguably symbolised the two things against which Winckelmann apparently felt most repulsion: the body of a woman, and what Potts calls the violence done to the 'ethical ideals of nobility

and calm' (FIWOAH: 2). Potts sees Winckelmann's decision to have 'woman' symbolise the death of nobility as particularly troubling. To eroticise and idealise male beauty is one thing, but to represent 'woman' as its *base* opposite is another. Potts puts this somewhat euphemistically again – the choice of this image, Potts says, brings 'into view anxieties surrounding sexual difference that hover insistently yet largely hidden on the margins of Winckelmann's very male constitution of the Greek ideal' (FIWOAH: 3–4).

Yet Winckelmann chose *not* to begin the book with an image of a male body and the ideals it might symbolise because, Potts claims, he was aware of the contradiction between the necessary *abstract* nature of an 'ideal' and its representation through a *particular* form (of body). The 'blankness' and 'stilling of emotion and desire' which is present in idealising neo-classical sculpture, Potts asserts, signalled 'death' for Winckelmann, though he also knew that representations of beautiful bodies – those of men *and* women – could be invested with erotic (sexual) and sado-masochistic fantasies, such as the one depicting the dead or nearly-dead female warrior (FIWOAH: 2). Winckelmann's view of the relations between historical reality and belief in ideals is, whether he desired it to be or not, a materialistic one. Ideals, that is, are produced 'out of' materiality and its interests and values are inseparable from them, and, the implication is, always end up (with death) in a return to them.

Sexual desire, therefore, can be understood as a metaphor of human and social materiality in general: that is, sign of our necessary embodiment and containment (*to hold and to control*) in individual and collective natures. Winckelmann was concerned with the relationship between what we – our natures – 'are' (and what those of the Greeks and his own eighteenth-century society were), and what we *desire* 'to be' and 'to have'. Hence the question of 'freedom' and how it might be figured:

> We confront in Winckelmann, more vividly than in any other writer of the eighteenth century, the question of how the Greek nude could be seen to embody the ideal of subjective and political freedom with which it came to be so closely identified. He does not simply assume, like most writers of the period, that a truly beautiful art, such as that of the ancient Greeks, must have been produced by a free society. Notions of freedom play an integral role in the ideal subjectivity he sees represented by the beautiful figures of antique statuary. (FIWOAH: 4)

In one sense, though, that representation was, Winckelmann knew, delusional. Greek society was based upon the existence and exploitation of a slave population whose forced labour 'freed' the citizenry – dominated by men – precisely to engage in speculation about the nature of freedom, the love of ideals, and the ideals of love. Greek sculpture was an art 'of' these ideals, but it was also, inevitably, a representation 'of' this actual society of elite citizenry and mass slavery. The necessary embodiment of such ideals in the materials of sculpted male figures was/is a metaphor of this 'ofness' – the material ('flawed marble') reality gives expression to the ideal. Winckelmann knew that he wanted, but couldn't have, this ideal/wanted; wanted, but couldn't have, his sexuality/wanted; wanted, but couldn't have, his 'freedom'.

Potts is convinced that Winckelmann was writing *simultaneously* about Greek art and society and his own times and desires – the two sets of concerns are indistinguishable. One becomes a metaphor of the other, one a projection or interpretation of the other: neither one is original, nor the other merely secondary. Winckelmann's letters, for instance, indicate his constant concern with 'male friendship and love' (FIWOAH: 6). Moreover, the:

> . . . focus [in his art-historical writings] on the image of the boyish youth also clearly connects with Winckelmann's own individual sexual preferences. These no doubt gave a particular impulse to the erotic charge he invested in this image in his writing, by making it both desirable and ideal in an unusually intense way. Moreover, within the cultural and artistic conventions of his time, it was as boy or youth that the male figure could most readily be seen as desirably beautiful, though obviously not in any too explicit sexualised a way. (FIWOAH: 165)

Why does Winckelmann like boys? Because, Potts says, the young male body symbolised *for him* manhood prior to 'its shaping by social or political circumstances', and before 'too insistent a formation of its sexual identity' had occurred. It could intimate a subjectivity *for him* that was 'self-sufficient, free and unalienated' (FIWOAH: 165). Winckelmann desired these things and wanted to see them in young men – presumably in actual young men, as well as in their sculpted representations. Presumably also Winckelmann wanted to be able to 'shape' these young men – in his fantasies, if not in reality – so that, *for him*, they could become a material upon which his own freedom of action could be deployed. These bodies – real and sculpted

– symbolised, therefore, as much Winckelmann's desired freedom as that which might be desired for any political state. In both cases Winckelmann seems to have known that freedom of action – the power to be able to use power against others, in one's own interests – was conditional upon material strengths, and conditional upon an inevitable *inequality* between those (individuals, classes, genders, or political states) competing to be powerful.

If Winckelmann found it difficult to locate an image of a young male body that might symbolise this ideal adequately then it was because, as Potts says, he was highly resistant to the idea that such an abstraction (or fantasy) *could* be embodied in an actual sculpted form; that it could, in fact, find adequate visual representation *at all* (FIWOAH: 165–6). For any form selected to represent this ideal would be the end (material 'death') of the ideal. Once or twice, Potts records, Winckelmann imagines the ideal body 'as a free flow of exquisite, but potentially empty, contours' (FIWOAH: 172); 'a floating, undulating line, dissolving any sense of shape in a free play of form' (FIWOAH: 170); a form in which flesh and blood had been annihilated. Winckelmann, along with J.-J. Rousseau, the philosopher Diderot noted, had lived at the time of the French Revolution, and knew the intimate cohabitation of ideals and dread at the core of the Enlightenment in philosophy and politics (FIWOAH: 181). The minds in bodies create the dreams of unity and happiness for which minds and bodies are destroyed. It is to a depicted dream, and its symbolic meanings around the time of the French Revolution, that I turn finally in this chapter.

What do funnels and ventilators mean? What do horses and cows signify? What do black men with large erect penises suggest? What do young and sexually immature men imply? Remember, all along I have been considering artists' and writers' *representations* of such things. Remember, I have been considering art-historical *interpretations* of such representations. Remember, you are considering my *account* of art historians' interpretations of artists' and writers' representations of such things. (Remember, also, that Barrell notes that landscape paintings were certainly idealised representations but, as such, these ideals were real and had real effects).

What was true of Winckelmann is true of all art historians: their understanding of the past is inevitably linked to their own lives and social circumstances, whether they would like this to be the case or not. Radical art historians, on the whole, have wished to make a virtue out of the necessity that the present situation is what the history, and history of art, *of* the past is made *from*. To acknowledge this is not

to claim, however, that art historians – radical or otherwise – simply 'invent' the details that constitute this history (although they, occasionally, probably have done).[11] As far as is known, for instance, the artist Anne-Louis Girodet *did* live and work in Paris in the 1780s and 1790s. He *did* produce, in 1791, a painting called *The Sleep of Endymion* (Illustration 10). I shall consider an interpretation of this painting in a moment.

What art historians *do* do, though, is create the patterns of detail and structures of relationship between elements of historical material that interest them. They also introduce concepts and arguments that adduce, inform, and articulate these patterns and relationships. Those concepts and arguments are motivated by, and exemplify, the perspectives and values of their proponents: that is, their understanding of the nature of the world and judgement about what is valuable within it. This happens *whether or not* art historians are aware of doing it. Radical art historians, on the whole again, have thought it better to acknowledge this fact about the nature of knowledge and sought to develop concepts and arguments explicitly and reflexively.

This provides no guarantee, however, that they will be 'right' (or even interesting) in the accounts they present. The question of 'rightness' or 'historical truth' is a *relative*, not an absolute one. It is relative in two ways. First, because the judgement that something is 'right' or 'wrong' is *always* a judgement made by a specific person or group of persons, equally laden with partial interests and values. If a group of art historians should agree to assert, for instance, that art-historical X is 'true', then what has come into existence is really a *consensus* that X constitutes, in effect, a 'fact' for art historians. Nothing can exist as a 'fact', or be believed to be 'true', unless it is *believed and asserted* to exist by an individual or a group. And there can *always* be disputes about whether X remains true or false, a fact or fiction. Second, 'rightness' or 'historical truth' is also inevitably relative because what art historians do, apart from argue right or wrong, is adopt different *emphases*. That is, they often account simply for different things, have different interests and motivations, have different sets of priorities and values. This usually means that they wish for different things to be 'of interest' – of interest to their own preferred constituency (say women, for feminists), or of interest to something broader called 'the profession' or their colleagues (for example, the associations of art historians in Britain and the US, or the members of university departments of art history), or of interest to students and the public outside the university. Or of interest to a

combination of all of these. Having an *emphasis* or a *preference* cannot be right or wrong. If a particular emphasis (say, an interest in dogs in art) is said to be misplaced, or merely inane, it's inevitably because someone *else* says it is, someone with merely a different opinion or preference.

Radical art historians have always been aware, however, that people in positions of *authority*, for instance in universities, museums, and book publishers, have relatively more powerful means to propagate their own interests and emphases. Through controlling the nature of courses and faculty appointments, by selecting to buy certain artworks and organise certain exhibitions, or by giving a commissioned book a certain title, a particular kind of art history – what Griselda Pollock calls 'institutionally dominant art history' – attained and retains its dominance. This conservative art history has interlocked with wider conservative authority and social interests in the world outside the university: a world which is controlled by capitalist, 'neo-colonial', patriarchal, and heterosexist structures of inequality and exploitation. (In my Conclusion I turn to the 'neo-colonial' aspects of this world and debates about its history and current status in art history.)

How might all of this, then, link with Whitney Davis' 1994 account of Girodet's painting, in an essay entitled 'The Renunciation of Reaction in Girodet's *The Sleep of Endymion*'?

Well, the picture represents, for Davis, a messy and contradictory entanglement of political, homosexual/homophilic, and art-historical elements – those drawn both from French revolutionary society in the 1790s *and* from US academic politics of the 1990s. Davis has in his view, not only Girodet's painting, but also the account of French art around 1800 produced by the social art historian Thomas Crow. Davis' essay is partly an engagement with an essay by Crow involving a discussion of Girodet included in the same collection as his own.[12] Davis, like Potts, is concerned with the symbolism of masculinity in art and its relations to political action and sexuality. Davis, like Winckelmann, is interested in the homoeroticism of the male nude depicted in classical and neo-classical art. Davis, like Pollock, is interested in institutionally-dominant art history (which, for him, includes *Marxist* art history) that equates art with virility. Davis wishes Girodet's painting 'of' a reclining, apparently self-absorbed if not sleeping, physically attractive man, to mean something Other.

The Sleep of Endymion, Davis notes, has usually been understood by commentators to exemplify a 'decadent' post-revolutionary 'neo-classicism' of reaction (RRG: 168). Like many paintings based on

Girodet's that attained the then anti-revolutionary label 'romantic', *The Sleep of Endymion* has been seen as conservative in political and moral terms. Davis believes Crow's account of the painting is an instance of what he calls a 'revised species of formal analysis' (RRG: 171). This formalism makes David's classicism its necessary point of reference, but fails to explain how Girodet's painting 'replicated – repeated, revised, and refused – its ancestral classicism' (RRG: 169). Crow invokes 'politics', Davis asserts, but does so very narrowly and peremptorily: *The Sleep of Endymion* is, for Crow, Davis claims, a straightforward parable of 'a Socratic death', the 'logical end point of the mortal, political attitudes and actions of the various heroes depicted in David's "pre-revolutionary" history paintings' (RRG: 193).

Though these paintings by David – for instance, *The Oath of Horatii* (1784) and *Socrates at the Moment of Grasping the Hemlock* (1787) – were, like *The Sleep of Endymion*, based on legends from Greece, they have always been thought to contain *pro*-revolutionary messages. Davis believes that to read *The Sleep of Endymion* this way, as Crow does, is understandable, but dangerous politically and conservative art-historically. It is not simply, Davis says, that Crow wants to play the game of reading paintings 'as a series of "moves" in the "game" of constituting form, a kind of style-competition or style-debate' (RRG: 171–2). Though this certainly involves a reduction of their significance historically, as far as Davis is concerned, far worse is the 'ideology of politics', as well as the specific political ideology, underlying Crow's perspective.

By 'ideology of politics' Davis means Crow's understanding of politics as a kind of discrete 'level' in society – a particular and limited sphere or field of activities synonymous with 'public life' (RRG: 170–1). This notion was the ideology (and ideal) of politics born in/as the French Revolution – 'the Party is the People!' – and continued within Marxist revolutionary ideology in the twentieth century – 'the Party is the Proletariat!' Crow's particular political ideology is commitment to a Marxism that relies upon a notion of masculine action, virtue, and virility that, for Davis, is unacceptable. There is a continuity for Davis, therefore, between the art and politics of the 1790s that Crow writes about (and, according to Davis, idealises), and the admittedly residual Marxism of the 1990s. Both rely upon 'ideologies of masculinity and modes of public effectivity or political virtue' that Davis finds highly suspect (RRG: 172). Girodet, Davis believes, was similarly critical of the contemporary ideology of masculinity and the Endymion story allowed him to materialise this doubt in a painting. Crow, because of

his own perspective and values, is particularly badly placed, Davis believes, to recognise the doubts about the relationship between masculinity and revolutionary politics that Girodet's painting was intended to prompt.

Although Davis recognises that, in one sense, *no one can know or not* whether Girodet intended his painting to be seen in a supportive relation to Davidian classicism (because evidence that might be identified as 'conclusive' either way is unavailable), he cannot be wrong in saying that the meaning of the painting is *not* exhausted by this question (RRG: 170). That is, the Endymion story – such as in Keats' poetic version of 1818 – challenges 'classical or classicizing conceptions of history and male agency', and promotes a figure felt by some of its contemporary readers to be 'decadent, "effeminate", and un-Grecian' (RRG: 185). A war of reference and counter-reference went on in the 1790s over the forms given to mythical figures and to different emphases in the legends within which they acted. For example, Jean-Baptiste Regnault's *Liberty or Death*, shown in the Salon of 1794, Davis observes, revised the unheroic effeminate figure of Endymion in order to 'depict a beautiful, athletic ephebe making the aggressive gesture of the Davidian public man undertaking decisive action' (RRG: 174).

This is an artists' game, Davis notes, of 'imitating, reversing, and negating what other agents are doing, working under stress or threat of failure and with the final goal to emerge preserved, identified, and rewarded' (RRG: 175). It should be clear by now that it is also a game played by art historians! Davis wants to turn Crow's reading round and to turn round the meanings of masculinity in art, and in radical art history. He enlists his own reading of the myth of Endymion to do this, noting that Crow has little time for the actual dream that the dream-figure Endymion is said to have dreamed, or to consider what Girodet 'dreamed' Endymion dreamed in his *Endymion* (RRG: 178). Though lengthy and containing several significant variations, the legend of Endymion briefly is as follows. Endymion, a mortal, is caused to fall into sleep by the goddess Selene so that she can make love (have sexual intercourse) with him, but he never awakes from the sleep. Davis' concern, however, is with *how* Girodet chose to emphasise and select elements within this legend.

Girodet chooses to depict Endymion 'just about to be used sexually by Selene' (RRG: 179). That is, Selene, in the guise of a 'moonbeam as phallus', behaves in 'conventionally "masculine" fashion, acting as the pursuing lover who is attempting actively to gratify desire for the beautiful but passive boy, the beloved' (RRG: 181). The intermediary

between the two is the alert, 'sly Eros' who introduces an 'unreasoning' (desiring) Selene to 'reasonless' (asleep) Endymion. Davis makes the legend and the painting into a parable about the relations between power, action, politics, and masculinity. Endymion, he says, in his eternal sleep, has dropped 'out of history' and somehow had his mortality suspended (RRG: 179–80). His will has been divided from his body and things happen to him only passively – 'he performs phallic acts without phallic desire' (RRG: 180). Like women in patriarchy? Is he a man made symbolically female through his passivity?

What of the social collective the three figures – Eros, Selene, Endymion – form? All three, Davis claims, 'partly embody and partly fail to embody an ideal of active, publicly engaged, and virtuous masculinity' (RRG: 183). In its depiction of a young man naked Girodet's Endymion renounces active masculinity's 'supposed incompatibility with male beauty, sensuality, and homoeroticism' (RRG: 190). Endymion is not dead, through heroic sacrifice or base slaughter as David or Crow might wish, but *enjoying* himself – and is being enjoyed by others – sensuously, Davis tells us. He tells us this because he wants to, and because the interpretative space in the picture is there:

> The interest of Girodet's *Endymion* lies precisely in the way it . . . explores, without resolving, the tension between public action on the basis of rational principle and the mortality of a beautiful man, a tension forced into an absolute dichotomy by others . . . who insisted . . . that a public man need not be interested in his beauty and a beautiful man could not be interested in the public. (RRG: 190)

Girodet's Endymion is important for Davis because it enables him to argue that, at the time it was painted, notions of male and female, active and passive, hetero- and homosexual, public and private, had *not* solidified into the oppositions they were to become by the beginning of the twentieth century and the arrival of the world that, for instance, Charles Demuth had to operate within. There was, a century earlier, still an ambivalence and creative 'unfixity' to the sets of equivalences that would eventually run: 'male/active/heterosexual/public' and 'female/passive/homosexual/private'.

The Sleep of Endymion is an 'agent' that acts to shuffle these terms – or, to put it a different way, Davis desires to see it like this. In doing so he makes his own ideal out of the painting, whose:

deferral of . . . action, 'history', masculinity and the 'political' – this so-called 'timelessness – does not obliterate but rather guarantees the endless beauty and desirability of the male body which remains intact, and indeed unchanging, as a body open to both feminine and masculine regard and possibly even to its own sensual pleasures and sexual dreams. (RRG: 194)[13]

In my Conclusion I turn finally to questions of race and neo-colonialism in art and art history. These issues are inseparable, it should be obvious by now, from (amongst others) questions of class, gender, and sexual orientation. For we are not *either* male, or middle-class, or Asian, or homosexual. Feminism, gay and lesbian rights, and ethnic-identity groups have all proposed serious challenges to the 'classism' of Marxism and Marxist art history, offering alternative politics and intellectual perspectives. Davis' critique of Crow thus stands for much besides the scholarly debate of late eighteenth-century French painting. Is there any principle or ideal now, however, that might link these interests that are so separate – in art history, as much as in 'politics'? What kind of agreed goal or 'end', if any, might there be now to the collective project once called 'radical art history'?

Notes

1 On differences between 'culture' and 'society', see Terry Eagleton *The Idea of Culture*: especially 8, 25, 46.

2 For a useful bibliography on identity, sexuality, and representation, see the sources identified in Whitney Davis 'The Subject in the Scene of Representation', in 'The Subject in/of Art History: A Range of Critical Perspectives', *Art Bulletin*, December 1994.

3 See Beryl Lake 'A Study of the Irrefutability of Two Aesthetic Theories', in Charles Harrison and Fred Orton (eds) *Modernism, Criticism, Realism*.

4 See Clark 'Olympia's Choice', in *The Painting of Modern Life* and 'Jackson Pollock's Abstraction', in Serge Guilbaut (ed.) *Reconstructing Modernism: Art in New York, Paris, and Montreal 1945–1964*, Cambridge, Mass.: MIT Press, 1990. An alternative, and shorter, version of this essay appears as 'The Unhappy Consciousness', in Clark *Farewell to an Idea*.

5 For instance, Lisa Ticker's article, 'The body politic: female sexuality and women artists since 1970', *Art History*, June 1978 vol. 1, no. 2: 236–49, discussed in Chapter 1, is, arguably, less concerned with 'sexual orientation' than with the experience and meaning of women being 'in' women's bodies and how this experience and meaning is represented by certain artists.

6 On sexuality defined in terms of identities and/or activities, see Judith
 Butler *Gender Trouble: Feminism and the Subversion of Identity*, London
 and New York: Routledge 1990, especially 'Foucault, Herculine, and the
 Politics of Sexual Discontinuity': 93–111.
7 See Peter Starr *Logics of Failed Revolt*, especially 'May '68 and the
 Revolutionary Double Bind'.
8 See, for instance, Steve Baker *The Postmodern Animal*, London:
 Reaktion, 2000, and Ben-Ami Scharfstein *Of Birds, Beasts, and Other
 Artists: An Essay on the Universality of Art*, New York and London:
 New York University Press, 1988.
9 Conventional art and art history, of course, have focused continually on
 representations of *women's* bodies. See valuable critical assessments of
 this tradition in, for example, Lynda Nead *The Female Nude: Art,
 Obscenity and Sexuality*, in Lucy Gent and Nigel Llewellyn (eds)
 Renaissance Bodies: The Human Figure in English Culture c.1540 – 1660,
 London: Reaktion, 1990, and Tamar Garb *Bodies of Modernity: Figure
 and Flesh in Fin de siecle France*, London: Thames and Hudson, 1998.
10 Potts' account of homosexuality is indebted to D.F. Greenberg *The
 Construction of Homosexuality*, Chicago and London: University of
 Chicago Press, 1988.
11 For instance, one of the issues Mieke Bal considers in her study of
 Rembrandt, which I discuss in Chapter 5, was the 'wish' of art histor-
 ians to identify lots of paintings as authentic 'Rembrandt's'. The reaction
 against this desire by later generations of art historians who sought
 to cull the number was, arguably, a different but related kind of 'wish'
 as well. See *Reading 'Rembrandt'*, Introduction: 9–12, and 'Visual
 Storytelling: Fathers and Sons and the Problem of Myth': 94–137.
12 Thomas Crow 'Observations on Style and History in French Painting of
 the Male Nude, 1785–1794', in Norman Bryson *et al. Visual Culture:
 Images and Interpretations*: 141–67. See also Thomas Crow *Emulation:
 Making Artists for Revolutionary France*, New Haven and London: Yale
 University Press, 1995.
13 Davis himself, admittedly, could be accused of a kind of art-historical
 formalism or 'iconographic idealism' – after all, his analysis of Girodet's
 painting only really posits the picture as a scene in a narrative. He spends
 no time on the representation's nature as a *material* artefact. Nor does
 Davis attempt to discover any of the contemporary readings the painting
 may have evoked in order to consolidate his own interpretation. His
 account is offered, quite intentionally I suspect, as an example of defen-
 sible art-historical 'wishful thinking'.

Select bibliography

Baker, S. *The Postmodern Animal*, London: Reaktion, 2000

Battersby, C. *Gender and Genius*, London: Women's Press, 1989

Beckley, B. and Schapiro, B. (eds) *Uncontrollable Beauty: Towards a New Aesthetic*, New York: Allworth Press, 1998

Crow, T. 'Observations on Style and History in French Painting of the Male Nude, 1785–1794', in Norman Bryson *et al. Visual Culture: Images and Interpretations*, Wesleyan University Press/University Press of New England: Hanover and London, 1994

Deepwell, K. (ed.) *Women Artists and Modernism*, Manchester: Manchester University Press, 1998

Duncan, C. 'Virility and Domination in Early Twentieth Century Vanguard Painting', in N. Broude and M. Garrard (eds) *Feminism and Art History: Questioning the Litany*, New York: Harper and Row, 1982

Garb, T. *Bodies of Modernity: Figure and Flesh in Fin de siècle France*, London: Thames and Hudson, 1998

Gent, L. and Llewellyn, N. (eds) *Renaissance Bodies. The Human Figure in English Culture c.1540–1660*, London: Reaktion, 1990

Hickey, D. *The Invisible Dragon: Four Essays on Beauty*, Los Angeles: Art Issues, 1993

Iverson, M., Crimp, D., and Bhahba, H. *Mary Kelly*, London: Phaidon, 1997

Kirwan, J. *Beauty*, Manchester: Manchester University Press, 1999

McDonald, H. *Erotic Ambiguities: The Female Nude*, London and New York: Routledge, 2000

Nead, L. *The Female Nude: Art, Obscenity and Sexuality*, London and New York: Routledge, 1992

Nochlin, L. *Representing Women*, London: Thames and Hudson, 1999

Ockman, C. 'Profiling Homoeroticism: Ingres' *Achilles Receiving the Ambassadors of Agamemnon*', *Art Bulletin*, June 1993: 259–74

Perry, G. *Gender and Art*, New Haven and London: Yale University Press/Open University, 1999

Pointon, M. *Naked Authority: The Body in Western Painting 1830–1908*, Cambridge: Cambridge University Press, 1990

Robinson, H. (ed.) *Visibly Female: Feminism and Art Today: An Anthology*, London: Camden Press, 1987

Scharfstein, B. *Of Birds, Beasts, and Other Artists: An Essay on the Universality of Art*, New York and London: New York University Press, 1988

Screen Reader in Sexuality, London and New York: Routledge, 1992

Williams, R. *Problems of Materialism and Culture*, London: Verso, 1980

Conclusion

The means and ends of
radical art history

Key texts

Albert Boime *The Art of Exclusion: Representing Blacks in the Nineteenth Century*, London: Thames and Hudson, 1990: AE.

Annie E. Coombes *Reinventing Africa: Museums, Material Culture and Popular Imagination in Late Victorian and Edwardian England*, New Haven and London: Yale UP, 1994: RA.

James D. Herbert *Fauve Painting: The Making of Cultural Politics*, New Haven and London: Yale UP 1992: FPMCP.

bell hooks, 'Introduction: Art Matters' and 'Representing the Black Male Body', in *Art on My Mind: Visual Politics*, New York: The New Press, 1995: AMM.

Stuart Hall, 'Cultural Studies and the Centre: Some Problematics and Problems', in Stuart Hall, Dorothy Hobson, Andrew Lowe and Paul Willis (eds) *Culture, Media, Language: Working Papers in Cultural Studies, 1972–1979*, London: Hutchinson, in association with the Centre for Contemporary Cultural Studies, University of Birmingham, 1981: CSC.

CONCLUSION

Radicalism in art history and 'identity-politics'

'Identity-politics' has become a name given, in the last ten years or so, to certain kinds of activism present inside the academy and in society at large. By 'activism' I mean a set of related beliefs, organisations, and interventions developed with explicit political and ideological aims. Throughout this book I have endeavoured *not* to convey the erroneous impression that 'radical art history' has consisted in one distinct group of people – the 'academic activists' – based in universities, working in alliance with, another, *different* group – the 'political activists' – active elsewhere in 'mainstream' social life and institutions. Such an impression would be fundamentally wrong on two counts.

First, it suggests that the institution of the modern university is somehow separate, or significantly distinct, from all other institutions in a society. Historically, this has never been the case. Universities, at least since the nineteenth century, have *always* drawn their members – academic staff, students, ancillary workers of all kinds – from the broader society and have always contributed, economically, socially, politically, and ideologically, to the organisation, maintenance, and transformation of the broader society. In Britain, before the 1960s' expansion of higher education brought in more students and students from lower middle-class backgrounds, it was certainly true that the relatively few universities that existed were socially elitist and exclusive. Their students and lecturers were mostly upper middle-class men who had attended private schools. The idea of the university in Britain as a protected 'ivory tower' of cloistered dons involved in esoteric and antiquarian activities unrelated to the needs or concerns of most people *was* connected to the reality of this exclusiveness.

Feminism – one of the core 'identity-politics' activisms – agitated in the late 1960s and 1970s to get women admitted as staff and students to the universities as part of an attempt to bring about a transformation of *all* institutions and social relations in British society. Universities certainly were elitist and exclusive, but so, feminists argued, were most, if not all, other institutions – such as state administration, the legal professions, medicine, the media, and the Houses of Parliament. A similar situation existed in the US and throughout the rest of the western world. Feminists interested in art history saw connections and causal links – as Pollock and Parker's, and Nochlin's, texts, discussed in Chapter 3, indicate – between the social exclusiveness of universities, the dominance of men within departments of art history (and in art galleries, museums, and publishing), and the fixation within the

discipline upon male individual creative genius. These were all facts of a patriarchal dominance within the society *as a whole*, across *all* its formal and informal institutions governing all kinds of human inter-relationship. To act as a feminist, to be an activist in a university and seek to change how it was organised, was to be political in the same way as in *any other social institution or social relationship*. This is not to deny, however, that debates took place over which particular insti-tutions might be more or less powerful in a patriarchal society.

Second, the impression that radicals in art history were separate and distinct from activists in other spheres of life outside the univer-sity is wrong because in many cases, particularly in the 1970s and early 1980s, *these were often the same people*. Marxists and femin-ists, in particular, in Britain in this period, were teaching or studying art history in universities *and* taking part in political activities in the wider society intended to bring fundamental change. Lippard's text, also discussed in Chapter 3, suggests that she found this integrated radicalism of social movement and intellectual project refreshingly different from the situation in the US – a society in which any signif-icantly *popular* left-wing political organisation had largely been eradicated during the state-sanctioned anti-communism of the 1950s.[1] British social historians of art, such as Clark, Tagg, and Orton, as well as less clearly 'Marxist' authors and artists, like Fuller, Burgin and Green, had roots in various political organisations connected to either the mainstream or peripheries of left-wing activism in Britain in the period from the mid-1960s to the late 1980s.[2] Although different authors exposed the political basis of their writing in differing ways, and to differing extents, radical art history was an authentic movement for intellectual and social change – both in universities and in society at large.

Was?

In the writing of this book it has been hard to avoid slipping occasionally into the past tense when discussing the movement, or project, of radical art history. Any work of history is, in one sense, retrospective, but I have insisted that history, though about the past, is always written in the now, and is motivated by the interests and values of the writer. Terms like 'movement' and 'project' carry more than a whiff of assumed self-consciousness and unity-of-purpose about them, as art historians should particularly know – such notions are the stock-in-trade, particularly, of modernists concerned with avant-garde art and artists since the late nineteenth century. Now, I believe radical art history *was* an identifiable group – but, rather like the 'movement'

called the Abstract Expressionists, some of its participants collaborated closely, some not at all, and some elements were certainly antagonistic.

Certain formal and some more diffuse 'institutions' had important roles in nurturing and articulating radical art history – for instance, the department of fine art at Leeds University (a 'home', at various points, to Clark, Orton, Pollock, Rifkin, Tagg, and Harris); *Block* magazine in London based at what was then Middlesex Polytechnic; the Marxist Caucus on Art at the College Art Association of America; The Women's Art History Collective; the US feminist art magazine *Heresies*; the Women's Workshop of the Artists' Union; in New York the Ad Hoc Committee of Women Artists; *Feminist Art News* in London, the Women's Art Alliance; the Women Artists' Slide Library.[3] But the movement of radical art history, as a whole, was *disparate*. Though alliances and allegiances of various kinds emerged, or were mooted, at various points and in various ways – that, for instance, 'theorists of the sign' needed a notion of ideology and social formation; or that feminist analysis of film needed a 'theory of the subject' – these were always local, if sometimes sustained, interactions: phenomena in an essay, at a conference, or an exhibition, or in an artwork, part of a complex, extensive, and sometimes contradictory field of agents and actions.

As a historian I need to work with evidence. This has mostly meant in this book a study of the texts that I have used as the basis to construct the 'identity' of radical art history. I have proposed that its elements – that is, its texts – share a broad 'historical materialism' of outlook: a belief that artworks, artists, and art history should be understood as artefacts, agents, structures, and practices rooted materially in social life and meaningful only within those circumstances of production and interpretation. This is a broad and, perhaps, generous definition. A broad and generous hypothetical correlate to it is that radical art historians also shared a basic understanding of the nature of society since the late 1960s. This was of a society driven by capitalist economic interests operating in the organisation of work, education, political, media, and military institutions. The society also contained other kinds of exploitative social relations, based, for instance, on factors of gender, race, and sexual preference. Marxists believed, however, that class and class struggle was the primary motor of historical development in capitalist society and that other forms of exploitation, though they certainly agreed they existed, were either a product of the basic antagonism of class, or peripheral to it. In either case, inequalities based upon, for instance, gender, or race, or sexual

orientation, would not be resolved, Marxists believed, until a socialist revolution had brought the end of capitalism.

As much as Pollock thought feminists could learn from Marxism she cautioned them to remain committed to the autonomous study of gender formation and inequality. While some feminists had seen themselves as socialists in the 1960s and 1970s, as many others saw feminism as a distinct and self-sufficient political movement. The diverse activisms of 'the moment of 1968' were as broad and complex as their art-historical exemplars: some protagonists wished to ally struggles around class and gender, some around class and race, some around race and gender, some around gender and sexual identity, and some even around all of them.[4] The moment of 1968's 'movement' was as internally differentiated as radical art history itself. Arguably, however, it shared the same recognition that a variety of antagonisms constituted the basis of social life, all of which were rooted in material interests. The division between Marxists and 'separatist' feminists indicates only one form of fundamental contradiction in belief over the nature of society and the most important form of political activity relevant to changing it. This antagonism, as I've shown, has also had its art-historical exemplars.

Though these contradictions were present in some of radical art history's earliest expressions – as they were in 'the moment of 1968' itself – the turn to the political Right in Britain and the US in the early 1980s effectively ended the political optimism that had motivated the generation of people who came to occupy the universities in the name of integrated intellectual and social change. Some older radicals, such as Clark, had seen the defeat of radicalism in the 1960s as an earlier signal moment – the basis for his 'retreat' into academia. But many others were energised by that time (or at least the myth of it), and carried on the spirit of its radicalism throughout the 1970s, though economically and politically things got tougher as the world capitalist economies entered a period of recession with high inflation and unemployment and the shadow of the Cold War returned.

If universities, though exclusive before the 1960s, had always been part of wider society then this became much more obvious to everyone in the 1980s and 1990s. In Britain, especially, the numbers of people undertaking degrees in art history rose enormously in this period and many more lower middle-class and working-class men *and* women were admitted to the institutions. More women became lecturers, though they continued, on the whole, to occupy junior academic positions. Universities became more 'inclusive', reflecting the diversity of much, if not the whole, of society. But the expansion in numbers was *not*

accompanied by the appointment of enough new staff, the allocation of sufficient department resources, or the creation of needed additional institutions.

In contrast, the 1960s' developments in higher education had included all these indices of growth – a general expansion took place funded by the economic boom of the time – but by the 1990s over a decade of cuts in university funding continued while student numbers were pushed up. Radical academics who had found jobs in these institutions were, of course, in favour of increased student access ('inclusivity'), but saw it occur while the quality of their resources and conditions of work were systematically reduced. The flight of British academic 'high-flyers' to more wealthy universities in the US was a symptom of this general decline. But what also declined, just as importantly, was the belief in the connection between education and radical social change. The advanced-capitalist 'New World Order' of the 1990s, led by the sole remaining superpower, the US, was one in which the diverse social utopianisms of the 1960s – socialism, gender equality of opportunity and women's rights, genuine *inter*cultural societies, a world without homophobia – had little or no place.[5]

With the end of the USSR, China's tacit embrace of capitalist economic development, the decline of the left wing of the British Labour Party under 'New Labour' and that of other left-of-centre groups in Europe and the US, belief in socialism has disappeared, while 'identity-politics' has survived and even flourished in the academy. The term has been used, in a derogatory fashion, by the Marxist critic Terry Eagleton to attack forms of political argument and struggle based on 'single issues', such as *gender* inequality, or *racial* group, or *sexual* proclivity.[6] Eagleton's view is that 'single-identity' groups, agitating for change in local areas of social organisation, or in certain aspects of life – like sexual activity – have lost sense of, or have always lacked, a *collective* political project able to unite people who are not necessarily gay, or female, or black. Identity-politics, he argues, has emphasised differences too much over what people share in common. It has overemphasised malleable 'culture' (understood as art and the 'whole way of life'), in contrast to other important facets of human existence (for instance, the material resistance to humanity offered by the natural world). Eagleton believes 'society' should be understood to be as much – if not more – a set of quite inflexible economic and social arrangements, as a set of interpretable and mutable 'identities' and 'representations'. Capitalism, Eagleton's point is, cannot simply be wished away or 'deconstructed' like a literary text or artwork can be.

Socialism, however, as much as feminism, or anti-racism, or gay and lesbian rights groups, was *always also* a form of 'identity-politics'. The term might be used derogatively, for instance by a feminist or gay rights activist, to describe socialist fixation on *class* identity that understands it as the privileged basis for understanding the historical development of society and proposes it as the primary historical agency able to bring fundamental change (Whitney Davis implies as much in his essay which I considered in Chapter 7). All these other forms of 'identity-politics' developed within art history at the expense of a Marxism that entered intellectual and political crisis in the 1980s, from which it has failed to recover. The crisis was one of its own making, though: how, its protagonists asked, could the primacy of class identity be reconciled with the claims of feminists or blacks or gays that other forms of social being and struggle were equally important? *It could not.* If the USSR voted, in the end, for its own dissolution, then so, in a way, did most Marxists in the West who could not continue to believe in what had long ago become another dogma. What is underestimated at our peril, however, is the significance of capitalist economic forces in social development throughout the world and for this reason Marxism, in its analytic and diagnostic modes, remains of unparalleled importance within critical intellectual thought.

Race and representation

In the early days of radical art history, however, an attention to questions of race and visual representation arguably did not imply any necessary politics, nor any kind of necessary dispute between Marxism and political campaigns around racial identity. My argument throughout has been that a broad 'historical materialism' unites radical art history's practitioners and this would include those concerned with the politics of race and representation as much as those of gender and representation. One does not have to be a woman to talk legitimately and supportively about women and art, or be black to talk legitimately and supportively about African-Americans and art. Albert Boime has done both, from the perspective of this broad historical materialism.

Take, for example, his 1990 book *The Art of Exclusion: Representing Blacks in the Nineteenth Century*. One may well dispute his accounts of Rosa Bonheur or the Puerto Rican painter Francisco Oller, but this should not be done on the basis of saying his views are

invalid *because* he is not a woman or Puerto Rican. Any 'identity-politics' that reached this view would richly deserve Eagleton's criticisms. Boime's text attempts to bring the issue of racial identity and its representation in artworks into alignment with an analysis of US capitalist society in the nineteenth century.

Through a variety of case-studies dealing with different kinds of media – drawings, prints, photographs, and paintings – Boime demonstrates that the myth of America as 'a utopian enterprise' was founded 'on the back of slaves' (AE: xiv). Though ranging from what he calls 'benign' stereotypes to out-and-out 'vicious representation', the depiction of social relations between blacks and whites in North America formed a significant part of that country's visual culture and the idealistic rhetoric of freedom upon which its political independence was supposedly based (AE: xiv). In the nineteenth century the question of black slavery shaped most visual representations in some way, although these were almost entirely produced by 'privileged white artists' (AE: xiv). Much of Boime's text is taken up, therefore, with the analysis of artworks that framed this question in a particular way. Like Clark, Boime spends some time on one or two oil paintings to which he appears to accord quite a lot of significance – such as Winslow Homer's *Gulf Stream* (1899) or John Singleton Copley's *Watson and the Shark* (1778). However, he is also interested in 'minor' genres and what might be called the popular visual culture of racism in the US in the nineteenth century.

In his discussion of prints and illustrations in magazines and newspapers of the time, such as Frederick Opper's *Darkies' Day at the Fair* from the popular journal *World's Fair Puck* (1893) – the title surely indicates enough of the content – Boime suggests that such ubiquitous representations indicate the nature of popular racism in American society. The emergence of Social Darwinism, Boime argues, and the 'mad scramble for African colonies facilitated the acceptance of the inherent inferiority of black peoples. In the graphic arts, this international discrimination is most visible in the satirical magazines burgeoning in the last decade of the century, which mercilessly lampooned blacks and colonised culture' (AE: 39). A similar vein of popular racist imagery is discussed by Annie Coombes in her book on British society around the turn of the twentieth century, which I consider later.

Not all illustrations and artworks were racist in this manner, however. According to Boime, a *variety* of attitudes towards the issue of black identity and slavery were represented in the visual culture of

the day (although Boime tends to convey the impression that popular imagery was unremittingly aggressively racist). The broad themes were those relevant to both the supporters and opponents of slavery: the humanity or inhumanity of slavery as a system, the question of the competence of black people to run their own lives or their ability to 'integrate' into white society, and the potential of the black to rise above ' "brute" status' and achieve spirituality (AE: xiv).[7] Boime's sense of the social meaning of this documentation is rather akin to Green's 'left post-structuralist' notion of discourse. Generally, Boime claims, images:

> of black people exemplify the strategies of cultural practice in addressing societal conditions . . . visual culture . . . tell[s] us much about how both the oppressors and the oppressed struggle for recognition, power, and control over their lives . . . As an agent of ideological practice, visual expression often participates in the overreaction and thus discloses the fragile character of the very system it seeks to reinforce. (AE: xiv)

Boime believes that artists have had a significant role in the creation of the modern ideologies of racism in the West since the European military and economic colonisation of the Americas, Asia, and Africa that began in the Renaissance.

Their role in 'codifying the iconographic environment' of western racism, he claims, has been 'devastating' (AE: 8). Take, for instance, Boime suggests, Mantegna's *Adoration of the Magi* (1464), in the Uffizi Museum in Florence, or many other versions of the same scene in Renaissance art. Boime sees in this a Freudian 'wish fantasy'. Missionaries and slavers do not have to invade the black king's land and take his wealth and people by force. Instead, a 'noble and "wise" black ruler comes of his own volition to the white man's land and lays down his wealth and his power at the feet of the Christ child' (AE: 9). Even in these depictions, however, Boime notes that the black king is given inferior status, usually pushed behind the other kings.

Architects, sculptors, and painters in America reproduced this racism, Boime notes, in, for example, Daniel Chester French's allegorical 'four continents' sculpture for the US Customs House in New York. The building's architect Cass Gilbert chose French who represented *America*'s allegorical female figure as alert and lively, while French's *Africa*'s figure (also a Grecian pastiche) was 'almost caricaturely depicted as slumped over in deep slumber' (AE: 11). Visual artists,

Boime asserts, had a particularly important role in representing the supposed *physical* characteristics of ancient or 'primitive' black people – for instance, skin colour and bone structure – as well as the contrasting features of 'Christianised' and 'liberated' blacks (AE: 13). Caricatures and cartoons were thus important means of creating mythologies of type and were reproduced in massive numbers as the technology and market for illustrated magazines and newspapers developed in the later nineteenth century.

Boime devotes a good portion of his text to the analysis of large-scale paintings, and attempts to deploy formal analysis to explain how these pictures created hierarchies of race within their narrative and compositional structures. Richard Caton's *War News From Mexico* (1848), for example, uses a triangular organisation to produce an allegory of power and status. The white people in the scene are depicted inside the porch of the house and the newspaper they are reading (informing them of US involvement in a battle over territory) is the narrative and pictorial centre to the painting. The rectangular shape of the newspaper is 'echoed' by the rectangle of the porch, which at its top bears the sign 'American Hotel'. Outside this rectangle is a black man to the left, who 'sits uncomprehendingly on the bottom step of the porch' and a white woman at the right: black and woman, racially and sexually inferior to the white men in the picture are, Boime claims, 'consigned to the bottom of the social, as well as the visual pyramid' (AE: 17).

Boime constructs even more ingenious 'readings' of paintings, including Copley's *Watson and the Shark*, a picture he sees as a complex allegory of positions over the slavery issue. The painting shows a small boat at sea in which seven men attempt to rescue another in the water around which a shark is circling, after having already once attacked its victim and severed part of a leg. One of the men in the boat is black, but seems strangely uninvolved in the rescue bid. Brook Watson, the man who commissioned this painting of a *fictitious event* was a wealthy merchant and Tory leader – that is, he wanted America to remain part of the British empire, yet saw the abolition of slavery as a necessary reform for his country's economic and social development. Whose liberty was more important, then, the painting asks: white Americans or blacks?

No clear answer is provided. The black man in the boat, Boime proffers, is the servant of the white men and waits, when directed, to hand the rope to the others. At best, Boime says, the black man 'registers a sense of compassion for the hapless Watson' (AE: 22). Watson, then, the commissioner of the painting, is the depicted man in the

water, and his position there is symbolic of his own doubt over his political views and economic interests. His severed leg is also symbolic, but multi-accentual: according to Boime, it was a 'common symbol' of the dismembered British empire or a disunified state. The bite of a shark had also long been associated with the system of slavery (AE: 35). Watson's doubts over the future of America and its relation to Britain is signified, Boime argues, by the compositional form Copley chose to use. This was an inverted triangle that also turned 'the social pyramid upside down' and *apparently* placed Watson, the master, in the position of victim and the black man, the servant, in the position of master (AE: 33).

However, while their 'positions' have been reversed, with the white man 'below' and the black man 'above', Boime notes that Watson maintains his control over the black man who ' "serves" him the rope. That is, the black rescuer remains "mastered" by Watson despite the reversal'. Watson is thus *simultaneously* hunter and victim and this 'dialectical relationship should be understood as a pictorial solution to his need to redeem himself from his guilty past' as a slaver (AE: 35). Watson asks, metaphorically, for forgiveness and receives it, metaphorically, from his victims 'he himself has greedily devoured. Thus, the shark within him has been exorcised, and, by extension, the shark-infested waters of the colonial appendage are cleared' (AE: 36).

When is a funnel just a funnel? When is a severed leg just a severed leg? Boime's reading is certainly itself 'masterly' and its twists and turns a pleasure to follow. What slightly disconcerts me, though, is its sense of completeness – no recognition of any 'unknowables' here, as Orton points to in his account of Jasper Johns. Boime agrees that paintings are a kind of text but seems to see them as transparent – as books that can be completely understood (AE: xiii). His own work of interpretation, though brilliant, is too seamless. *Is* it agreed, for instance, that the face of the black man in the boat seems to register 'compassion' for Watson? Boime's account of Copley's painting, like his account of some paintings by Bonheur, sometimes presents hypothesis or assumption as accomplished 'fact'. As such these stipulations constitute a kind of art-historical 'wish fantasy' of their own.

One person's wish fantasy (or ideological projection), though, is another person's cold, objective 'truth'. Annie Coombes examines the interaction between popular and 'scientific' aspects of racist ideologies in Britain in the late nineteenth and early twentieth centuries in her 1994 study *Reinventing Africa: Museums, Material Culture and Popular Imagination in Late Victorian and Edwardian England*. Coombes,

like Green, operates with a notion of 'discourse' drawn from post-structuralist, as well as 'cultural Marxist', thinkers, and is concerned with the manner and effects of museum displays of materials from African tribal societies. That is, she is interested in what these artefacts and representations were made to mean *in Britain for a British public* at the time of the 'scramble for Africa' when modern popular imperial-nationalism reached its xenophobic height.

Ideologies of racism, British imperial destiny, and nationalism are inseparable, Coombes contends, from their articulation and represen-tation within the spaces of the museum display and collection. Like Wallach, then, Coombes thinks the museum institution has a pivotal role in organising the meaning of national identity, and in organising it through portrayal of the British relationship to 'Africa'. 'Africa' in this sense is *entirely* the 'discursive construct' (invention) of its colonisers from Britain: a set of signs that purport to tell the truth about that continent but really only reveal the wish fantasies in British nationalism itself.

Both 'discourse' and 'ideology' are important terms in Coombes's analysis. The former importantly indicates the sense of a 'structured organisation of meanings' around a set of objects, practices, and concepts. The latter importantly retains the sense that these meanings are *expressive* of a set of particular material interests, values, and attitudes – those of the colonial British. The mainstays of these ethno-graphic displays were industrial capitalists, entrepreneurs, civil servants, amateur scientific bodies, emergent 'professional' geographers, and anthropologists. The composition, transmission, and popular interpre-tation of these displays raises complex issues. Coombes's aim, she says, is to understand more about the museum as:

> a repository for contradictory desires and identities, and the means
> by which different publics have been implicated by the narratives
> of belonging and exclusion produced within its walls ... [her]
> book seeks to demystify the link (in the West) between those
> cultural values which could be said to reside in the museum and
> deep-seated attachments to a concept of racial purity, coupled
> with an equally tenacious anxiety about its contamination and
> degeneration by 'black' races cast in this scenario as the forces
> of evil. (RA: 2)

Like Boime and Green, Coombes investigates a wide range of materials that might be said to constitute the visual culture of popular racism in

Britain around 1900. Unlike Marxists such as Clark or Barrell, however, Coombes shows little interest in the category of 'art', or in the idea that any artworks produced at the time might have had a 'critical' or subversive role in this moment of 'popular imperialism'. Though it could be argued quite convincingly that *no* artists in Britain existed at the time with any interest in being critical of nationalist ideology – there was no avant-garde tradition in that country similar to the one in France – Coombes simply has a different set of priorities, much closer to those practising 'cultural studies' analysis than to those of the social history of art.

The 'spectacle' of Africa, for Britons, then, was composed out of a diversity of materials that were artefactual, visual, and textual. Although photographs, objects, and accompanying textual captions were the stuff of museum displays for public consumption, the 'experts' involved, within the emerging disciplines of, for instance, anthropology and comparative anatomy, were also building up what they thought, and represented, as 'scientific knowledge'. Internally highly diverse, these popular and scientific accounts, Coombes warns, should not be reduced to the stereotypical notions of Africa as 'land of darkness', 'the white man's burden', or 'the savages'. Often, even *anti-racist* studies, Coombes remarks, see the representation of African materials in museums simply in terms of 'trophies' or 'curiosities', and so miss the complexities of the discourses that accounted for them (RA: 2).

Coombes notes, echoing a point made by Boime in relation to nineteenth-century pictures of black people in the US, that the predominantly visual character of display conventions led to an emphasis on 'Africa' understood *visually and physically* – particularly through representations of the bodies of black men and women presented as spectacle (RA: 215–16). But this was as true of claimed 'scientific' knowledges, as of the popular museum displays, such as the 1897 exhibition of Benin (Nigerian) bronze sculptures at the Horniman Museum in London. Coombes importantly qualifies and connects the meanings of both 'popular' and 'scientific'. Popular is *not* a shorthand term for 'working-class', rather it refers to the interaction and exchange of different classes and class fractions in the formation of ideas and values (RA: 3). As such this would *include* the claims made by middle-class experts using the language of 'science'. What Coombes calls 'social imperialism', then, is a discourse and ideology made out of this fusion of popular and 'expert-scientific' elements – simultaneously nationalist and related to different class-specific understandings of 'Africa' in British culture (RA: 214).

The representation of Nigerian Africa in Britain in the 1890s, for instance, was bound up with the concept of, and anxiety over, racial and social 'degeneration'. How could a people such as the *contemporary* Nigerians, British colonisers and scientists wondered, ever have produced the extraordinarily beautiful and highly naturalistic bronze sculptures in Benin? Three hundred Benin brass plaques were also exhibited at the British Museum in 1897 and became the site of a great deal of media and anthropological 'interest'. It was claimed by some that they simply could not have been produced by Africans at all, and must have been taken to Nigeria, or produced there, by Europeans. Others argued that Nigerian society had once been a great 'civilisation', many hundreds of years ago, and since then had degenerated into its present situation of primitive vacuity. According to Coombes, the ethnographers H.O. Forbes and Pitt Rivers both agreed in *private* that the bronzes were entirely of African origin, though Pitt Rivers *publicly* concurred with British Museum specialists that they were probably of sixteenth-century Portuguese origin (RA: 46). This suggests that at least some of these 'scientists' experienced a troubling contradiction between aspects of their technical analysis and evaluation and the demands of popular-nationalist ideology.

Indeed, the concept of 'degeneration', said to occur through processes of 'racial mixing' or population depletion, was entirely a British, and European, invention:

> Not only the social sciences, but aesthetic discourses produced from within the emergent art and anthropological establishments, propounded theories that were rooted in such a belief ... The spectre of 'degeneration' then, was never easily confined to Africa and the other colonies. It haunted the very centre of the imperial heartlands and threatened to undermine irrevocably the myth of racial purity which continues to cling so tenaciously to notions of 'Englishness' today. (RA: 216)

Retaining the Benin bronzes in London as a symbol of British superiority (rather like the ongoing dispute between Greece and the British state over the 'Elgin Marbles' – what the Greeks call the Parthenon frieze sculptures) became a significant national issue. It also enabled the keepers of the ethnographic collection at the British Museum to enhance their status in the eyes of both the government and the institution's directors. Coombes notes the continuing significance of the 'Benin bronzes' in Britain into the 1990s, an instance of disputed 'cultural property' as much as remain the 'Elgin Marbles'.

The titles given to these artefacts reveal a fundamental aspect of their 'discursive meaning' – Lord Elgin had 'acquired' the Greek statues in the nineteenth century in much the same way that the Edo artefacts had been 'acquired' after the British looted the city of Benin. The exhibition 'Treasures of Ancient Nigeria', held at the Royal Academy in London in 1983, rekindled many of the issues. It is not simply a question of whether these artefacts should be returned by the British to the places where they were found. In a society which is claimed to be 'pluralistic' and 'multicultural', Coombes asks, what status do these relics of 'an older imperial identity' have in contemporary Britain? (RA: 221–4) What does it mean to be 'British' now? US citizens have experienced a very different form of appeal to their social and national identity in the twentieth century as that country has been much more significantly diverse racially, as Boime's essay on the representations of black people in the nineteenth century indicates. I turn to an essay by bell hooks on the identity of contemporary African-Americans in a moment.

The question of the meaning of the 'Benin bronzes' or 'Elgin Marbles' *in London* – in 1900 *or* 2000 – is inseparable from the issue of British attitudes towards Africa and the Orient as sites, once for direct military and political colonisation, and now for their post-imperial economic exploitation and indirect manipulation. To return them would imply the belief, on the part of the British authorities, that the peoples of those parts of the world were now capable of competently looking after artefacts that were removed ostensibly on the grounds that the local inhabitants were unfit, because of the 'degeneration' of their societies, to act as their curators. Their return would also imply admission of their illegal possession by the British.[8] Both implications remain largely unthinkable because post-imperial racism continues to be a highly significant aspect of British foreign policy. Though British society may be relatively 'multicultural' now, its ruling political elite, like that of the US, is still predominantly white, middle-class, and male.

The 'curation' of these artefacts within the western institution of the ethnographic collection or art museum also produces them as *art objects* and in doing so inserts them within the discourses and ideologies of art history. Whatever functions such artefacts served within the societies that produced them – their original meaning being as inseparable from that set of circumstances as Courbet's *Stone-Breakers* was from those of Paris in 1848 – their renaming as artworks, and relocation within art history operates a fundamental transformation. Although art history recognises in many ways the original religious significance of

most European Renaissance paintings, hanging them in the secular National Gallery in London, or the Metropolitan Museum in New York inevitably changes the way they are seen by both 'specialists' – art historians and critics, museum curators, contemporary artists – and everyone else.

This problem of 'meaning translation' between *different* societies or continents – one of the central concerns of anthropology – is equally present, then, *within* a single society or continent. Indeed, it is also always present in the interpretation of *all* artworks and art-historical texts. 'Translation' always involves issues relating to the interests and values of those producing the artefacts, those producing the interpretations and those, in turn, who come to interpret the interpretations. Coombes notes that one strand of art history – modernism – has consistently dealt with artefacts from African or Asian or Inuit cultures in terms of their formal and putatively 'spiritual' relation to avant-garde art and artists working in the late nineteenth and early twentieth centuries (RA: 5). I discussed the ideal and ideology of 'primitivism' in Kuspit's account of Matisse's paintings in Chapter 4. Kuspit's notion of 'the primitive' is based upon the Freudian idea of a basic core to psychobiological human life devoted to the expression and satisfaction of sexual instincts. Freud developed his theories, however, precisely in the wider situation of the imperialist colonisation of Africa by European nations that took place in the late nineteenth and early twentieth centuries. 'Primitivism' as a 'discourse', then, has always had a range of historically interlocking meanings and references. It is another, though related, account of 'the primitive' in Matisse's art to which I turn now.

Somatic/aesthetic/exotic: bodies and blackness

James D. Herbert's 1992 study *Fauve Painting: The Making of Cultural Politics* includes an attempt to submit Matisse's canonically modernist and primitivist paintings, including *Blue Nude* (Illustration 7), to a critique based upon feminist and anti-racist principles. As such, his book is a contribution to the development of a wide field of analyses, across a range of disciplines over the last ten years or so, that has been termed 'post-colonial studies'. The term 'post-colonialism' is associated with a set of related political and cultural processes, events, and organisations around the world. The notion of 'post-colonial' is complex and contains a variety of interacting elements.[9]

The 'post' in 'post-colonial', for instance, like the 'post' in 'post-modernism' or 'post-structuralism', has two related senses. It means 'over', 'finished', or 'after'. But it also means 'in the light of', 'in relation to', 'meaningful in terms of'. Things said to constitute post-modernism in art, for instance – such as a renewed interest in the use of narrative and figurative elements in painting (Illustration 3) – are meaningful in *contrast* to the situation that is usually claimed to have characterised modernism in art; that is, the predominance of abstraction. The two terms, figuration and abstraction, exist, therefore, in a relation of mutual reference and interdependence. The same is true of the concepts of 'structure' (form) and 'structuration' (change) that define the concerns of 'structuralist' and 'post-structuralist' intellectual currents, respectively. The two sets of terms feed off each other.[10] The terms 'colonial' and 'modern' also share a suffix: '-isation', which means both a *process* and, though this meaning is less often intended, an *achieved state* (that is, colonisation, modernisation).

'Post-colonialism', while sometimes used to suggest a situation *after* the end of colonisation (as if the effects of colonisation had been eradicated), is really, then, the name given to the continuance of what was once *direct* colonial control through other, *indirect*, means. It also refers to *accounts* of colonialism, in the same way that modernism refers both to artworks and art-historical or critical accounts. Britain has post-colonial relationships – all individually quite different – with, for example, Australia, Zimbabwe, and South Africa; all countries that Britain once directly ruled. The US, in contrast, has a *neo*-colonial relationship with much of Latin and South America – that is, in most cases, the US had not *formally occupied and controlled* countries to the south of its borders, though there have been numerous and important exceptions.[11] 'Post-' and 'neo-'colonialism, both of which are, at once, processes and states of domination, share important features. US political influence now is mostly wielded economically, or through treaties, agreements, and programmes of various kinds, as well as through the manipulation of influential intermediaries within those countries.

'Post-colonial *studies*' has grown up across social science, humanities, and arts subjects, within universities in the countries that both colonised and were colonised. It is a set of accounts of the changed nature of *all* the societies and cultures involved in colonisation. That is, post-colonial studies of literature and art include, for instance, the writings of black or Asian people living in England – such as Hanif Kureishi, Salman Rushdie, or Rasheed Araeen – as much as that of those

living in India or South Africa. In the US, where a substantial black population has lived for centuries, the importance of the study of their literature and art has been recognised for a much longer period.[12]

In principle, because post-colonialism has changed *all* these countries involved, and therefore affected *all* people, post-colonial studies in the humanities would include the literature or visual art of *all* social groups. The Benin bronzes in London are an object of post-colonial studies because, as Coombes shows, they have come to be 'of' the British in some crucial ideological respects. What do Matisse's 'primitivist' paintings produced around 1900–1910 tell us of North Africa, a region the artist visited and some of whose cultural artefacts he found relevant, as did Picasso, to his own concerns as an artist?

Herbert acknowledges at the outset that Fauvist ('wild beast') paintings implicate in their 'expressionistic primitivism' related questions of social class, gender, and sexuality, and the meanings of African blackness. In their yoking together of 'impressionist' themes (modern subjects) and 'post-impressionist' formal elements (such as linear and chromatic abstraction), Fauvist artworks enter, in their own way, Herbert claims, the game of national politics in France (FPMCP: 9). 'In London, in the Parisian suburbs, on the French Mediterranean shore [where Matisse lived] – all sites previously depicted by earlier French painters – Fauve pictures joined in territorial conflicts often heavily laden with issues of class' (FPMCP: 9–10).

Fauvist paintings, those by Matisse and, to a lesser extent, those by André Derain, supersede the means and effects of both impressionism and post-impressionism by depicting subjects beyond the boundaries of Europe, through the exploitation of African 'artistic resources' (FPMCP: 14). If the meaning of 'popular' for Coombes is an interaction of elements from different classes in Britain around 1900, then Herbert's notion of Fauvist art includes a similar sense of mixing or 'hybridisation'. His study, he says, is concerned with:

> a set of dialogues both cooperative and antagonistic undertaken by a certain body of paintings: dialogues between the *grande tradition* and Impressionism, between reactionary nationalism and republicanism, between genders, classes, between Europe and Africa, between the Fauves and Picasso. (FPMCP: 14)

Matisse's art did not simply *reflect* a pre-existing social and political situation in France. His paintings of the French pastoral landscape, for instance, Herbert claims, 'integrated signs of republicanism and Latin

nationalism at a time when no one attempted such a thing within the realm of politics narrowly defined'. As such they did not find a politics, but rather made one. Matisse's paintings of African subjects authorised, 'in the name of knowledge', French colonial expansion to the south (FPMCP: 11).

Herbert is happy to admit the tendentious nature of his argument. He delights in admitting that his accounts of Matisse's paintings are part construction, though he qualifies this as 'an ongoing negotiation between the past of Fauvism and my present' (FPMCP: 11–12). Echoing Orton, Herbert declares that it is impossible to locate 'once and for all' the meaning of Fauvist paintings, nor do the intentions of their producers, he states, 'carry a determining weight'. The meanings these pictures acquired may never have been intended, nor 'the ideological tasks these canvases performed' once they left the contexts of the artist's mind and entered others (FPMCP: 12).

Certain *facts*, however, are presented as significant elements within these other 'contexts'. Matisse had been to Biskra in 1906, a town in Algeria whose economy was based upon female prostitution for European tourists. Matisse had also seen many items of African culture that had been transported to France. Matisse's *Blue Nude*, whose subtitle was 'souvenir of Biskra', is, for Herbert, an artefact 'intricately entwined in that politics of space that goes by the name of colonialism' (FPMCP: 146). Though apparently depicting a black woman's body, the surrounding objects depicted are oriental, rather than African, and all are posed within Matisse's European studio. Like the Benin bronzes in the British Museum, Matisse has made the depicted black body into a representation 'of' his *own* life and society. The picture, like British ethnographic discourse, 'engaged, indeed produced, Western ambiguities about Africa' (FPMCP: 167). The studio setting 'domesticated' Africa, brought the foreign home to France, and recreated 'Africa' within Matisse's personal interior space (FPMCP: 171).

Yet, unlike Boime, Herbert identifies a *lack* of coherence in the meanings of the paintings he examines – there is a limit, therefore, to the mastery of his art-historical account set, apparently, by the limits to the coherence of the artwork itself:

> ... the 'bluish reflections' in *Blue Nude* serve to highlight white flesh, not black. Signs of ethnicity, in the end, simply do not add up in Matisse's painting. Anatomy that to French viewers suggested black Africa is set in a European pose; skin tone connotes both the blackest of Africans and the fairest of

Europeans. And Matisse depicts all in an oasis of northern Africa using a style that spoke of the Latin *grande tradition*. *Blue Nude* points beyond the Latin world, but in many directions at once, and back toward Europe as well. Its collection of geographic attributes, mere fragments, seem . . . eclectic and randomly juxtaposed . . . (FPMCP: 158)

The black body in *Blue Nude*, then, is the creation, the wish fantasy, of a white European male artist in the same way that the filmic woman for Mulvey is the creation, the wish fantasy, of white, male-dominated, Hollywood narrative cinema. Both, that is to say, are representations created to serve the interests of the representer, and not the interests of those represented. *Blue Nude* is a depiction of a black *woman*'s body and so combines the wish fantasies of colonialism's and patriarchy's exploitative gaze.

bell hooks' essay 'Representing the Black Male Body', one of a series of essays on art, art criticism, and black visual culture in the US included in her 1995 book *Art on My Mind*, examines what she calls the 'feminisation' of African-American men in the aesthetic realm (AMM: 205). hooks, like Green and Coombes, is concerned with a wide gamut of visual representational practices and artefacts involved in the production of intermeshed class, gender, sexual, and racial identities. Her name, which she wishes spelt with initial lower case letters, itself draws attention to the nature of identity as a basic element of individual and social life. Like 'Van Gogh' or 'Rembrandt', *bell hooks* signals an interruption of the normal practice of reading – reading *identities*, reading *authority*, and reading meanings altogether as an elemental human communicative practice.

hooks also has a particular interest in art, art criticism, and art history. Unlike Coombes or Green, she declares a *continuing* commitment to what appears to be the special quality of art activity. She couches this in terms of art's ability to *transcend* race and gender. 'Art', she says, 'and most especially painting, was for me a realm where every imposed boundary could be transgressed. It was the free world of color where all was possible' (Introduction: AMM: xi). Abstract Expressionist painting, in the past thirty years subject to almost innumerable 'revisionist' radical art-historical critiques of its political, masculinist, and heterosexist basis, remains for hooks one of her greatest pleasures (Introduction: AMM: xi).[13] 'Art' functions, in one sense, for her then, as a space of *knowing* utopian dreaming – where 'color' can be 'free'.

But there is also a sharp political point to her refusal of radical orthodoxy. This engagement with mainstream art as a form of 'expressive creativity' (Introduction: AMM: xi) is possible, she says:

> because the work of these artists has moved *us* in some way. In our lived experience we have not found it problematic to embrace such work wholeheartedly, and to simultaneously subject to rigorous critique the institutional framework through which work by this group is more valued than that of any other group of people in this society. Sadly, conservative white artists and critics who control the cultural production of writing about art seem to have the greatest difficulty accepting that one can be critically aware of visual politics – the way race, gender, and class shape art practices (who make art, how it sells, who values it, who writes about it) – without abandoning a fierce commitment to aesthetics. (Introduction: AMM: xii)

hooks' use of 'us' (by which she means black artists) here unsettles any assumption that there may be a simple *identity* to radical art history and cultural studies, or to any related political activism outside the universities.

The proliferation of 'identity-politics' generates potentially as much conflict *between* its constituent elements as that generated between them and mainstream conservative society, hooks is absolutely clear about this. Black artists and critics certainly have to confront an art world still rooted in the 'politics of white-supremacist capitalist patriarchal exclusion' (Introduction: AMM: xii). But this entity against which they struggle also contains men and women who have seen themselves as enemies of the *same* system, but whose attitude to race issues, hooks claims, actually aligns them with the establishment.

hooks speaks from, and in, the identity of a 'progressive' African-American woman. Her book, she says, was written because of a dearth of material in the US on African-American art and aesthetics (Introduction: AMM: xiv). Although certain 'individual progressive black females' – such as Sylvia Ardyn Boone, Judith Wilson, Kellie Jones, Coco Fusco, and hooks herself – have tried to address the issues facing black artists, she asserts that a 'conservative mainstream' *and* those from 'more progressive audiences' claiming to be their 'allies in struggle' have operated to block needed developments (Introduction: AMM: xiii). Some 'men of colour', as well as some white feminists, are identified by hooks as part of this resistance. She cites approvingly an essay by Michele Wallace, critically indexing Nochlin's influential text, discussed

in Chapter 3, entitled 'Why Are There No Great *Black* Artists? The problem of Visuality in African-American Culture' (Introduction: AMM: xii; my italics).

hooks' examination of the depiction of the black male body in US culture includes a discussion of the inadequacies of psychoanalytic concepts available through which to understand the processes of what she calls 'aestheticisation' and 'feminisation' acting upon, within, such representations. Like Boime and Coombes, hooks agrees that emphasis upon the physicality and visibility of black people – their visible bodilyness – is a key feature of racist ideologies (AMM: 205). Psychoanalysis, as Mulvey and Pajaczkowska argue, is the necessary intellectual ground upon which an analysis of fascination with the body and its sexuality must be based. Yet, hooks says, when she turned to it she found that no developed work on the interplay of sexual and racial materiality existed. In fact, it was one:

> of the few disciplines where white critical thinkers were unwilling to reassess their work in light of contemporary interrogations of racist biases in the development of specific epistemological frameworks. The rigid refusal to consider race as at all relevant on the part of feminist critics using psychoanalysis to reformulate critical thought in relation to gender served as a barrier, making it impossible for a substantive body of diverse work to emerge. (AMM: 203)

Obviously, hooks' opinion here is open to question. But, assuming her basic point is correct, might it not be the case that white (and possibly other black) feminists refused to consider race an issue in psychoanalytic theory *because* they saw themselves as anti-racist – that is, blind to the idea that 'racial differences' *could* be a feature of basic human materiality? Most socialists and feminists have understood racism to be a cultural, political, and ideological phenomenon, and precisely fought attempts by racists to portray racial difference as a 'natural' or 'biological' fact that could then be linked to arguments, for instance, about genetic or social inferiority.[14] Indeed, it is not clear whether or not hooks *herself* understands racial features to be a core aspect of what is proposed as an *unchanging human psychobiological nature*, or whether she is simply calling for a recognition that ideologies of race are implicated in the representation of *all* forms of sexuality, the operation of 'the gaze', fetishism and voyeurism, and so on, that psychoanalysis has been used to interrogate.

In either case, hooks' complaint about the interests and values of psychoanalysis highlights one of the central problems of its use within radical art history. That is, the core ideas of psychoanalysis are represented in a confusing manner: sometimes as an account of auto-nomic *somatic* processes – 'drives' – basically unaffected by social life and thus ahistorical (in the same way that a liver processes blood), and sometimes as *psychosomatic* processes amenable to fundamental change *because* humans live in specific historical worlds, where, for instance, sexism and racism in advertising, film, and television bombard them daily. Usually, in fact, the psychoanalytic ideas mobilised within radical art history are connected with other explanatory concepts concerned with social structures and signifying practices (for example, in Mulvey's and Pajaczkowska's texts), and thus contain an even more complex and confusing combination of *both* somatic and psychosomatic arguments.

hooks' essay was originally published in a catalogue for a 1994 exhibition at the Whitney Museum of American Art in New York called 'Black Male: Representations of Masculinity in Contemporary American Art'. She observes that within 'neocolonial white-supremacist capitalist patriarchy' the black male body is still perceived as the embod-iment of 'bestial, violent, penis-as-weapon hypermasculine assertion' (AMM: 205). She traces this racist stereotype back to the 1970s in the US, through a consideration of the image of black sportsmen in the mass media, when the black male body became comprehensively commodified in advertisements (AMM: 207). Even earlier, though, black sportsmen such as Jack Johnson and Joe Louis had made their own powerful bodies positive political symbols of 'rebellious masculinity, an assertion of militant resistance to racial apartheid' in US society (AMM: 206).

This myth of potency was appropriated in the 1970s, however, by white capitalist corporations and depoliticised: black men capitulated to commodification of their bodies, a capitulation which signals, for hooks, the 'loss of political agency, the absence of radical politics' (AMM: 207). Contemporary sports stars, such as the basketball player Michael Jordan and the boxer Mike Tyson, have lent their images to a 'visual aesthetic that reaffirms the repressive racialised body politics of the dominant society' (AMM: 208). Central to this racism is the reassertion of an aggressive black 'homosocial male bonding' and heterosexual domina-tion of women (hooks mentions Tyson's conviction for rape). hooks sees in Jordan's book *Rare Air: Michael on Michael* a concomitant submis-sion to a process of 'visual objectification that renders his body passive in ways that feminise it' (AMM: 209).

This ideology is by no means confined to popular culture. hooks considers Robert Mapplethorpe's collection of photographs *Black Book* to be a continuation, in 'art photography', of the same visualised racism. Though she concedes his images of gays and male prostitutes sometimes 'disrupt and challenge conventional ways of seeing' black men, they don't, hooks concludes 'necessarily counter the myriad ways those same images may inscribe and perpetuate existing structures of racial or sexual domination' (AMM: 209).

By this hooks means they reproduce the racist ideology of a division between the bodies and minds of black people – both men and women. White-supremacist culture, she says, has 'always deemed all black folks more bodies than minds' (AMM: 204). It is this confluence of racism and sexism that has fetishised the black body, 'only to exploit that embodiment in ways that create a modality of dehumanisation and estrangement' (AMM: 204). A similar process of alienation has turned women into 'signs' only of their bodies, feminists such as Mulvey and Pollock argue, but hooks believes this has happened to black *men* as well as women. Black people have had to confront the problem, not of losing touch of their 'carnality and physicality', but of finding ways of relating to it that are 'liberatory' and not confined to the 'racist/sexist paradigms of subjugated embodiment' (AMM: 204).

hooks is impatient with 'white feminism' because it seems only interested in patriarchy's reduction of women to their materiality and elevation of men to the life of the mind. Black men had always been treated in white society as women were, hooks believes: in this sense, then, of being seen *only* as bodies they were 'feminised' (AMM: 205). The radical social movements of the 1960s and 1970s, based upon issues and identities relating to class, gender, race, and sexual orientation, had little or no coherence intellectually or politically when it came to dealing with the various combinations of these elements in African-American people. The false antithesis of 'body' and 'mind' was at the root of the problem:

> If black men were seen as beasts, as rapists, as bodies out of control, reformist movements for racial uplift countered these stereotypes by revering the refined, restrained, desexualised black male body. If black women were depicted as sexual savages, hot pussies on the lookout for ready prey, then these stereotypes were countered by images of virtuous, repressed black ladyhood. Radical militant resistance to white supremacy, typified by the sixties' and seventies' black power movements, called out of

the shadows of repression the black male body, claiming it as a site of hypermasculine power, agency and sexual potency. That celebration was combined with a critique of white racist stereotypes. (AMM: 202–3)

During the 1980s and 1990s the development of black gay and lesbian activism complicated and problematised the radicalisms of white heterosexual Marxist and feminist politics *and* their related intellectual currents within the universities. One generation of self-proclaimed subversives thus became challenged by a succeeding generation that saw the former now as part of the 'establishment'.[15]

'Arguments and values', not 'theories and methods'

The unity identifiable within radical art history was never that of *either* an agreement over priorities in politics or in the selection of objects of study. This study has indicated, indeed, the rich diversity of both and the existence of sharp antagonisms between different factions, especially in the last fifteen years when 'identity-politics' flourished at the expense of a 'classist' Marxism that could not survive either politically or philosophically. It collapsed under the weight of its corrupt and incompetent practical correlates principally, the 'actual existing socialism' of the USSR – and because a rigorously conducted self-critique left most of its exponents unwilling to defend the traditional centrality of class, the role of the Party, and the state as the revolutionary basis for a 'dictatorship of the proletariat'.

Not for a minute, however, did most of these already 'western' (that is anti-Stalinist) Marxists embrace the 'New World Order' of US-dominated world capitalism. In fact, the growth in mordant 'anti-capitalist' groups, with no coherent sense of how its deposition might be achieved or what might replace it, has been a significant feature of the last ten years, particularly in activist groups concerned with, for instance, ecological issues, third world poverty and debt, and animal rights.

Radical art history's 'identity-politics' factions have grown in size over the last fifteen years and become significantly 'institutionalised' – in the relatively neutral sense that courses on, for instance, gender, sexuality, gay and lesbian, and black art have entered many programmes for under- and postgraduate studies in universities, taught by tenured academics (and many with less secure positions) specialising

in these 'fields' now recognised in many departments as legitimate parts of the subject of art history. Whether they like it or not, for their students, they now represent at least part of the 'establishment', the figures of authority and power in university departments.

Radical art history surely *is* over, however, in terms of its original impetus and roots in 'the moment of 1968'. Though many of those activist-scholars, now institutionally ensconced, are still politically active, the *utopian and practical-organisational dynamic* for radical social change of which they were a part has faded. In Britain, as I have noted, the links between radical academic work and a popular socialist movement were severed in the mid-1980s with the defeat of the NUM and the transformation of the Labour Party into a 'social-democratic' organisation no longer hostile to capitalism, increasingly like the US Democratic Party.

Ironically, the belief that radical art historians *did* share – broad commitment to a historical materialist understanding of art and culture *within* human life, society and its historical development – was the basis precisely *for* the elaboration of the different emphases that the materialisms of 'identity-politics' engendered. At different moments in the period since about 1970 some of these factions in political and academic radicalism came together – 'socialist feminism' and 'black feminism' were, still perhaps are, names for two of these instances. One of the dangers of the idea of a 'new art history', as Orton and Pollock have argued, is that it separates out these elements and even sets them against each other. The actual history has really been one of mutual critique, attempted integration, and subsequent highly varied and often creative development – in the long-term work or 'projects' of individual scholars, and within the wider diverse 'movements' and groups of which these scholars have been part during the last thirty years or so. The other big danger is that the idea of a 'new art history' works to *de-politicise* what has always been a (fragmentary) part of the broad (but fragmentary) social and political radicalism of the 1960s: that radical art history, like traditional art history, gets represented as just *academic*.

Stuart Hall's 1981 account of the development of cultural studies in Britain in the 1960s is instructive, by way of conclusion. In 'Cultural Studies and the Centre: Some Problematics and Problems', Hall explains the history of what is now seen as mostly only an academic subject. Though the study of 'popular' or 'mass culture' at the Centre for Contemporary Cultural Studies at the University of Birmingham began in the mid-1960s, its roots lay importantly in trade-union and working-

class radicalism in the country at large. That is, 'cultural studies' became the name for a set of inquiries about the nature of history and contemporary society that was linked to traditions of socialist organisation in Britain and in many other countries around the world. Many of 'cultural studies' originating intellectuals – for instance, Raymond Williams and E.P. Thompson in Britain in the 1950s and 1960s, Antonio Gramsci in Italy and Walter Benjamin in France in the 1930s – were deeply involved in political parties and other initiatives organised to challenge capitalist power in the societies of Western Europe.[16]

These activist-scholars were never opponents either of 'high art' or of its study – Williams, for instance, was professor of drama at Cambridge University – but they saw a need to move beyond the tradi tional disciplinary boundaries in the study of the humanities in order to understand fully the nature of contemporary society and the relationships between culture, society, and the political order as a whole. Their interest was in *all* the kinds of cultural production present in the complex societies of industrial and consumer capitalism.

The traditional notion of English literature or art history as a study of 'the best, the highest' – culture in the ideal, idealist, and idealistic sense – was not wrong but inadequate. Along with the urgent need to question values and interests in determining what might be said to be the best novel or painting (said to be the best by whom?, when?, where?), there was a need to explore wider definitions and evaluations of culture, through, for instance, notions of 'mass', 'popular', and 'working-class'. In short, culture understood not simply as a set, or canon, of artefacts, but as *process*: 'elements within a whole way of life'. This, then, was a move:

> to an anthropological definition of culture [and notion of] cultural practices . . . [which imply] a historical definition of cultural practices . . . [and] . . . questioning the anthropological meaning and interrogating its universality by means of the concepts of social formation, cultural power, domination and regulation, resistance and struggle. (CSC: 27)

As such, cultural studies begins to sound a lot like radical art history. Both shared a similar causal connection to the political radicalism of the 1960s, though both had earlier roots as well. Both have opened up the study of art and culture broadly to inquiries rooted in questions about contemporary society and the ordering of power and identities within it. Both will go on, in a variety of forms, and can

learn from each other. The name given to *this* inquiry, finally, is much less important than the spirit and the rigour with which it is carried out, along with its protagonists' sense of vital relation to the present condition of society and investment in belief in a better future for all humanity.

Notes

1 See, for instance, Mike Davis 'Why the U.S. Working Class is Different', *New Left Review*, no. 123, September–October 1980: 3–43; 'The Barren Marriage of American Labor and the Democratic Party', *New Left Review*, no. 124, November–December 1980: 43–84; and David Craven *Abstract Expressionism as Cultural Critique: Dissent During the McCarthy Period*, Cambridge and New York: Cambridge University Press, 1999.

2 My study has, of practical necessity, been limited to a consideration of British and US radical art history. Accounts of its development in, for instance, Germany demonstrate a similar rootedness in movements for social change (see O.K. Werckmeister 'Radical Art History', *Art Journal*, vol. 42, Winter 1982). The journal *Kritische Berichte*, founded in 1972, is still a mainstay of radical art history in Germany. An exemplary case-study in German radical art history is Reinhardt Bentmann's and Michael Muller's *The Villa as Hegemonic Architecture*, Atlantic Highlands: Humanities Press: 1992, with a Foreword by O.K. Werckmeister and Introduction by David Craven.

3 See Rozsika Parker and Griselda Pollock, 'Fifteen years of feminist action: from practical strategies to strategic practices', in *Framing Feminism: Art and the Women's Movement 1970–1985*: 3–78; and A. Wallach 'Marxism and Art History', in B. Ollman and E. Vernoff (eds) *The Left Academy: Marxist Scholarship on American Campuses*, vol. II, New York: McGraw-Hill, 1984.

4 See, for example, Sheila Rowbotham *Women, Resistance and Revolution*, Harmondsworth: Penguin, 1974, and *Women in Movement: Feminism and Social Action*, London and New York: Routledge, 1992.

5 The difference between 'multi-' and 'inter-'cultural, and 'multi-' and 'inter-'social is significant. Aspects of British and US contemporary popular music, for instance, may be genuinely 'intercultural', but the two countries are not fundamentally *intersocial* in racial terms. An example of 'intersocial utopianism' is a song, written by Woodie Guthrie in 1942, in the middle of World War II, called 'She came along to me'. One verse reads: 'And all creeds and kinds and colours of us are blending/Till I

suppose ten million years from now we'll all be just alike/Same colour, same size, working together and maybe we'll have all the fascists out of the way by then/Maybe so.'

6 See *The Idea of Culture*, especially 65–7.

7 On the contemporary relevance of his study, see an interview which touches on the riots in Los Angeles in 1992, 'An Interview with Albert Boime' (by Barbara Anderman), *Rutgers Art Review*, no. 15, 1995: 71–87.

8 On the issue of 'restitution' of cultural property, see Elazar Barkan *The Guilt of Nations: Restitution and Negotiating Historical Injustices*, New York and London: Norton, 2000.

9 See, for instance, Edward Said *Culture and Imperialism*, London: Chatto and Windus, 1993; Nicholas Thomas *Indigenous Art/Colonial Culture*, London: Thames and Hudson, 1999; and Susan Hiller (ed.) *The Myth of Primitivism: Perspectives on Art*, London and New York: Routledge, 1991.

10 This discussion of 'postness' is extended in Jonathan Harris 'Grounding Postmodernism', in Shearer West (ed.) *The Bloomsbury Guide to Art History*, London: Bloomsbury, 1996.

11 See Noam Chomsky *Turning the Tide: US Intervention in Central America and the Struggle for Peace*, London: Pluto Press, 1985, and *On Power and Ideology: The Managua Lectures*, Boston: South End Press, 1987.

12 See, for instance, Homi K. Bhabha *Nation and Narration*, Routledge: London, 1990; Martin Bernal *Black Athena: The Afroasiatic Roots of Classical Civilisation*, London: Vintage 1991; and Paul Gilroy *The Black Atlantic: Modernity and Double Consciousness*, London and New York: Verso, 1993.

13 See Michael Leja *Reframing Abstract Expressionism: Subjectivity and Painting in the 1940s*, New Haven and London: Yale University Press, 1993.

14 See Steven Fraser (ed.) *The Bell Curve Wars: Race, Intelligence and the Future of America*, New York: Basic Books, 1995.

15 See Susan Gubar *Critical Condition: Feminism at the Turn of the Century*, New York: Columbia University Press, 2000, and Sheila Rowbotham *Promise of a Dream: A Memoir of the 1960s*, London: Allen Lane, 2000.

16 See, for instance, Raymond Williams *Culture and Society*, London: Chatto and Windus, 1958, *The Long Revolution*; E.P. Thompson *The Making of the English Working Class*, London: Penguin, 1968; Antonio Gramsci *Selections from Cultural Writings*, London: Lawrence and Wishart, 1985; and Walter Benjamin *The Arcades Project*, Cambridge, Mass.: Harvard University Press, 1999.

CONCLUSION

Select bibliography

Aldred, N. and Ryle, M. (eds) *Teaching Culture: The Long Revolution in Cultural Studies*, Leicester: NIASE, 1999

Anderman, B. 'An Interview with Albert Boime', *Rutgers Review*, 15, 1995: 71–87

Art Bulletin 'The Problematics of Collecting and Display, Part 1', in March 1995: 6–24

Art Bulletin 'The Problematics of Collecting and Display, Part 2', in June 1995: 166–85

Art Bulletin 'Inter/disciplinarity', December 1995: 534–52

Art Bulletin 'Aesthetics, Ethnicity, and the History of Art: A Range of Critical Perspectives', December 1996: 594–621

Association of Museum Directors *Different Voices: A Social, Cultural and Historical Framework for Change in the American Art Museum*, New York: Association of Art Museum Directors, 1992

Benjamin, W. *The Arcades Project*, Cambridge, Mass.: Harvard University Press, 1999

Bernal, M. *Black Athena: The Afroasiatic Roots of Classical Civilisation*, London: Vintage, 1991

Bhahba, H.K. *Nation and Narration*, Routledge: London, 1990

Block Reader in Visual Culture, London and New York: Routledge, 1996

Eagleton, T. *The Idea of Culture*, Oxford: Blackwell, 2000

Gilroy, P. *The Black Atlantic: Modernity and Double Consciousness*, London and New York: Verso, 1993

Giroux, H.A. and McLaren, P. (eds) *Between Borders: Pedagogy and the Politics of Cultural Studies*, London and New York: Routledge, 1994

Hall, S. *et al. Culture, Media, Language*, London: Hutchinson, 1980

Harris, N. *Presenting History: Museums in a Democratic Society*, Washington DC: Smithsonian Institution Press, 1995

Morley, D. and Hsing Chen, K. (eds) *Stuart Hall: Critical Dialogues in Cultural Studies*, London and New York: Routledge, 1996

October: The First Decade 1976–86, Cambridge, Mass. and London: MIT Press, 1986

October: The Second Decade 1986–96, Cambridge, Mass. and London: MIT Press, 1996

Said, E. *Orientalism*, Harmondsworth: Penguin, 1985

Said, E. *Culture and Imperialism*, London: Chatto and Windus, 1993

Steele, T. *The Emergence of Cultural Studies 1945–1965: Cultural Politics, Adult Education and the English Question*, London: Lawrence and Wishart, 1997

Thomas, N. *Indigenous Art/Colonial Culture*, London: Thames and Hudson, 1999

Williams, R. *Television: Technology and Cultural Form*, London: Fontana, 1974

Williamson, J. *Decoding Advertisements: Ideology and Meaning in Advertising*, London: Marion Boyars, 1978

Index

Abstract Expressionism 111, 117, 211,
 224 n11, 264, 280
academicism 25, 43
academies 102
accessibility 6, 28
Ackerman, J.T. 39, 57 n12
activism 7, 9, 14, 20, 99, 211, 262
Ad Hoc Committee of Women Artists 264
advertisements 14, 16, 35, 84, 114, 143,
 170, 189 n15, 200, 213–8
aesthetic 15, 38, 48, 77, 83, 98, 119, 131,
 135, 139–43, 154, 156, 166–7, 171–5,
 188–9 n8, 195, 198, 200, 219, 231,
 232, 235, 257 n3, 274, 281, 282
agency 49–56, 156, 183, 184, 194, 199,
 203, 205, 222 n1, 224 n11, 236, 255–7
Alberti, Leon Battista 179, 180
Aldred, N. 225 n26, 290
Alpers, S. 14, 58 n19, 161, 178–83, 190
 n18, 194, 231
Althusser, L. 23, 32 n31, 47, 65, 176, 189
 n16
Amiens Cathedral 176
analogy 70, 90 n14, 204, 241
analytic attention 4, 13, 17, 26, 31 n22,
 170
analytic construction 26, 27
analytic procedures 10, 24, 35, 40, 48,
 65, 110, 218
analytic specificity 66, 167
anarchism 68
Anderman, B. 31 n25, 290
Andersen, W. 88–9 n5
Anglo-US art history 15, 16, 288 n2
Anguissola, S. 104, 106, 112
animal rights activism 240–1

Antal, F. 91
anthologies 13
anthropology 23, 46, 88, 153, 167, 169,
 185, 228, 272, 274, 276, 287
anti-capitalism 188, 198, 209, 224 n14,
 285
anti-colonialism 9, 39
anti-communism 263
anti-imperialism 15
anti-Nazism 7
Apollo (UK) 45–6, 59 n28
apotropaic images 245–6
Araeen, R. 277
architectural history 30 n16
architecture 210
Aristotelianism 51
Aronowitz, S. 89 n9, 224 n17
art 5, 9, 12, 14, 15, 18, 24, 25, 26, 27,
 70, 105, 113–17, 140, 210, 275
Art and Society Forum of History
 Workshop Conference 29 n3
art appreciation 22
Art Bulletin (US) 30 n16, 91, 98, 290
art criticism 13, 113, 117–8, 141, 153,
 197, 198, 200, 201, 211, 280
art critics 5, 10, 11, 25, 70, 72, 117, 153
Art Forum (US) 232
art historians 10, 11, 14, 18, 19, 22, 25,
 57 n11, 99, 117, 246, 251
Art History (UK) 236
art history: as a discipline 1, 2, 4, 6–7, 8,
 9, 20, 31 n22, 42, 46, 97, 104, 110,
 178, 185; as a profession 4, 5, 9, 20,
 28, 30–1 n16, 39, 101, 286; as a unity
 30 n16; balkanisation of 30 n16;
 bourgeois 24, 110; brain-drain from

UK to US 16; British 8, 15, 19, 28–9 n3, 30 n16, 116; critical 6, 7, 8, 9, 13, 78; curriculum 10, 13, 285–6; dreary professional literature 8, 9, 22–3; feminist 3, 4, 5, 7, 12, 21, 23, 24, 84, 88, 96–123, 109; graduates 2, 3, 6; heroic phase 8, 23, 44, 66; institutionally-dominant 8–9, 10, 15, 21, 22, 26, 27, 35–7, 45, 100, 106, 253; mainstream 15, 22, 23, 26, 37–9, 52, 98, 124 n13; Marxist 3, 4, 5, 7, 12, 15, 21, 24, 48, 64–88, 96, 110; merely academic 7, 8, 20, 24, 64–5, 109, 286; methods and approaches 7, 30 n16; new 6–10, 13, 20, 22, 25, 27, 33 n36, 35, 39, 42, 44, 65, 185, 200, 286–8; non-transcribed 18; old 10, 12, 15, 27, 39–43, 103; Open University (UK) 31 n18; patriarchal 101; projects 4, 10, 23; psychoanalytic 4, 7, 26; publishing 9, 18, 45, 96, 262; radical 4, 6, 7, 8, 9, 10, 12, 13, 14, 15, 16, 17, 18, 20, 21, 23, 24, 26, 27, 28 n3, 31 n24, 35–9, 46, 47, 56, 56 n5, 59 n30, 130, 156, 163, 164, 185, 188, 197, 209, 213, 216, 228, 230, 251–2, 257, 262–4, 281, 283, 285–8; revisionist 78; right-wing radical 6; social 7, 8, 9, 13, 20, 48, 49–56, 64–88, 88 n5, 90 n14, 96, 108, 144, 177, 203, 229, 241; structuralist 26; survey 104; survey courses 16, 30 n16, 105; teachers 2, 4, 5, 9; US 8, 15, 19, 30 n16, 116, 253–7
art movements 5
Art News (US) 96
art theorists 10, 11, 14, 117
art theory 13, 16
artefacts 5, 10, 11, 12, 13, 17, 18, 19, 41, 78–9, 80, 121, 135, 138, 145, 164, 184, 258
artists 5, 16, 25, 26, 105, 153, 200
Association of Art Historians (UK) 44
Association of Museum Directors (US) 290
Aufterheide, P. 33 n26
authority 76, 177, 187, 194, 199, 203, 253–7, 280
authors 5, 11, 12, 14, 16, 120, 186–7, 199, 203
autonomy 48, 50, 55, 73, 100, 117, 122, 171–5, 201, 211, 212, 231
avant-garde 54, 72, 74, 90 n16, 103, 133, 135, 152–6, 156 n2, 238, 263, 276

Baker, E.C. 29 n13, 126
Baker, S. 258 n8, 259
Bal, M. 15, 26, 31 n26, 34 n37, 42, 56 n1, 58 n20 n22, 161, 178, 183–8, 194, 202, 231, 258 n11

Baltimore Museum of Contemporary Art 77
Bann, S. 188 n7, 190
Baranik, R. 223 n8
Barbizon School 240
Barkan, E. 289 n8
Barnard, M. 32 n29, 60
Barrell, J. 63, 65, 71, 81–4, 87, 90 n15, 91 n24, 131, 143–4, 209, 218, 229, 239, 243, 251, 273
Barthes, R. 57 n16, 126 n32, 171, 186, 188 n7, 189 n11, 190, 223 n7, 225, 225 n25
Battersby, C. 259
Baudelaire, C. 195
Baudrillard, J. 212, 225 n24
Bauhaus 79
Baxandall, M. 42–3, 58 n24, 60, 179, 181 190 n18
BBC 73
Beardsley, A. 233
Beaton, C. 59 n37
beauty/beautiful 139, 169
Beck, J. 31 n23
Beckley, B. 259
belief 211–12, 241, 247–57
Bell, C. 200
Belting, H. 30 n16, 56 n1, 60
Benglis, L. 122
Benjamin, W. 41, 91, 224 n13, 287, 289 n16, 290
Bennett, T. 57 n8, 225
Bentmann, R. 91, 288 n2
Berger, J. 5, 14, 29 n13, 84, 126, 157 n7, 189 n14
Berman, P. 33 n36
Bernal, M. 289 n12, 290
Betterton, R. 125 n22, 126, 126 n29
Bhabha, H. 259, 289 n12, 290
Biblical scripture 29 n10
Bibliothèque nationale, Paris 175
binary oppositions 35, 41, 43, 44, 45
biological materialism 139–40
Bird, J. 28 n1, 223 n8
Blackburn, R. 30 n14
Blackburn Museum and Art Gallery 175
Blair, Tony 43–4
Block (UK) 16, 20, 31 n17 n24, 103, 143, 203, 213, 224 n15, 225 n25, 264, 290
Bloomsbury Group 200
Bodone, P. 145
Boime, A. 8, 29 n5, 31 n25, 60, 70, 74–6, 78, 83, 91–2, 102, 131, 162, 227, 229, 236–41, 242, 243, 261, 267–71, 272, 273, 279, 282, 289 n7
Bonheur, R. 98, 103, 236–41, 243, 267
Boone, S.A. 281
Borch, T. 181
Bourdieu, P. 32 n30

Bourgeureau, W.A. 239
Bowie, M. 158 n17
Bowlt, J.E. 92
Brancacci Chapel, Santa Maria del
 Calmine, Florence 174
Braque, G. 55
Bredekamp, H. 30 n15
Brettel, R. 29 n10, 57 n15
Brilliant, R. 30 n16
Bristol University 20–1
British Museum 274–5, 279
Brookner, A. 81
Broun, E. 124 n11
Bryson, N. 24, 26, 28 n1, 30 n15, 34
 n37, 49, 129, 147–52, 158 n20, 161,
 170–5, 176, 180, 185, 189 n10 n11
 n14 n15, 190, 196, 200, 216, 231, 240,
 243, 258 n12
Bürger, P. 90 n16, 211
Burgin, V. 16, 24, 159, 193, 196–202,
 204, 214, 218, 223 n8 n10, 230, 263
Butler, J. 126, 159, 258 n6

Cabanel, A. 75
Cage, J. 206
Caleb Bingham, G. 78
Cambridge University 20, 287
camera obscura 182–3
Camille, M. 161, 170, 175–8, 185, 189
 n16 n17
canon 9, 10, 11, 29 n10, 37, 40–1, 50–6,
 57 n6, 71, 98, 100, 113, 119, 153,
 209, 213, 218–22
Canterbury Cathedral 172, 174, 180
capitalist societies 2, 3, 19–20, 24, 54, 64,
 72, 79, 80, 81, 87, 108, 115, 130, 143,
 197, 199, 200, 201, 214–15, 268
caricature 11
Cassatt, M. 103, 106–7, 111
castration anxiety 137, 155, 186
catalogue raisonné 105
catalogues 18
categories 4, 10, 23, 100, 130, 189–90
 n17, 220–2
Catholic Church 76, 175–8
Caton, R. 289
Center for African Art, New York 77
Centre for Contemporary Cultural
 Studies, Birmingham University 286
Cézanne, P. 102
Champa, K. 227, 232–6, 242
Chaplin, S. 32 n29
Charles the Bald 169
Cheetham, M. 32 n29, 33 n34
Cherry, D. 126
Chicago, J. 119, 122
Chomsky, N. 289 n11
churches 5
civilisation 37, 77, 201, 274

Civil War (US) 77
Cixous, H. 126 n32
Clark, T.J. 5, 7–8, 9, 10, 12, 13, 14, 15,
 16, 21, 22, 26, 29 n5 n6 n7, 36, 37,
 38, 40, 43, 44, 56 n2, 59 n37, 60 n43,
 63, 64–73, 88 n1 n2, 88–9 n5, 89 n8
 n12 n13, 90 n14, 90 n15, 74, 82, 83,
 85, 87, 88, 91, 96, 98, 99, 100, 101,
 108, 109, 110–11, 112, 116, 117, 122,
 130–1, 143–4, 158 n15, 162, 164–5,
 167, 176, 177, 178, 179, 183, 194,
 195, 204, 209, 211–12, 213, 218, 219,
 220, 221, 222, 222 n2, 223 n3 n9, 225
 n23, 225, 229, 241, 243, 257 n4, 263,
 264, 265, 268, 273
Clarke, J. 227, 241–6
class 3, 14, 19, 23, 33 n34, 40, 69, 72,
 83–4, 88, 90 n16, 102, 108–9, 130,
 138, 147, 162, 195, 211, 221, 264,
 267, 278–80
classicism 75–6, 254–7
classism 257, 285
Clayson, H. 31 n25
Cockburn, A. 30 n14
code 145, 207–8, 210, 217–18, 233–6
Cold War 7, 208, 265
Coleridge, S.T. 146
collections 9
College Art Association (US) 30 n16, 39,
 264
Collins, B.R. 30 n16, 60
commodities 9, 25, 198–9, 202, 210,
 216–18, 283–4
communication 13, 39, 167, 212, 280
communism 68, 117, 209
Communist Party (US) 206
concepts 4, 10, 12, 13, 15, 27, 85, 136,
 138, 125 n19, 152, 159 n21, 164, 165,
 173
conceptual art 196–202, 200–2, 223
 n8
conjunctural analysis 65–6, 85, 100, 110,
 165, 199, 229
consciousness 8, 44, 54, 149, 153, 155,
 231
conservation 18
Conservative Party 44
Constable, J. 71, 81, 82, 84, 229, 239
constructivism 55, 89, 211
consumption 17, 213–18
context 10, 12, 21, 26–7, 42, 49–56, 70,
 98, 135, 177, 183–4, 244
conventions 13, 49–56, 89–90 n13, 72,
 101–2, 111, 112, 121, 131, 133, 144,
 156, 164–88, 228, 250–1
Coombes, A.E. 261, 268, 271–6, 278,
 280, 282
Copley, J.S. 268, 270–1
corporations 9

Courbet, G. 7, 12, 26, 40, 48, 64–74, 89–90 n13, 90 n15, 98, 101, 110–11, 131, 144, 204, 219, 222 n2, 229, 239, 240, 275
Courtauld Institute of Art, London 88
Couture, T. 75
Coward, R. 59 n29
Cowie, E. 87, 91 n28, 107, 124 n14, 155, 159
Craven, D. 91–2, 188 n5, 189 n9, 288 n1 n2
creativity 15, 100–1, 105, 110, 117, 122, 125 n18, 194
Crimp, D. 225, 259
crisis in art history 35, 57 n12, 184–5
criteria 11, 12, 15
Croiset, N. 114
Crow, T. 92, 253–7, 258 n12, 259
cubism 10, 13, 47–56, 60 n42, 79
Culler, J. 26, 183, 188 n2
cultural studies 14, 19, 41, 46, 213, 220, 225 n26, 281, 287–8
Cunningham, M. 206
Cuno, J. 33 n36
curation 9, 151

dadaism 211, 234
Daley, M. 31 n23
David, J.-L. 89, 254–5
da Vinci, Leonardo 232
Davis, M. 288 n1
Davis, W. 39, 40, 57 n13 n14, 159, 227, 253–7, 257 n2, 258 n13, 267
Day, G. 223 n3
Debord, G. 88 n3
Debray, R. 156 n1
deconstruction 24, 25, 39, 187, 266
Deepwell, K. 127, 259
Delacroix, E. 75, 102
Deleuze, G. 126, 156 n1, 212
Democratic Party (US) 286
Demuth, C. 232–6, 256
depiction 84, 122, 152–6, 166–7, 174, 206
Derrain, A. 278
Derrida, J. 40, 198, 199, 200, 223 n7
description 13, 17, 27, 31 n22, 53, 55, 178–83, 207–8
design history 19, 228
desire 136–8, 147–52, 154, 163, 171, 196, 247–57, 272
determination 224 n20
Diderot, D. 251
Diggens, J.P. 125 n24
discourse 164–88, 218–22, 272
discrimination 36–7
disinterestedness 39, 117
display 9, 18, 79, 100
dissemination 17

Doane, M.A. 159
documentary 87
documentation 18, 122, 177, 181, 184
Dou, G. 179
Doy, G. 92
Doyle, T. 121
drawings 19
Duncan, C. 8, 29 n5, 59 n28, 90 n20, 92, 259
Dunn, P. 223 n8
Duchamp, M. 234
Dvořák, M. 8, 23, 44

Eagleton, T. 28, 33 n33, 34 n38, 60, 125 n20, 188–9 n8, 224 n14, 225 n29, 225, 257 n1, 266, 268, 290
Ecker, G. 127, 223 n4
Eco, U. 146, 158 n18, 190
École des Beaux Arts 74–6
ecological activism 209
Edwards, S. 32 n29, 60
Eliot, G. 236
Ellis, J. 59 n29
embodiment 12, 140–3, 149, 195, 231, 247–57
Empire State Building 81
empirical 16–17, 38, 49–56, 70, 122, 137–8, 149, 162, 164, 176, 178, 195, 196, 204, 216, 236
English studies 23
Enlightenment 251–2
epochal history 65
'the erotic' 242
essentialism 39, 116
ethnic identity and representation 4, 14, 19, 20, 24, 262–88
ethnicity 177
Etlin, R.A. 125 n20
eurocentricity 189 n10
Evans, D. 158 n17
Evans, W. 86
evidence 17, 18, 70, 83, 86, 149, 173, 239–40, 241, 245, 264
exemplification 10, 11, 12, 13, 172
experience 25, 104, 107, 122, 132, 139, 140, 177, 218, 222, 241, 257 n5
experts/expertise 87, 187, 273
exploitation 96, 132, 138, 163, 250–1
extrapolation 11

facts 252–3, 271, 279
fantasy 138–56
fascism 138, 206
fauvism 79, 152–6, 276–80
Feaver, W. 81
femininity 102, 104, 106–8, 123 n6, 124 n13, 135
feminism 2, 3–4, 9, 12, 16, 19, 20, 21, 23, 24, 36–7, 44–6, 59 n29, 88,

96–123, 123 n4, 126 n31, 130, 139, 150, 154–6, 162–3, 176, 197, 198, 209, 212, 229, 231, 232, 236–41, 242, 262, 276
Feminist Art News (UK) 264
feminist-socialism 114–15
Fernie, E. 32 n29, 60
fiction 11, 122, 202
film 14, 16, 87, 107, 132–8, 184, 213
Fischer, E. 8
Fish, S. 33 n35
Fiske, J. 226
Flitterman-Lewis, S. 159
Florence, P. 226
Floyd Bennet Field 91 n22
Forbes, H.O. 274
formal analysis 8, 9
formalism 38, 57 n8, 59 n32, 60 n38, 67, 151, 157 n12, 166, 184, 197, 198, 201, 211, 224 n11, 254, 258 n13
formations 17
Foster, H. 197, 210, 223 n9, 225 n22 n24, 226
Foster, K. 7, 28 n3
Foucault, M. 47, 87, 218, 223 n7, 243
Fragonard, H. 123 n6
Francesca, Piero della 170
Frankenthaler, H. 111
Frascina, F. 29 n11, 92, 125 n25, 191
Frazer, S. 289 n14
freedom 248–50
French, D.C. 269
Freud, S. 135–56, 157 n6 n13, 159, 186
Fried, M. 179, 190 n18, 198, 211
Fry, R. 200
Fukuyama, F. 225 n21
Fuller, P. 129, 136, 138–143, 145, 152, 156, 157 n12 n13, 158 n14 n16, 166, 167–8, 186, 195, 203, 222, 230, 231, 232, 263
funding bodies for art 17, 33 n36
Fusco, C. 281

Gabhart, A. 124 n11
Gainsborough, T. 71, 81, 82
galleries 5, 9, 14, 17, 18
Garb, T. 127, 258 n9, 259
Gauguin, P. 50
gay and lesbian rights activism 2, 40
gay and lesbian studies 232–57
'the gaze' 144, 147–52, 195, 231, 248–57, 280, 282–5
gender and sexual identity 2, 3, 4, 14, 19, 23, 24, 39, 87, 132–156, 217, 221, 242–6, 278–80
generalisation 11, 13, 35, 66, 111
Gent, L. 258 n9, 259
Gentileschi, A. 106
Gerome, J.-L. 75, 239

Giddens, A. 224 n12
Gilbert, C. 269
Gilroy, P. 289 n12, 290
Girodet, A.-L. 75, 252, 253–7, 258 n13
Giroux, H.A. 225 n26, 290
Godeau, A.S. 159
Godfrey, T. 223 n8
Gombrich, E.H. 37, 39, 41, 56 n5, 57 n6, 104, 151, 171
Gornick, V. 29 n13, 127
Gouma-Peterson, T. 125 n23, 127
Gowing, L. 179, 190 n18
Gramsci, A. 124 n8, 287, 289 n16
'great art' 12, 37, 48, 50–56, 73, 100–6, 113, 117, 118, 139–43
'great' male artists 9, 100, 118, 130, 163, 184, 263
Greek art 143, 157 n11
Green, D. 223 n3
Green, N. 24, 193, 218–22, 230, 231, 243, 263, 269, 272, 280
Greenberg, C. 60 n38, 195, 198, 211
Greenberg, D.F. 258 n10
Greer, G. 124 n13, 127
Guattari, F. 126 n32, 156 n1, 212
Gubar, S. 289 n15
Guthrie, W. 288–9 n5

Haacke, H. 223 n8
Hadjinicolaou, N. 23, 32 n31, 92
Hall, S. 17, 165, 224 n17, 261, 286–8, 290
Halle, M. 224 n19
Harris, A.S. 125 n19, 127
Harris, J. 29 n11, 92, 223 n3 n8, 224 n11, 225 n23, 226, 264, 289 n10
Harris, N. 33 n36, 290
Harrison, C. 59, 60, 224 n18
Hartman, H. 107, 124 n14
Haug, W.F. 226
Hauser, A. 8, 65, 67, 89 n7 n8 n10, 92, 124 n10
Hawkes, T. 191
Hebdige, D. 16, 193, 197, 202, 209–13, 214, 218, 219, 230
Herbert, J.D. 261, 276–80
Heresies (US) 264
hermeneutics 32 n30
Hess, T.B. 29 n13, 205
Hesse, E. 120–3, 126 n30 n32, 131, 194, 236
heurism 25, 66–7
Hewitt, A. 157 n9
Heywood, I. 32 n29
Hickey, D. 259
'high/low art' 41, 78, 110, 117, 143, 186–7, 200, 212
Hill, Benny 45
Hiller, S. 289 n9
Hindess, B. 224 n17

Hirst, P. 224 n17
historical materialism 12, 23, 24, 36, 56
 n3, 58 n18, 44, 109, 130, 139, 163,
 167, 212, 229, 230, 264, 267, 286–8
historical sociology of culture 22
historicism 67
history 2, 5, 11, 22–3, 33 n35, 64, 69, 70,
 86, 88, 99, 104, 112, 152, 165, 173,
 184, 208–9, 210, 222, 256–7
history painting 74
Hitchcock, A. 132
Hofmann, H. 224 n11
Holbein, H. 145
Holly, M. 33 n34
Hollywood films 14, 132–8, 215, 231,
 280
Holub, R.C. 189 n12
Holzer, J. 114
Homer, W. 77, 268
homosexuality 177, 206–8, 209, 217,
 230, 232–57, 258 n10
hooks, b. 243, 261, 275, 280–5
Horniman Museum, London 273
Hsing Chen, K. 31 n21, 188 n3, 290
Hughes, J. 125 n17
Hughes, T. 126 n30
humanism 12, 37, 57 n6, 57 n7, 101,
 113, 125 n20, 197, 198, 200, 201, 224
 n11
humanities 5, 6, 13, 20, 25, 185
humanity 288
Hunter, A. 114
Huysmans, Baron 258
hyper-realism 183

iconoclasm 175–8
iconography 8, 51, 90 n15, 177–8, 258
 n13
idealisation 39, 142–3, 153–4, 155,
 181–2, 246, 247–57
ideologies 3, 7, 24, 43, 58–9 n27, 44, 69,
 72, 76, 77, 81, 85, 103–6, 111, 113,
 117, 130, 139, 140, 147, 151, 162,
 163, 169, 175–8, 180, 183, 189 n16,
 217, 230, 254, 271, 279
ideology critique 12, 131, 148
identification 145, 147, 217–18
identity 7, 23, 85, 106, 120–3, 131–56,
 215–18, 257 n2, 280
identity politics 224 n14, 230, 238,
 262–3, 266–8, 281–5
idolatry 175–8
illusionism 54–6, 137–8, 171–5
imperialism 3, 273–6
Impressionists 74–5, 168, 229, 232, 278
indeterminacy 172, 199
individualism 101, 113, 130, 163, 198–9
industrialisation 82
Ingres, J.-D. 75

instanciation 12
Institut de France 76
Institute of Contemporary Arts, London
 108, 116
institutionalisation 118–19, 154, 285–6
institutional reproduction 2, 19, 20, 117
institutions 3, 5, 8, 17, 19, 24, 26, 65,
 71, 73–81, 86, 96, 100–1, 103, 106,
 117, 120, 131, 151, 162–4, 195, 264,
 281
intellectualism 13
intentions (artists) 52, 71, 244
interdisciplinarity 9, 13
interests 4, 8, 24, 36, 38, 81, 85, 104,
 115, 130, 134, 247–57, 272
interpretation 11, 18, 26, 27, 29 n10, 33
 n34, 51, 80, 104, 141–3, 157 n12, 184,
 186–7, 207–8, 210, 246, 251, 256, 258
 n13
Iverson, M. 191, 259

Jacobs, P. 30 n14
Jakobson, R. 217, 224 n19, 225 n27
Jameson, F. 212, 225 n24, 226
Janson, H.W. 104
Japp, A. 88 n3, 225 n23
jargon 5, 118, 126 n27
Jencks, C. 32 n29
Johns, J. 199, 203–8, 228, 233, 271
Johnson, P. 80
Jones, K. 281
Jordanova, L. 159
Judt, T. 156 n1

Kalf, W. 181
Kampen, N.B. 227, 242–3
Karras, M. 114
Kauffman, A. 103
Keats, J. 255
Kelly, M. 114, 122, 126 n31
Kepler, J. 182
Kermode, F. 29 n10
Kettles Yard Gallery, Cambridge 196
Kirwan, J. 259
Klein, M. 140–3, 157 n13
Klingender, F. 8
Klugman, K. 226
Klumpe, A. 237
Knabb, K. 88 n3
Kollwitz, K. 124 n7
Kooning, W. de 102
Kowinski, K. 226
Kramer, M. 114
Krasner, L. 120
Krauss, R. 10, 47–56, 60 n39, 60, 115,
 122, 190 n21, 197, 223 n9
Kristeva, J. 47, 158 n15, 159, 171, 189
 n11
Kritische Berichte (Germany) 288 n2

Kuhn, T. 159
kunstwollen 41
Kureishi, H. 277
Kuspit, D. 129, 152–6, 164, 195, 198, 199, 222, 230, 231, 235, 276

Labour Party (UK) 208, 266, 286
Lacan, J. 47, 114, 135, 147–52, 158 n17, 158–9 n21, 223 n7
Laclau, E. 89 n9, 224 n14 n17
Laing, D. 157 n11
Lake, B. 257 n3
Landau, S. 30 n14
language 13, 30 n16, 73, 101, 133, 134, 144, 146–7, 164, 171–4, 199, 200, 201, 202–3
'late capitalist society' 7
Lavin, I. 56 n1, 57 n12
Leaman, M.R. 30 n16
Leeds University 20, 85
Leeson, L. 114, 223 n8
Leighton, P. 60, 60 n39
leisure 220–2
Leja, M. 92, 289 n13
Lenin, V.I. 123 n4
lenses 181, 183
Lessing, G.E. 198
Leutz, E. 78
liberation 132, 136, 150, 284
life-drawing 102–3
linguistics 21, 23, 146–7, 165–6, 185, 188 n2 n7, 205, 206
Lippard, L. 5, 16, 95, 108, 113–18, 125 n21, 127, 130, 139, 229, 263
Lipton, E. 59, 60
literary studies/theory 21, 57 n8, 86, 184
Llewellyn, N. 258 n9
logocentrism 40
looking 14, 15, 42, 83, 132–56
Lorrain, J. 124 n8
Louis-Philippe, King 75
Louvre Museum, Paris 143
Lukács, G. 124 n8
Lyotard, J.-F. 189 n13

Macherey, P. 32 n31
Manet, E. 40, 48, 75–6, 90 n15, 195
Mantegna 269
Mapplethorpe, R. 284–5
maps 181, 183
Marin, L. 191
market 21, 25, 83, 117, 119, 197
marriage 26, 55, 99, 113, 121, 194, 237–8
Marx, K. 8, 12, 24, 124 n8, 147, 157 n11, 162, 188 n1, 217
Marxism 7, 8, 10, 15, 23, 40, 44, 46, 50, 56, 56 n3, 58 n18, 59 n29, 65, 81, 84,

85, 87, 88, 89 n9, 97, 103, 106, 107, 123, 123 n4, 130, 139, 143, 147, 150, 158 n20, 162, 166, 176, 187, 200, 202, 204, 208, 209, 211, 212, 213–22, 224 n20, 230, 231, 238, 253–7, 267, 273, 285–8
Marxist Caucus on Art (US) 264
Marxists 3, 8, 23, 24, 37, 138
Masaccio 174–5, 180
masculinity 107, 123 n6, 140 n8, 236–7, 253–7
mass culture 84, 133–8, 169, 200, 209–13, 286–8
mass media 19, 99, 210
material culture 228
material interests 3
materialism 166, 220–57, 286–8
Mathews, P. 125 n23, 127, 189 n9
Matisse, H. 102, 111, 152–6, 198, 199, 235, 276–80
May 1968, 'moment' of 3, 14, 15, 19, 21, 47, 48, 64, 132, 150, 171, 196, 265, 286
Mayne, J. 159
McDonald, H. 259
McGee, P. 226
McLaren, P. 225 n26, 290
McWilliam, N. 91 n23
meaning 7, 29 n10, 144, 171–5, 180, 188–9 n8, 204–8, 211, 279
media studies 14
mediation 13
Mellencamp, P. 226
Menil Collection, Houston 77
Merleau-Ponty, M. 146
Merquior, J.G. 191
meta-discursive/meta-language 17, 52, 53, 219
metaphor 26, 27, 42, 55, 122, 144, 145, 162, 165, 175, 188 n1, 201, 206–8, 218, 224 n19, 249, 271
metonym 206–8, 224 n19
Metropolitan Museum of Art, New York 73–4, 276
Metz, C. 146, 158 n18, 159
Micas, N. 237, 239
Michelangelo 41, 101, 102, 125 n18, 232
Middlesex Polytechnic 20, 28 n1, 44, 103, 264
Millett, J.-F. 240
Millett, K. 107, 124 n14
mimetic 166–70, 171–5
mirror phase/stage 145, 158 n17
mirrors 181, 183
Mirzoeff, N. 32 n29
misogyny 137–8
mixed-media 13
modernisation 20, 43, 86, 185

modernist art 48, 54–6, 60 n42, 68, 72–3, 75, 79, 80, 101, 116, 119–23, 126 n31, 152–6, 197, 203–8, 211, 212, 231, 224 n18, 235, 276–80
modernity 14, 54–5, 68, 79, 212
Modersohn-Becker, P. 124 n7
Monet, C. 239
monographs 9, 101, 105, 184
Moran, Barbara K. 29 n13, 127
Morisot, B. 98, 103, 106–7, 122
Morland, G. 81, 82
Morley, D. 31 n21, 188 n3, 290
Moser, M. 103
Mouffe, C. 89 n9, 224 n14 n17
movement 74, 131, 136, 209, 263, 286–8
Moxey, K. 33 n34
Mukařovský, J. 158 n18
Muller, M. 92, 288 n2
multiculturalism 25, 33 n36, 36, 275, 288–9 n5
multidisciplinarity 13
Mulvey, L. 14, 87, 91 n28, 129, 132–8, 140 n8, 143, 147, 150, 152, 154, 156 n2 n5, 164, 194, 195, 196, 203, 214, 217, 231, 243, 280, 282, 284
Munch, E. 50
Museum of Modern Art, New York 48, 73, 78–80, 90 n22
museums 5, 9, 14, 17, 18, 33 n36, 77, 78, 117, 151, 163, 165, 197, 253, 262, 272–6
Myers, K. 193, 213–8, 219, 243

narcissism 137–56, 198
narratology 185–8
National Gallery of Art, London 73, 163, 276
National Union of Mineworkers (NUM) (UK) 208, 286
nation-states 3, 76, 79, 87
naturalisation 170, 174–5
naturalism 51, 66, 239
nature 218–22, 249–50
Nead, L. 56 n3, 127, 258 n9, 259
Nelli, P. 104
Nelson, R.S. 30 n16, 60
Nevelson, L. 124 n7
New Labour 43–4, 58 n27, 200, 266
New Left 15, 19, 21, 230, 238
Newman, M. 223 n8
new social and political movements 2, 19, 46, 109, 201–2, 209, 230
New Vienna School 38
Nietzsche, F. 41
1960s 5, 7, 8, 11, 14, 19, 21, 22, 27, 39, 46, 64, 96, 130, 131, 212–13, 230, 235, 238, 262, 266, 284, 287
1970s 7, 8, 13, 14, 15, 19, 21, 22, 25, 28 n3, 30 n16, 39, 44, 47, 59 n29, 48, 89

n9, 85, 88, 96, 106, 118, 121, 132, 135, 139, 154, 163, 176, 185, 198, 202, 205, 209, 232, 262, 283, 284
1980s 20, 22, 24, 87, 88, 106, 118, 121, 135, 150–1, 154, 156, 156 n5, 163, 176, 189–90 n17, 185, 188, 197, 202, 204, 208, 209, 213, 230, 263, 285
1990s 20, 21, 22, 43, 109, 156, 202, 230, 253–7, 266, 285
Nochlin, L. 45, 95, 96–102, 105, 113, 123 n2 n5 n6 n7, 124 n9, 125 n19, 117, 118, 119, 127, 131, 162, 195, 262, 281
Norris, C. 32–3 n33

objectivity 23, 24, 25, 26, 37, 104, 151, 157 n12,
objects of study 7, 10
Ockman, C. 259
October (US) 16, 31 n17, 290
Oedipal phase 143
Offen, K. 123
O'Hara, F. 206
O'Keeffe, G. 120
oil painting 198–203, 219–22
Olin Wright, E. 124 n16
Oller, F. 267
Onians, J. 59 n28
Opper, F. 268
Orton, F. 7, 8, 9, 14, 29 n5 n8, 21, 22, 25, 31 n24, 59 n28 n36, 92, 101, 125 n25, 183, 190 n21, 193, 194, 199, 203–8, 213, 224 n16 n18, 226, 230, 233, 243, 271, 279, 286
'the Other' 176–7, 218, 253–7, 263, 264
Oxford Art Journal (UK) 93
Oxford University 20, 37

Pacht, O. 38, 42, 57 n9, 58 n21 n22, 60
paintings 13, 14, 16, 17, 19, 22
Pajaczkowska, C. 129, 143–7, 150, 152, 158 n17, 166, 167, 195, 231, 282
Panofsky, E. 8, 36, 38, 41, 51, 57 n7, 178
Paris, J. 158 n15
Parker, R. 95, 103–8, 117, 118, 124 n9 n12 n13, 125 n22, 126 n31, 127, 229, 262, 288 n3
Parthenon frieze sculptures (Elgin Marbles) 274, 275
Pascal, B. 200
'the pastoral' 83
patriarchy 7, 19, 20, 23, 36, 99, 103, 107, 119, 130, 132–56, 163, 177, 186, 194, 198, 213, 214–8, 233, 256, 263, 280–5
patrons 16, 72, 82, 83, 100
pedagogy 6, 11, 18–19, 20, 28, 31 n22, 35, 76, 96, 131

Peirce, C.S. 146, 158 n18
Pelli, C. 78, 80
Penley, C. 226
Perry, G. 259
Perry, W.C. 140
perspective 4, 12, 24–5, 26, 36–7, 39, 40, 65, 66, 82, 104, 113, 119, 130, 148, 156, 170–5, 179, 190 n21, 201, 252
Petersen, K. 124 n13
phallocentrism 137–8, 195
phantasy 142–3, 194
philosophy 12, 21, 64, 99, 111, 139, 173, 199, 204, 208, 224 n13, 242
photography 13, 16, 49, 84–8, 107, 112, 114, 180, 183, 200, 218, 224 n13, 284–5
Picabia, F. 234
Picasso, P. 10, 47–56, 59 n33, 60 n39, 102, 112, 115, 153, 190 n21, 206, 278
picture/picturing 182–3, 218
Pietropaolo, L. 159
Pissarro, C. 89 n12, 239
Plath, S. 126 n30
pleasure 14, 15, 17, 18, 22, 132–56, 163, 195, 220, 280
Pleynet, M. 158 n15
Pliny 171
Pogglioli, R. 90 n16
Pohl, F. 33 n36
Pointon, M. 28 n2, 31 n20, 31 n22, 42, 58 n23, 93, 259
political correctness 25, 33 n36, 36
Pollock, G. 5, 7, 9, 12, 13, 21, 22, 24, 25, 29 n5 n8 n9, 31 n24, 36, 41, 46, 56 n3, 59 n28, 60, 92, 95, 96, 101, 103–13, 117, 118, 122, 124 n9 n12 n13, 125 n18 n19 n22 n25, 126 n26 n28 n31, 127, 130, 138, 139, 141, 154, 163, 164–5, 176, 183, 190 n21, 194, 203, 213, 214, 217, 218, 221, 223 n5, 224 n16, 229, 232, 243, 253, 262, 264, 265, 284, 286, 288 n3
Pollock, J. 40, 48, 55, 59 n37, 72, 101, 117, 195, 231
Pope-Hennessy, J. 57 n11
popular culture 84
portraits 103
post-colonialism 23, 115, 150, 276–80
post-epistemological age 25
post-impressionism 278
post-modernism 23, 48, 52, 78–9, 150, 189–90 n17, 196–202, 209–13, 277
Post-painterly Abstraction 211
post-structuralism 23, 40, 46, 85, 87, 126 n32, 187, 192–222, 230, 242, 272, 277
Poster, M. 156 n1
Potts, A. 91 n23, 227, 246–57, 258 n10

Poulantzas, N. 224 n17
Precisionism 232
prejudices 36–7
presence 198–203, 210, 220
Preziosi, D. 39, 40, 56 n1, 57 n14, 191
primitivism 152–6, 164, 198, 235, 270, 276
private schools 21
producers 16, 49, 71, 152, 194
product 217–18
production 17, 109, 120, 144, 195, 213, 229
profits 14
projection 246–57, 271
prints 13, 14, 19
psychoanalysis 40, 42, 46, 48, 59 n32, 88, 114, 123, 126 n32, 130–56, 157 n13, 158 n16, 162–3, 184, 185–6, 187, 195–6, 198, 203, 206, 217, 231, 242, 243, 244–5, 246–57, 282–5
psychology 99, 151, 153, 170
'the public' 67, 71, 72, 83, 89–90 n13, 90 n15, 99, 116, 118, 120, 130, 143, 162, 176, 195, 222 n2, 235, 256

quality 15, 235

race 257, 267–88
radical relativism 24, 25, 33 n35
Rampley, M. 41, 58 n17
Rand, E. 159
Raphael 101, 148–9
Rauschenberg, R. 206
reader-reception theory 186, 189 n12
readers 1–6, 27, 28, 172, 186, 207–8
reading 13, 41, 51, 59 n30, 80, 186, 258 n13
Reagan, Ronald 200, 208
real history 22
realism 66, 68, 82, 84, 91 n27, 111, 119, 167, 174–5, 180–2, 186, 201
reality 11, 84, 87, 91 n25, 174–5, 178, 201, 249, 251
recuperation 64–5, 98–9, 104, 113, 118
reductivism 111, 122, 165, 229
Rees, A.L. and Borzello, F. 28 n1
Reese, T.F. 32 n30
reflection 12, 70, 112, 165, 177, 183, 211, 220
reformism 113, 119
Regnault, J.-B. 255
Reich, W. 157 n9
relative relativism 24, 57 n6
Rembrandt/'Rembrandt' 102, 183–8, 194, 258 n11, 280
Renaissance 38, 39, 43, 99, 102, 109, 145, 148, 170, 173, 178–9, 182, 189 n10, 198, 269, 276

representation 8, 11, 13, 14, 15, 16, 18, 24, 25, 39, 42, 51, 52, 68, 82, 83, 85, 121, 130, 147, 168, 176, 177, 202–3, 218–22, 240, 251, 257 n2, 272–6
restitution of cultural property 289 n8
restoration 18
revisionism 98, 123 n3, 280
revolution 67, 68, 89 n11, 89–90 n13, 97, 99, 119, 123 n3, 211
Reynolds, D. 226
Reynolds, J. 179
Riegl, A. 8, 23, 41, 51, 57 n9, 58 n19, 60 n40, 179
Rifkin, A. 9, 13, 22, 25, 29 n3 n9, 33 n36, 39, 41, 43, 58 n17 n24, 60, 218, 264
Rivers, P. 274
Robinson, H. 259
Rococo 123 n6
romanticism 75–6, 101, 142, 254–7
Rose, J. 159
Rosler, M. 33 n36, 114, 223 n8
Rosolato, G. 158 n15
Ross, A. 226
Rossi, P. de 104, 112
Rousseau, J.-J. 251
Rousseau, T. 222
Rowbotham, S. 32 n32, 124 n15, 288 n4, 289 n15
Royal Academy of Art, London 73, 103, 163, 275
Royal Academy, France 76
Royal Commissions 86
Rubin, W. 53, 60 n42
Rushdie, S. 277
Russian Revolution 67
Ryle, M. 225 n26, 290

Said, E. 289 n9, 290
Saint Simonism 237–8, 239
Salon des Refuses 74
Sand, G. 236
Sandwell, B. 32 n29
Sartre, J.-P. 57 n11, 149
Saussure, F. de 51, 188 n2 n7
Saxl, F. 8
Schapiro, B. 259
Schapiro, M. 8, 42, 93, 161, 166–70, 188 n5 n6, 189 n9, 191, 194
Scharfstein, B.-A. 258 n8, 259
Schefer, J.-L. 145, 158 n15
Schiff, R. 26, 34 n37
Schlosser, J. von 8
Schnapp, J.T. 157 n9
Schneider Adams, L. 32 n29
science 23, 24
scopocentric 15, 27, 42
scopophilia 134–56
scopophobic 15, 42

scoposceptic 15, 42
Screen (UK) 93, 135, 144, 156 n4, 259
sculpture 13, 14, 16, 17, 19, 138–43, 246–51
Sebeok, T. 224 n19
Seddon, P. 223 n3
Sedlmayr, H. 38, 57 n10
seeing 13–14, 17, 42, 81, 84–5, 210
Segal, H. 157 n13
Segal, L. 32 n32, 124 n15
selection 15, 16, 18, 27, 30 n16
semiotics/semiology 7, 41, 42, 46, 54, 88, 144–7, 184, 188 n7, 207–8, 217–18
sensations 14
separatist feminism 23, 107, 115, 119, 136, 231, 265
Seurat, G. 90 n15
sexual difference 106–10, 134–9, 147, 163, 194, 202, 229, 249, 258 n6
sexual inequality 109
sexualised human body 222, 232–57
sexual orientation 20, 24, 134–8, 232–57, 257 n5
sexual relationships 132–56
Sharon, M. 114
Sherman, C. 86, 112
Shor, I. 33 n36
signs 7, 144, 155, 162–88, 188 n7, 213, 220
Silverman, K. 159
Sistine Chapel ceiling 18
Situationists 64, 88 n3, 212, 225 n23
sketch 74–5
slavery 268–71
Sloane contingent (upper-class Londoners) 21
Smith, T. 91 n26
Smithsonian Institution National Museum of American Art, Washington DC 77
social: change 3, 4, 28; change art 114–18, 139; order 5, 106, 147–52; processes 9, 48, 106, 177; radicalism 6; realism 67, 87; relations 3, 19; sciences 5, 6, 13, 37
social history of art history 1, 11, 18, 21, 27
socialisation 100
socialism 12, 21, 43, 68, 88, 108, 119, 202, 211, 213, 230, 231, 233, 265, 282
socialist-feminism 32 n32, 103, 108, 115, 229
socialist revolution 3–4, 123 n4
socialists 19, 23, 29 n3, 84, 131
society 6, 7, 8, 26, 68, 76, 96, 99, 101, 105, 115, 134, 156 n5, 163, 164, 174, 195, 217, 222 n1, 233, 254, 257 n1, 287–8
Society of Architectural Historians (US) 30–1 n16

sociology 99, 210, 242
Southampton Museum of Art, New Hampshire 90–1 n21
soviet 68, 89 n11
Soviet Socialism 89 n11
Soviet Socialist Realism 67
space 222
Spanish-American War 90–1 n21
Spare Rib (UK) 124 n9
Spector, Jack 157 n6, 159
Spencer, J. 32 n29
Squiers, C. 226
standards 37
Starr, P. 30 n14, 88 n4, 156 n1, 158–9 n21, 189 n11, 258 n7
'the state' 24, 67, 75–6, 78, 91 n26, 102, 105, 163, 221, 251
Steele,T. 225 n26, 290
structuralism 7, 10, 23, 31 n21, 42, 46, 48, 59 n32, 85, 88, 139, 141, 144–7, 162–88, 188 n2, 194–222, 277
structuration 224 n11, 277
structure 23, 49–56, 69, 73, 79, 98, 100, 105, 107–9, 115, 118, 130, 144–7, 162–88, 194–222, 222 n1, 224 n11, 243, 252, 272, 277
Stubbs, G. 81
students 2, 3, 4, 5, 6, 9, 16, 19, 135, 211
style 16, 50–1, 66, 88–9 n5, 123 n6, 152, 168, 205, 210, 254
subculture 205–8
the subject 134–8, 141, 146, 147–52, 163, 194–222
surface 204–8, 210
surrealism 79, 212
surveillance 87
symbol 8, 9, 137, 142–3, 152–6, 233–4, 245–6

Tagg, J. 16, 31 n24, 63, 65, 84–8, 91 n28, 93, 144, 181, 190 n20, 201, 218, 231, 263, 264
taste 21, 22, 83, 195, 200
technology 85, 181, 200, 270
teleology 212
television 5, 14, 18, 135, 210, 213
Testaferri, A. 159
textbooks 2
texts 10, 11, 12, 13, 15, 16, 17, 18, 21, 26–7, 184, 218, 271
textuality 144, 165–6
Thames and Hudson publishers 9
Thatcher, Margaret 197, 200
theory 6, 7, 14, 17, 19, 20, 27–8, 31 n21 n26, 33 n34
Theory 5, 17, 27, 31 n21, 196
Thomas, N. 289 n9, 290
Thompson, E.P. 82, 287, 289 n16
Tickner, L. 44–5, 59 n28, 127, 257 n5

Timpanaro, S. 125 n17, 225 n29
totalisation 212
totalitarianism 159 n21
Touraine, A. 88 n4
tourism 220–2
tradition 4, 7, 8, 9, 12–13, 21, 23, 24, 27, 46, 66, 69, 71, 73, 83, 123–4 n7, 131, 153, 169, 181–2, 278–80
truth 2, 3, 11, 25, 241, 252–3, 271
Turkle, S. 59
typification 111

Uffizi Museum, Florence 269
universities 2, 3, 5, 6, 7, 9, 14, 18–19, 20, 21, 22, 25, 33 n36, 65, 96, 99, 103, 118, 131, 186–7, 210, 230, 252, 262, 265–6, 285
University of California, Berkeley 48
useful knowledge 3
utopianism 79–80, 87, 122, 133, 171, 211, 212, 213, 237–8, 268, 280, 286, 288–9 n5

Vaizey, M. 81
Valadon, S. 124 n7
Valéry, P. 57 n11
value 4, 6, 8–9, 10–11, 12, 13, 14, 17, 18, 19, 24, 25, 27, 31 n22, 36–8, 43, 50–6, 72, 73, 80, 81, 85, 100–1, 104, 115, 119, 120, 139, 169, 187, 199, 215–8, 219, 228, 244, 247–57, 272
Van Eyck, J. 181
Van Gogh, V. 9, 26, 41, 101, 125 n18, 173, 183, 184, 190 n21, 194, 280
Vasari, G. 104, 171
Vassar College 96
Vermeer, J. 180, 185
video 14, 87
Vietnam War 3
Vigée-Lebrun, E. 123 n6
vision 26, 148–50, 186
'the visual' 14, 42, 43, 80, 190 n17, 198
visual culture 14, 24, 26, 181, 183, 213, 268–9, 273
visual-ideological 81, 111
visualisation 181–2
visuality 150, 282
visual poetics 185
Vogue (US) 59 n37
voyeurism 133–8, 150, 186, 231, 282–5

Wagner, A. 26, 95, 118–23, 126 n30 n32, 131, 154, 156, 194, 195, 230, 231, 232, 236, 243
Wainwright, H. 32 n32, 124 n15
Waldman, D. 226
Walker, J.A. 32 n29
Wallace, M. 226, 281

Wallach, A. 8, 29 n5, 59 n28, 63, 65, 66, 76–81, 90 n20, 90–1 n21, 91 n22, 92–3, 151, 162, 229, 272, 288 n3
Wallis, B. 29 n11, 226
Walters Art Gallery 124 n11
Warburg, A. 8, 36, 41, 44, 58 n17
Warhol, A. 102
Warnke, M. 30 n15
Weber, M. 41
Werckmeister, O.K. 7, 8, 21, 28 n3, 29 n4, 91, 93, 288 n2
West German art history 7, 15
White, H. 22
Whitney Museum of American Art, New York 121, 283
Wilde, O. 233
William, Prince 20–1
Williams, R. 22, 29 n12, 89 n9, 125 n17, 188 n1, 190 n19, 224 n20, 225 n25 n28, 259, 287, 289 n16, 290
Williamson, J. 225 n25, 290
Wilson, J.J. 124 n13, 281
Wilson, R. 81, 91 n23
Winckelmann, J. 246–51
wish 247–57, 269, 271, 272, 280
Witzling, M.R. 125 n22, 127
Wolff, J. 222 n1

Wölfflin, H. 8, 23, 36, 178
Wollen, P. 156 n2, 158 n15, 191
women 7, 44, 96–123, 185–6, 256
Women Artists' Slide Library 264
Women's Art Alliance 264
Women's Art History Collective 124 n9, 264
Women's Health Information Centre, London 114
Women's Liberation Movement 96, 124 n9
Women's Movement 14, 15, 21, 110
Women's Workshop of the Artists' Union (US) 264
Wood, P. 91 n27
Woods, C.S. 57 n10, 58 n21 n22
works of art themselves 13, 17, 18, 27, 49
World War I 57 n8, 60 n39, 234
World War II 13, 16, 90 n22, 117, 120, 246, 288–9 n5

Yale University 121
Yalter, M. 114
Young-Bruehl, E. 157 n13

Žižek, S. 223 n6
Zoffany, J. 102–3, 163
Zuccarelli, F. 84